ICONOGRAPHY AT THE

CROSSROADS

INDEX OF CHRISTIAN ART

OCCASIONAL PAPERS II

Iconography at the Crossroads

PAPERS FROM THE COLLOQUIUM

SPONSORED BY THE INDEX OF CHRISTIAN ART

PRINCETON UNIVERSITY

23–24 MARCH 1990

·

EDITED BY

Brendan Cassidy

INDEX OF CHRISTIAN ART

DEPARTMENT OF ART AND ARCHAEOLOGY

PRINCETON UNIVERSITY

Copyright © 1993 by the Trustees of Princeton University
Published by the Department of Art and Archaeology,
Princeton University, Princeton, New Jersey 08544-1018

Library of Congress Cataloging-in-Publication Data

Iconography at the crossroads : papers from the colloquium
sponsored by the Index of Christian Art, Princeton University,
23–24 March 1990 / edited by Brendan Cassidy
p. cm. — (Occasional papers / Index of Christian Art)
Includes bibliographical references and index.
ISBN 0-691-03212-2. — ISBN 0-691-00037-9 (pb.)
1. Christian art and symbolism—Medieval, 500–1500.
2. Art, Medieval—Congresses. 3. Art, Byzantine—
Congresses. 4. Art, Renaissance—Congresses. I. Cassidy,
Brendan. II. Princeton University. Dept. of Art and
Archaeology. Index of Christian Art. III. Series: Occasional
papers (Princeton University. Dept. of Art and Archaeology.
Index of Christian Art) ; 2.
N7850.I26 1993
704.9′ 482′ 0940902—dc20 93-16268

This book is printed on acid-free paper,
and meets the guidelines for permanence and
durability of the Committee on Production Guidelines
for Book Longevity of the Council on Library Resources.
Printed in the United States of America
by Princeton University Press
Princeton, New Jersey 08540

10 9 8 7 6 5 4 3 2 1

TO THE MEMORY OF

HOWARD MAYER BROWN

AND

WENDY WEGENER

Contents

•

Preface

•

THE AIM of the conference *Iconography at the Crossroads* was to provide a forum for examining the various ways in which historians approach the iconography of medieval and Renaissance art. The increasing importance of images in historical scholarship and the current reevaluation of the practice of art history suggested that the time was right to assess the position of iconography in these intellectual crosscurrents. Both art historians and scholars in other fields were invited to contribute. One criterion in selecting the speakers was that they should represent a broad spectrum of approaches.

The first, very heartening, conclusion was that iconography was still the focus of exciting and innovative research, and the attendance of over 350 people at the two-day conference attested to its still considerable attractions. To all our speakers I should like to express my deepest gratitude for making the conference a singularly rewarding occasion. To those among the Princeton faculty, Margaret Bent, Slobodan Ćurčić, and William Jordan, who presided over some of the sessions, I offer thanks.

The organization of such an event is inevitably a collaborative effort, often demanding extra-curricular skills that people did not know they had. My colleagues in the Index, Adelaide Bennett, Lois Drewer, and Robert Melzak, were ever-ready to offer advice and assistance. Marie Holzmann, who shouldered the burden of many of the organizational details, applied herself to the task with her usual diligence and good will. John Blazejewski, the Index photographer, was ever-patient and helpful on the many occasions when I interrupted his routine to call upon his professional expertise.

In publishing this volume I have benefited enormously from the help of Brenda Gilchrist, our copy-editor; from Elizabeth Powers at Princeton University Press; from Phillip Unetic, our designer; and from my colleagues in the department, especially Mary Vidal, who read and commented on some of the papers, and Robert Bagley, who provided much-appreciated advice and support. The former chairman of the department, Yoshiaki Shimizu, remained enthusiastic and interested in the progress of the volume. And, in ways too numerous to mention, my wife, Ann Gunn, rendered encouragement and practical help as the book inched its way to completion.

Leaving my heaviest debt to last, I wish to acknowledge two people with whom I have worked closely for some years: Christopher Moss and Katherine Kiefer. As coordinators of the Department of Art and Archaeology's publication program, their task is not an easy one. To them fall the inevitable chores involved in publishing. Besides proofreading, typesetting, and overseeing all aspects of production, they are the ones to track down the elusive page

references that an author omitted from a footnote. They seek out the photograph that will replace the out-of-focus snapshot that a contributor submitted to substantiate the central point of his argument. Assailed by the importunate demands of writers and editors, printers and designers, they carry out their work assiduously and with good humor, all the while treading deftly to avoid ruffling feathers. It has been an education and a pleasure to work alongside them.

Our work was not completed without a note of sadness. Wendy Wegener, who recently received her Ph.D. in art history from Princeton and who translated from German the paper of Wolfgang Kemp, died suddenly in 1992. She was looking forward to seeing the results of her labor in print. With her untimely death we have been robbed of the pleasure of future collaboration. And as the book was going to press the newspapers reported the unexpected death of Howard Mayer Brown in Venice. As the obituarist in *The New York Times* made clear, his death has deprived the history of music of one of its most distinguished scholars. This volume is dedicated to the memory of them both.

BRENDAN CASSIDY

List of Illustrations

•

0.2.40, fol. 57v (photo: courtesy of the Master and Fellows of Trinity College)

Richard Trexler, "Gendering Jesus Crucified" (following p. 119)

1. The Master of Rohan, Crucifixion and Phinehas Punishing the Lovers, from Book of Hours, 1420–30. Paris, Bibl. Nat., MS. lat. 9471, fol. 237 (photo: Bibliothèque Nationale)

2. Laurent de La Hyre, Mary Magdalen at the Foot of the Cross, ca. 1630, oil on canvas. Saint-Denis, Musée d'Art et d'Histoire (photo: Musée d'Art et d'Histoire)

3. Matthias Grünewald, Resurrection, from the *Isenheim Altarpiece*, ca. 1512–16, oil on wood. Colmar, Unterlinden Museum (photo: Giraudon/Art Resource)

Wolfgang Kemp, "Medieval Pictorial Systems" (following p. 133)

1. Scenes from the Life of Christ, early fifth century, ivory diptych. Milan, Museo del Duomo (photo: Hirmer Fotoarchiv)

2. Scenes from the Life of Christ, early fifth century, ivory diptych. Milan, Museo del Duomo (photo: Hirmer Fotoarchiv)

3. Scenes from the Prodigal Son, around 1425, embroidery. Marburg, Universitäts Museum (photo: Bildarchiv Foto Marburg)

4. Tabula Odysseaca "Tomassetti," stone relief. Vatican, Museo Sacro (after A. Sadurska, *Les tables iliaques*, Warsaw, 1964, pl. 16)

5. Mithraic relief. Wiesbaden, Städtisches Museum (photo: Bildarchiv Foto Marburg)

6. Ceiling painting, third quarter of twelfth century. Zillis, St. Martin (photo: Bildarchiv Foto Marburg)

7. Schematic rendering of ceiling painting. Zillis, St. Martin (after W. Myss, *Bildwelt als Weltbild. Die romanische Bilderdecke von St. Martin zu Zillis*, Beuron, 1965, fig. 3)

8. Ceiling painting, detail. Zillis, St. Martin (photo: Bildarchiv Foto Marburg)

9. Ceiling painting, detail. Zillis, St. Martin (photo: Bildarchiv Foto Marburg)

10. Hereford World Map, late thirteenth century. Hereford Cathedral (after B. Hahn-Woernle, *Die Ebstorfer Weltkarte*, Stuttgart, 1987, pl. 20)

11. Ebstorf World Map, around 1235. Ebstorf Cloister (after B. Hahn-Woernle, *Die Ebstorfer Weltkarte*, Stuttgart, 1987, pl. 24)

12. Marcantonio Raimondi, *Quos Ego*, engraving, after 1516

Marilyn Aronberg Lavin, "Piero della Francesca's Iconographic Innovations at Arezzo" (following p. 149)

Diagram A (p. 140). Florence, Santa Croce, chancel. Disposition of the cycle of the True Cross, Agnolo Gaddi

Diagram B (p. 141). Arezzo, San Francesco, chancel. Disposition of the cycle of the True Cross, Piero della Francesco

1. San Francesco, Arezzo, general view of chancel (photo: Alinari)

2. Agnolo Gaddi, Story of Adam's Death, 1388–92, Florence, Santa Croce, chancel, right lunette (photo: Alinari)

3. Piero della Francesca, Story of Adam's Death, 1452–66. Arezzo, San Francesco, chancel, right lunette (photo: Soprintendenza per i Beni Artistici e Storici, Florence)

4. Piero della Francesca, Sheba Venerates the Wood, 1452–66. Arezzo, San Francesco, chancel, right wall, second tier left (photo: Soprintendenza per i Beni Artistici e Storici, Florence)

5. Piero della Francesca, The Meeting of Solomon and Sheba, 1452–66. Arezzo, San Francesco, chancel, right wall, second tier right (photo: Soprintendenza per i Beni Ambientali Architettonici, Artistici e Storici, Arezzo)

6. Piero della Francesca and assistant, Burial of the Wood, 1452–66. Arezzo, San Francesco, chancel, altar wall, second tier right (photo: Alinari)

7. Piero della Francesca, Annunciation, 1452–66. Arezzo, San Francesco, chancel, altar wall, third tier left (photo: Alinari)

8. Piero della Francesca, The Dream of Constantine, 1452–66. Arezzo, San Francesco, chancel, altar wall, third tier right (photo: Soprintendenza per i Beni Ambientali Architettonici, Artistici e Storici, Arezzo)

ICONOGRAPHY AT THE

CROSSROADS

Introduction: Iconography,
Texts, and Audiences*

•

BRENDAN CASSIDY

T HE TITLE of this volume is adapted from that of a famous essay by Erwin Panofsky, *Hercules at the Crossroads*.[1] Besides conjuring up the spirit of one of the luminaries of iconography, it is meant to suggest that iconography stands at the crossroads of several disciplines, all of which draw upon images as a source of information for their particular areas of inquiry. Included here are essays by scholars employed in departments of literature, history, music, and medicine who have ventured beyond the traditional confines of their own fields to make themselves at home in art history. And the title has yet a third implication, namely that iconography stands at a particular turning point in its own history: its role in the study of medieval and Renaissance imagery is no longer quite as clear-cut as it used to be.

Given the countless books and articles announcing themselves as iconographic studies, it is surprising that there is some confusion about what iconography is. One of the most successful definitions has the merit of being all embracing yet concise: "the term 'iconography,'" writes Bialostocki, "applies to the descriptive and classificatory study of images with the aim of understanding the direct or indirect meaning of the subject matter represented."[2] This covers it fairly well: iconography describes, classifies, and interprets subjects represented in the visual arts. The formula is clear enough. The practice, however, is not, and the sticking point is interpretation. How are images to be interpreted? What can iconography tell us about the past and what should we not expect it to tell us, or, put another way, where should we locate the limits of interpretation? How does the period eye of the twentieth-century viewer affect interpretation?[3] What is the epistemological status of the interpretation we elicit from the mute image and how are we to choose among conflicting interpretations of the same work? And finally, what kinds of relationship exist between texts and images? The reader will find some of these questions addressed, either directly or indirectly, in this volume. Although some of our contributors might prefer to distance themselves from a practice

* I should like to thank Robert Bagley, Pamela Sheingorn, Dorothy Glass, Katherine Kiefer, and Christopher Moss, who read this essay in draft form and made valuable suggestions for its improvement.

[1] *Hercules am Scheidewege und andere Bildstoffe in der neueren Kunst* (Studien der Bibliothek Warburg, XVIII), Leipzig and Berlin, 1930.

[2] *Encyclopedia of World Art*, vol. VII, London, 1963, s.v. "Iconography and Iconology," 770.

[3] For the concept of the 'period eye' see M. Baxandall, *Painting and Experience in Fifteenth Century Italy*, Oxford, 1972.

they consider reactionary and out-of-date, the fact that visual subject matter serves as the point of departure for their essays allows us to enroll them for the purposes of this volume in the ranks of the iconographers.

Art history has of late been condemned for what are seen as inadequacies in its traditional practice. It has been criticized for adhering to outmoded forms of enquiry and for its reluctance to exploit methodologies pioneered in other branches of the humanities and social sciences.[4] Of those twin pillars of the discipline, style and iconography, the former in particular has been subjected to severe censure. The study of style has come to be regarded in some quarters as the banal identification of similarities and transmitted influence. Style analysis as the instrument of the connoisseur is seen as an arcane pursuit practiced by an elite in the service of the art market. A more searching criticism is that style history has for too long been a hermetically closed discipline. Its exponents are seen to cross and recross the same well-trodden paths without feeling the need to venture into the surrounding countryside. Students are taken on a tour from one masterpiece to the next, stopping only to compare the drapery folds of the Madonnas of Master A and Master B. One style begets another style, artists influence other artists, but the impact of extra-artistic factors rarely enters the discussion. A token nod in the direction of social context with a reference, say, to the patron of an altarpiece, is considered all that is required to acknowledge that art indeed is part of the larger cultural, economic, religious, and social experience of humankind. This may be an outdated caricature of a certain kind of art history. Its currency, nowadays, has been considerably diminished by the self-consciousness that theorists both inside and outside art history have imposed on the discipline. But it was not so long ago that such an approach prevailed.

Compared with style, iconography seems to have fared rather better in the current bout of self-examination brought on by art history's identity crisis. As practiced by the 'Warburg School,' iconography could scarcely be accused of a myopic fixation on exclusively artistic evidence. Neither could it be arraigned for focusing only on the canon,[5] for although over-extended library budgets might benefit from a moratorium on iconographic studies of Giorgione's *Tempesta* and anything painted by Bosch, iconographers generally have been attracted to what is iconographically interesting rather than what is conventionally regarded as great art.[6] But, in art history's examination of conscience, iconography has not totally escaped blame. And much of the criticism has come from the practitioners themselves. In this respect the recent history of iconography differs from that of style, where the criticism has been more wholesale and has been meted out by scholars unsympathetic to the very notion of style criticism and connoisseurship.

[4] The most trenchant criticism is found in Norman Bryson's introduction to *Calligram. Essays in New Art History from France*, Cambridge, 1988.

[5] These are two of the most frequently heard criticisms of art history. See, for instance, V. Burgin, "Something about Photography Theory," in *The New Art History*, ed. A. L. Rees and F. Borzello, London, 1986, 41–42.

[6] As Gombrich noted of Warburg, "Sometimes he hardly appeared to differentiate between the design for a postage stamp and a great painting." See E. H. Gombrich, *Aby Warburg: An Intellectual Biography*, 2nd ed., Oxford, 1986, 317.

The modern study of iconography has reached us along various lines of descent: via the French tradition, with its interest in textual sources, best exemplified by Emile Mâle; through the Princeton school, with its greater emphasis on traditions of visual representation, most usually identified with Charles Rufus Morey; and from Germany through the interdisciplinary and intercultural approach pioneered by Aby Warburg.[7] This last inspired a great deal of Anglo-American research in the post-war period and helped rescue art history from the prevailing formalist approach which relegated iconography to the diagnostic role of substantiating the dates and origins of works of art. The seeds of change were sown in England and America in the 1930s, and iconography played a pivotal role in the more broadly based methods that some scholars were advocating. Meyer Schapiro, politically sympathetic to Marxism, called for an art history that studied art within the social and political context of its production.[8] Scholars such as Fritz Saxl and Edgar Wind of the Warburg Institute, which had recently transferred from Hamburg to London, encouraged an interdisciplinary *Kulturwissenschaft* in contrast to the aestheticism that had dominated English writing on art.[9] But of the great number of art historians who left Germany and Austria ahead of the rising tide of Nazism, none was to be more influential than Erwin Panofsky. Panofsky practiced a brand of scholarship that, to borrow a metaphor from his mentor Aby Warburg, refused to be hemmed in by the police who patrolled the boundaries of art history.[10] With his formidable erudition, Panofsky was well equipped to range widely across the literature, philosophy, and theology of a period, drawing the most disparate evidence into his purview in order to determine what he called the intrinsic meaning of works of art. For Panofsky art was one of a number of symptoms, or to use the term that he adopted from Cassirer, 'symbolical values,' "which reveal the basic attitude of a nation, a period, a class, a religious or philosophical persuasion."[11] The historian's task was to diagnose, for instance, the political or religious implications suggested by the choice of a particular theme and the way it was represented. This interpretative program, christened 'iconology' by Warburg, proved an extremely attractive alternative to the prevailing history of style.[12] Not only did it provide occasion for impressive displays of learning, it offered a clearly-defined procedure for investigation as well. By immersing oneself in a culture one was supposed to emerge with a richer understanding of the society from which an image derived and thus better prepared to recognize its implicit

[7] Studies of Warburg continue to accumulate. See most recently *Aby Warburg. Akten des internationalen Symposions, Hamburg 1990*, ed. H. Bredekamp, M. Diers, and C. Schoell-Glass, Weinheim, 1991, with references to earlier studies.

[8] See Schapiro's article, "Nature of Abstract Art," *Marxist Quarterly*, I, 1937, 77–98; reprinted in M. Schapiro, *Modern Art. 19th and 20th Centuries: Selected Papers*, New York, 1982, esp. 187–88.

[9] On Saxl see G. Bing, "Fritz Saxl (1890–1948): A Memoir," in *Fritz Saxl 1890–1948. A Volume of Memorial Essays from his Friends in England*, ed. D. J. Gordon, London, 1957, 1–46.

[10] See the remark in A. Warburg, "Italienische Kunst und internationale Astrologie im Palazzo Schifanoja zu Ferrara," in *Atti del X Congresso internazionale di Storia dell'arte in Roma, 1912. L'Italia e l'arte straniera*, Rome, 1922, 191; reprinted in his *Gesammelte Schriften*, vol. II, Leipzig and Berlin, 1932, 478–79.

[11] E. Panofsky, *Studies in Iconology: Humanistic Themes in the Art of the Renaissance*, Oxford, 1939, 7.

[12] Warburg seems to have first used the term iconology in the lecture he delivered before the congress of art historians in Rome in 1912; see W. S. Heckscher, "The Genesis of Iconology," in *Stil und Überlieferung in der Kunst des Abendlandes. Akten des 21. Internationalen Kongresses für Kunstgeschichte, Bonn 1964*, Berlin, 1967, III, 239–62; reprinted in W. S. Heckscher, *Art and Literature. Studies in Relationship*, ed. E. Verheyen, Durham, N.C. and Baden-Baden, 1985, 253–80.

meaning.[13] In the process of immersion texts were uncovered that helped to explain iconographies. In a later formulation of iconological theory in relation to Netherlandish painting, Panofsky took even further the notion of iconography as symptomatic.[14] He suggested that artists deliberately encoded doctrinal and other messages within images. Rather than what they appeared to be, naturalistic slices of contemporary Netherlandish life, the domestic and church interiors of Jan van Eyck or Rogier van der Weyden contained in fact networks of religious symbols masquerading as everyday objects. The historian's task was to reveal them for what they really were.

"Disguised symbolism," the notion that details of seemingly straightforward images carried ulterior meanings, proffered enticements that many scholars were unable to resist. Not only was there the challenge of an intellectual puzzle, but the solution was to be found in the scholar's preferred haunt, the library. Panofsky's iconology was infectious. He swept up in his wake scores of eager young historians in thrall to the sheer intellectual excitement of his approach. In attempting to emulate the master's erudition many abandoned themselves to an orgy of text hunting in the indices of the *Patrologia Latina*, in search of that textual nugget that would reveal the secret of a Netherlandish triptych or an Italian fresco. The reader could follow the course of the hunt through a covert of impressively recondite footnotes whose length at times threatened to bundle the body of the text off the page. Perhaps not surprisingly, the scope for scholarly ingenuity and imagination that iconology offered was also the source of the disrepute into which it has fallen. Panofsky himself was to become aware of the preposterous conclusions to which the indiscriminate application of iconology could lead as he saw his approach travestied by many less gifted followers.[15] Recent years have seen a reassessment of such practices and of the presuppositions, particularly regarding "disguised symbolism," on which iconology was based.[16]

A unifying thread seems to connect the various criticisms made of iconography; texts, in one way or another, have been implicated in iconographical malpractice. Much that is unsatisfactory in iconographical writing has stemmed from an excessive reliance on and a misuse of texts. This may be understandable, since the written word provides the milieu in which

[13] A recent critic of this approach has suggested that what you achieve in fact is a more thorough knowledge of the general culture rather than of the particular object under scrutiny; see J. F. H. H. Vanbergen, *Voorstelling en betekenis. Theorie van de kunsthistorische interpretatie*, Louvain, Assen and Maastricht, 1986, as cited in J. B. Bedaux, *The Reality of Symbols. Studies in the Iconology of Netherlandish Art 1400–1800*, The Hague, 1990, 10.

[14] E. Panofsky, *Early Netherlandish Painting*, Cambridge, Mass., 1953, chapter 5.

[15] Panofsky regretted that his method had been so misused; see Bedaux (as in note 13), 14.

[16] See, for instance, C. Harbison, "Religious Imagination and Art-historical Method: A Reply to Barbara Lane's 'Sacred Versus Profane'," *Simiolus*, XIX, 1989, 198–205. Panofsky himself has been subjected to a barrage of often intemperate, and sometimes unjustifiable, criticism; see especially D. Preziosi, *Rethinking Art History: Meditations on a Coy Science*, New Haven and London, 1989, 111–121. Ironically, in France, the homeland of much of the theory which some scholars would like to see replacing traditional art historical methodologies, Panofsky continues to enjoy considerable prestige as a theorist; see the papers by various authors published by the Centre Georges Pompidou, *Erwin Panofsky*, Paris, 1983. He has even been mentioned alongside Saussure in the pantheon of early semioticians by G. C. Argan, "Ideology and Iconology," *Critical Enquiry*, II/2, 1975, 299, 303; see also the remarks of M. Bal and N. Bryson, "Semiotics and Art History," *Art Bulletin*, LXXIII, 1991, 174; and C. Hasenmuller, "Panofsky, Iconography and Semiotics," *Journal of Aesthetics and Art Criticism*, XXXVI, 1978, 289–301.

academics, even art historians, are most comfortable. The visual is more intractable, offering only ambiguous answers to many of the questions that the text-bound historian is inclined to ask. However, it is not the appeal to texts for clarification of the meaning of an image that is the issue, for iconography would scarcely be possible without texts. It is rather the tendency to reduce art to illustration of particular kinds of texts and the inclination to account for medieval and Renaissance images as if they were verbal statements made by non-verbal means. Equally problematic is the failure to appreciate the complexity of the relationships between words and images.[17]

A major failing of a certain kind of iconographical writing was that it adopted a method popularized by Panofsky in his study of certain types of painting and applied it indiscriminately to all kinds and periods of art. Among iconographers it became normative to attempt to discover a textual source that would explain what an image meant at the time it was made. This approach is inappropriate for many types of image.[18] In addition, the texts among which meanings were sought were predominantly the writings of medieval churchmen, and classical authors and their humanist admirers; again this approach is warranted only in some contexts. Imaginative sleuthing among the byways of theology and literature may be justified when dealing with the imagery created for Dominican chapter houses and the *studioli* of Italian noblewomen. But the large numbers of people who looked upon frescoes in their parish churches, the merchants who commissioned altarpieces, and the ladies for whom books of hours were made were not intellectuals with minds well-stocked with abstruse learning. These audiences would have viewed images within frames of reference that had little to do with the bookish learning of monks or humanists.

What is true of the audience is equally true of the artist. With some notable exceptions (Mantegna, Leonardo, and Rubens come to mind), artists were rarely scholars. It was not for their learning that they earned reputations. The proper object of their talents was to represent the characters and events of history, mythology, and religion in ways that were visually compelling. They would have made the same complaint to the overzealous iconographer that Turner made of Ruskin, "He knows a great deal more about my paintings than I do, he puts things into my head and points out meanings I never intended."[19] Only occasionally would artists have had to resort directly to written sources,[20] or receive from the often cited but

[17] The literature on the relationship between texts and images continues to proliferate. For particularly cogent general remarks, see M. Curschmann, "Images of Tristan," in *Gottfried von Strassburg and the Medieval Tristan Legend. Papers from an Anglo-North American Symposium*, ed. A. Stevens and R. Wisbey, London, 1990, 1–17.

[18] The significance of the intertwined beasts that decorate Insular carpet pages, for instance, is not to be found in texts. Their prime purpose was ornamental (whatever the atavistic impulse that might have accompanied their first use among the artists of the Dark Ages). They may have had connotations beyond the purely aesthetic, but they did not emerge from the artist's mind and hand because of something he read or had read to him. See on this issue most recently E. Kitzinger, "Interlace and Icons: Form and Function in early Insular Art," in *The Age of Migrating Ideas*, ed. J. Higgitt and M. Spearman, Edinburgh, 1993; and R. Bagley, "Meaning and Explanation," *Archives of Asian Art*, XLVI, 1993.

[19] Quoted in A. Wilton, *The Life and Work of J. M. W. Turner*, London, 1979, 222. Of course, Turner's remark begs many questions, but this is not the place to delve further.

[20] Among the few scraps of evidence of how late medieval artists dealt with unusual iconographies is a payment to Ciecho de la Gramatica for translating from the Latin into the vulgar tongue the life of the little-known San Savino that Pietro Lorenzetti was expected to paint. See P. Bacci, *Dipinti inediti e sconosciuti di Pietro Lorenzetti, Bernardo Daddi, etc. in Siena e nel contado*, Siena, 1939, 92.

rarely sighted humanist or theologian detailed instructions about the subjects they were expected to represent.[21] For most commissions they would have drawn from a common fund of oral lore and pictorial tradition. Late medieval painters would have *known* how to represent the *Flight into Egypt* and *Saint Francis Receiving the Stigmata*. Renaissance artists would have *known* the story of Diana and Actaeon. If they had to refresh their memories, a few popular texts would have provided for most iconographic eventualities: the Bible, the *Golden Legend*, and Ovid's *Metamorphoses*. But mostly their acquaintance with the stories would have been acquired in less deliberate, non-literary ways. And left to his own devices, the artist's sense of what was important in, for example, the account of a martyr's life would have as much to do with the pictorial possibilities of the narrative as any moral that the author or narrator of the text intended to convey.

The search for a moral or for some profound intellectual significance in images has bedeviled the study of iconography.[22] It has less to do with the medieval and Renaissance view of art than with the prevailing modern view that the function of art is to express emotions and ideas.[23] Only at some times, in some places, and in particular cultural milieux, were images created to convey philosophical propositions or subtleties of Christian doctrine. Medieval artists would have concurred with Dr. Johnson's observation that the visual arts are not well suited to communicate non-visual information and abstract ideas.[24] Altarpieces and portal programs make poor substitutes for Aquinas's *Summa Theologiae*. Artists were aware of this; they relied on texts in the form of inscriptions to ensure that their figures and scenes were correctly identified.

Audience, artist, and the medium itself, therefore, would seem to conspire against the once widespread notion that the thoughts and opinions of intellectuals consistently provide the most appropriate access to visual iconography. It has become clear that the meaning of works of art should be sought in a much wider range of human experience. Texts remain

[21] Skepticism about the role of intellectual advisors in determining iconographic programs has been expressed by C. Gilbert, "The Archbishop and the Painters of Florence," *Art Bulletin*, XLI, 1959, 83–85; idem, *Italian Art 1400–1500: Sources and Documents*, Englewood Cliffs, 1981, xviii–xxvii; and C. Hope, "Artists, Patrons and Advisors in the Italian Renaissance," in *Patronage in the Renaissance*, ed. G. F. Lytle and S. Orgel, Princeton, 1981, 293–343. For a documented instance of theologians' involvement see most recently E. Hall and H. Uhr, "Patrons and Painters in Quest of an Iconographic Programme: The Case of the Signorelli Frescoes in Orvieto," *Zeitschrift für Kunstgeschichte*, LV, 1992, 35–56.

[22] See on this most recently C. Harbison, "Meaning in Venetian Renaissance Art: The Issues of Artistic Ingenuity and Oral Tradition," *Art History*, xv, 1992, 19–37.

[23] Umberto Eco makes the point that demands of form rather than expression were more to the fore in medieval artistic practice and, "medieval theories of art are invariably theories of formal composition, not of feeling and expression." See U. Eco, *Art and Beauty in the Middle Ages*, trans. H. Bredin, New Haven and London, 1986, 41 (originally published as "Sviluppo dell'estetica medievale," in *Momenti e problemi di storia dell'estetica*, I, Milan, 1959, 115–229).

[24] Boswell records the following conversation with Dr. Johnson:

> When I (Boswell) observed to him (Johnson) that Painting was so far inferiour to Poetry, that the story or even an emblem which it communicates must be previously known, and mentioned as a natural and laughable instance of this, that a little Miss on seeing a picture of Justice with the scales, had exclaimed to me, "See there's a woman selling sweetmeats;" he said, "Painting, Sir, can illustrate, but cannot inform."

See J. Boswell, *The Life of Samuel Johnson*, Everyman ed., London, 1906, vol. II, 540. Pictures can, of course, convey information about the visible world much more satisfactorily than texts, but the thrust of Johnson's remark is surely correct.

fundamental as evidence of historical lives. But it is in the poetry and letters, the chronicles and inquisition records as much as in the dry abstractions of the scholastic treatise that the tastes and attitudes of people are revealed.

They may not be revealed directly, however, for texts, as we now know, are slippery. Authors often do not say what they mean or mean what they say. Sometimes what they do not say is more revealing than what they do say. Often they say what they say because others said it before them. And frequently the people whom they address do not agree about what is being said.[25] The unreliability of the written word should serve to undermine iconographers' confidence that when they have found texts which seem to account for visual themes or motifs that their work is complete. The connection between texts and images is more intricate. In the first place, the relationship between a text and the subject of a work of art is not the same as the relationship between a text and the art object itself. Texts rarely inspire works of art directly. And although they frequently provide art with its themes, the visual and textual explorations of these themes evolve along different tracks that seldom run parallel. Sometimes they converge when the turns taken by one tradition are followed in the other. Occasionally they might even meet.[26] But at other times the visual and the literary traditions lead quite separate existences, and their independence has not been sufficiently appreciated. Someone claiming that a text is the source of an image must also be prepared to demonstrate that their similarity is not simply adventitious. The Christian and classical traditions are sufficiently rich that they will rarely disappoint a conscientious researcher who looks hard enough in the corpus of texts for a reference to just about anything that a painter might have included in his picture.[27] Likewise it requires to be demonstrated rather than assumed that the meaning a textual commentator assigns, for instance, to an episode from the Old Testament, is equally applicable to its illustration in a work of art. Biblical exegetes offered conflicting, even contradictory interpretations of what texts meant. A more rigorous system of checks and balances needs to be applied in crediting texts with the inspiration for pictures.

The issue of textual sources for images raises another problem that has been ignored. Iconographers make use of those editions of texts (or convenient translations of them) that scholarly consensus has decided are the standard ones. Even assuming that early painters or their advisors did refer to texts for guidance, it was certainly not to the versions brought to us by Migne or Loeb.[28] A considerable distance often lies between the convenient editions on which historians rely and the manuscripts that they ostensibly represent. This may not affect

[25] Theoretical writing on the reception of texts has become a growth industry. One of the clearest expositions of the question is R. Chartier's "Texts, Printing, Readings," in *The New Cultural History*, ed. L. Hunt, Berkeley and Los Angeles, 1989, 154–75.

[26] When, in the 1370s, for example, the *Visions of St. Bridget* began to circulate in manuscripts a new pictorial formula for the Nativity of Christ appeared in Italy. The motifs found in some of the paintings so closely mirror details of Bridget's description of Christ's birth that here the new iconography clearly owes its genesis to a text. On the influence of Bridget's *Visions* see H. Cornell, *The Iconography of the Nativity of Christ*, Uppsala, 1924.

[27] The same point is made by Michael Baxandall, *Patterns of Intention*, New Haven and London, 1985, 132.

[28] See the remarks of S. Nichols, "Philology in a Manuscript Culture," *Speculum*, LXV, 1990, 1–9; and the introduction of L. A. Finke and M. B. Schichtman in *Medieval Texts and Contemporary Readers*, Ithaca, 1987.

interpretation significantly, since artists rarely if ever adhere scrupulously to a text even on those occasions when they have recourse to one, but it should introduce a note of caution.

Where does all of this leave the historian? The essentially textual culture to which the scholar belongs stands at some remove from the essentially oral and pictorial experience of the early artist. Much of the common knowledge shared by peoples of the past has since passed out of currency and now has to be learned, and reading remains the principal means of acquiring information. This constitutes the root of the iconographer's dilemma. Books, the tools of the scholar's trade, do not always provide the most appropriate way of approaching the shifting and not readily circumscribable world of the early artist. To bridge the cultural gap requires a sensitivity to this fundamental difference in the mental landscapes. Scholars may have to avail themselves of texts to gain entry to unfamiliar subjects or to reconstruct the contexts in which works of art once made sense. But they must also know when to let go of their texts and approach images on their own terms and on terms that would have been familiar to their creators. The elements of style (composition, line, and color) are themselves meaningful in ways that have been insufficiently explored. Historians must accept that those who live by the pen and those who live by the brush or chisel work to quite separate agendas, and consider carefully before ascribing to works of art ideas that more properly reflect their own scholarly predispositions.

What then has been the response to criticism of iconography? One thing seems certain: the once dominant principle of 'find a text and you've found the answer' is no longer thought sufficient. Texts, of course, still provide the *clavis interpretandi* that allows historians to pick their way through the semiotic fields in which the mute images of past ages are embedded, but they are being used more circumspectly now than before. In the papers in this volume the authors have drawn upon the evidence of texts in a variety of ways to illuminate the iconographic issues that have attracted their interest. There is no common thread uniting their approaches. However, some of the papers display tendencies that have emerged in iconographic research as a result of current scrutiny of the methods of art history. A concern with the audience is more apparent now than before, and that audience is recognized for the heterogeneous mix of rich and poor, male and female, literate and illiterate, cleric and layperson, that it was. Also, the meanings of works of art are no longer assumed to be the product of scholarly cerebration; their meaningfulness is now just as likely to be sought in their social function. The ways in which images affected people's behavior and how they used and responded to them has become as research-worthy as the pursuit of intellectual and textual sources.

The paradigm, the shared set of beliefs and suppositions, within which iconographic research takes place is gradually changing. The notion of the intellectual artist or his advisor conveying a specific message across the ages to be received by an equally intellectual and objectively-minded scholar is being replaced by the recognition that the medieval artist, his original audience, and his modern interpreter are captives of their time, their class, their gender, their education, their prejudices, and whatever else contributes to make a human personality and social being. With the deck so heavily stacked against us no one now should believe that when we attempt to write history we are recreating the historical facts of the

matter.[29] In art history this loss of innocence has perhaps taken longer than in some other disciplines. But now, with ideas derived from anthropology, semiotics, and reception theory, iconography is refashioning itself. New kinds of contemporary texts, other than the theological or philosophical, are being deployed to provide the frames of reference within which various classes of people might have made sense of what they gazed upon. What individuals saw in works of art did not necessarily correspond to the orthodox points of view that church or state or even artist might have preferred them to find. Confident certainty about what works of art mean is beginning to give way to a more modest and realistic acceptance of their ineluctable ambiguity. Indeed, the exploration of that ambiguity, beginning with the artist's own 'heteroglossia' and tracking the subsequent history of his work's reception, should increasingly become a fertile area of research.[30] Turning a critical eye on themselves, scholars of medieval art are already investigating the ideological baggage that accompanied the ideas and assumptions they inherited from their precursors in the discipline.[31]

This volume provides what I hope is a fairly balanced conspectus of current approaches, with contributions by both art historians and representatives from other branches of the humanities. It includes essays on methodology, as well as specific iconographic readings of texts and artifacts, and reassessments of some of the major figures from iconography's own history. Panofsky, his origins, and his legacy figure prominently in several of the essays. Some writers are critical; others recognize the enormity of Panofsky's contribution and the continuing relevance of the iconological method as originally conceived by Warburg.

Irving Lavin identifies the preoccupations of Panofsky's career as the search for meaning in works of art and the concern to establish art history as a humanistic discipline rather than the narrowly aesthetic pursuit that it once was. Like several Renaissance artists, Panofsky aimed to show that art was an intellectual, not just a mechanical endeavor. With his emphasis on the mutually supportive roles of form and content in works of art, Panofsky found the taxonomic and descriptive procedures of the Index of Christian Art at Princeton compatible with the kind of art history he advocated. His great and lasting contribution was to expand the range of evidence used in the study of art and to situate the search for meaning at the core of scholarly research. His legacy still defines the practice of the discipline today.

[29] This is not the place (nor am I the person) to prescribe what it is we are doing as historians, but Thomas Kuhn's notion that it is the scientific community that validates sound knowledge, not any appeal to the natural world, seems equally applicable to history. In writing history we are hoping to secure the agreement of others in the interpretive community that our reconstruction of a state of affairs based on the evidence available corresponds to their understanding of how it might have been. In Kuhnian terms, this would constitute historical truth (though he would not use the word). See T. Kuhn, *The Structure of Scientific Revolutions*, 2nd ed., Chicago, 1970; and idem, *The Essential Tension*, Chicago, 1977, especially his essays "The Relations Between the History and the Philosophy of Science," 3–20, and "Second Thoughts on Paradigms," 293–319.

[30] For Bakhtin's concept of heteroglossia, see G. S. Morson and C. Emerson, *Mikhail Bakhtin: Creation of a Prosaics*, Stanford, 1990.

[31] The recent meeting of the College Art Association at Seattle (1993) included a session on medievalists such as Focillon, Alföldi, Kantorowicz, and Saxl, in which their ideas about medieval art were shown to be deeply influenced by their personal histories and aspirations.

Michael Holly reconsiders the ideas of Panofsky's mentor, Aby Warburg. As she explains, the divide separating some of the so-called old and new art histories is not as wide as current polemics would suggest. Warburg, in precept and practice, anticipated many of the concerns of the new art history. Imagery in general and not just the great works interested him. He insisted on the inseparability of form and content in works of art and was dismissive of the narrow focus of aesthetes and connoisseurs. His own research ranged widely across disciplinary boundaries. The fragmentariness of his lectures and the pains he took to avoid facile explanations reveal his acute awareness of the complexity and indeterminacy of historical processes and events.

Other contributors identify failings in traditional iconographic approaches. Keith Moxey's criticism of Panofskian iconology strikes at its epistemological foundations. He accuses iconology of operating in the context of a correspondence theory of truth that claims for itself access to historical fact. In adopting this superior position iconology promotes the fiction that its conclusions are unmediated and non-ideological. Moxey challenges this position, arguing instead for a history of art that recognizes that all historical writing is socially constructed and thus politically charged. Images considered as part of social sign systems, operating both in the then and the now, would remove the ahistorical claim to truth on which iconology rests.

Michael Camille reproaches Panofskian iconology for its concentration on written models for interpretation. He emphasizes that speech was more important than writing in the Middle Ages. Taking the trumeau at Souillac, an iconographic puzzle that has proved particularly intractable, he draws on the information supplied by texts to suggest ways in which contemporaries, whether monks deprived of both meat and sex or illiterate laypeople, might have responded to the struggling men and biting animals on the trumeau. Instead of the single, authorized, official, and closed meaning which traditional iconography aimed to find in a text, he argues that the Romanesque image may entertain multiple meanings that speak more to the body than to the mind, and that the possibility of contemporary misinterpretations and unofficial readings must also be recognized. In sum, he argues for a more flexible approach to understanding the ways in which medieval images worked.

This emphasis on the audience distinguishes several of the papers. Craig Harbison attempts to situate his reading of van Eyck's Berlin Madonna within the context of contemporary people's experience rather than the writings of theologians. Certain features of van Eyck's Madonna, her oversized crown, her draperies, the prayer tablet on the pillar beside her, as well as less obvious details, suggest a relationship with local statues of the Virgin that were deemed miraculous. Although pilgrimages to such images were a common occurrence in people's lives, the journey might also be taken in the mind by imagining the miraculous statue towards which devotion was directed. Van Eyck's panel, once part of a diptych, might be seen as a wealthy burgher's vision of the Virgin from a pilgrimage shrine. An important conclusion may be drawn from Harbison's paper. The traditional view of stylistic influence that privileges the impact of artistically accomplished or innovative images should be expanded to include images which, though modest aesthetically, were celebrated for their thaumaturgic powers.

Turning his attention to an image at the core of medieval and Renaissance Christianity, the Crucified Christ, Richard Trexler seeks to explain why Christ is never shown naked even though the Bible says that he was "stripped of his garments." What were the motivations behind the desire to cover Christ's nudity? This fundamental iconographical question, he insists, can only be answered by considering images in relation to the people who stood before them. Their meaning has more to do with how they affected people than what exegetes said and thought about them. To discover how people might have behaved on seeing Christ's genitalia Trexler draws upon the sub-texts implicit in the writings of churchmen. The theologians' explanations of why images should be draped reveal indirectly the kinds of reaction that they feared from laypeople. Trexler looks behind the official prohibitions to see the sexual and gender implications of the naked body of God.

Two contributors who take Byzantine art as their subject again draw upon the evidence of texts in novel ways. Herbert Kessler explains how churchmen, in order to illuminate the more ineffable points of Christian doctrine, availed themselves of metaphors drawn from artistic practice. In a reversal of the usual flow of influence, art, or at least descriptions of artistic processes, served the requirements of exegesis rather than the other way around. Notions of outlining, coloring in, replacing the wax maquette with the bronze sculpture were used to explain the New Testament's completion of the law adumbrated in the Old. In turn, these metaphors were given visual expression in the Parousia and tabernacle miniatures of Cosmas Indicopleustes's *Christian Topography* in the Vatican and in images of the Mandylion.

Henry Maguire establishes that different types of Byzantine holy man, whether monk, soldier, apostle, or prophet, were represented in different formal modes. The style of representation was part of their iconography; frontality, movement, and degrees of modeling reflected the spiritual nature of the saints represented. He points to analogies between styles of visualization and textual descriptions of the same figures. The ascetic monk might be compared to a column of virtue; in pictorial terms this translated to a figure that was incorporeal, rigid, frontal, and immobile. The superhuman qualities of monks were thus expressed in their hieratic representation. The apostles, on the other hand, witnesses of Christ's humanity, are more corporeal and varied in pose and gesture. These distinctions in the style of post-biblical saints and apostles, indicate their respective relationships to the twin natures of God: the divine and the human. The semantics of such distinctions would have been apprehended by the Byzantine audience.

One of the great fresco cycles of Renaissance art, the Legend of the True Cross by Piero della Francesca in Arezzo, is the subject of Marilyn Lavin's paper. She identifies innovations introduced by Piero into the traditional iconography and pictorial disposition of the incidents recounted in the legend, and interprets them as implying a wider Christian message. Besides Piero's emphasis on the Franciscan context of the cycle, she recognizes allusions to the conversion of pagans, the cult of relics, the fight against heresy, and the liberation of the Holy Land.

Wolfgang Kemp, too, takes as his point of departure the way in which works of art are composed and framed. He recognizes in the multi-framed images typical of medieval art

three systems of visual representation which he distinguishes as the thematic, the narrative, and the systematic. He accounts for the historical necessity of this way of organizing pictorial information, whether it is on a sixth-century ivory diptych, a fifteenth-century textile, or the ceiling paintings of Zillis, in terms of medieval conceptions of time and history and what might be called sacred geography. The linear and metonymous nature of the Christian story as epitomized in the Bible stands in opposition to the cyclical and metaphorical nature of pagan myth and engendered a different world view that found expression in medieval art.

The importance of iconography to the history of music is shown by the contributions of two musicologists. Howard Mayer Brown argues for the importance of illustrated literary Romances as sources of information for a social history of Renaissance music. They provide evidence that cannot be found elsewhere. As a case study he examines the romance of *Cleriadus et Meliadice,* the illustrated versions of which help clarify the sometimes ambiguous references to music and its performance that are found in the text. The particular questions that engage his interest and his training as a musicologist allow him to draw from the miniatures significances that would elude the art historian.

Another music historian, H. Colin Slim, looks at prints by the Netherlandish artist Maarten van Heemskerck where music is used as a sign of dissipation. He offers a reading of an allegory that is based on his identification of the music inscribed upon a choir book borne on a satyr's back. In recognizing the music as a secular song of love, here sung by a procession of clerics, he is able to show that the purpose of the print was to satirize the contemporary practice of adapting secular music for ecclesiastical purposes, a practice that aroused the disdain of Erasmus, among others. Only the specialist knowledge of the musicologist could have led to the identification of the subject of the print.

Drawing upon a different kind of specialized knowledge, Ynez O'Neill reveals the significance of two particularly intriguing drawings. A historian of medicine, she establishes through a close reading of the textual evidence that anatomists of the twelfth and thirteenth centuries held a theory that the activity of the brain was located in the meninges. These were believed to be divided into three compartments or cells corresponding to the sites of imagination, reason, and memory. Having determined that such a theory was current, she proceeds to explain the two mysterious diagrams, which had previously defied interpretation, in terms of this doctrine of localization and early methods of cranial dissection.

V. A. Kolve, a professor of English, has long advocated the reading of medieval literature iconographically. He believes that a knowledge of the symbolic codes employed in the visual arts can help us to understand literary imagery. Taking Christine de Pizan's *Book of the City of Ladies,* he shows how Christine's explanation of how and why she came to write her text can be clarified in the light of well-known visual iconographies. The ray of light that falls on her lap and the trio of ladies who encourage her in her task allude to the Annunciation to the Virgin Mary and to the three persons of the Holy Trinity. By drawing upon the significance conjured up by these visual iconographies, Christine implies that, like the Virgin, she was specially chosen and empowered by a higher authority in the persons of the female trinity to convey women's truth, challenge misogyny, and effect a reconciliation of the sexes.

John Fleming, also a historian of literature, similarly adopts an iconographic approach to reveal the meanings within a text, albeit a text of a singular kind. When Christopher Columbus bequeathed the use of his signature to his heirs he accompanied it with precise instructions as to how the letters and punctuation marks were to be arranged. Columbus's concern with the composition of his signature suggests to Fleming that it was not simply a verbal construct but that it was also a visual design related to other quasi-pictorial genres such as heraldry, religious and craft signatures, and cartography, and that it concealed allegorical meanings behind the facade of its apparent literal sense. Not only did the signature incorporate a punctuational rebus, but it was constructed according to the golden section and number symbolism and alluded to the Virgin Mary, marine navigation, the inspiration of the Holy Spirit, and Columbus's own personal mythology.

Such a wide diversity of topic and approach suggests that, contrary to prognostications of its imminent demise, iconography is alive and well, and as fruitful a subject for research as ever. Its character may be changing but its survival is not in doubt. Two things remain certain. First, the more data that can be made available to researchers, the better equipped they will be to make sense (good, or otherwise) of societies often radically different from their own. Second, an ability to distinguish between Saint Agnes and Saint Agatha will remain a prerequisite for the scholar interested in the information that images can provide, whatever his or her methodological or ideological orientation. The Index of Christian Art at Princeton has served scholarship in both these capacities for more than seventy years. As an archive of some 26,000 iconographic subjects drawn from countless thousands of medieval works of art, it is potentially more valuable now than ever. As the boundaries between disciplines are increasingly breached, so the files of the Index are becoming an important source of information for a wider constituency of scholars. Changes in the forms of Catholic worship as a result of Vatican II have severed many of the links that united the medieval and Renaissance church with the modern one and depleted the stock of common knowledge of practices and beliefs that had remained essentially unchanged since the Middle Ages. The decline in the teaching of Latin and Greek, the languages of medieval and Renaissance official culture, has erected a further barrier between their society and ours. In consequence, archives like the Index, as repositories of visual information on lost or declining traditions, provide an ever more vital link with the unfamiliar past.

Unwriting Iconology*

•

MICHAEL ANN HOLLY

IN PLATO'S *Phaedrus*, that ancient source from which Derrida rederives deconstruction, speaking is exalted over writing. It is there *written* that spoken language provides a more immediate access to the realm of truth and being, while writing runs the risk of being divorced from context and consequently subject to all sorts of "mischievous" misinterpretation. Nevertheless, writing still attains a higher philosophical status than painting. Near the end of the dialogue, Socrates compares the written word to the pictorial image and condemns paintings for always saying the same thing over and over again. If you ask them a question, they preserve a solemn silence. Their fate is a lamentable one, he says; having no parent to protect them, they stand to suffer maltreatment by later observers who regrettably can no longer decipher what it is they were once talking about.[1] While there are some traditional art historians today—even iconographers, perhaps—who would agree that paintings have indeed been subjected to the kinds of interpretive abuse that Plato anticipated—particularly at the hands of the so-called new art historians—they would be less willing to grant Socrates his indictment of pictorial arts as monotonous repetition. I wonder if there is a contradiction here. The liveliness of the discipline has always depended upon the questions asked as much as upon the answers given. I am not sure how we arrived at this melodramatic crossroads of calling some art histories "old" and some "new," but I would argue that the choice is not as problematic as current disciplinary hysteria construes it, especially if we read the "right" kinds of "old" iconographers—Aby Warburg will be my example in this essay, although, of course, there could well be many others—and especially if we juxtapose what was meant by theory and representation then next to some ideas about their role in art history today.

While I recognize that the enterprise of iconology in its contemporary codification, i.e., reading visual images as historical documents, connotes directionality, coherence, and lack of fragmentation, I would like to "unwrite" it back to its genesis in Warburg's thought at the turn of the century. At that historical moment, we can confront it in all its unformed and fragmentary aspects. Warburg posed no interpretive system; he only suggested partial clues to unraveling what he saw as the great psychohistorical mystery of the transformation of

* A version of this essay was presented at the XXVIIᵉ Congrès International de l'histoire de l'art in Strasbourg in 1989 and will be published in the *Actes* of that congress.

[1] Plato, *Phaedrus* (trans. W. C. Helmbold and W. G. Rabinowitz), sect. 275, lines 42–56. See also J. Derrida, *The Truth in Painting*, trans. G. Bennington and I. McLeod, Chicago, 1987; and C. Norris and A. Benjamin, *What is Deconstruction?*, London and New York, 1988, 16–20.

images. His written work, though slight (not a problem, of course, if we regard writing in the problematic way that Socrates does), is principally identified with two *Nachlebens*: the survival of ancient gods and demons in later astrological symbolism and the survival of certain kinds of expressive movement in Renaissance and post-Renaissance art. To characterize his work so dryly, however, is to miss its powerful psychological charge. A victim of great psychic conflict, Warburg was convinced that the monitoring and charting of both the changing expression and the altering contexts of images would reveal the struggle in Western culture between the forces of reason and unreason. Like Freud, he was intent upon excavating "life in its subterranean routes."[2]

When he resuscitated the late sixteenth-century term of "iconology," Warburg conceived of it as "the study and interpretation of historical processes through visual images."[3] The art historian who practices it engages in deciphering original meanings in their cultural contexts, according to Hans Belting:

> The process of decoding itself is celebrated as a hermeneutic act, symmetrically complementing the original, historical encoding. Too often this degenerates into a perpetuation of a humanist parlor game, an exercise only promising success in the cases of Renaissance and Baroque works of art, especially those with literary texts and programs expressly created for them. This certainly does not apply to the original version envisioned by Aby Warburg, which sought to locate art within a vast repertoire of forms of cultural expression, as one of an entire array of symbolic languages within world culture. But this approach was instead narrowed into a method for interrogating works of art from the age of humanism.[4]

Remember, if you will, the picture atlas Warburg devoted to Mnemosyne, whose "aspiration was to present something like a basic vocabulary, the *Urworte* of human passion."[5] On large, canvas exhibition screens (sometimes numbering forty or so) in his Hamburg library, he compulsively arranged and rearranged a compendium of images from the past and present: postcards of classical sculpture, photographs of Renaissance paintings, newspaper clippings of contemporary events. One array of images might contain a Medici family tree, a map

[2] E. Gombrich, *Aby Warburg: An Intellectual Biography*, 2nd ed., London, 1986, 245. See also idem, "The Ambivalence of the Classical Tradition: The Cultural Psychology of Aby Warburg (1866–1929)," in *Tributes*, Ithaca, 1984, 116–37. While his written work may be "slight," numerous routes for coming to terms with his innovative ideas about how to talk about works of art exist: the intellectual biography by Gombrich, publications of lectures and several essays in a couple of editions, reminiscences by a number of important Warburg Institute scholars who succeeded him, etc. G. Bing, "A. M. Warburg," *Journal of the Warburg and Courtauld Institutes*, XXVIII, 1965, 299–313; K. Forster, "Aby Warburg's History of Art: Collective Memory and the Social Mediation of Images," *Daedalus*, CV, 1976, 169–76; C. Ginzburg, "From Aby Warburg to E. H. Gombrich," *Clues, Myths, and the Historical Method*, trans. J. and A. C. Tedeschi, Baltimore, 1989; F. Saxl, "The History of Warburg's Library (1866–1944)," in Gombrich, *Aby Warburg* (cited above), 325–38; W. Waetzholdt, "Aby Warburg," *Kunst und Künstler*, XXVIII, 1929–30, 116–17; E. Wind, "Warburgs Begriff der Kulturwissenschaft und seine Bedeutung für die Aesthetik," *Zeitschrift für Aesthetik und allgemeine Kunstwissenschaft*, XXV, 1931, Beiheft; D. Wuttke, "Aby Warburg und seine Bibliothek," *Arcadia*, I, 1966, 319–33; idem, ed., Aby *Warburg, Ausgewählte Schriften und Wurdigungen*, *Saecula Spiritalia*, 2nd ed., I, Baden-Baden, 1980.

[3] The paraphrase is M. Roskill's in *The Interpretation of Pictures*, Amherst, 1989, 96.

[4] H. Belting, *The End of the History of Art?*, trans. C. S. Wood, Chicago, 1987, 18–19.

[5] Gombrich, *Aby Warburg* (as in note 2), 287.

of the heavens, a record of the mystical visions of Hildegard of Bingen, a blood-letting chart of Renaissance barbers that inscribed signs of the zodiac on the human anatomy, or an illustration of Phaeton's tragic fall to earth among weeping Nympha—that female motif which so troubled Warburg throughout his life.

The pictorial archetype of the Mnemosyne project, what Warburg called a "ghost story for the fully grown up,"[6] suggested to me a way of talking about the power of iconological thinking. By scattering texts, by juxtaposing images, nonlinear arguments about its significance might also emerge. What I would like to do is juxtapose some seemingly unrelated "texts" as well—Plato's *Phaedrus*, Derrida's deconstruction, excerpts from the "new" art history, fragments of Warburg's lectures, allusions to the Palazzo Schifanoia frescoes responsible for the development of the concept of iconology in the first place—in order to see how each "text" might serve as a critical commentary on the others in an effort to reconcile old with very old, and with new.

Several recent assaults on the founders of the discipline of art history assert that Warburg and his legacy of iconologists had no social conscience, only loosely understood the impact of politics on art, rarely dealt with ideological constructs, and perhaps, most surprisingly, were "suspicious of theoretical reflection" (I am citing this litany of charges from the overtly polemical manifesto *The New Art History*, of 1986, edited by A. L Rees and F. Borzello).[7] Consequently, they claim that many practitioners of the new kind of art history regard their work in manifest opposition to those who originally forged the iconological paradigm.

I feel compelled to assert my bias right away. I am much less interested in any traditional art history that purports to have established, through assiduous and patient empirical research, the "truth" of past artistic production than I am in the sometimes shrill "unhistorical" revisionism of contemporary criticism. I do not think we can afford not to address what the paintings are themselves "saying," and yet it is often what they do not say that the interpretive deconstruction of recent art history brings to light, as opposed to the iconographic reconstruction of earlier decades. But here is also where I think earlier theoreticians might still have something to say to committed feminist, Marxist, psychoanalytic, and semiotic readers today, as well as to those art historians who claim their parentage in this identifiably "traditional" branch of the discipline.

The term "art theory" may well have been employed from the Renaissance through the Enlightenment as a means of validating certain philosophical practices of art, but art historians in the second half of this century have become increasingly uncomfortable with its implications. For the word "theory," when applied to their own scholarly enterprise, suggests that the history of art is an interpretive activity rather than an empirical practice. The debates of the past decade between traditional and revisionist art histories have been waged precisely over this epistemological point. The issue is a complex one, involving the history of the discipline, its clear gender and class biases, its origins in identifiably elitist institutions, its

[6] Ibid.
[7] *The New Art History*, ed. A. L. Rees and F. Borzello, London, 1986, 7.

stubborn resistances to other modes of disciplinary inquiry, and its internal divisions over what constitutes the story of art as advanced in its standard histories.

About ten years ago, scholars began to speak of a "crisis." No longer secure with the idea of empirical research, an insecurity sparked in large part by poststructuralist critiques in literary criticism, historians of art spoke of "theory" as that something which was ideologically opposed to "history." At stake seemed to be the conception of Art as such. The crisis mentality eventuated in a stiffening of positions. On the one side, those scholars who long had an investment in positivistic pursuits (iconographers being a timely example here) proudly reasserted their role as "historians" and became outspoken in their dismissal of extra-artistic analyses, particularly those that paraded their origins in psychoanalysis, feminism, semiotics, and Marxism. On the other side, the self-proclaimed "new" art historians (read "theoreticians") decried the politically invested, what they called the conservatively capitalist, motives of academically entrenched art historians, particularly in England and the United States. Two book titles from the middle of this decade—*The End of the History of Art?* (H. Belting, 1984) and *The End of Art Theory* (V. Burgin, 1986)—suggest that the result of the controversy raging in a discipline unaccustomed to attack was that feelings of crisis had turned into self-aggrandizing visions of the apocalypse.[8] Voices have become a little less strident in the past couple of years, and it now seems possible to map the historical geography (the roads, the crossroads) of the disciplinary changes and attempt a brief overview of the panoply of theoretical positions now inhabiting the field.

In its modern origins, art history certainly engaged theoretical issues. The noted founders of the discipline in its German *Kunstwissenschaft* phase were all involved with principles of interpretation. Burckhardt, Panofsky, Wölfflin, Riegl, Warburg, and later Gombrich, to name only an illustrious few, may have been in fundamental disagreement about the central issue in art-historical interpretation—why and how styles of art come into being and then pass away again—but not one avoided explanations for the process on the ground that theorizing was something extrinsic to the study of art as art (something that reactionary art historians today might claim). All in fact offered grand interpretive schemes to account for the diachronic process at work, and if their focus on the objects (as well as the objects themselves) differed, their primary commitment to interpretation never faltered.

For these early analysts, "theory" would be the term assigned to the mode of explanation, and more often than not, the argument underlying the historical evidence had to do with the cause of stylistic change and whether it could be attributed to factors intrinsic to the history of images or to the psychosocial and cultural world that surrounded the images' production. The points were rarely argued apart from specific historical examples; in fact, it is usually from the complex of talk on individual artists or works or periods or genres that a contemporary historiographer has to extract something that can be dubbed the "theory."[9]

[8] Belting (as in note 4) and V. Burgin, *The End of Art Theory: Criticism and Postmodernity*, Atlantic Highlands, N.J., 1986. For a review of this material, see my "Art Theory" in *Johns Hopkins Guide to Literary Studies*, ed. M. Groden and M. Kreiswirth, forthcoming; and *Visual Theory: Painting and Interpretation*, ed. N. Bryson, M. Holly, and K. Moxey, Cambridge, 1991.

[9] See M. Podro, *The Critical Historians of Art*, New Haven, 1982; and M. A. Holly, *Panofsky and the Foundations of Art History*, Ithaca, 1984.

This situation has been turned inside out, of course, in recent art history. Here indeed theory is foregrounded, even to the extent that the historical examples that come to its defense sometimes appear as afterthoughts. Challenges to the reigning canon of art-historical thinking were first mounted within the discipline. We all certainly recognize the impact of works by, say, Gombrich, Alpers, and Baxandall, who compelled us to read Renaissance images differently from the way for which the iconographic method had securely prepared us.[10] But for the most part, critiques of the discipline in the past decade have been mounted by "outsiders," particularly literary critics who look with bemused superciliousness upon what seem to them to be antiquated theoretical models in art history "proper." Semioticians, Bryson being an example, appropriate concepts from Barthes, Lacan, and Saussure to argue that art in no straightforward way reflects reality, but instead engages in the active production of a universe of meaning. It is itself a semiotic system actively involved with other systems of signification of the social world of which it is a part.[11] Coming from a different direction altogether, Marxist critics such as Clark and Crow have investigated the conditions of production and the public for whom painting was intended. In doing so, they have reanimated the field of social criticism and demonstrated a lively irreverence for the petrified concepts of formalists and iconographers alike.[12]

Perhaps nothing, however, has shaken the very foundations of the discipline as much as the feminist criticism of the past two decades. Nochlin, Pollock, and Tickner, among many others, have contended that the only viable conceptual framework for the study of women's artistic history is one that emphasizes the ways in which gender is socially constructed. They simultaneously have restored a certain power to images, underscoring the observation that art is as capable of constituting ideology as it is of reflecting it, a political commitment going way beyond the mission of art history proposed by either the formalist tradition or the iconological method.[13] Recent discussions about the nature of visuality, the differentiation of modes of looking, and the specific identity of the viewing subject—debates that come together under the term the "gaze"—have been deeply influenced by insights primarily developed within feminist studies, and particularly within film criticism. The most important perspective to mention here is psychoanalysis (Freudian and Lacanian), a mode of inquiry that has

[10] See, for example, E. Gombrich, *Art and Illusion: A Study in the Psychology of Pictorial Representation*, 2nd ed., Princeton, 1961; S. Alpers, *The Art of Describing: Dutch Art in the Seventeenth Century*, Chicago, 1983, and *Rembrandt's Enterprise: The Studio and the Market*, Chicago, 1988; M. Baxandall, *Painting and Experience in Fifteenth Century Italy*, Oxford, 1972, and *Patterns of Intention: On the Historical Explanation of Pictures*, New Haven, 1985.

[11] N. Bryson, *Vision and Painting: The Logic of the Gaze*, New Haven, 1983, and Bryson's introduction to *Calligram: Essays in the New Art History from France*, Cambridge, 1988.

[12] T. J. Clark, *Image of the People: Gustave Courbet and the 1848 Revolution*, Princeton, 1982, and *The Painting of Modern Life: Paris in the Art of Manet and His Followers*, New York, 1984; T. Crow, *Painters and Public Life in Eighteenth-Century Paris*, New Haven, 1985; see also K. Moxey, *Peasants, Warriors, and Wives: Popular Imagery in the Reformation*, Chicago, 1989; J. Wolff, *Aesthetics and the Sociology of Art*, London, 1983.

[13] L. Nochlin, "Why Are There No Great Women Artists?" in *Women, Art, and Power*, New York, 1988, 145–78; G. Pollock, *Vision and Difference: Femininity, Feminism, and the History of Art*, London, 1988; L. Tickner, "Feminism, Art History, and Sexual Difference," *Genders*, III, 1988, 92–128; see T. Gouma-Peterson and P. Mathews, "The Feminist Critique of Art History," *Art Bulletin*, LXIX, 1987, 326–57.

contributed considerably to the bridging of the gap between visual and verbal art in a manner that iconography never anticipated.[14]

Clearly art history is no longer the secure iconographic and monographic study of monuments, artists, styles, periods, and so forth. The question is, "Was it ever effectively so?" The "new" art history, in the process of foregrounding the theoretical as opposed to empirical commitments of its founders, is now focusing on the history, context, and politics of visual representation and interpretation. It interrogates gender boundaries and the unequal power distribution they encourage. It examines the distinction between the so-called high and popular cultures and their attendant artistic expressions. It engages in a dialogue between art forms in an effort to overcome the privileging of either the word or the image. In short, the general deconstructionist debates that are opening up into more general discussions of cultural critique are also informing contemporary art theory and encouraging scholars to trespass disciplinary boundaries with impunity.

If the metaphor sounds familiar, it is because it was articulated eighty years ago by Warburg in a lecture in which he first employed the term "iconology." At the Tenth International Congress of Art History in Rome in October 1912—the month and year according to Heckscher in which "iconology was born"—Warburg spoke of his unusual reading of cosmology in the zodiacal representations of the Palazzo Schifanoia in Ferrara as "an iconological analysis which does not allow itself to be hemmed in by the border police."[15]

His half-hour lecture on the mysterious frescoes investigated the *Nachleben* of the Olympian gods as they found their way into Renaissance astrological symbolism. Like his picture atlas, the fifteenth-century Ferrarese paintings juxtaposed a series of disparate images, this time in three horizontal registers: at the top were Olympian gods in their chariots; in the middle, astral demons; at the bottom, knights and ladies from the court of Borso d'Este. Warburg discovered the key to the cycle of months residing in the iconographic metamorphosis of Olympian deities into late Egyptian, Indian, Arabic, Latin, and medieval astrological symbols. In his colorful words, "under the seven-layered traveling clothes of the weathered wanderers through time, nations, and peoples, there beats a Greek heart."[16]

At issue was the influence of antiquity on the artistic culture of the early Renaissance, but "the resolution of a pictorial riddle," as Schiff has pointed out, was, of course, "not the

[14] See particularly M. Bal, "On Looking and Reading: Word and Image, Visual Poetics, and Comparative Arts," *Semiotica*, LXXVI, 1989, 283–320; L. Mulvey, "Visual Pleasure and Narrative Cinema," *Screen*, XVI, 1975, 6–18; C. Penley, ed., *Feminism and Film Theory*, New York, 1988; K. Silverman, *The Acoustic Mirror: The Female Voice in Psychoanalysis and Cinema*, Bloomington, 1988.

[15] Quoted in W. Heckscher, "The Genesis of Iconology," *Stil und Überlieferung in der Kunst des Abendlandes: Akten des 21. International Kongresses für Kunstgeschichte in Bonn, 1964*, III, *Theorien und Probleme*, Berlin, 1967, 246. Warburg's lecture, "Italienische Kunst und internationale Astrologie im Palazzo Schifanoja zu Ferrara," appeared in the *Atti del X Congresso internazionale di Storia dell'arte in Roma, L'Italia e l'arte straniera*, Rome, 1922, 179–93, and also in Warburg's *Gesammelte Schriften*, II, Leipzig and Berlin, 1932, 459–81. It has recently been translated by P. Wortsmith as "Italian Art and International Astrology in the Palazzo Schifanoia in Ferrara," in *German Essays on Art History*, ed. G. Schiff, New York, 1988, 234–54. See also W. Heckscher, "Petites Perceptions: An Account of Sortes Warburgianae," *Journal of Medieval and Renaissance Studies*, IV, 1974, 101–35. No scholar has been more responsible in raising these questions for me than Professor Heckscher.

[16] Quoted in Schiff (as in note 15), 250.

sole purpose of his talk." "I was less interested," Warburg claimed, "in the neat solution than in the formulation of a new problem."[17] At several moments he employed the adjective "icon-ological" to describe the kind of analysis that allowed him to venture outside the delineated domain of the art historian. "Thoughts are free," he exclaimed, and his study ventured far into the "marginal": especially into imagery considered poor by the standards of Renaissance art history. With his particular manner of "associative thinking," he managed to offend most of the art-historical establishment, for example, Dvořák, who promptly called for a return to the "investigation of the investigatable facts of art history."[18] Of course, Warburg engaged in deliberate confrontation. In his preparatory notes for the occasion, now housed in the War-burg Institute's archives, he rails against the "simplists," the "snobs," the "sentimentalists," and "above all the 'Guardians of Zion'—the zelotic priests, by which term he understood the self-confessed specialists in their own field."[19]

Warburg's lecture, like Derrida's musings in the "Parergon" about the problem of de-ciding what does or does not belong to a work of art, was an exercise in the powers of desul-tory thought: "there is simply no deciding just what is intrinsic to the artwork and what belongs either to or outside the frame."[20] To put the matter in contemporary critical terms, Warburg considered the language of Renaissance art as always subject to dislocating forces at work, despite its illusions of framing. Representational meaning, he well knew, is always in process. If ever it can be said to be a product, it is a product of intertextual conflict and stylis-tic features in the process of differentiation—between the work's expressive mythopoeic "substratum" and its historical symbolization—and not the result of any one-to-one icono-graphic correspondence between a classical text and a domesticated image.

Since Warburg, the iconographic method has sought to establish the "essential priority of logos over mythos,"[21] word over image. But semiotics has taught us that images are them-selves languages as well, thus offering the possibility of reversing the equation, of unwriting iconology back to the way Warburg first conceived of it. He never thought of Renaissance paintings as transparent windows onto the world. To translate his thinking into contempo-rary vocabulary, he always recognized that "images are signs that pretend not to be signs."[22] He saw even mimetic representation not as the transcription of some reality, but the process by which a cultural and social world constructs a vision of itself.

Despite the variety of subjects that Warburg treated in his studies, from Ghirlandaio's and Botticelli's expressive drapery to the serpent rituals of the Pueblo Indians, a few themes connect all of his work. The lure of *Kulturwissenschaft* was strong. Warburg was trained in the practice of nineteenth-century historical writing, and he clearly had faith in the ability of science to chart the transformation of human consciousness. Therefore, it would be complete-ly implausible to suggest that he anticipated in most regards developments in late twentieth-

[17] Ibid., lvi, 250.
[18] Quoted in Heckscher, "Iconology" (as in note 15), 246–47.
[19] Ibid., 258.
[20] Paraphrased in Norris and Benjamin (as in note 1), 18.
[21] Ibid.
[22] Paraphrased from W. J. T. Mitchell, *Iconology: Image, Text, Ideology*, Chicago, 1986, 43; see also 8–11.

century art theory. On the other hand, I do think it is interesting to contemplate why some new, and some traditional, art historians have managed to forget all that he obliquely challenged in the theoretical commitments of the discipline, choosing as they do to concentrate instead on his straightforward iconographic triumphs.

Like the new art historians, Warburg, too, was interested in general issues of representation in all images, and those that garnered the title "minor arts" were as significant for his studies as were the "masterpieces" of the High Renaissance. The notion of artistic genius was in many ways as alien to his sensibilities as it is to any social historian today. And any contemporary word-and-image scholar, such as those found in recent literary criticism, would be hard put to match Warburg's devotion to finding narrative strategies common to both literary and visual production. Unlike most of his contemporaries, he militantly refused to separate notions of form and content, for both mirrored equally the transformations in human sensibilities. He forever spoke of collective social memory and obsessively believed that the study of art would provide clues to the fundamental opposition of the forces of darkness and enlightenment that have forever structured the collective human psyche.

I wonder why the discipline itself seems to have taken so little heed of his challenging theoretical program. The answer cannot lie only in the speculation that so few Anglo-American historians read German with ease. Was it the fact that he principally published empirical results, or that he published little at all? Did his so-called "psychological madness" or his methodological mania seem to require disciplinary suppression? Might we not say in some general way that the new art history could be read as an indication of the return of the repressed—a resurfacing of the early theoretical unconscious of the discipline into the contemporary fascination with critical theory?

Warburg worried over the fate of not only art, but "culture" itself in the face of militaristic societies and technological advancement. He railed against the aesthetes who regarded the pursuit of art as tantamount to the pursuit of beauty, and mocked the nearsighted connoisseurs who missed out on the power of images to express psychosocial dilemmas. The study of art was for him a serious study of history and the power of history to shape contemporary consciousness. In his quest to discover meaning in the past, he excluded nothing from his purview. His erudite eclecticism is precisely what should appeal to the postmodernist inclinations of the new art historians, even if we have lost the sense that there is any meaning there to be discovered.

On that melancholic note (with which the fragile Warburg would undoubtedly have been sympathetic), let us return to the beginning and my ancient source, the *Phaedrus*. Predicated upon the difference between speech and writing, that dialogue is itself of course responsible for the powerful reading that Derrida brought to it. His rhetorical analysis has exposed the places in the text that depend upon crucial oppositions of terms, in order to show how those terms are hierarchically ordered, so that the repressed side of the equation takes on a kind of logical priority. What Plato intended to say is that writing is a poor substitute for the immediacy of speech; what he ended up saying (by demonstrating it) is that writing is indispensable to philosophy.[23]

[23] See Norris and Benjamin (as in note 1).

By extension, as deconstructionism has argued, all ideologies draw rigid boundaries between what is acceptable and what is not—such as that espoused by both new and old art histories and their respective claims to distinguish between what is true or false, what is central or marginal, what is superficial or deep, indeed what is new or old—at the same time as their principles are dependent upon the suppressed structure and force of the "other." Maybe deconstruction is not necessary to make the fairly obvious point, as Bann has done, that the "'revolutionary' nature of a 'new art history' could only be substantiated with reference to some notion of traditional art-historical practice."[24]

But I might still need the *Phaedrus* to consider the deep intellectual need for maintaining the difference between thinking and writing, especially as the opposition relates to Warburg and his legacy. Warburg, like Socrates, had great difficulties in codifying his ideas in writing. "So deeply convinced" was he, according to Gombrich, "of the complexity of the historical processes that interested him that he found it increasingly vexing to have to string up his presentation in one single narrative" which did not allow him the polysemy of his picture atlas. "Every individual work of the period he had made his own was to him not only connected forward and backward in a 'unilinear' development—it could only be understood by what it derived from and by what it contradicted, by its *ambiente*, by its remote ancestry and by its potential effect in the future."[25] The creative fragmentariness of his lectures, in combination with the juxtaposition of historical and mythical explanations (the crossroads of synchronic and diachronic analysis) clearly anticipated—no, I will put it more strongly—helped to engender the rich complexity of contemporary art theory:

> . . . far more noble and splendid is the serious pursuit of the dialectician [said Socrates] who finds a congenial soul and then proceeds with true knowledge to plant and sow in it words which are able to help themselves and help him who planted them; words which will not be unproductive, for they can transmit their seed to other natures and cause the growth of fresh words in them . . . the living animate discourse of a [teacher] who really knows. Would it be fair to call the written discourse only a kind of ghost of it?[26]

The only trouble is, that those who come after sometimes forget or even deny that similar sentiments have been voiced before. It was Warburg at the beginning of the century, and *not* a new art historian near its end, who complained to a friend, "Not until art history can show . . . that it sees the work of art in a few more dimensions than it has done so far will our activity again attract the interest of scholars and of the general public."[27] Of course, the revisionist art historians have less at stake in remembering the force of these words than the traditional art historians have in forgetting that they were ever uttered.

[24] S. Bann, "How Revolutionary is the New Art History?" in Rees and Borzello (as in note 7), 23.

[25] Gombrich, *Aby Warburg* (as in note 2), 284.

[26] Plato (as in note 1), sect. 276, lines 10–12, 52–56, and sect. 277, lines 1–3.

[27] Cited in Gombrich, *Aby Warburg* (as in note 2), 322, from a letter to J. Mesnil of 18 August 1927: "Erst wenn die Kunstgeschichte zeigen wird . . . dass sie das Kunstwerk in einigen Dimensionen mehr sieht als bisher, wird sich das wissenschaftliche und allgemeine Interesse unserer Tätigkeit wieder mehr zuwenden."

The Politics of Iconology

•

KEITH MOXEY

THE IDEA for this volume, *Iconography at the Crossroads*, can be interpreted broadly enough to encompass a reconsideration of Panofsky's concept of iconology. Despite the fact that iconology's currency as an art historical method belongs to the past, displaced first by social history and more recently by what has been called "contextualism," its epistemological status, that is, its status as a form of knowledge has never been adequately assessed or systematically challenged. Insofar as a critique of the epistemology of iconology—as of any knowledge claim that depends upon a correspondence theory of truth—has relevance for the forms of knowledge that currently inform the history of art, the following analysis has implications that extend beyond its purported subject.

Panofsky drew a distinction between iconography, which he regarded as the study of the conventional subject matter of works of art, and iconology, which he defined as the study of their intrinsic meaning, the one allegedly dealing with the surface of culture while the other penetrates to the "essential tendencies of the human mind."[1] Iconology purported to allow the historian to see through the work into the mental landscape of the culture that produced it. The knowledge resulting from the application of the iconological method depended on movement from one level of interpretation to another. Iconology's governing metaphor was one of penetration: of laying bare secrets hidden from view or delving beneath mere appearances to establish the truth. The doctrine of "symbolic forms," which Panofsky derived from Cassirer, enabled him to claim that iconological meaning corresponded with the mind's capacity to represent. According to neo-Kantian epistemology, symbolic forms were the means by which mind and nature were bonded together. While unmediated access to nature was regarded as impossible, symbolic forms were alleged to fix, match, or correspond with the underlying structure of reality.

The truth claim on which Panofskian iconology depended—that iconology affords us access to intentionality—must be questioned in the light of theoretical transformations that have affected other disciplines in the humanities and sciences. The nature of scientific knowledge has been radically reconceived, for example, by Thomas Kuhn, who has argued that the truth value of a scientific theory is determined by its acceptance by the community of scientists and not by its relation to anything that might exist in nature.[2] In the humanities, the

[1] E. Panofsky, "Iconography and Iconology: An Introduction to the Study of Renaissance Art," *Meaning in the Visual Arts*, Garden City, N.Y., 1955, 41.

[2] T. Kuhn, *The Structure of Scientific Revolutions*, Chicago, 1962.

success of structural semiotics, first developed by Saussure, who argued that the linguistic sign or word bears only an arbitrary relation to the thing to which it refers, has posed a decisive challenge to the notion that knowledge might somehow be guaranteed by direct appeal to experience. Deconstructive criticism, inspired by Derrida, has gone even further by analyzing and revealing the ways in which language itself affirms presence or being while relying on its absence for its capacity to function.[3] Thus the very means by which knowledge is constructed, and on which truth claims depend, has been found intrinsically unable to afford assurances of finality or certainty. The result of these historical developments is that the type of epistemological idealism, the belief that mind and world are bonded by means of mental structures, on which Panofsky's enterprise depended, has been largely discarded. Art history's reluctance to confront structural and poststructural theory may give the following review of our discipline's epistemological options some relevance to the theme of this volume.

If we abandon the claim ever fully to "know" the historical horizon we study, and if we abandon a theory of knowledge based on the belief that symbols afford us access to the truth, what basis can we find for a discipline involved in the production of knowledge about images? One of the most appealing solutions is the phenomenological view, which bases itself upon the spectator's existential response to images. The appeal of this approach lies in its recognition of the power of vision. We are tempted to trust more the truths vouchsafed to us by the sense of sight than those provided by language. Illusionistic images appear so similar to our visual experience of the world that it is often difficult to accept the claim that they are just as coded a form of signification as language. Such a claim appears to defy common sense. Why would they need to be deciphered when they would appear to correspond so closely to our sensual experience? We translate the immediacy with which the sense of sight grants us access to the objects of everyday life to our interpretation of images. It is this act of translation that accounts for the success of resemblance theories of representation.

According to the resemblance theory, which has been energetically and sophisticatedly defended by Gombrich, the act of representation is inextricably bound up with the notion of mimesis.[4] Based on Gestalt theories of perceptual psychology, Gombrich argued that artists engage in a complex negotiation with the world around them in the effort to match the artistic conventions of their culture with their perceptual experience of nature. On this account, the image is the product of a process in which artists match artistic skill—their mastery of the illusionistic devices of their time—against the reality that surrounds them. Despite the major difficulties confronting this theory in relation to non-Western art, as well as to historical periods in the West characterized by an attenuated illusionism or by abstraction, it has certain advantages for dealing with the generally mimetic character of European art. As Bryson has pointed out, the most important problem facing the resemblance theory is its violation of the historical principles upon which our discipline rests. For the history of art to be genuinely historical, nothing about the objects it studies, should escape definition in historical terms. In positing that mimesis is a constituent element of the work of representation, the

[3] J. Derrida, "Differance," in *Speech and Phenomena, and Other Essays on Husserl's Theory of Signs*, Evanston, 1973, 129–60.

[4] E. H. Gombrich, *Art and Illusion: A Study in the Psychology of Pictorial Representation*, Princeton, 1960.

resemblance theory posits an a-historical constant, namely nature, against which all works must be evaluated.[5]

An alternative to the resemblance theory of representation may be found in semiotics. Semiotics claims that language is a signifying system which relies for its operation not on the way in which words invoke their referents, but on their relation to all the other words in the language.[6] Saussure argued that every word is constituted of a material word/image, or *signifier*, which is accompanied by an ideal meaning, or *signified*. Saussure's theory has been widely applied in the study of anthropology, literature and psychoanalysis, as well as art history.[7] By defining language as a self-contained system within which individual words draw their meaning, Saussure effectively lifted it out of the context of all the other signifying systems that constitute social life. An alternative to Saussure's model, one that is of greater interest to the historian since it insists that language is intimately related to other dimensions of culture, is found in the work of Bakhtin and Volosinov. According to these authors, the word draws its meaning from its social function rather than from its location within a hermetic system. Language, in other words, is shaped and colored by its social situation so that it is always ideologically charged. "The domain of ideology coincides with the domain of signs. They equate one another. Whenever a sign is present, ideology is present too. *Everything ideological possesses semiotic value.*"[8]

The semiotic status of the model used by Bakhtin and Volosinov is threatened by the specter of the base/superstructure distinction which insists that the play of signs in ideology is a function of a more fundamental reality, namely, the class struggle. This view may therefore be usefully supplemented by reference to the work of C. S. Peirce. Peirce's notion of the sign is far broader and more philosophical than Saussure's. Rather than restrict its activity to language, Peirce claimed that the sign could cover all kinds of coded behavior. By dividing his concept of the sign into a triad consisting of the Sign, its Object and an Interpretant, Peirce defined it not solely in terms of the system to which it belongs but also of the way in which it has previously been understood.[9] Peirce's inclusion of the Interpretant means that our understanding of the sign is always mediated. The meaning of signifying systems is never stable since they are grasped on the basis of previous interpretations of their significance. Our very perception of the sign is conditioned by the ways in which our culture has taught us to recognize it. If we transfer a semiotic view of language as a signifying system based on convention to our understanding of images, it is possible to sever the link between images and nature postulated by the resemblance theory of representation. This affords us a model of representation that is fully historical because it depends on socially constructed signs rather than on

[5] N. Bryson, *Vision and Painting: The Logic of the Gaze*, London, 1983, see esp. chaps. 1 and 2.

[6] F. de Saussure, *Course in General Linguistics*, trans. C. Bally and A. Sechehaye, New York, 1959.

[7] For art-historical examples see the review article by M. Bal and N. Bryson, "Semiotics and Art History," *Art Bulletin*, LXXIII, 1991, 174–208.

[8] V. Volosinov, *Marxism and the Philosophy of Language*, trans. L. Matejka and I. R. Titunik, Cambridge, Mass., 1973, 10. See also M. Bakhtin, *The Dialogic Imagination, Four Essays*, ed. M. Holquist, trans. C. Emerson and M. Holquist, Austin, 1981.

[9] C. S. Peirce, "Logic as Semiotic: The Theory of Signs," in *Semiotics, An Introductory Anthology*, ed. R. Innis, Bloomington, 1985, 1–23.

mimesis. The study of the historical horizon becomes the study of the ways in which various signifying systems percolated through works of art, as well as through the societies in which they were produced. Works of art become systems of signification that are contiguous to and continuous with the systems that articulate and structure all other aspects of social life.

The dominant metaphor for this type of interpretation is tracing or delineating, not penetrating. As Barthes put it: "In the multiplicity of writing everything is to be *disentangled*, nothing *deciphered*; the structure can be followed, 'run' (like the thread of a stocking) at every point and at every level, but there is nothing beneath"[10] Like all systems of signification, the work of art is regarded as an active principle in the life of culture, communicating social values in the same way that language does. Its function within its historical horizon becomes the focus of interest, rather than its passive reflection of the historical circumstances in which it was produced. From a semiotic perspective, iconography would be the study of the conventions used by a particular culture to encode the values that structure its identity. It would study the formulae used in the articulation of particular themes not because they afford us access to the intellectual life of the period but because they shaped the character of social life. The focus would be on the social work performed by the structures of signification rather than on their intrinsic meaning. Because of our inability to penetrate the mind of the period or to establish what Baxandall has called a "period eye," semiotic theory does not pretend to offer a univocal meaning for the work of art.[11] The significance of the work shifts and changes according to the interpretation placed on it by the historian.

Semiotics thus prompts us to reevaluate the role of the historian as well as the function of interpretation. For a semiotic theory of the interpreter as a social subject we can turn to Lacan's application of Saussure's linguistics to psychoanalysis.[12] According to Lacan the human subject is created by means of the alienating power of language. Language splits the original core of subjectivity through the introduction of the concept of the Other. The subject no longer exists within and for itself but is made aware that it is itself an object for another subject. While language, or in Lacan's term the Symbolic, grants the subject access to cultural and social life, it also defines the subject in terms of what it is not. Such a view of human subjectivity implies that the sign systems manipulated by the subject must always be unstable in their meaning. If the human subject is both the subject and the object of language, the possibility of univocal meaning is necessarily lost. Language defines the author's subjectivity to the same extent that the author's subjectivity defines the language. Language structures and shapes the utterance as much as the utterance instantiates and materializes the language. Just as the sign systems that belong to the historical horizon are not univocal, neither is the discourse of the historian. What the author wishes to say is never found in the place in which it is said.

What is the status of the knowledge produced on this understanding of the subjectivity of the interpreter? If the historian is formulating lexical sign systems about the visual sign

 [10] R. Barthes, "The Death of the Author," in *Image, Music, Text*, ed. and trans. S. Heath, New York, 1977, 142–48.

 [11] M. Baxandall, *Painting and Experience in Fifteenth Century Italy*, Oxford, 1972.

 [12] J. Lacan, "The Mirror Stage as Formative of the Function of the I" and "The Agency of the Letter in the Unconscious or, Reason Since Freud," in *Écrits, A Selection*, trans. A. Sheridan, New York, 1977, 1–7, 146–78.

systems of works of art, but neither the signs in the historical horizon nor those in the inter-preter's own time may be regarded as stable, what sort of truth claim can be made for them? While clearly subscribing to a relativist position, a semiotic view of interpretation would not entail that "anything goes." To use the words of W. J. T. Mitchell: "I am not arguing for some facile relativism that abandons 'standards of truth' or the possibility of valid knowledge. I am arguing for a hard, rigorous relativism that regards different versions of the world, including different languages, ideologies and modes of representation."[13] If we subscribe to a semiotic model according to which all sign systems are ideological, we cannot escape the conclusion that those systems used by historians in the articulation of their interpretations are equally freighted with ideological content. The writing of history on this model is identical with the production of ideology. This being the case, the criterion for deciding which inter-pretation is to be preferred over any other will correspond with the evaluating interpreters' views of the political and social situation in which they are located. As I have argued else-where,[14] the prospect of invoking political and social criteria for deciding between competing interpretations cannot be regarded as favoring the straightforward imposition of the political values of the author on the understanding of the past. A valid historical interpretation will continue to be one that makes every effort to grapple with the strangeness, or "otherness," of the historical horizon it seeks to interpret. The interpreter, however, cannot escape the grip of the cultural forces that have shaped her or his social and political attitudes.

Once we accept the centrality of politics to any act of interpretation, it becomes evident that the politics of iconology or any other form of knowledge that is based on a correspon-dence theory of truth is to present itself as value-free. The politics of iconology is to claim that it has no politics. As long as art history continues to subscribe to the notion that the know-ledge produced through the application of any of its methodological procedures bears a privi-leged relation to the truth, it must perpetuate a myth of certainty and finality. In order that our discipline can enter a fruitful dialogue with the discourses that currently animate other fields in the humanities, it must transform its conception of knowledge from one that pur-ports to afford us access to historical verities to one that provides us with interpretations that are consciously inflected according to specific social and political views. In terms of the sub-ject of this volume, therefore, the choice suggested by the crossroads metaphor might be en-visioned in the following terms: methods such as iconology can either continue to be used in the production of knowledge, unaware that their claims to certitude are ideologically moti-vated, or we can accept a more epistemologically circumscribed yet politically empowered view of their creative function within the culture in which we live.

[13] W. J. T. Mitchell, *Iconology: Image, Text, Ideology*, Chicago, 1986, 38.
[14] K. Moxey, "Semiotics and the Social History of Art," *New Literary History*, XXII, 1991, 985–99.

Iconography as a Humanistic Discipline
("Iconography at the Crossroads")

•

IRVING LAVIN

I MUST BEGIN with three preliminary explanations concerning the title of this little vignette. All three observations refer to the vocabulary used by Erwin Panofsky, whose name more than any other we associate with the study of the subject matter of works of art, to explain what he thought he was doing. First, I use the term iconography advisedly. Inspired by Aby Warburg, Panofsky drew a sharp distinction between iconography and iconology, reserving the latter term for the discursive interpretation of the deepest level of meaning conveyed in the visual arts. I am concerned here not with iconology but with what might be called the pre-iconological foundation for intellectual analysis, namely, the process of describing the content of a work of art as systematically as possible so that its underlying meaning may be discerned as systematically as possible through iconological study. I was rather dismayed to learn recently from Rosalie Greene, the director *emerita* of the Index of Christian Art at Princeton, that late in his life Panofsky gave up the term iconology altogether: "get rid of it, we don't need it any more," she said he said. I realized that what I have to say is indeed very close to getting rid of "iconology" (which never really caught on in professional parlance anyway), except I had not thought about it in quite that way; Panofsky was much more perspicacious than I, and much more succinct.

The second point concerns the second part of my title, which echoes that of Panofsky's famous little essay, "The History of Art as a Humanistic Discipline." The paper was first published in 1940 and then reprinted in 1955 as the introduction to his famous little volume of essays (Panofsky was fond of referring to his shorter efforts as "little"), itself significantly called *Meaning in the Visual Arts*. Both titles encapsulate the distinctive nature of Panofsky's primary preoccupation and his singular contribution to the study of art history. This point is crucial to my argument and I want to explain it with some care before continuing. A fundamental common denominator underlies Panofsky's vast outpouring of articles and books on an immense variety of subjects, from his astonishing dissertation on Albrecht Dürer's theoretical ideas about art (published in 1914 when Panofsky was 22, it brought him instant notoriety as a kind of child prodigy) to his last major work, published posthumously in 1969, a volume on Titian which he produced only at the urging of friends because, as he said, he felt

inadequate to write about his favorite artist.[1] The study of Dürer's aesthetics revolutionized our understanding of the position in European history of Germany's great national painter, who had previously been treated as the epitome, the very incarnation of the pure, mystical German spirit. Panofsky showed, to the dismay of many, that Dürer was in fact the principal channel through which the classical tradition of rational humanism, reborn in Italy in the Renaissance, was transmitted to Germany, transforming its culture forever (Figs. 1, 2). At the end of his career Panofsky revolutionized our understanding of Italy's most beloved painter of the Renaissance by showing, again to the dismay of many, that Titian was not just the painter's painter *par excellence*, the pure colorist, the virtuoso of the brush, the unrestrained sensualist of form and light. On the contrary, Titian was also a great thinker who suffused his brilliant displays of *chiaroscuro* with layers and layers of wide learning and profound meaning, like the many layers of oil glazes that lend to his canvases their luminosity and depth. One of the prime instances of this transformed understanding of Titian—and how one understands Titian is how one understands the nature of painting itself, indeed of visual expression generally—was his analysis of one of Titian's seminal works, commonly known by the rather common title of *Sacred and Profane Love* (Fig. 3). Panofsky showed that the picture, which includes two females, one scrumptiously dressed, the other divinely nude, in fact belonged in a long tradition of intellectual allegories. It can only have been providential, I might add, that the same tradition ultimately produced the official seal of the Institute for Advanced Study, in which an adorned figure of Beauty contrasts with the naked Truth (Fig. 4).[2] (Panofsky served as Professor of Art History at the Institute from 1936 until his death in 1968; 1992 was the centennial of his birth.)

The visual arts had since antiquity been low man (or low woman, since the arts are always represented as women) on the totem pole of human creativity, far behind literature, music and history, for example. Painting, sculpture and the like were classed as mechanical arts, rather than liberal arts, since they were considered the products of manual, rather than intellectual labor. Panofsky was the first to hear clearly, take seriously and apply systematically to all art, what artists since the Renaissance—Leonardo, Raphael, Dürer, Michelangelo, Titian and the rest—were saying, sometimes desperately: that art is also a function of the brain, that man can speak his mind with his hands. Panofsky's predecessors were mostly concerned with the classification of artists, styles and periods, or with the social, religious and political contexts in which art was produced, or with the psychological and formal principles that determine its various forms. Panofsky also engaged in all those activities, but he was especially devoted to meaning. The artist had something special to say and found special ways to say it. (In 1934 Panofsky, who has often been accused of being antagonistic toward modern art, published a miraculous meditation on precisely this theme with respect to the movies; a pioneer effort to define the principles of what would now be called "filmic" tech-

[1] *Die theoretische Kunstlehre Albrecht Dürers (Dürers Aesthetik)*, Berlin, 1914; *Problems in Titian, Mostly Iconographic*, New York, 1969.

[2] I have in progress a study of the Institute's seal and the history of the equation of Beauty and Truth.

nique, he wrote the piece to support the nascent Film Library at the Museum of Modern Art.)[3] This insistence upon and search for meaning—especially meaning in places where no one suspected there was any—led Panofsky to a new understanding of art as an *intellectual* endeavor, and to a new definition of art history as a humanistic discipline.[4] It is no accident that one of Panofsky's primary contributions as a historian should have been in the definition and defense of the idea of the Renaissance. The modern struggle of art history to gain recognition was a reenactment of the struggle of Renaissance artists to have their activity counted among the liberal arts.

The third explanation concerns my subtitle, which is borrowed, a bit coyly perhaps, from the title of the present volume. The phrase is itself a *double entendre*, referring to one of Panofsky's grandest iconographical studies, *Hercules at the Crossroads*,[5] and also to the fact that the iconographical method, so-called, has come under attack in recent years as an overly intellectual, socially unaware and irrelevant enterprise. In fact, to tell the truth, I did not realize Iconography *is* at a crossroads—I thought she had long since crashed and followed her older sister, Stylistic Analysis, into art historical limbo. I thought iconography died when the study of history *per se* came to be conceived as an exercise in social irrelevance, and the humanistic ideal itself passed away. Where there is a crossroads, however, I suppose there may yet be traffic.

"Iconography at the Crossroads" is particularly appropriate at Princeton because Princeton became, after all, the *locus classicus* of iconography, inhabited by two of the subject's inspiring geniuses, Charles Rufus Morey and Erwin Panofsky. Panofsky might have described their meeting at Princeton as, to paraphrase one of his *bons mots*, a happy accident at the crossroads of tradition. Panofsky was awed by Morey and often expressed his great admiration for and indebtedness to the tall, handsome WASP who brought the ungainly little German Jew to Princeton and secured his appointment at the Institute for Advanced Study. In the remarks that follow I shall conjure up these two benign spirits—I knew them both and I promise they are that—at the point where their intellectual paths met in Princeton.

[3] "Style and Medium in the Motion Pictures"; often reprinted, most recently in G. Mast and M. Cohen, *Film Theory and Criticism. Introductory Readings*, New York and Oxford, 1979, 243–263. Reprinting the essay in 1947, the editors of *"Critique," A Review of Contemporary Art* referred to it as "one of the most significant introductions to the aesthetics of the motion picture yet to be written."

[4] After completing this essay I received from Dieter Wuttke, who is preparing an edition of Panofsky's letters, a copy of an article that includes a remarkable and very pertinent letter about Aby Warburg written by Panofsky in 1955 (D. Wuttke, "Erwin Panofsky über Aby M. Warburgs Bedeutung. Ein Brief des Kunsthistorikers an den Bankier Eric M. Warburg," *Neue Zürcher Zeitung*, Feuilleton, January 7, 1992, 17f.). Panofsky credits Warburg with precisely the same emphasis on subject matter and content that I ascribe to Panofsky. I may therefore be guilty of the very error of misattribution Panofsky decries in observing that Warburg's ideas were better known through the writings of the "Warburg School," including Panofsky, than from the much less widely read works of the master himself! Still, there is a fundamental difference: Warburg was ultimately concerned with psychic truth (E. H. Gombrich, *Aby Warburg. An Intellectual Biography*, Oxford, 1986, 73ff.), whereas Panofsky was after intellectual meaning. For Warburg art history was a means toward a "psychology of culture"; for Panofsky it was a humanistic discipline.

[5] *Hercules am Scheidewege und andere Bildstoffe in der neueren Kunst* (Studien der Bibliothek Warburg, XVIII), Leipzig and Berlin, 1930.

In his essay on the discipline of art history Panofsky is concerned first of all to define the nature of humanistic study, and to defend the process whereby the study of art in particular had been transformed from an elite form of aesthetic satisfaction into a wide-ranging scholarly enterprise that encompassed the whole gamut of historical materials and methods and came to be accepted without question as a proper and fully accredited academic subject. Panofsky defines the subject of the art historian's study as an interconnected amalgam of three constituent elements: form, subject matter and content, and he quotes C. S. Peirce's definition of the distinction between the latter two: "Content, as opposed to subject matter, is that which a work betrays, but does not parade." Content is, Panofsky says, "the basic attitude of a nation, a period, a class, a religious or philosophical persuasion—all this unconsciously qualified by one personality, and condensed into one work."[6]

The curious thing is that he never actually defends the notion of the history of art as a humanistic discipline—he simply asserts, "It may be taken for granted that art history deserves to be counted among the humanities."[7] The reason he thought it could be taken for granted is evident from a preceding passage in which he distinguishes between the "naïve" appreciator of art and the art historian. It is a bit long and we may take exception to what it includes and what it leaves out; but in view of the accusations of narrowness often leveled, and sometimes with justice, at iconography, the passage is worth quoting at least to indicate what Panofsky himself thought he was about. Unlike the naïve art lover, he says:

> The art historian *knows* that his cultural equipment, such as it is, would not be in harmony with that of people in another land and of a different period. He tries, therefore, to make adjustments by learning as much as he possibly can of the circumstances under which the objects of his studies were created. Not only will he collect and verify all the available factual information as to medium, condition, age, authorship, destination, etc., but he will also compare the work with others of its class, and will examine such writings as reflect the aesthetic standards of its country and age, in order to achieve a more 'objective' appraisal of its quality. He will read old books on theology or mythology in order to identify its subject matter, and he will further try to determine its historical locus, and to separate the individual contribution of its maker from that of forerunners and contemporaries. He will study the formal principles which control the rendering of the visible world, or, in architecture, the handling of what may be called the structural features, and thus build up a history of 'motifs.' He will observe the interplay between the influences of literary sources and the effect of self-dependent representational traditions, in order to establish a history of iconographical formulae or 'types.' And he will do his best to familiarize himself with the social, religious and philosophical attitudes of other periods and countries, in order to correct his own feeling for content. But when he does all this, his aesthetic perception as such will change accordingly, and will more and more adapt itself to the original 'intention' of the works. Thus what the art historian, as opposed to the 'naïve' art lover, does, is not to erect a

[6] *Meaning in the Visual Arts*, Garden City, N. Y., 1955, 14.
[7] Ibid., 22.

rational superstructure on an irrational foundation, but to develop his re-creative experiences so as to conform with the results of his archaeological research, while continually checking the results of his archaeological research against the evidence of his re-recreative experiences.[8]

In referring to Panofsky's text and in co-opting his title, I certainly do not intend to urge universities to establish departments of iconography in any sense of the word. But I do believe the intellectual revolution about which Panofsky wrote so eloquently and to which he contributed so fundamentally, has reached the point of no return, and we must face the consequence. We normally suppose iconography to be a branch of art history, whereas I think the reverse is true, for two, interrelated reasons. Our definition of art has so broadened as to include virtually any man-made image; and our attitude toward art thus defined has so deepened as to preclude the notion that the meaning of a work of art is exhausted either by its aesthetic value, on the one hand, or by its social value, on the other. The study of the history of art, conceived in this broader sense, has become the study of the history of the meaning, conceived in this deeper sense, of images.[9]

I want to try to prove my point by retracing Panofsky's geographical and intellectual pilgrimage from Hamburg, Germany, to Princeton, New Jersey, from the iconographical point of view. Panofsky himself recounts the saga of his displacement in another beautiful composition, "Three Decades of Art History in the United States: Impressions of a Transplanted European," first published in 1953, which he appended as the epilogue to *Meaning in the Visual Arts*. From this bittersweet reminiscence it becomes clear that there is a consonance between Panofsky's experience as a refugee from Fascism, his passionate embrace of the humanistic tradition, and his taking it for granted that the history of art belongs among the humanities. For its openness, its enthusiasm, its candor—but above all for its sheer perspicacity—Panofsky's account of his "Americanization" and estimation of what he found here, inevitably recalls Tocqueville. It has no equal as an assessment, by a sophisticated but somewhat surprised European intellectual, of this strange and rather barbaric new land into which he had been, as he says, transplanted. Whereas most historians emphasize what America gained from the talented immigrants—those delicious apples America caught from the tree that Hitler shook—Panofsky suggests that for him it was a two-way street.[10] He distilled the two main benefits he felt he received from his translocation into one of the most extraordinary of the many extraordinary paragraphs of that extraordinary memoir:

> To be immediately and permanently exposed to an art history without provincial limitations in time and space, and to take part in the development of a discipline still animated by a spirit of youthful adventuresomeness, brought perhaps the most essential gains which the immigrant scholar could reap from his transmigration. But in addition it was a blessing for him to come into contact—and occasionally into conflict—with an Anglo-Saxon positivism

[8] Ibid., 17f.

[9] On the foregoing, see I. Lavin, "The Art of Art History," *ARTNews*, LXXXI, 1983, 96–101.

[10] The familar aphorism about Hitler's apples was invented by Walter W. S. Cook, founder of the Institute of Fine Arts of New York University, who was Panofsky's first employer in America (*Meaning* [as in note 6], 332).

which is, in principle, distrustful of abstract speculation; to become more acutely aware of the material problems [posed by works of art,] which in Europe tended to be considered the concern of museums and schools of technology rather than universities; and, last but not least, to be forced to express himself, for better or worse, in English.[11]

However, I think Panofsky may have been a little coy in this case, because I suspect that he found something more when he came to Princeton in 1933, of great importance for his future work and development—the Index of Christian Art. He found in the Index an unparalleled and unfathomable reservoir of carefully organized and easily accessible material out of which he could realize his great, all-encompassing vision of the history of art among the humanities. Ironically, this was not the purpose for which the Index was originally intended. Ironically, in fact, the diminished esteem in which iconography has been held by art historians in recent years has been counterbalanced by the greatly increased use to which the Index has been put by people in other fields: the literary historian looking for illustrations or visual analogies to his text, the lexicographer interested in medieval naval terminology studying the boats in which Christ rides on the Sea of Galilee, the economic historian interested in medieval agronomy studying the hoes Adam wields in Paradise.

In order to make clear my case for the indebtedness of Erwin Panofsky to the Index of Christian Art, however, I must first confess that, personally, I sometimes think iconography is an invention of the devil. At least, it is a devilishly duplicitous notion that marries two things almost genetically incompatible, an abstract idea called an image, and a concrete object called a work of art. Plato long ago warned us that abstract ideas and concrete things really cannot be reconciled, and yet that to my mind is exactly what good iconography seeks to accomplish. Conversely, while it is duplicitous in theory, iconography as it is sometimes currently practiced might also be described as deceptively simple—based, that is, on a conception of the meaning of works of art that has become obsolete. I venture to say that during the half century or so before the recent demise of iconography, far more systematic effort was devoted to studying and classifying subject matter than to any other aspect of art. In part, of course, this popularity was due to the brilliant achievements of great practitioners like Panofsky. Another, historically no less important factor was the commonly held belief that subject matter is somehow the most "scientific," the least ambiguous, aspect of art. Different observers, it seems, are more apt to agree on the title of a work than on almost anything else about it. Nonsense. On the contrary, the form, style if you will, of a work of art is no less important to its meaning, and no less susceptible to rational and fruitful analysis than its subject. As the passage I quoted earlier testifies, Panofsky entertained this strange notion, too.

Interest in the systematic study of subject matter developed mainly in the period between the two world wars, and resulted in the creation of the two oldest, most elaborate and comprehensive tools we have for the analysis of works of art, namely, the Index of Christian Art and the classification system known as Iconclass. It is important to bear in mind that both projects were developed in order to help art history escape as far as possible from the subjec-

[11] *Meaning* (as in note 6), 329.

tive quagmire of impressionistic art criticism. Although they have this goal in common, and although they pursue it in largely the same way, by classifying works of art according to the subjects they depict, the two systems reflect radically different points of view toward the significance of subject matter itself. I am going to compare them briefly, not to choose between them, since they have both become indispensable and mutually reinforcing tools of our trade, but simply to illustrate my point about Panofsky, the Index, and the nature of art history.

Morey, who started the Index just after the first World War, was not primarily concerned with what Warburg and Panofsky called iconology, that is, the social, symbolical, philosophical, ideological, and theological implications of represented themes. Rather, Morey wanted to use subject matter as a means of replacing or buttressing purely stylistic analysis in classifying works of art geographically and chronologically. Certain subjects are more popular in some places and at some times than others. Also, certain ways of representing some subjects are more popular in some places and times than in others. In this latter context, especially, the design of the individual work becomes crucial, for variations in the treatment of a given subject make it possible to establish affiliations and differences between works on what is apparently a far more objective basis than stylistic analysis alone can provide. The approach led to a dual structure for the Index, which starts with the objects, groups them initially by subject matter, and then also includes detailed descriptions that enable the researcher to use the features noted in a particular work in a comparative study of modes of depicting a given theme. Following this method, the Princeton school of art history was able to make major contributions to the taxonomy of medieval art, and to our understanding of the processes by which medieval art evolved.

The Dutch scholar Henri van de Waal, who invented and developed the system known as Iconclass during the 1940's and '50's, derived his ideas largely from the theories of significant form represented by Ernst Cassirer, Aby Warburg, and Panofsky, and his approach was almost the reverse of Morey's. Van de Waal was concerned with iconography precisely in the sense of conceptual import, and the alternative instrument he invented focuses exclusively on subject matter, the significance of a theme being determined by its relation to other subjects of the same or related species. This approach provides the means to classify objects on a purely thematic basis, regardless of when or where they were made, or what they actually look like. Here, a thoroughly structured framework of all possible subjects becomes essential, a framework in which any subject and any work of art may find their appropriate places.

Although subject matter is thus the common ground of both systems, the Index is ultimately morphology-oriented and therefore incorporates comprehensive descriptions of works of art, whereas Iconclass is content-oriented and consists in a comprehensive and thoroughly hierarchical classification of themes. Works of art are the Alpha and Omega of the Index, whereas in the entire Iconclass system there is no reference, nor can there be, to any work of art. Iconclass is as profound as can be concerning subjects that may be represented, including sometimes many variants of the same theme, but it is oblivious to the way they are represented. The Index is quite superficial concerning the classification of subjects, including sometimes many variant examples under the same heading, but it contains more or less elab-

orate descriptions of the way they are depicted in individual works. Iconclass, to take a tiny detail for example, includes a separate category for Crucifixions in which Christ is dead on the Cross, which the Index does not; in the Index descriptions, however, under the category Crucifixion, one can find those cases in which the dead Christ's head droops to the left, rather than the right—a potentially crucial distinction for the iconographer with imagination. In practice, to be sure, both systems are sensitive to their contentual alter egos: the hierarchies of Iconclass may be infinitely extended to incorporate thematic variants represented by individual works of art; conversely, subjects may be added to the Index or subdivided when greater descriptive precision is required. Nevertheless, the main virtue of Iconclass lies in its logic, consistency and comprehensiveness. The great virtue of the Index lies in its *ad hoc* hybridity and Anglo-Saxon positivism, that is, the indissoluble link it forges between the subject of a work of art and its design.[12]

Panofsky perceived that link: his classic definition of the Renaissance in art—often challenged but never surpassed—as the reintegration of classical form with classical subject matter, depends upon it. Here we grasp the profound insight this reciprocity may provide into the historical process itself. To my mind, indeed, the link between form and content holds the very key to the significance of works of art, to the study of the significance of images in general, and hence to art history ("iconography," "iconology"—call it what you will) as a humanistic discipline.

BIBLIOGRAPHICAL NOTE

I append this note for readers who may wish to pursue further the matters discussed here. Brendan Cassidy has kindly provided the following bibliography on the Index of Christian Art: H. Woodruff, *The Index of Christian Art at Princeton University: A Handbook*, Princeton, 1942; R. B. Green, "The Index of Christian Art: A Great Humanistic Research Tool," *Princeton Alumni Weekly*, LXIII, 1963, 8–10, 16–17; A. C. Esmeijer and W. S. Heckscher, "The Index of Christian Art," *The Indexer*, III, 1963, 97–119; W. L. Burke, "The Index of Christian Art," *The Journal of Documentation*, VI, 1950, 6–11; L. Drewer, "What Can be Learned from the Procedures of the Index of Christian Art," in P. M. Daly, ed., *The Index of Emblem Art Symposium*, New York, 1990, 121–38; I. Ragusa, "The Princeton Index of Christian Art," *Medieval English Theater*, IV, 1982, 56–60; M. M., "The Princeton Index of Christian Art: After Twenty Years," *UCLA Librarian*, XXXIX, 1986, 13–15; E. De Jongh, "Index of Christian Art voor Utrechts Instituut," *Vrij Nederland*, 22 September 1962, 7; A. C. Esmeijer and W. S. Heckscher, "Wij richten de scijnwerper op: De Index Afdeling van het Kunsthistorisch Instituut," *Solaire Reflexen/Orgaan voor het personeel van de Rijksuniver-

[12] Leendert D. Couprie, the current Director of Iconclass, who was kind enough to read this paper in manuscript, offered a very felicitous paraphrase of the distinction I am making here: idealist vs behaviorist.

siteit te Utrecht, xi, 1964, 2–3; B. Cassidy, "The Index of Christian Art: Present Situation and Prospects," *Literary and Linguistic Computing*, vi, 1991, 8–14.

The Iconclass system is contained in the comprehensive compendium, bibliography and index by H. van de Waal, completed and edited by L. D. Couprie, R. H. Fuchs, E. Tholen and G. Vellekoop, *Iconclass: An Iconographic Classification System*, 17 volumes, Amsterdam, 1973–85. For a fine discussion of Iconclass and Henri van de Waal, see C. R. Sherman, "Iconclass: A Historical Perspective," in *Visual Resources. An International Journal of Documentation*, iv, 1987, 237–46. Iconclass has been widely applied in indexing projects and the bibliography concerning it is quite large. Another system, based on descriptive themes as well as subjects, has been developed by F. Garnier, *Thesaurus iconographique. Système descriptif des représentations*, Paris, 1984. Invaluable tools for the study of subject matter classification in general are the annual bibliographies published since 1984 in *Visual Resources*, and the database and specialized document collection maintained by the Clearinghouse on Art Documentation and Computerization at the Thomas J. Watson Library of the Metropolitan Museum of Art, New York. I am indebted to Helene E. Roberts, editor of *Visual Resources*, and Patricia Barnett, Clearinghouse Director, for their generous responses to my inquiries.

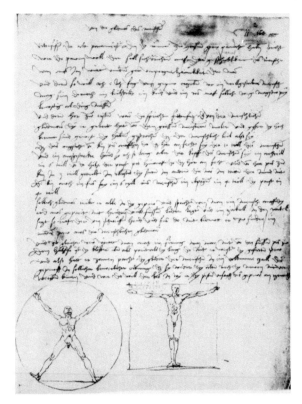

1. Albrecht Dürer, Vitruvian Man, drawing. London, British Museum (after W. L. Strauss, *The Complete Drawings of Albrecht Dürer*, New York, 1974, V, p. 2431)

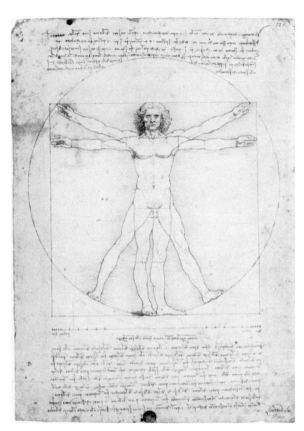

2. Leonardo da Vinci, Vitruvian Man, drawing. Venice, Galleria dell'Accademia (after L. Cogliata Arano, *Disegni di Leonardo e della sua cerchia alle Gallerie dell'Accademia*, Milan, 1980, p. 32)

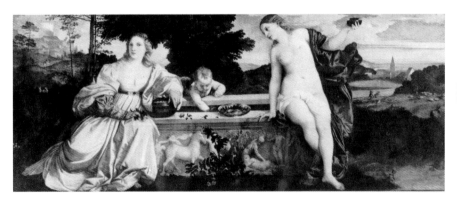

3. Titian, *Sacred and Profane Love*. Rome, Galleria Borghese (after C. Hope, *Titian*, London, 1980, pl. v)

4. Official seal of the Institute for Advanced Study, Princeton

Mouths and Meanings: Towards an
Anti-Iconography of Medieval Art

•

MICHAEL CAMILLE

THEORY AND PRACTICE as represented by four figures in a frontispiece to a twelfth-century medical treatise by Constantinus Africanus in the Vatican Library (Fig. 1) cannot help but remind me of a current conflict in art history.[1] Those espousing Theory point adamantly to their empty texts (like the figures top left and bottom right) in opposition to those who either stretch a finger toward the elusive object beyond the frame (top right) or hold it up to the elegant scrutiny of the connoisseur (bottom left). While these bearded sages might once have been lecturers at the Warburg versus those at the Courtauld Institute, and today proponents of the so-called New versus the Old art history, their twelfth-century *disputatio* is between direct experience and knowledge that is mediated through texts. Iconography is a mediation of *icon* through *logos*, especially in Panofsky's more developed term, iconology.[2] There could be no meaning for Panofsky without pointing to the scroll of verbal explanation. In this essay I shall argue that, by limiting itself to written models of interpretation, iconography does not take enough account of the uninscribed codes and cultural practices that are generated orally and performatively. This is especially true of the medieval image in which the autonomous intentionality of the modern "art" object is lacking and where production and reception are subject to relations and interests of power operating outside the producer's control.

Art history's obsession with written language derives from the late nineteenth century when, as a new discipline, we sought to ally ourselves with the prestigious positivist "science"

[1] This is an image of the harmony rather than the conflict between ancient medical theory and practice; Rome, Biblioteca Vaticana, Pal. Lat. 1158, *Constantinus Africanus*, see L. Schuba, *Universitätsbibliothek Heidelberg, Die medizinischen Handschriften der Codices Palatini in der Vatikanischen Bibliothek*, Wiesbaden, 1981, 118.

[2] See the "classic" formulation by E. Panofsky in "Iconography and Iconology," first printed in *Studies in Iconology: Humanistic Themes in the Art of the Renaissance*, New York, 1939, slightly revised in his *Meaning in the Visual Arts*, New York, 1955, 51–81. Panofsky's methodology, perhaps adequate in dealing with certain types of Renaissance painting but fraught with problems for the study of earlier and later periods, has had enormous influence in disciplines as varied as sociology (Pierre Bourdieu) and anthropology (Clifford Geertz). Although in their introduction to a recent book, *The Iconography of Landscape*, Cambridge, 1988, geographers S. Daniels and D. Cosgrove identified Panofsky's logocentrism, they failed to see its limitations for their own project; "While, by definition all art history translates the visual into the verbal, the iconographic approach consciously sought to conceptualize pictures as encoded texts to be deciphered by those cognisant of the culture as a whole in which they were produced" (p. 2).

of philology.[3] Although the more recent influence of theories based on Saussurian linguistics has undoubtedly energized the discipline they have simultaneously taken us further away from the specific problems of the visual, which are now all too easily subsumed under the rubric of the textual. Suffused with language, either iconically (in the form of inscriptions and speech scrolls) or indexically (by referring to written narratives of the Bible text) medieval art is often described as though it were entirely text-driven. Ever since Mâle's influential metaphor, taken over from Romantic writers like Victor Hugo, that medieval artists are "writers in stone," the notion of legibility has been used unproblematically, reducing medieval images to a neatly coded series of signs waiting to be decoded by scholarly exegetes.[4]

The past decades have seen literacy become a crucial area of research in history, sociology, and anthropology, all of which have brought into question the notion of "reading" past cultures through texts. Brian Stock has argued that from the eleventh century onward written models of interpretation gradually took over from oral traditions in various "textual communities," even where literacy itself was not present.[5] The role of images in this crucial transition remains to be explored but it is clear that the matrix in which medieval art functioned was one in which speech had priority over writing.

These words, for example, were delivered orally at the Princeton conference to hundreds of attentive ears and eyes, an audience that could, and indeed did, answer back and disagree. But now, transposed through a textual grid, they become an altogether different kind of discourse—a revised, rethought, written document. Medieval images, whether in books or on walls, were, like medieval texts, dynamically delivered and performed aloud rather than absorbed in static isolation. The difficulty for the art historian becomes one of double translation—to explore in writing, ideas that might have originated through writing

[3] The tyranny of the philological method has been especially unfortunate in the field of manuscript illumination, which under the influence of K. Weitzmann, *Illustrations in Roll and Codex: A Study of the Origin and Method of Text Illustration*, Princeton, 1947, rev. ed. 1970, constructed genealogical *stemmata* of illustrative recensions, hypothesized numerous "lost models," but perhaps most dangerous of all viewed manuscript illustrations as secondary to the text. Philology as a method of getting at literary meaning has recently come under attack from a new generation of scholars of medieval literature, see *Speculum*, LXV, 1990, "The New Philology," ed. S. Nichols, especially the essays by S. Fleischmann and R. H. Bloch.

[4] E. Mâle, *Religious Art in France: The Thirteenth Century*, ed. H. Bober, Princeton, 1984, 3 (which we should not forget was first published in 1889) took the metaphor of medieval art as "sacred writing" from earlier Romantic sources like Victor Hugo's *Notre Dame de Paris*, 1831, and Ruskin's *Bible of Amiens*, 1881. According to D. Frey, *Gotik und Renaissance*, Augsburg, 1929, 40, "linguistic imagery becomes the immediate foundation of pictorial presentation." A recent set of essays asking new questions about the logocentric assumptions is contained in *Word and Image*, V, 1989, ed. H. L. Kessler, devoted to "Reading Ancient and Medieval Art." A recent diatribe which usefully collects together texts but fails to address the visual aspect of the equation is L. G. Duggan, "Was Art Really the Book of the Illiterate?" *Word and Image*, V, 1989, 227–51.

[5] B. Stock, *The Implications of Literacy: Written Language and Models of Interpretation in the Eleventh and Twelfth Centuries*, Princeton, 1983. In "Seeing and Reading: Some Visual Implications of Medieval Literacy and Illiteracy," *Art History*, VIII, 1985, 44 n. 5, however, I drew attention to Stock's use of the same cliché about cathedrals "proclaiming the Gospels in stone." For a more recent and far-reaching discussion of "textuality" and vision, see Stock's "Medieval Literacy, Linguistic Theory, and Social Organization," in *Listening for the Text: On the Uses of the Past*, Baltimore and London, 1990, 30–52. Another important scholar of early medieval literacy is Michael Richter, see especially, "A Socio-Linguistic Approach to the Latin Middle Ages," in *The Materials, Sources and Methods of Ecclesiastical History*, ed. D. Baker, Oxford, 1975, 69–83.

like Holy Writ, but which were then mediated outside or beyond it, in rituals, prayers, sermons, but most importantly of all, in images.

I have deliberately chosen to discuss a work of medieval art that has long intrigued art historians precisely because of its resistance to written models of explanation. The trumeau on the right side of the inner west wall of the Abbey of Sainte-Marie at Souillac in southern France is one of a group of fragments, including a narrative relief, two prophets, and a smaller piece of relief sculpture, that according to Schapiro "we can no longer reconstruct"[6] (Fig. 2). Can we even call the work a trumeau since it does not stand in the center of the doorway holding up the lintel? The original placement of these reliefs is unknown but scholars have attempted various reconstructions. According to one theory they formed a porch with side walls as at Moissac while another has them in a more conventional portal with tympanum. In all reconstructions the trumeau is seen as leading the viewer into the sacred space rather than being looked back to from within it.[7] The ambiguity as to spatial location made it easier for Focillon and other early twentieth-century formalist writers to isolate the trumeau as a paradigmatic example of "Romanesque" form. This label also disqualifies it from the contest of "meaning." A drawing by Viollet-le-Duc shows him as a viewer standing at the site, as in our Fig. 2, whereas in our century the trumeau has most often been isolated as a fragment in photographic reproductions (Fig. 3).[8]

On its front face, stone turns to feathers, claws and fur, textures that ruffle and slither between the cranky joints of shaft and pillar to create an architecture of animality, a spiraling ascent and descent of biting bestiality (Fig. 3). Four birds on the left and four lions on the right twist inward and upward to engorge a small, torn, helpless thread of quadrupeds in the center, dragging them downward. Contrary to their fall, a naked man struggles upward at the summit, his vulnerable flank torn by a beak and his face contorted with pain as he is held in the vice-like grip of a lionish mouth.

Mâle, logocentric code-breaker of the cathedrals, was, for once, lost for words when describing this work and relied on the rhetorical trope of its indescribability and overinterpretation:

[6] M. Schapiro, "The Sculptures of Souillac," in *Medieval Studies in Memory of A. Kingsley Porter*, II, Cambridge, Mass., 1939, 359–87, repr. in *Romanesque Art. Selected Papers*, London 1977, 102–30. Schapiro's idea of the medieval "fragment" is challenged by K. F. Morrison, "Interpreting the Fragment," in *Hermeneutics and Medieval Culture*, ed. P. J. Gallacher and H. Damico, New York, 1989, 27.

[7] For particular theories of the original placement and reconstructions of the fragments, see J. Thirion, "Observations sur les fragments sculptés du portail de Souillac," *Gesta*, xv, 1976, 167–72; and R. Labourdette, "Remarques sur la disposition originelle du portail de Souillac," *Gesta*, xviii, 1979, 29–35; for the earlier porch see G. Cany and M. Labrousse, "L'Eglise abbatiale sainte-marie du Souillac: sa tour porche et sa nécropole," *Bulletin monumentale*, cix, 1951, 389–404. An excellent and as yet unpublished Master's thesis by J. R. Blaettler, *Mantle of Zeal: Rebuilding at Souillac*, University of Chicago, 1983, reconstructs the trumeau in a central position below the Theophilus relief and seeks to construct an aesthetic and theological whole from the fragments without forcing unitary meaning on them.

[8] For this pencil drawing dated 9 September 1842 see *Eugène Viollet-Le-Duc 1814–1879*, Paris, Caisse Nationale des Monuments Historiques, Paris, 1979, pl. 16, notice 93. For modernist fragmentation of the relief in photographs see H. Focillon, *Art of The West: Part I, Romanesque*, London, 1963, figs. 105–6; and V. H. Debidour, *Le bestiare sculpté du Moyen Age en France*, Paris, 1961, 75, 179. It can be seen earliest in A. Kingsley Porter's *Romanesque Sculpture of the Pilgrimage Roads*, Boston, 1923, ills. 350–53.

What has not been written about the Souillac trumeau? It has been attributed in turn to the Celtic and to the Barbarian spirit surviving in the provinces of the central plateau. A cosmogony, almost, has been read into it.[9]

Yet Mâle went on to argue that the sculptor of the Souillac trumeau "knew manuscripts from Limoges" with similar intertwining beast constructions. "There can be no doubt," he goes on, "that the sculptors of Southwest France were inspired by manuscripts and they learned from miniatures." This is another convention for getting around the problem of signification—the location of sources or influence. It also assumes a modern idea of stored meanings contained in pattern books or manuscripts. Only in a culture suffused with texts can things "refer."[10] How does a sculptor's enlarging of a design from a few inches on the vellum page to well over life-size change the significance of the motif? In their different media and context these bifurcating bodies cannot have the same meaning. The beasts curling around the L of the word *Liber* in an early twelfth-century Bible (Fig. 4) not only start to spell out the word *book* but are part of a codicological construct. By contrast the trumeau is not part of a linear sequence of signs. It cannot be "read." I shall argue that its sources are somatic rather than semantic.

Other visual sources that scholars have located for the combative zoo of the trumeau are secular Islamic carvings and textiles, where griffons and lions appear in similar configurations. But what significance has this appropriation of visual signs belonging to the enemies of the faith? Romanesque art is often interpreted as crusader ideology, but here Muslim motifs are monumentalized almost, as one scholar has suggested, as "trophies."[11] Does this indicate that they were perceived as exotic and "other"? If so it suggests borrowing that is not formal but political, and a sophisticated awareness of what is "foreign" and what is "ours."

Schapiro linked the trumeau to its location and the relief of Theophilus above it in his famous 1939 essay on the sculptures of Souillac. In contrast to Mâle, he saw its present position, pushed to one side of the arch and beneath the Theophilus relief, as typical of its anti-textuality:

> The very existence of the trumeau implies that sculpture has begun to emerge as an independent spectacle on the margins of religious art, as a wonderful imaginative workmanship addressed to secular fantasy. The trumeau is a passionate *drôlerie*, brutal and realistic in detail, an elaboration of themes of impulsive and overwhelming physical force., corresponding to the role of violence at this point in the history of feudal society.[12]

Schapiro's modernist/Marxist bias against the religious context makes the pillar into a "Mirò-like" sculpture, a playful and autonomous work of the imagination, separate from and marginal to the carefully coded narrative of feudal treachery that he brilliantly explicates for

[9] E. Mâle, *Religious Art in France: The Twelfth Century*, ed. H. Bober, Princeton, 1978, 20–21.

[10] See W. J. Ong, *Orality and Literacy: The Technologizing of the Word*, London, 1982, 123–25.

[11] R. M. Capelle, "The Representation of Conflict on the Imposts of Moissac," *Viator*, XII, 1981, 80–100.

[12] Schapiro (as in note 6), 123. In his important review of Schapiro's collected essays, *Art Quarterly*, II, 1979, 211–18, O. K. Werckmeister discussed "the contradictions" in Schapiro's approach to the trumeau as conditioned by modernist strategies and his unwillingness to see any Christian ideology in the biting beast motif, which, as Werckmeister showed, could even be derived from the liturgy.

the Theophilus relief above. The trumeau was not marginal if it was designed to be the central pillar of an ensemble as in the elastic examples at Moissac and Beaulieu with their similar undulating edges (Fig. 5). The two sides of the trumeau depict scenes of struggle between old and young men, the only "iconographically" identifiable one today being Abraham about to kill his son Isaac on the left (Fig. 6). On the other side are figures identified by some as the brothers Jacob and Esau above two pairs of wrestling figures (Figs. 7 and 8). These tangential biblical narratives immediately implode Schapiro's "secular" reading of the pillar and weave a meta-marginal "human" thread adjacent to the central animal activities. Flanked by two prophets and below the scene of Theophilus's trangression and salvation, this elaborate carving is more than a whimsical *drôlerie* (a word relating to much later Gothic marginal bands with problematic relationships to the adjacent text). The column was one of the most forceful signs of power, elevation, and degradation, even on its own, in this period.[13] Like the spiral column behind Theophilus himself in the relief above, it was a marker of movement into and out of sacred space and a site of attention for its various audiences.

The first and most important of these audiences were the Benedictine monks who set up the trumeau in their church and controlled access to it. We might think of their responses as the most "textual" as long as we remember that for them words were performed and sung in the liturgy, remembered and intoned in meditation, rather than only inscribed in books. For the monk there was no such thing as a single "meaning." Sculpted images, not only narratives like the Theophilus relief, but forms like the trumeau, invited meditation and what we would call psychological projection. Other groups, the illiterate or semi-literate visitors to the church, pilgrims, local people, who were part of what was a feudal city around the wealthy monastery in the twelfth century, would also not have read, but rather felt the power of the trumeau as they passed under it.

VIOLENCE, EATING, AND THE SACRED

The violence represented on the face of the trumeau is predominantly that of the mouth. The ripping of animal flesh would have resonated for the monks, evoking not only the bloody meat of animals from which they were meant to abstain, but also the rite at the very center of their lives, which involved eating a body. Fasting was an especially important issue in monastic reforms and was a major structuring principle of religious experience.[14] Some monks went around in constant craving for red meat. The Cistercian Caesarius of Heisterbach relates the story of a lay brother who "as he slept began to gnaw with his teeth on the wood on which he

[13] On the significance of the column, see M. Camille, *The Gothic Idol: Ideology and Image-making in Medieval Art*, Cambridge, 1989, 199–203.

[14] For monastic dietary habits, see A. Rouselle, "Abstinence et continence dans les monastères de Gaule méridionale à la fin de l'antiquité et au debut du Moyen Age. Étude d'un régime alimentaire et de sa fonction," in *Hommage à André Dupont (1897–1972)*, Montpellier, 1974, 239–54; and C. W. Bynum, *Holy Feast and Holy Fast: The Religious Significance of Food to Medieval Women*, Berkeley, 1987, 31–48. An initial in a twelfth-century Clairvaux manuscript depicts monks at table eating vegetables, see Troyes, Bibliothèque Municipale, MS. 392, fol. 73, described in L. Morel-Payen, *Les plus beaux manuscrits et les plus belles reliures de la Bibliothèque de Troyes*, Troyes, 1935, 87.

was lying prostrate, the devil making him think he was chewing flesh."[15] It is as though such taboos against animal flesh have been twisted by the designers of the trumeau into a manic ritual of ravenous swallowing and regurgitation. As Bakhtin observed, "the most important of all human features for the grotesque is the mouth" and the image of swallowing is the "most ancient symbol of death and resurrection."[16] The chains of biting birds can indeed be traced back to Coptic textiles and Islamic pattern books as Mâle noted, but the important questions concern not the sources utilized by the carver but how they were "brought to life" and made significant for current bodily practices. Entrance points in twelfth-century churches were dangerous intersections of inner and outer, described in terms of bodily metaphors like orifices, eyes, and mouths, and where the human being eaten alive by great teethed jaws is commonly found (Fig. 9). These have mostly been linked to otherwordly visions of Hell which is traditionally represented as a great gaping maw.[17] But the instinctual gratification of these "jaws" is also to be understood in terms of the primordial fear of predators. Wild animals, especially wolves, still stalked the forests of France.

For the monastic observer such images would have recalled to memory currently performed texts, most notably the Psalms, such as Psalm 21: "They gaped upon me with their mouths as a ravening and a roaring lion," but their meaning is not tied to any single text. Monks were trained to store words and combine them in complex multiple levels of meaning and spiritual allegory according to Saint Bernard, who nevertheless would have called the trumeau "deformed form."[18] Klingender argued in his book, *Animals in Art and Thought to the End of the Middle Ages*, that scholars have been wrong to insist that animal motifs can only be interpreted by the "icontestable" association of documents. Iconographers, he notes, apply "classificatory principles of nineteenth-century science" to images that historically had "a multiplicity of significant associations."[19]

Animals were seen by monks as ideal repositories for demonic possession: asses, pigs, and phantom quadrupeds were always invading the sacred space of the choir according to Caesarius of Heisterbach. Beasts could also be tried in secular and ecclesiastical courts for

[15] See Caesarius of Heisterbach, *A Dialogue on Miracles*, trans. H. Von E. Scott and C. C. Swinton Bland, London, 1929, 285. For the monk who could not eat the coarse convent bread until Christ dipped it into His wound, see p. 283.

[16] M. Bakhtin, *Rabelais and His World*, Cambridge, Mass., 1968, 316–17. The same body metaphors are explored in L. Marin, *Food for Thought*, Baltimore, 1989, 100–101.

[17] The front of the trumeau was interpreted as Hell by W. Weisbach, *Religiöse Reform und mittelalterliche Kunst*, Zurich, 1945, 97. Werckmeister (as in note 12), 214, noted the line of Psalm 73:19 "cast not to the beasts the souls that confess you," which was chanted during the monastic Office of the Dead and compared the figure on the trumeau to similar figures devoured by jaws on the carved lintel at Beaulieu.

[18] This is in the famous letter to Saint William of St. Thierry, trans. in C. Davies-Weyer, *Early Medieval Art 300–1150: Sources and Documents*, Englewood Cliffs, 1971, 168–70, now discussed by C. Rudolph, *The "Things of Greater Importance." Bernard of Clairvaux's Apologia and the Medieval Attitude Toward Art*, Philadelphia, 1990. For a discussion of this text in relation to monastic life see M. Camille, *Image on the Edge: The Margins of Medieval Art*, Cambridge Mass., and London, 1992, 56–75.

[19] F. Klingender, *Animals in Art and Thought to the End of the Middle Ages*, Cambridge, Mass., 1971, 328. For a Spanish bishop's views on animal depictions "sculpted in church, so that seeing them men will be terrified and . . . refrain from sinful deeds," see C. Gilbert, "A Statement of Aesthetic Attitude around 1230," *Hebrew University Studies in Literature and the Arts*, XIII, 1985, 137.

crimes such as murder.[20] Sexual intercourse with them was common, as evidenced in the Penitentials. Whereas we tend to anthropomorphize animals in a Disney fetishism, medieval viewers did the opposite. Animals had no souls. A late twelfth-century English psalter illustrates Psalm 48 "man that understandeth not is like the beast that shall perish" by showing three quadrupeds falling into the jaws of Hell (Fig. 10). The downward plunge of the small beasts on the trumeau at Souillac and the human figure struggling above them are surely meant to evoke this basic distinction between man and beast, which, as Levi-Strauss argues, is one of the most fundamental of taboos. Anthropological studies of how humans use animal categories as terms of abuse and social distinctions help us to understand more about the Romanesque menagerie.[21]

The frequently forgotten figure who surmounts the trumeau is human (see Fig. 3). The pillar, intended to stand in the center of the doorway, was often the site for negative depictions of human subjugation, as at Moissac, where stretched atlantes strain to hold up the lintel and tympanum (see Fig. 5). This heaviness is the weight of the flesh that bears down upon the human soul, preventing its ascendance. In monastic psychology, fasting was a means of purification, which "empties the soul of matter and makes it, with the body, clear and light."[22] One of the most powerful aspects of sculpture in this regard is its three-dimensionality: it enacts the substantiality of flesh, which, on the one hand, is enhanced by being formed from clay, by God as the first artist, but, on the other, is corrupted by the sin of the fall. The figure at Souillac has clambered out of the animal only to be about to be sucked back into it again, or rather chewed by the beastly teeth.

The mouth was the site of vocal production as well as material ingestion. According to Saint Bernard not only should "the eyes fast from curiosity" but the tongue from "vain and scurrilous words," and Alan of Lille argued that "Fast macerates the flesh, elevates the soul, restrains the spark of concupiscence, and excites reason For what can it profit if the mouth rejects food while the tongue lapses into mendacity."[23] The source of praise for God was monastic reading or *meditatio*, where, in Leclercq's phrase, the monk was meant to *ruminate* on the Word, literally by chewing on its significance and masticating its meaning.[24] For Peter of Celle, reading is "a rich pasture where animals large and small . . . by interior rumination on the divine flowers of the Divine Word retain nothing else in their hearts and mouths."[25] These are the metaphorical modes of thinking encouraged in monastic communities which

[20] A. Evans, *The Trial and Criminal Prosecution of Animals*, London, 1906, 140–44; and J. Vartier, *Les Procès d'animaux du Moyen Age à nos jours*, Paris, 1970.

[21] See C. Levi-Strauss, *Totemism*, Boston, 1983, 3; and the highly relevant study by B. Leach, "Anthropological Aspects of Language: Animal Categories and Verbal Abuse," in *New Directions in the Study of Language*, ed. E. H. Lenneberg, Cambridge, Mass., 1964. A warning against assuming that we can interpret animal signs from past cultures and even that "images are readily recognisable as such" is perceptively provided by W. Davies in "Finding Symbols in History," in *Animals Into Art*, ed. H. Murphy, London, 1989, 186.

[22] Bynum (as in note 14), 36–37.

[23] Cited in ibid., 4.

[24] For monastic *ruminatio*, see J. Leclercq, *The Love of Learning and the Desire for God: A Study of Monastic Culture*, New York, 1961, 89–90; and M. Camille, "Sounds of the Flesh/Images of the Word," *Public Access*, iv/v, 1990, 161–69.

[25] Peter of Celle, *Selected Works*, trans. H. Feiss, Kalamazoo, 1987, 103.

help us imagine how they might also have "read in the marble," to use Saint Bernard's phrase. The only flesh that the monk should desire is that of the vellum page from which he read. The subject of the masticating monk and the way the activation of the word works in twelfth-century manuscripts is treated in another paper, but suffice it to state here that it served only to make the mouth an even more meaningful force for the monastic audience.[26]

The mouth is one of the somatically and psychologically sensitized areas of the skin along with the genitals and anus, resonant with cultural connnotations of exclusion, containment, and of course sexuality. One of the most mysterious aspects of the trumeau are the depictions of human combats on the sides. On the left Abraham is prevented from killing his son by the hand of an angel swooping down to offer the lamb in substitute (see Fig. 6) while on the right are three pairs of figures, all combining an older and younger man (see Figs. 7 and 8). The atlantes on the Beaulieu trumeau (see Fig. 5) are contrasting old and young men, suggesting this distinction has some significance. One theory of the iconography of the trumeau is that it "illustrates" sin (the wrestlers), its dramatic consequences (the Hellish front), and its redemption through sacrifice (Abraham).[27] Such a sequential reading from right to left all too literally "reads" the trumeau abstracted from its physical site. This is not to say that these images do not relate to one another. This is again where we might ask what words or stored biblical and patristic texts might have occurred to the monk. In *The City of God* Saint Augustine suggested how the monastic meditator might have seen Abraham as another trial or test of strength like the wrestlers alongside:

> It is a reminder that not every trial is to be reckoned a temptation, but rather a probation For the Scripture says: "Abraham stretched out his hand and took the knife to kill his son. But an angel of the Lord called to him from heaven: Abraham, Abraham! He answered Here I am. He said: Do not lay a hand on the boy; do nothing to him. I know now that you fear God, since you have not withheld your only son from me."[28]

The half-naked wrestlers on the left face are a stock formula of the Romanesque "haunted tanglewood," although the age difference is marked (Fig. 8). In this context of violence and intergenerational conflict, could the embrace of the older and younger males suggest then current concerns and rules against "the unmentionable vice" that led to the separation of the young novices from the older monks in dormitories?[29] Wrestling is also used as a metaphor for the soul's struggle with evil by many writers appropriating this sign of secular pastimes, of "play," to the cloister, which Peter of Celle in his *Discipline of the Cloister* actually compared to an athletic stadium.[30] Set alongside Abraham, the wrestling figures might draw

[26] For the image of "digesting" the word in twelfth-century manuscripts, see Camille (as in note 5), 29.

[27] M. Vidal, *L'art roman en Quercy*, Paris, 1959, 255, cited in Thirion (as in note 7), 167.

[28] Augustine, *The City of God*, XVI, 32, trans. G. G. Walsh and G. Monahan, New York, 1952, 544.

[29] See I. Forsyth, "The Ganymede Capital at Vézelay," *Gesta*, xv, 1976, 241–47. Peter Damian's *Liber Gomorrhianus* (ca. 1049) recommended penalties for those who sodomized youth (which he considered worse than sinking into similar shame with an animal), including scourging, loss of tonsure, and fasting for three days a week, *PL* 145, 174. See also M. Goodich, *The Unmentionable Vice: Homosexuality in the Later Medieval Period*, Santa Barbara, 1979, 25–30; and J. Boswell, *Christianity, Social Tolerance and Homosexuality*, Chicago, 1980.

[30] Peter of Celle (as in note 25), 89. The wrestler motif has been traced back to classical sources. It also occurs in twelfth-

attention to paternal love within its proper bounds, rather than to the clammy excesses of hands around flesh in carnal embrace. The Rule of Saint Benedict stipulated that the abbot had to be "father teaching his sons," a relationship perhaps perverted by the stones here.[31] Taboos often intensify the very desires they seek to prohibit. Would not such images of flesh sucking and grasping flesh arouse the very feelings that they were meant to negate? We must be careful, as Peter Brown urged, not to project our modern notions of "sexuality" onto medieval monastic experience. Genital sexuality was only one small aspect of the tumultuous struggle between good and evil that the monk was urged to enact within himself and was less dangerous than the darker demons of Pride and Anger.[32]

According to another clerical commentator, Gerald of Wales, the monastery was a site of interior struggle. He wrote this in a letter complaining to his bishop of a young novice plagued by a demon "that does not stop rubbing his body with its own until he is so agitated that he is polluted by an emission of semen." He concludes that the monasatic life was an "arena in which conflict is always imminent . . . a struggle with the spirits of wickedness."[33] The monastic community at Souillac did not need to refer to their texts (as we do) to understand or feel the "spirits of wickedness"; they came upon them at night in twitching carnivorous obsessions, biting as hard as the twisted forms of the trumeau to take over their bodies. These are the ways in which the trumeau may have represented and articulated themes of mental and physical struggle in the monk's life.

Up to now I have attempted to speak of the trumeau in terms of the spiritual life of the theologically trained monk. This is what I would call its "dominant" meaning, referring to the traditional, institutional associations and expectations that biting and beasts and struggle would have had in the Souillac community. In oral cultures meanings have to be constantly re-enacted. They are not made *ex nihilo*, but constructed out of lived codes and conventions and only then imposed upon others. In this case a "theological reading" of the trumeau would interpret the animals as incarnations of sins, the wrestlers as signs of lust. The stone literally becomes the flesh to be avoided. But meanings are also contested, fraught, shaky—precisely because they have been imposed from above and, in the case of monumental art, are not written down except in the image itself.

ANIMAL FABLE AND ANIMISTIC MAGIC

Animals, because people shared their lives with them on an intimate level that we can no longer imagine, were powerful sites of social projection. In fables and beast epics, which were

century decorated initials such as Boulogne, Bibliothèque Municipale, MS. 2, fol. 81v., reproduced in P. D'Ancona and E. Aeschlimann, *The Art of Illumination*, New York, 1969, pl. 71.

[31] T. Fry et al., *The Rule of St. Benedict*, Collegeville, Md., 1981, 64:2–3.

[32] P. Brown, *The Body and Society: Men, Women and Sexual Renunciation in Early Christianity*, New York, 1988, 421–22.

[33] Gerald of Wales, *The Jewel of the Church: A Translation of "Gemma Ecclesiastica" by Giraldus Cambrensis*, trans. J. T. Hagen Davies, Medieval Texts and Studies, 1979, chap. 14, 177–78.

popular in oral as well as written form, they became anthropomorphic signs of human vice. Latin beast epics such as the poem *Ysengrimus* written by a monk of Ghent were learned "textual" versions of stories told by word of mouth inside and outside monasteries.[34] The deeds of *Ysengrin* were even painted on the cell walls of some monks according to a later writer.[35] *Ysengrimus* is exactly the kind of text that iconographers overlook because of the erroneous way in which sacred and profane discourses are separated. It concerns the antics of a greedy wolf who is a bishop and an abbot, living off the "fat and gentle sheep" in his monasteries. He ends up being eaten alive in a horrendously violent scene by the pigs of the sow-goddess Saularia and having pieces of his body sanctified as holy relics. This upside-down world of bloated bodies, farting spirits, and gobbling and guzzling carnivores has much in common with the forms of Romanesque sculpture, especially the emphasis on oral gratification and the mouth:

> Reynard did not dare jump into the hospitable mouth (rash people often have a nasty fate) and though he had just been and was continually being ordered to enter he would rather have dossed down outside for four and twenty nights. For reflecting that the wolf's jaws were once expert in biting, he did not believe they had got blunt enough.[36]

Laughter and fear are very close to one another, so although our first impulse is to shiver at the monstrous jaws in stone, works such as *Ysengrimus* turn bodily dismemberment into laughter. I am not suggesting that the trumeau "illustrates" an animal fable, and especially not a Latin text like the *Ysengrimus*, only that it articulates wider cultural metaphors of animality linked to human appetite and embodiment rather than the theological. This is where iconography is insufficient. It does not include the possibilities for projecting new and different words on images. This is where we can see an "anti-iconography" at work, the re-reading of a work against its "official" ideological purpose which has to occur if works of art have any history at all.

To the lay people outside the monastery, and many of the brothers within, the trumeau beasts had nothing to do with texts or any type of narrative, but rather served the magical protective function that eagles and lions had served for centuries as guardians of the sacred space, as omnipresent forces of evil and as apotropaic warders off of evil. The *Ysengrimus* itself describes the centuries-old practice of propping open the jaws of an animal, usually a wolf, and hanging it over a doorway, in order to act as a grim warning to unfriendly men or evil spirits.[37] In imagining the responses of pilgrims and visitors we must be ready to see not

[34] *Ysengrimus*, text with translation, commentary and introduction by Jill Mann, Leiden, 1987, is an excellent edition. For animal fables in general, see *Epopée animale fable fabliau: Actes du IVᵉ Colloque de la Société Internationale Renardienne*, ed. G. Bianciotto and M. Salvat, Paris, 1981.

[35] For fables painted on monks' cells see L. Randall, *Images in the Margins of Gothic Manuscripts*, Berkeley, 1966, 5, n. 12. The English Cistercian author of the *Pictor in carmine* rails against the representations of "the fabled intrigues of the fox and the cock" in the house of God; see M. R. James "Pictor in carmine," *Archeologia*, XCIV, 1951, 142.

[36] *Ysengrimus* (as in note 34), 211.

[37] *Ysengrimus* (as in note 34), 397. The apotropaic aspects of Romanesque art have not yet merited serious study, but for now see A. Weir and J. Jerman, *Images of Lust: Sexual Carvings on Medieval Churches*, London, 1986; L. J. A. Lowenthal

only this magic but multiple misinterpretations, partial comprehensions rather than a seamless coherent recognition.

I have attempted to avoid positing any single message or meaning for the Souillac relief. Instead of the closure of an objective "iconographic" interpretation I hope to have suggested what the feminist historian of science Donna Haraway calls "situated knowledges":

> A splitting of senses, a confusion of voice and sight, rather than clear and distinct ideas We seek not the knowledges ruled by phallogocentrism (nostalgia for the presence of the one true Word) and disembodied vision, but those ruled by partial sight and limited voice. We do not seek partiality for its own sake, but for the sake of the connections and unexpected openings situated knowledges make possible. The only way to find a larger vision is to be somewhere in particular.[38]

The body, both represented in the image and felt in the bodied observer, strikes me as a crucial feature of eleventh- and twelfth-century sculpture. Romanesque images, as opposed to the more systematic, and, I would argue, "literate" structures of Gothic sculptural programs, speak to different and multiple groups simultaneously—so that even when constituted for a monastic community, their trajectory was toward the openness of oral rather than the systematization of written culture. Later, more coded Gothic art, segregating the center more clearly from the periphery, relegates the body to a specific place, subjugated below the saintly as in the squatting monsters below the tall jamb figures on cathedral doorways. This makes the relationship between matter and spirit "readable" in a way that Romanesque art in its perverse unprogrammaticalness, refuses.

The conflicted forms and chiasmal animation of early twelfth-century sculpted images like the Souillac trumeau are also typical features that Walter Ong associates with the psychodynamics of orality. These are: "additive rather than subordinate," "aggregative rather than analytic," "redundant or copious" and "agonistically toned."

> Many, if not all, oral or residually oral cultures strike literates as extraordinarily agonistic in their verbal performance and indeed in their lifestyle. Writing fosters abstractions that disengage knowledge from the arena where human beings struggle with one another Orality situates knowledge within a context of struggle. Proverbs and riddles are not used simply to store knowledge but to engage others in verbal and intellectual combat When all verbal communication must be by direct word of mouth, interpersonal relationships are kept high—both attractions, and even more, antagonisms.[39]

"Amulets in Medieval Sculpture I: A General Outline," *Folklore*, xvix, 1978, 3–10; and J. Leclercq-Kadaner, "Exorcisme symbolique et quête de l'égalité d'âme sur un bas-relief roman de Ligurie," *Cahiers de civilisation mediévales Xᵉ–XIIᵉ siècles*, xxvii, 1984, 247–49.

[38] D. Haraway, "Situated Knowledges," in *Simians, Cyborgs and Women: The Reinvention of Nature*, London, 1991, 196.

[39] Ong (as in note 10), 36–77. For the relationship of graphic forms to speech see J. Goody, *The Interface between the Written and the Oral*, Cambridge, 1987, 8–11. The hermeneutics of writing are discussed in P. Ricoeur, *Interpretation Theory: Discourse and the Surplus of Meaning*, Fort Worth, 1976, 39.

For the carvers of these antagonistic images, almost certainly members of the illiterate rather than the literate part of Souillac's "textual community," sculpture was a form of communication that spoke directly from and to the body.[40] Unlike the nearby Theophilus narrative with its iconography of increasing chirographic control and feudal bureaucracy, here was a less rigorously encoded space where current desires and fears could be displayed in old magical ways. Like so much twelfth-century sculpture, the Souillac relief is more like a scream rent from a human body than words written outside it, words that have made us "stone" deaf, even when the stones themselves "cry out."

[40] The question of the orality and literacy of Romanesque sculptors is raised in N. Kenaan-Kedar, "Les modillons de Saintonge et du Poitou comme manifestation de la culture laïque," *Cahiers de civilisation mediévale Xᵉ–XIIᵉ siècles*, xxix, 1986, 311–30, which puts the sculptors in subversive relation to their monastic patrons. A problem for medievalists trying to use the notion of orality is that the concept as used in anthropology is constantly being revised, see D. W. Cohen, "The Undefining of Oral Tradition," *Ethnohistory*, xxxvi, 1989, 9–18. Very few published studies as yet treat the issue of speech versus writing, an exception being W. R. Cook, "A New Approach to the Tympanum of Neuilly-en-Donjon," *Journal of Medieval History*, iv, 1978, 333–45. For another exception and an analysis of how "images of discord and struggle . . . ironically reinforce" the "victorious frame" in Romanesque sculpture, see L. Seidel, *Songs of Glory: The Romanesque Façades of Aquitaine*, Chicago, 1981, 55. This pathbreaking study was one of the first to go beyond "iconography" and present these monuments through the complexity and richness of audience expectation, ideology, and desire.

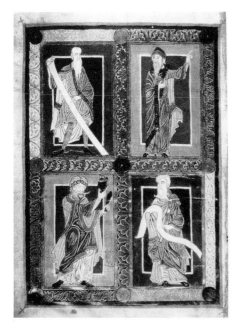

1. Proponents of Theory and Practice, from *Constantinus Africanus*. Rome, Bibl. Vat., Pal. lat. 1158, fol. 1

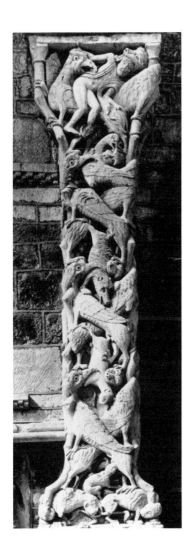

2. Sculptures on inner west wall. Souillac, Abbey Church of Sainte-Marie (photo: James Austin)

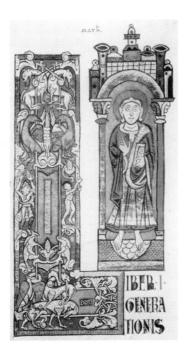

4. "Liber Generationis," opening of Saint Matthew's Gospel. Paris, Bibl. Nat., MS. lat. 254, fol. 10r

3. Pillar to right of doorway. Souillac, Abbey Church of Sainte-Marie (photo: James Austin)

5. (left) Front and right side of the trumeau. Beaulieu-sur-Dordogne (photo: James Austin)

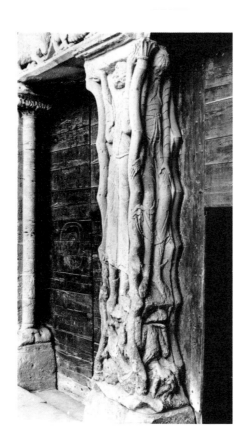 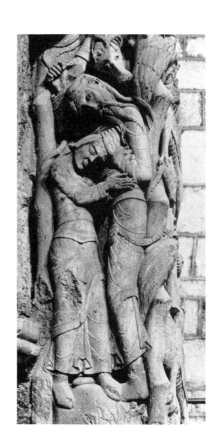

6. (right) Pillar on right of doorway, middle section, left face, Abraham and Isaac. Souillac, Abbey Church of Sainte-Marie (photo: James Austin)

7. (left) Pillar on right of doorway, top section, right face. Souillac, Abbey Church of Sainte-Marie (photo: James Austin)

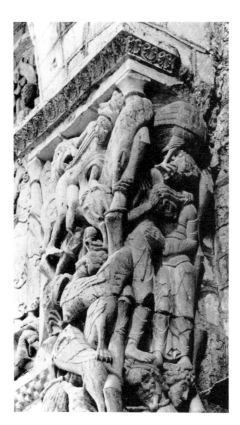 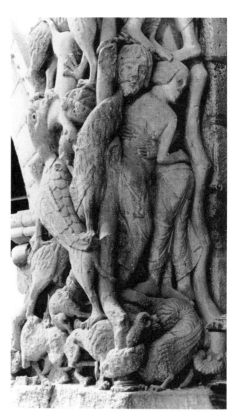

8. (right) Pillar on right of doorway, bottom section, right face, wrestlers. Souillac, Abbey Church of Sainte-Marie (photo: James Austin)

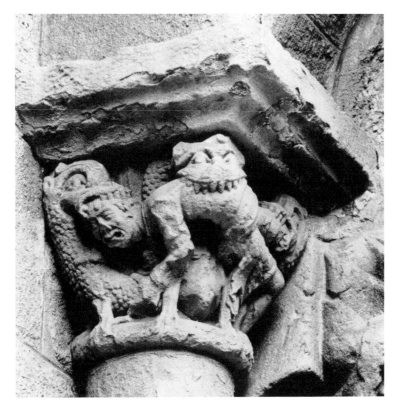

9. Capital with hellbeasts. Beaulieu-sur-Dordogne (photo: James Austin)

10. Psalm 48 with animals falling into Hell on left, from a Psalter. Paris, Bib. Nat., MS. lat. 8846, fol. 84r

Medieval Art as Argument*

•

HERBERT L. KESSLER

MEDIEVALISTS generally assume that images contain arguments, that the pictures they study present messages drawn from written and visual sources structured in reasoned steps. And they accept as part of their work the explication of those arguments.[1] Most pay little attention, however, to the use medieval theologians made of art in their exegeses or, in turn, to the determining role that written references to artistic processes played in the formation of Christian imagery.[2]

Pictures had attained sufficient authority during the Early Christian period to be cited in theological tracts.[3] What exegetes found particularly appealing was art's capacity to assimilate more than one textual source within a coherent and plausible narrative, certainly because, in this, art paralleled and enabled their own work of reconciling diverse written accounts. Thus, Cyril of Alexandria adduced painting to help Bishop Acacius comprehend

* I presented some of the material included in this essay in my paper, "Matter, Manufacture, and the Mysteries of the Holy Image," at the 1990 Dumbarton Oaks symposium "The Holy Image" in Washington, D.C. Daniel H. Weiss read several drafts of this article and offered valuable criticisms. I am at present expanding the arguments for a book tentatively entitled *Spiritual Tablets: Pictures as the True Reading of Scripture*.

[1] An excellent example is S. Lewis's article, "*Tractatus adversus Judaeos* in the Gulbenkian Apocalypse," *Art Bulletin*, LXVIII, 1986, 543–66. Exegesis shares both title and attention with art; and Lewis draws freely on Berengaudus's Apocalypse commentary, legends, and other texts to explicate the manuscript's often puzzling pictorial interpretations, finding evidence in them of support for contemporary anti-Semitic persecutions.

[2] Lucas of Tuy's citation of unusual iconography in his attack on the Albigensians has received some notice; see, recently, C. Gilbert, "A Statement of the Aesthetic Attitude around 1230," *Hebrew University Studies in Literature and the Arts*, XIII, 1985, 125–52. A. Kartsonis has uncovered in a late seventh-century treatise what she terms "pictorial polemics" against the Monophysites (*Anastasis*, Princeton, 1986, 40ff.). Art's role in controversies over heresies awaits full study; in the meantime, see M. Camille, *The Gothic Idol: Ideology and Image-making in Medieval Art*, Cambridge, 1989.

[3] A commentary attributed to Bede (*PL* 102, col. 105f.), for example, was frequently adduced from the ninth century on to explain Paul's odd enumeration of thirty-nine lashings in 2 Corinthians 11:24; see G. Henderson, *Bede and the Visual Arts*, Jarrow Lecture, 1980, 7. Citing the forty-stroke limit set in Deuteronomy, the text bolsters its reading by pointing to an illustration in a manuscript that the writer deemed authoritative because of its provenance in Early Christian Rome. The fact that it contained numerous scenes ("omnes paene") illustrated in their proper places in the text ("per loca oportuna"), what would now be called its narrative aspect, made the cycle of pictures particularly valuable for interpretive purposes. That, itself, established historical authenticity within which the meaning drawn from the Old Testament was readily revealed ("pictoris sensus facillime patet"). The reference to a picture is surely no literary topos but a real citation; a close parallel to the iconography survives among the forty-seven episodes from Paul's life once depicted in the church of San Paolo fuori le Mura in Rome and known today through seventeenth-century watercolors (cf. S. Waetzoldt, *Die Kopien des 17. Jahrhunderts nach Mosaiken und Wandmalereien in Rom*, Vienna and Munich, 1964, no. 644, fig. 382). Theodorus's seventh-century *Life of Saint Spyridon of Trimithous* (ed. P. van den Ven, Louvain, 1953, 90) reports how a painted narrative image served in place of a text to verify an oral account.

typological method. Unable to understand how the "two male goats" required as offerings in the Jewish tabernacle could *both* stand for Christ, Acacius had sought instruction from the great fifth-century father. Cyril reminded the bishop that "only by deeply considering the matters in the divinely inspired Scriptures shall we find the hidden truth"; but he turned to a picture "to show that [a certain typological] reasoning is not beyond probability."[4] Citing the various ways painters represent the Sacrifice of Isaac, he focused on the common procedure in which a single figure is depicted over and over again to present distinct actions, what Kurt Weitzmann has called the "cyclic method." Cyril then drew his conclusion: the pictured protagonist is not "a different Abraham each time, although he is seen most of the time in a different pose, but would be the same man in every instance with the skill of the artist continually disposing him according to the needs of the subject matter."[5] So it is in Jewish Scripture, too, where Christ appears in different guises but remains constant.

The example from art allowed Cyril to argue that the Old Testament's specificity and closure are only apparent, that the Hebrew Bible is "very much less than the truth and [an] incomplete indication of the things signified."[6] And to support his contention, Cyril quoted the determining passage on typology from the Epistle to Hebrews—first to introduce his reference to painting and again to conclude his argument: "For the Law contains but a shadow (*skia*), no true image (*eikon*), of the good things which were to come" (10.1). He then developed the passage's opposition of shadow and image to explicate the relationship between the old covenant and the new in terms of artistic process: "We say that the law was a shadow and a type, and like unto a picture set as a thing to be viewed before those watching reality. The underdrawings (*skiai*) of artists' skill are the first elements of the lines in pictures, and if the brightness of the colors is added to these, the beauty of the picture flashes forth."[7] For Cyril, the Old Testament serves as an artist's preliminary sketch does, to block in essentials, whereas Christ's covenant is the more precise and perfect overpainting that supplants it. Here, the historical evolution of art itself is recapitulated, which began with tracing shadows and progressed to coloring-in of the outlines.[8]

For his understanding of the Hebrews text, Cyril relied on John Chrysostom, who had earlier likened the Old Testament to a preliminary drawing and the New to the finished picture: "As in a painting, so long as one [only] draws the outlines, it is a sort of 'shadow'; but when one has added the bright paints and laid in the colors, then it becomes 'an image.' Something of this kind also was the Law."[9] But in the *Adoration in Spirit and in Truth*,[10]

[4] Letter 41, *PG* 77, col. 217; *The Letters of St. Cyril of Alexandria*, trans. J. McEnerney, Washington, D.C., 1987, 180.

[5] Ibid., col. 220; trans. 181.

[6] Ibid., col. 217; trans. 180.

[7] Ibid., col. 217; trans. 180. See M.-J. Baudinet, "La relation iconique à Byzance au IX^e siècle d'aprés Nicéphore le Patriarche: un destin de l'aristotélisme," *Les études philosophiques*, I, 1978, 85–106. For a discussion of this important literary figure, see D. Sheerin, "Lines and Colors: Painting as Analogue to Typology in Greek Patristic Literature," *Abstracts of Short Papers. The 17th* Byzantine Congress, Washington, D.C., 1986, 317–18. I wish to thank Professor Sheerin for generously sharing the materials he has collected for his ongoing study of this question.

[8] Cf. Athenagoras, *Legatio pro christianis*, 17.3, ed. and trans. W. R. Schoedel, Oxford, 1972, 35.

[9] *In Epistolam ad Hebraeos*, 17:5 (*PG* 63, col. 130); *Homilies on the Epistle to Hebrews*, trans. F. Gardiner, Edinburgh, 1890, 48.

[10] *PG* 68, cols. 140–42.

Cyril carried the conceit still further. Noting that underdrawing is obliterated when a painting is finished, he advanced the idea that the New Testament not only fulfilled but also abrogated the Old, playing with *skiagraphia* and *chroma* rather than with *skia* and *eikon* to underscore the notion that the completed image covers up the preparatory work. And he extended the metaphor of art to the lost-wax process, to the destruction of a maquette when molten bronze is poured, concluding that "neither the bronze caster nor the painter would say that they destroy the underdrawings or crude models because they are useless, but so they can be fulfilled. Because what until then appeared less clear and less beautiful in the shadows and types attains a better and more vivid form in the finished work."[11]

During the next century, Cosmas Indicopleustes reiterated the metaphor of exegesis as artistic process. Setting out to describe and interpret the tabernacle in Book V of his *Christian Topography*, Cosmas naturally thought of the Epistle to Hebrews which, itself, contains an extended commentary on the Jewish sanctuary. The very first passage Cosmas quotes is the *skia/eikon* text, which he elaborates in the manner of Cyril of Alexandria but with a slight twist, "speaking of a shadow as when one draws a rough sketch of a man without taking a likeness of him, that is without representing his features and all his different members, so that it can be known what sort of a man he is, whether old or young, whether comely or uncomely, but merely sketches an outline of his bodily figure; by what he calls an image he means the characteristic features."[12] For Cosmas, the New Testament fulfillment does not totally obscure the "rough sketch" set down in Jewish Scripture; rather, it adds distinguishing details to the general forms. Undoubtedly, the sixth-century geographer was thinking of illustrations that make typologies explicit by providing features not specified in the basic texts.[13] Isaiah's Vision in the ninth-century Vatican codex of Cosmas's treatise (Biblioteca Apostolica, Cod. gr. 699, fol. 72v)[14] is typical of this very common procedure; in it, the enthroned "Lord" of Hebrew prophecy is portrayed as Christ (Fig. 1). As in the theological discourses, art's advantage is precisely that it permits both the Old Testament prefigurement and its Christian realization to operate simultaneously, and within a context that suggests historical reality.

What for Cosmas was still largely a literary trope came to be deployed during the following centuries in active support of images. Oblique references to artistic processes seem to underlie the famous Canon 82 of the Quinisext Council of 692, which ordered the replacement of symbols of Christ with fully painted portraits.[15] The canon opposes shadow and truth, just as the Epistle to Hebrews does, and equates the fulfillment of the Law in Christ

[11] Ibid., cols. 139ff.

[12] W. Wolska-Conus, *Cosmas Indicopleustès. Topographie chrétienne*, Paris, 1968–73, II, 15ff.; *The Christian Topography of Cosmas, an Egyptian Monk*, trans. J. W. McCrindle, London, 1887, 139f.

[13] The late fifth-century Cotton Genesis offers a precedent in picturing the "creator" of Genesis as the Christ Logos; see K. Weitzmann and H. Kessler, *The Cotton Genesis*, Princeton, 1986.

[14] C. Stornajolo, *Le miniature della Topografia cristiana di Cosma Indicopleuste; codice vaticano greco 699*, Milan, 1908. The manuscript is generally dated to the second half of the ninth century and attributed to a Constantinopolitan illustrator; but the codex itself has recently been assigned to Italy. See Wolska-Conus (as in note 12), I, 45–47 and J. Leroy, "Notes codicologiques sur le *Vat. gr. 699*," *Cahiers archéologiques*, xxiii, 1974, 75–78, with note by A. Grabar, 78–79.

[15] J. Mansi, ed., *Sacrorum Conciliorum nova et amplissima collectio*, Florence, 1759ff., XI, cols. 977–79.

with pigments used in painting. And in Hebrews' repeated use of *teleios* (perfection) to describe Christ's relationship to the Old Testament, it discovers an allusion to the completion of a work of art, declaring that "the perfect should be set down before everybody's eyes in colors."[16]

During the Iconoclastic controversy, supporters of images transformed the old association of Christ with painting in color into an effective defense. Writing in the third decade of the eighth century, John of Damascus, for instance, included in his argument in favor of images what Gerhard Ladner has rightly termed a "significant paraphrase" of Chrysostom's homily: "As the Law [is] a preliminary adumbration of the colored picture, so Grace and Truth are the colored picture."[17] A century later, Methodius could ask: "Why might one not describe Jesus Christ our Lord with the brilliance of colors as legitimately as with ink? He was never presented to us as of ink, but was manifested as a true man, truly endowed with form and with color."[18] And the Patriarch Nicephorus referred to the Iconoclasts simply as "persecutors of color, or rather, persecutors of Christ."[19] Fernanda de' Maffei has pointed out that this identification with Christ helps explain why color became a focus of the attack on images;[20] for the Iconoclasts, pigments were quintessentially dead matter unworthy of association with God. The arguments based on artistic processes, according to which paint fulfilled and perfected the preliminary sketch provided by Jewish Scripture, emerged in this battle as potent weapons against the Iconoclasts's assault.[21]

It is in the context of the Iconodulic reformulation of the *skia/eikon* trope that the most vivid pictorialization of the relationship between the Old Testament and the New is to be understood. This is the magnificent illustration of the *Kingdom of Heaven* in the Vatican manuscript of Cosmas's *Christian Topography* showing the enthroned Christ acclaimed by angels, "terrestrial men," and the resurrected dead (fol. 89r, Fig. 2). Although the miniature is often identified as the earliest representation of the Last Judgment,[22] the iconography is, in

[16] C. Mango, trans., *The Art of the Byzantine Empire: Sources and Documents*, Englewood Cliffs, N.J., 1972, 139–40.

[17] *Orationes pro sacris imaginibus*, *PG* 94, col. 1361; *On the Divine Images*, trans. D. Anderson, New York, 1980. See G. Ladner, "The Concept of the Image in the Greek Fathers and the Byzantine Iconoclastic Controversy," *Dumbarton Oaks Papers*, VII, 1953, 18–19.

[18] *Life of Euthymius of Sardis*; see J. Gouillard, "Le synodikon de l'orthodoxie," *Travaux et mémoires*, II, 1967, 173.

[19] *Adversus Iconomachos*, chap. 20 (J. B. Pitra, ed., *Spicilegium Solesmense*, Paris, 1888), 282. In the ninth-century Chludov Psalter (Moscow, Historical Museum, Cod. gr. 129, fol. 67r), Iconoclasts are shown destroying an icon of Christ simply by whitewashing it; see M. V. Shchepkina, *Miniatury Khludovskoi Psaltiri*, Moscow, 1977.

[20] *Icona, pittore e arte al concilio Niceno II*, Rome, 1974, 54ff.

[21] A curious inversion of the topos occurs in the life of Saint Nikon; see Mango (as in note 16), 212–13; and C. Schönborn, "Les icônes qui ne sont pas faites de main d'homme," *Image et signification* (*Rencontres de l'École du Louvre*), Paris, 1983, debat, 309. The Iconodules especially favored another metaphor derived from art production, that images are like impressions made by intaglio seals, physically present only in essence and not *of* the matter into which they are pressed. Theodore of Stoudios summed up this argument in his *Antirrheticus* (3.9): "A seal is one thing, and its imprint is another. Nevertheless, even before the impression is made, the imprint is in the seal. There could not be an effective seal which is not impressed on some material. Therefore, Christ also, unless he appears in an artificial image, is in this respect idle and ineffective. If he who looks at the seal and its imprint sees a similar and unchanged form in both, then the imprint exists in the seal even before the impression is made" (*PG* 99, col. 432; *On the Holy Icons*, trans. C. Roth, Crestwood, N.Y., 1981, 112).

[22] B. Brenk correctly tied the iconography to Cosmas's own treatise; see "Die Anfänge der byzantinischen Weltgerichtsdarstellung," *Byzantinische Zeitschrift*, LVII, 1964, 106, n. 2. See my forthcoming article, "Gazing at the Future: The *Parou-*

fact, more specifically the call of the righteous to Christ at the *Parousia* (Matt. 25:34). The mode of depiction, moreover, realizes the metaphor from Hebrews as it had been transformed through successive exegeses during the preceding centuries.

Integrating the enthroned Christ envisioned by the Old Testament prophets (cf. Fig. 1) with a picture of the three sublunary orders passed down from the sixth-century archetype,[23] the Vatican miniature is a coloring-in of an Old Testament sketch or outline; specifically, it is a bringing-to-completion, a perfecting, of the Old Testament tabernacle. One way that Cosmas had envisioned the tabernacle was in the shape of the ark of the covenant, divided into a rectangular outer precinct and an arched Holy of Holies (fol. 108r, Fig. 3). The two compartments correspond to the figured realms in the *Parousia* miniature, labeled below: "this world in which men and angels now are, thus the present condition," and above: "the second tabernacle, the Holy of Holies, the heavenly kingdom, the future world, the second condition, and place of the just."[24] In the miniature, images quite literally replace words, and color covers and obscures the outlined pattern. Moreover, Christ and his supernatural domain are equated with color within the miniature itself, where chromatic changes distinguish the lower from the upper region. The one sets brightly painted figures against white parchment; the other is completely painted over in heavy gold and rich hues. This repeats the system used generally throughout the codex, in which diagrams or wash are mostly used, or human forms are silhouetted on blank pages; and complete painting in heavy pigments is generally reserved for icons of Christ.

Not only does the Vatican miniature incorporate the analogy based on the Epistle to Hebrews between artistic processes and typology, it reintroduces the figure into the Epistle's central subjects, the Jewish tabernacle as the pattern of heaven and the annual blood sacrifice offered there as the type of Jesus' passion. Christ began his prophecy of the *Parousia* by predicting the destruction of the temple: "not one stone will be left upon another" (Matt. 24:2); and Hebrews, in turn, draws many parallels and contrasts between the old and new cults: the physical sanctuary of the Jews and Christ's realm "not made by human hands,"[25] the priestly rites and the eternal and spiritual sacrifice, the curtain closing off the Holy of Holies to everyone but the high priest and Christian revelation. Of these, the temple curtain, especially, indexes the Cosmas picture, the veil of Christ's flesh through which the Christian faithful gain access even to the Holy of Holies. In the diagram (Fig. 3), the curtain is the horizontal line, the sole interior element. In the *Parousia* (Fig. 2), it is the diapered gold cloth decorated with lilies behind Christ, recognizable by means of a comparison with the second

sia Miniature in the Vatican Cosmas," in *Byzantine East, Latin West: Art Historical Studies in Honor of Kurt Weitzmann*, ed. D. Mouriki, Princeton, forthcoming.

[23] Cf. Florence, Biblioteca Laurenziana, Cod. Plut. 9, 28, fol. 228v; and Smyrna, Evangelical School, Cod. B 8 (destroyed), p. 180; Wolska-Conus (as in note 12), I, 94ff., 225; and J. Strzygowski, *Der Bilderkreis des griechischen Physiologus*, Leipzig, 1899, pl. 30. Photius ridiculed Cosmas' contention that angels did not occupy heaven but resided with man beneath the firmament (see Wolska-Conus, I, 116).

[24] Wolska-Conus (as in note 12), III, 52.

[25] For the importance of the tabernacle to the Iconodules and in post-Iconoclastic art, see S. Dufrenne, "Une illustration 'historique,' inconnue, du psautier du Mont-Athos, Pantocrator N° 61," *Cahiers archéologiques*, xv, 1964, 83–95.

set of temple curtains depicted in the eleventh-century Sinai Cosmas (fol. 79r, Fig. 4).[26] Badly flaked in the Vatican manuscript (fol. 46v)[27] but clear in the Sinai codex, the diapered curtain also appears in schematic renderings of the tabernacle where, in reference to Hebrews 9.8, it is labeled *eisodos*, the entrance way (fol. 82v, Fig. 5).[28] Finally, the curtain decorated with lozenges recurs in depictions of the cosmos in the Vatican Cosmas (fol. 43r) and again, better preserved, in the Sinai manuscript (fol. 69r, Fig. 6). In these, the entire world is patterned on the tabernacle (cf. Fig. 3), with the earth below and heaven in the arched area above. As in the *Parousia* miniature (cf. Fig. 2), the celestial realm is distinguished from the terrestrial by the decorated veil, here symbolizing the firmament that divides the heaven from earth and appropriately painted in blue and gold.[29]

The Epistle to Hebrews likens Christ to the tabernacle, and also to the temple curtain which is the "entrance way"; Hebrews 10:19–20 declaims that "the blood of Jesus makes us free to enter boldly in the sanctuary by the new, living way which he has opened for us through the curtain, the way of his flesh";[30] and Hebrews 6:20 describes hope as an "anchor of our lives [that] enters in through the veil, where Jesus has entered on our behalf as forerunner, having become a high priest for ever in the succession of Melchizedek."[31] Commenting on these passages, Chrysostom tied the metaphors together: "See how he calls the body tabernacle and veil heaven. The heaven is a veil, for as a veil it walls off the Holy of Holies; the flesh is a veil hiding the Godhead; and the tabernacle likewise holding the Godhead. Again, Heaven is a tabernacle, for the Priest is there within" (Homily 15.4).[32] (It is precisely within his exegesis of this passage that Chrysostom introduced the metaphor of underdrawing and painting.) In his fifth book (for which this is the *explicit* miniature), Cosmas distilled

[26] Wolska-Conus (as in note 12), I, 47ff. *et passim* and K. Weitzmann and G. Galavaris, *The Monastery of Saint Catherine at Mount Sinai. The Illuminated Greek Manuscripts*, I, Princeton, 1990, 52ff. and fig. 147. The Cosmas manuscripts derive ultimately from an illustrated sixth-century exemplar that contained the tabernacle illustrations under discussion (see Wolska-Conus [as in note 12], I, 158ff. and more recently, idem, "La 'Topographie Chrétienne' de Cosmas Indicopleustès: Hypothèses sur quelques thèmes de son illustration," *Revue des études byzantines*, XLVIII, 1990, 155ff. and E. Revel-Neher, "On the Hypothetical Models of the Byzantine Iconography of the Ark of the Covenant," in *Byzantine East, Latin West* [as in note 22]). By incorporating a specifically Jewish form of the Ark, the illustrator of the Cosmas was re-enacting the typology: Christianity subsumes the Jewish cult; see H. Kessler, "Through the Temple Veil: the Holy Image in Judaism and Christianity," *Kairos*, XXXIII, 1991. The diapered temple curtain may go back to the earliest representations in Jewish art, exemplified for instance by a gold glass in the Vatican; see A. St. Clair, "God's House of Peace in Paradise: The Feast of Tabernacles on a Jewish Gold Glass," *Journal of Jewish Art*, XI, 1985, 6–15, esp. fig. 2; and Kessler, "Temple Veil." Diapered curtains are paralleled in east Christian art; see, for instance, a Coptic textile in New York (A. Weibel, *Two Thousand Years of Textiles*, New York, 1952, 82–83 and pl. 22) and the mosaics in the Church of the Nativity, Bethlehem (H. Stern, "Les représentations des conciles dans l'église de la Nativité à Bethléem," *Byzantion*, XI, 1936, 151–92 and fig. 19). The pattern of the Mandylion need have nothing to do with Late Antique metalwork as Ian Wilson has contended (*The Shroud of Turin*, New York, 1979, 121–22).

[27] What is left of the patterning appears to be random colored squares against a blue ground, not regular diaper.

[28] The counterpart in the Vatican manuscript also presented the diapered curtain but is too badly flaked to reproduce here.

[29] Cf. Cosmas, V.227; Wolska-Conus (as in note 12), II, 338. See C. Schneider, "Studien zum Ursprung liturgischer Einzelheiten östlicher Liturgien," *Kyrios*, I, 1936, 57–73. The clipeate portrait designates Christ as Pantocrator; see R. Warland, *Das Brustbild Christi*, Rome, Freiburg, and Vienna, 1986.

[30] Cf. also Chrysostom (as in note 9), *PG* 63, col. 27; trans. 375.

[31] Wolska-Conus (as in note 12), II, 359.

[32] Chrysostom (as in note 9), *PG* 63, col. 119; trans. 40.

the typology still further: "'For the Law contains but a shadow and no true image,' for as in a sketch (*skiagraphia*), he has signified by the inner tabernacle the ascension of Christ after the flesh, and the entry into it of just men. Wherefore, he again advises us: 'So now, my friends, the blood of Jesus makes us free to enter boldly into the sanctuary by the new, living way which he has opened for us through the curtain, the way of his flesh'" (V.29). And later: "See how he speaks of that entrance into what is within the veil, that is, the firmament into which Jesus entered, and into which we shall enter" (VII.16).[33]

A recurrent theme in Christian literature is that because the Jews rejected Christ they were denied the direct vision of God enjoyed by Christians. In the Epistle to the Romans, for instance, Paul declared that "[because the Jews] have sinned [they] are deprived of the divine splendor" (3:23); and in his letter to Acacius, Cyril likened his typological explication of the scapegoats to a "taking off the veil of the law [that allows us to] behold the naked truth [of Scripture]."[34] Cosmas summed it up in the following way: "When the veil of the temple was rent in half at the Passion of the Lord, three things were indicated. First, it proved the audacity of the Jews against the Lord. Next, it showed the approaching dissolution and abolition of the Judaic ritual. And third, that the inner tabernacle, which was invisible and inaccessible to all, and even to the priest, had become visible and accessible to men. Glory for all to Christ the King for ever and ever."[35] And writing around the time the Vatican image was being painted, Photios made a similar point: "Until then, the ark and the things inside are separated and hidden by the curtain. Up to this point the entrance (*eisodos*) is rendered impassable to man. By means of Christ's Crucifixion, the curtain was parted, heralding and announcing to everyone the entrance to heaven."[36] Setting the enthroned Savior within an opening in the curtain of the inner chamber, the miniature aligns itself with these texts. Through the incarnate God, faithful Christians (including the beholder of the image) are able to penetrate the veil of the firmament and even to glimpse the blue of heaven beyond.[37] The picture of Christ before the parted temple curtain in the Vatican Cosmas is nothing less than a figure of the holy icon.

Going further even than the accompanying commentary and the related exegeses, the illustrator of the Vatican manuscript deployed the central metaphors of the Epistle to Hebrews as variously interpreted in early Byzantine theology—*skia/eikon*, word/matter, tabernacle/heaven, veil/firmament, curtain/flesh, High Priest/Christ—to turn his miniature into an argument about art itself. Images, the miniature declares, are part of Christian self-definition not only because with the Incarnation God became visible or because through Christ the old dispensation was abrogated, but because they allow for a uniquely Christian appropriation of Hebrew Scripture. Jews persist in reading the Bible as law, as a closed and rigid written document; Christians understand it as art—to quote Cyril of Alexandria—"as a picture fertile with truth."[38]

[33] An allusion to Hebrews 6:20 in chapter 5:247 occurs immediately before the *Parousia* miniature in the Vatican codex.

[34] Letter 41 (as in note 4), *PG* 77, col. 207.

[35] Wolska-Conus (as in note 12), II, 47; trans. 148.

[36] *Fragmenta in Lucam*, *PG* 101, col. 1226.

[37] A similar hole into heaven is rendered in the nearly contemporary Chludov Psalter (as in note 19), fols. 22r and 102v.

[38] Letter 41 (as in note 4), *PG* 77, col. 220; trans. 181.

In light of this history, it is perhaps not surprising to discover that the Mandylion,[39] the archetypal image that authorized all other Christian images, was constructed from these same pictorial and textual materials, not the actual relic but rather the image of the Mandylion that became standard in Constantinople after Iconoclasm.[40] Judging from the two best preserved versions[41] and various descriptions, the soiled Edessan *acheiropoieton* brought to the capital in 944 presented Christ's face *within* the fabric, just as the legend of its creation would have it.[42] Entirely different are its representations in an eleventh-century menologion in Alexandria (Greek Patriarchate, Cod. 35, fol. 142v, Fig. 7)[43] and in the somewhat later manuscript of John Climacus's *Heavenly Ladder* in the Vatican (Biblioteca Apostolica, Cod. Ross. 251, fol. 12v, Fig. 8).[44] Like the heavenly images in the Cosmas manuscripts (cf. Figs. 2 and 6), this form of Mandylion is an amalgam of the diapered tabernacle curtain and a heavily painted circular icon of Christ. As an icon does, it too articulates the boundary between earth and heaven. And most significantly, through the allusion to the temple veil, it takes on the same typological aspect and evokes the *skia/eikon* allegory.[45]

[39] See E. von Dobschütz, *Christusbilder*, Leipzig, 1899; A. Grabar, *La sainte face de Laon*, Prague, 1931; K. Weitzmann, "The Mandylion and Constantine Porphyrogennetos," *Cahiers archéologiques*, XI, 1960, 163–84; A. Cameron, "The History of the Image of Edessa: The Telling of a Story," *Harvard Ukrainian Studies*, VII, 1983, 80–94; H. Belting, *Bild und Kult*, Munich, 1989, 232–53; and I. Ragusa, "The Iconography of the Abgar Cycle in Paris, MS. Lat. 2688 and Its Relationship to Byzantine Cycles," *Miniatura*, II, 1989, 35–52.

[40] On the complicated history of the Mandylion legend, see Cameron (as in note 39); H. J. W. Drijvers, "Abgarsage," in W. Schneemelcher, *Neutestamentliche Apokryphen*, 5. Auflage, I *Evangelien*, 389–94; and A.-M. Dubarle, *Histoire ancienne du Linceul de Turin*, Paris, 1985. A seventh-century Armenian treatise introduces the temple curtain as its first defense of images and, almost immediately thereafter, cites the Mandylion; see S. Der Nersessian, "Une apologie des images du septième siècle," *Byzantion*, XVII–XVIII, 1944–48, 58–87.

[41] See Belting (as in note 39), 235–37. Genoa, Convento di S. Bartolomeo; see C. Dufour Bozzo, *Il "Sacro Volto" di Genova*, Rome, 1974. The Vatican, Cappella di Matilda; see H. Pfeiffer, "L'iconografia della Veronica," *L'arte degli Anni santi*, exhib. cat., Palazzo Venezia, Rome, 1984, 112–19.

[42] Michael the Syrian reports that when the Edessan nobleman Athanasius had a copy made, the Mandylion already appeared old; see Cameron (as in note 39), 87–88.

[43] Grabar (as in note 39), 24ff.; Weitzmann (as in note 39), 168 and fig. 5; and N. Ševčenko, *Illustrated Manuscripts of the Metaphrastian Menologion*, Chicago, 1989, 47, and fig. 5G2. Dobschütz (as in note 39), 169, noted that representations of the Mandylion derived from the texts, not from the relic itself.

[44] C. Osieczkowska, "Note sur le Rossianus 251 de la Bibliothèque Vaticane," *Byzantion*, XI, 1934, 261–68 and J. R. Martin, *The Illustration of the Heavenly Ladder of John Climacus*, Princeton, 1954, 184ff. Martin and others associated the Vatican Climacus with Vatican gr. 2 and, hence, dated it ca. 1125; but A. Grabar, *L'Iconoclasme byzantin, dossier archéologique*, Paris, 1957, 19f., dated the manuscript to the eleventh century. Stylistic similarities with the *Panoplia Dogmatica of E. Zygabenos* (Vatican gr. 666) suggest a date at the beginning of the twelfth century; see I. Spatharakis, *Corpus of Dated Illuminated Greek Manuscripts to the Year 1453*, Leiden, 1981, 39ff.

[45] This classic image of the Mandylion was surely fashioned after the debates about Iconoclasm were fully under way in the eighth century, almost certainly after the end of Iconoclasm in 843. The early texts bearing on the underlying concept, including Chrysostom's *Homily on Hebrews*, were recirculated by the Iconodules; and, as the Vatican Cosmas makes clear, the pictorial elements were available in tenth-century Byzantium. The right wing of the tenth-century Sinai icon includes no hint of it, however (see K. Weitzmann, *The Monastery of Saint Catherine at Mount Sinai. The Icons*, I, Princeton, 1976, 944ff. and pls. XXXVI–XXXVII); and H. Belting's proposed modification of Weitzmann's reconstruction would eliminate the standard type of representation from the central panel as well (Belting [as in note 39], 235 and fig. 125). The Sinai icon does not provide a terminus post quem for the temple veil Mandylion first witnessed in the Alexandria Menologion, as replicas of the Mandylion and distinct narrative forms circulated at the same time the standard image was in use.

The relationship between the Old Law and cult and Christ's image may even be realized in the fringes that are usually a feature of this type of Mandylion.[46] These may allude to the fringes authorized in the Book of Numbers to remind the Jews of "the Lord's commands and to obey them, and not go [their] own ways led astray by [their] eyes and hearts" (15:37–40). Physical tokens instituted to serve as mnemonic devices, fringes also distinguished Jew from Gentile, as they still do today. Applied to the Mandylion, they would have justified images by recalling the tangible aids authorized for Jews and would, at the same time, have differentiated Christians from the old order; in Christ, Christians had fully realized forms, not just abstract signs. The point was stated emphatically at the Second Council of Nicaea: "If it were commanded to the people to have purple fringes, so much more is it to us to have pictures of holy men."[47] Surely a certain irony was intended by this evocation on Christ's holy portrait of the admonition to heed the Ten Commandments, which after all included the definitive prohibition of images; but a constant argument of the Iconodules was that the commandment applied only to the Jews.[48]

The connection to the Jewish cult was remembered when the Mandylion was brought into the imperial chapel at Constantinople in 944. Emperor, senate, and priests hailed the chest (*kibotos*) into which the *acheiropoieton* had been placed as a "second ark" superior to "the other less elevated ark containing the most holy, venerable, and mysterious covenant";[49] and the image, framed in gold, was deposited in the Pharos Chapel where, in addition to relics of Christ and the Virgin, the tablets of the law were housed.[50] The association was also recalled in the liturgy; the readings of Vespers on the feast of the Mandylion include long passages from Deuteronomy, including Moses' exhortation to Israel not to forget the law and a recapitulation of the Ten Commandments. The point is clear: with the coming of Christ, the old law had been at once both fulfilled and superseded, and the proscription of images revoked. In the end, the imagery was brought full circle in Orthodox churches where the Mandylion was painted above the altar or before the diakonicon, sometimes even restored as a hanging veil to set off the adytum and, at the same time, reveal its contents.[51]

The essential typology is made particularly clear in the twelfth-century Climacus, which also depicts the Keramion, the Mandylion's ceramic offset, alongside the *acheiropoieton*

[46] The Mandylion on the Sinai icon has fringes, as do other variants of the holy image. Fringes are also features of the temple veil in the tenth-century apse fresco in Tokalı Kilise (see A. Epstein, *Tokalı Kilise. Tenth-Century Metropolitan Art in Byzantine Cappadocia*, Washington, D.C., 1986, fig. 5). Grabar (as in note 39), 18, notes that, like the diaper pattern, fringes tend to disappear after the thirteenth century.

[47] Mansi (as in note 15), XIII, cols. 113–15.

[48] Cf. e.g. Nicephorus (as in note 19), chap. 3 *et passim* and Theodore of Stoudios (as in note 21), *PG* 99, cols. 334f.; trans. pp. 24ff.

[49] Cf. Constantine Porphyrogennetos, *Narratione de imagine Edessena*, *PG* 113, col. 419.

[50] See R. Janin, *La géographie ecclésiastique de l'empire byzantin*, I, 3, Paris, 1953, 241–43.

[51] See Grabar (as in note 39), pl. IV, figs. 1 and 3; and N. Thierry, "Deux notes à propos du Mandylion," *Zograf*, XI, 1980, 16–19. A good example is preserved in the church of Panagia tou Arakou, near Lagoudhera, Cyprus; the Mandylion is placed above the enthroned Virgin and Child in the apse. See A. Stylianou, "Ai toixographiai tou Naou tēs Panagias tou Arakou, Lagoudhera, Kupros," *IX Congrès international des études byzantines. Thessaloniki 1953*, I, Athens, 1955, 459ff.

itself.[52] As the caption establishes, the paired icons are meant to be seen as replacements for the tablets of the law; they are the *plakes pneumatiki*, the spiritual tablets of Christians.[53] Decades ago, John Rupert Martin recognized in the epithet a reference to 2 Corinthians: "it is plain that you are a letter that has come from Christ, given to us to deliver: a letter written not with ink but with the Spirit of the living God, written not on stone tablets but on the pages of the human heart. It is God who has qualified us to dispense his new covenant—a covenant expressed not in a written document, but in a spiritual bond; for the written law condemns to death, but the Spirit gives life" (3:3–6).[54] Writing at St. Catherine's on Sinai, John Climacus thought of himself as Moses' successor and entitled his treatise *Plakes pneumatiki*; indeed, in a letter that serves as the preface in the Vatican codex, Climacus's seventh-century biographer John of Raithu compared the author to Old Moses who had contemplated God on the same mountain and had received the carnal commandments.[55] This helps to explain why Moses' tablets are depicted in this place in the eleventh-century Climacus in Princeton (University Library, Garrett MS. 16),[56] represented as simple framed rectangles veined to suggest marble, their Christian replacement being indicated only by a cross (fol. 8v, Fig. 9). Building on this tradition of marking the preface with tablets of the law, the miniaturist of the Rossianus codex left two squares blank in the blue underpainting and allowed the ghosts to remain visible beneath the Mandylion and Keramion. The holy icons of Christ are seen then to cover up and complete the empty forms of the Jewish commandments, thus realizing the figure of Old Testament patterning and New Testament perfection in brightly colored pigments in a manner analogous to the Cosmas miniature.[57]

There is yet more. After introducing the contrast between written and spiritual law, the Letter to Corinthians continues,

> The law, then, engraved letter by letter upon stone, dispensed death, and yet it was inaugurated with divine splendor. That splendor made the face of Moses so bright, that the

[52] By showing the same portrait on cloth and in terra-cotta, the picture also stresses the Orthodox belief that holy images exist independent of the specific material through which they are expressed; cf. note 21. The miniature may be related to the late eleventh-century controversy over iconic matter initiated by Leo of Chalcedon; see *PG* 127, cols. 971–84; P. Stephanou, "La Doctrine de Léon de Chalcédoine et de ses adversaires sur les images," *Orientalia Christiana Periodica*, XII, 1946, 177–99; and A. Glavinas, *He epi Alexiou Komnenou (1081–1118) peri hieron skeuon, keimelion kai hagiōn eikonōn eris*, Thessaloniki, 1972.

[53] Writing at the beginning of the thirteenth century, Nicholas Mesarites also tied the images on the Mandylion and Keramion to the Decalogue and referred to them as portraits of the "lawgiver." See Dubarle (as in note 40), 40ff.

[54] Martin (as in note 44), 112.

[55] *PG* 88, col. 605.

[56] Dated 1087. Martin (as in note 44), 175ff.; *Illuminated Greek Manuscripts from American Collections*, ed. G. Vikan, Princeton, 1973, 98–99; and Spatharakis (as in note 44), 32–33. A tenth-century Climacus at St. Catherine's, Mt. Sinai (Cod. gr. 417, fol. 4r) incorporates the same motif, as does an eleventh-century manuscript in Paris (Bibliothèque nationale, Cod. Coislin 263, fol. 7r); Weitzmann and Galavaris (as in note 26), 28ff. and fig. 35; and Martin (as in note 44), 105.

[57] A more direct pictorialization of the same typology was introduced into the early sixteenth-century frescoes in the church of Panagia Podithou, Galata, Cyprus. There, over the apse, Moses is represented removing his sandals before the burning bush and, again, receiving the tablets from the hand of God; the Mandylion is depicted at the apex. See A. Papageorghiou, *Masterpieces of the Byzantine Art of Cyprus*, Nicosia, 1965, 32–33, and pl. XL.

Israelites could not gaze steadily at him . . . Moses put a veil over his face to keep the Israel-ites from gazing on that fading splendor until it was gone . . . That same veil is there to this very day when the lesson is read from the old covenant; and it is never lifted, because only in Christ is the old covenant abrogated. But to this very day, every time the Law of Moses is read, a veil lies over the minds of the hearers. . . . For us there is no veil over the face, we all reflect as in a mirror the splendor of the Lord (3:7–18).

Symbolizing the mystery of Jewish Scripture, like the temple curtain, Moses' veil was also entered into arguments about art. For Cyril of Alexandria, the law had been instituted to display pagan error, but Christ, "the way and the door," allows the faithful to "take off the veil of the law and by setting the face of Moses free of its coverings, to behold the naked truth" (Letter 41:8).[58] Quoting 2 Corinthians 3:18, John of Damascus seized the topos to defend images: "Israel of old did not see God, but 'we all, with unveiled face, behold the glory of God'."[59] And a Canon of the Feast of the Mandylion reminds worshippers that just as Moses' face was glorified even by God's back, so the new Chosen People must be metamorphosed by seeing Christ's face in the Holy Mandylion.[60]

In the legend of the Mandylion, a critical moment is recounted when the messenger of King Abgar finds Christ preaching to a crowd in Jerusalem but cannot portray him because of his radiance; Jesus then covers his face, leaving the image on the cloth.[61] As when Moses read Torah to the Israelites, Christ too was veiled while addressing his followers, but only for an instant; and when his face was uncovered, the veil bearing his image was proffered as an instrument of continuing revelation.[62] The Mandylion thus negotiates between Moses and Christ, between the written law filled with mysteries that must be explained and the image of Christ that renders God directly accessible.

Miraculously impressed from Christ's face, the Mandylion attested to Christ's dual nature and, in so doing, established the very possibility of holy icons.[63] Its Middle Byzantine representations went still further. They demonstrated the general tenet of Christian image theory that art is not simply a pictorialization of texts, however intricate and learned, but actual evidence of God's plan—indeed, because of Christ's Incarnation, they carry equal

[58] Letter 41 (as in note 4), *PG* 77, col. 208; trans. 172.

[59] John of Damascus (as in note 17), I, 16; *PG* 94, col. 1248; trans. 25.

[60] See V. Grumel, "Léon de Chalcédoine et le canon de la fête du Saint Mandilion," *Analecta Bollandiana*, LXVIII, 1950, 145.

[61] Cf. e.g. John of Damascus, *De fide orthodoxa*, 4, 16; *PG* 94, col. 1173; see von Schönborn (as in note 21), 213–14. According to the tenth-century "Letter of Abgar," Christ was actually in a synagogue, teaching an assembly of Jews; see Dobschütz (as in note 39), 203.

[62] Cf. L. Marin, "Masque et portrait: Sur la signification d'une image et son illustration au XVIIᵉ siècle," *Image et signification* (as in note 21), 163–79. Tellingly, the miraculous transfer of the image of Christ's face onto the cloth was seldom depicted in Eastern art for it would have required covering Christ's face; see Ragusa (as in note 39), 41.

[63] Long before the *acheiropoieton* was brought to Constantinople, John of Damascus (as in note 17, *PG* 94, col. 1261; *Letter to the Emperor Theophilus*, 5; *PG* 95, col. 352), the fathers at the Second Council of Nicaea (Mansi [as in note 15], XII, col. 963), Nicephorus (*Antirrheticus*, III, *PG* 100, col. 462, and *Refutatio et Eversio* [see P. Alexander, The *Patriarch Nicephorus of Constantinople*, Oxford, 1958, 244f., 256]), and others cited it to justify all holy images; and from the tenth century on, the Mandylion was celebrated in a special feast honoring sacred icons.

weight.[64] Exploiting the implications of the *skia/eikon* exegesis, the portrait of Christ super-imposed on the temple curtain reminded the faithful that, with the Incarnation, the Old Testament had been supplanted and its veils of mystery lifted. And, like the typologies it embodied, the image offered evidence for all to see that Christianity had not only appropriated Hebrew Scripture, but had also fulfilled, perfected, and, in the end, subverted it.

 Art is, itself, argument.

[64] Cf. John of Damascus (as in note 17), *PG* 94, col. 1248; trans. 25; and Theodore of Stoudios (as in note 21), *PG* 99, col. 392; trans. 78. It was precisely in this context that Nicephorus (as in note 63) adduced the Mandylion.

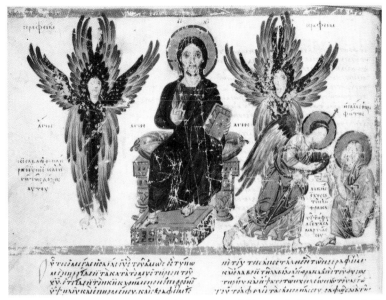

1. Vision of Isaiah, from *Christian Topography* of Cosmas Indicopleustes, ninth century. Rome, Bibl. Vat., cod. gr. 699, fol. 72v (photo: Vatican)

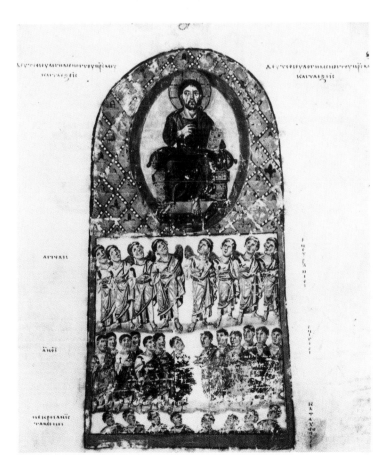

2. *Parousia*, from *Christian Topography* of Cosmas Indicopleustes, ninth century. Rome, Bibl. Vat., cod. gr. 699, fol. 89r (photo: Vatican)

3. Tabernacle, from *Christian Topography* of Cosmas Indicopleustes, ninth century. Rome, Bibl. Vat., cod. gr. 699, fol. 108r (photo: Vatican)

4. Temple curtains, from *Christian Topography* of Cosmas Indicopleustes, eleventh century. Sinai, St. Catherine's, cod. 1186, fol. 79r (photo: courtesy of K. Weitzmann)

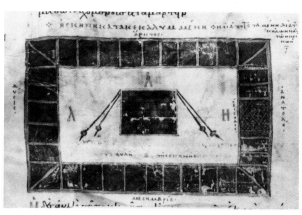

5. Tabernacle, from *Christian Topography* of Cosmas Indicopleustes, eleventh century. Sinai, St. Catherine's, cod. 1186, fol. 82v (photo: courtesy of K. Weitzmann)

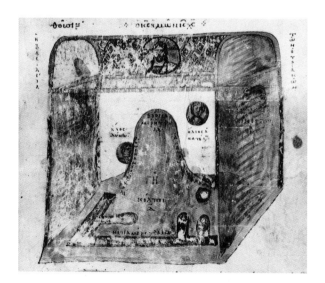

6. Cosmos, from *Christian Topography* of Cosmas Indicopleustes, eleventh century. Sinai, St. Catherine's, cod. 1186, fol. 69r (photo: courtesy of K. Weitzmann)

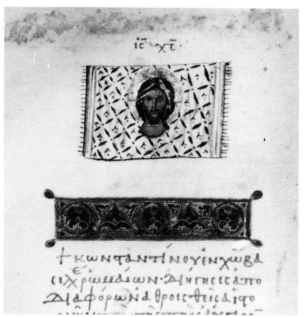

7. *Mandylion*, from *Menologion*, eleventh century. Alexandria, Greek Patriarchate, cod. gr. 35, fol. 142v (photo: courtesy of K. Weitzmann)

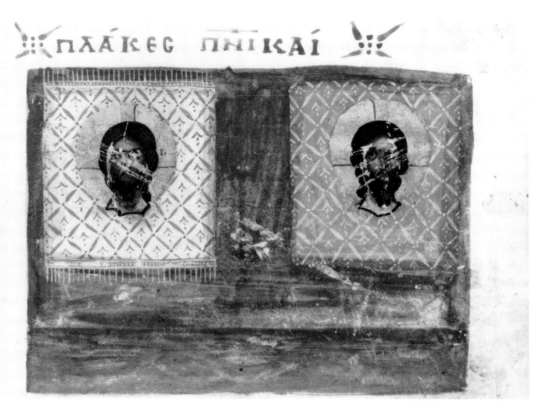

8. *Mandylion* and *keramion*, from *Heavenly Ladder* of John Climacus, early twelfth century. Rome, Bibl. Vat., cod. Ross. 251, fol. 12v (photo: Vatican)

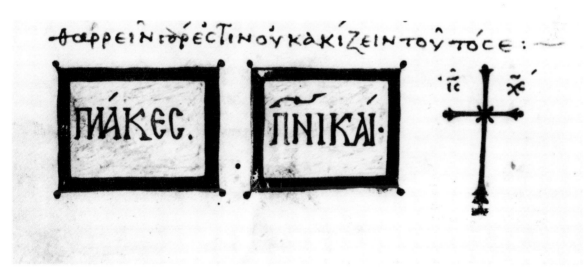

9. *Plakes pneumatiki*, from *Heavenly Ladder* of John Climacus, eleventh century. Princeton, University Lib., Garrett MS. 16, fol. 8v (photo: Princeton University Library)

Disembodiment and Corporality in
Byzantine Images of the Saints*

•

HENRY MAGUIRE

IT HAS LONG been recognized that Byzantine artists were capable of working within different formal "modes" at the same time; in other words, different types of subject matter tended to be given different characteristics of form, such as varying degrees of modeling, frontality, motion, and perspective.[1] This paper will attempt to bring the concept of formal "modes" into the realm of iconography, that is, into the classificatory study of meaning in Byzantine art. It aims to show how the Byzantines attached specific messages to specific formal elements, and how those messages formed a coherent and logical system of communication. Since it is not possible to cover the whole of Byzantine art here, I propose to test this thesis by examining only the iconography of portraits of the saints. I will look at the formal means by which different classes of saints, such as monks, soldiers, bishops, and apostles, were distinguished from each other, I will consider the iconographic significance of these variations, and, at the end, I will demonstrate their relevance to social history.

It is generally known that after Iconoclasm the Byzantines developed fairly precise portrait types for a number of the commoner saints.[2] These portraits consisted primarily of details of hair and physiognomy by which images of these saints could be readily recognized in works of art of widely differing periods and media. For example, the saints in a twelfth-century fresco from the church of Nerezi in Macedonia (Fig. 1), have no visible inscriptions by which they can be identified. But their portrait types can easily be distinguished. On the left stands Saint Procopius, with his smooth chin and elegant, bouffant locks of hair. The two bearded saints are the two saints Theodore: Theodore Stratelates, or "the general," in the middle, and Theodore Tiron, or "the recruit," on the right. To the casual glance both Theodores look very much alike; both have long faces with thick curly hair and long pointed beards. But a closer look at their features shows that they are not identical; the recruit has a more elongated face than the general; his beard is fuller, and his hair shorter, so that his ears

* In the preparation of this article I have benefited from the discussion that followed the original delivery of the paper at the conference on Iconography at the Crossroads, and especially from the comments of Irving Lavin.

[1] On the concept of "modes" in Byzantine art see especially E. Kitzinger, *Byzantine Art in the Making*, Cambridge, Mass., 1977, 19; K. Weitzmann, "The Classical in Byzantine Art as a Mode of Individual Expression," *Byzantine Art, An European Art, Ninth Exhibition Held under the Auspices of the Council of Europe. Lectures*, Athens, 1966, 149–77 (reprinted in idem, *Studies in Classical and Byzantine Manuscript Illumination*, Chicago, 1971).

[2] H. Buchthal, "Some Notes on Byzantine Hagiographical Portraiture," *Gazette des Beaux-Arts*, LXII, 1963, 81–90.

are fully visible.[3] The same features enable us to differentiate between the two Theodores in the mosaics and frescoes of the katholikon of the monastery of Hosios Loukas (Figs. 3 and 4), which were created over a century earlier than the frescoes at Nerezi, and in a much more schematic style. We may note, for example, how Theodore Tiron (Fig. 3) is distinguished by the give-away detail of his hairstyle, which is definitely "above the ears," as modern barbers would say.[4]

In the saints' lives, the Byzantines termed such images "lifelike," and declared that they strongly resembled the individuals who were portrayed. Their accuracy was repeatedly veri-fied, often through the agency of dreams or visions, which enabled the verisimilitude of icons to be checked against the true appearance of distant or departed saints.[5] The Byzantines have often been taken to task for excessive credulity in this regard, for many modern viewers have observed that these icons do not look lifelike at all. But this accusation misunderstands what the Byzantine beholders expected from a likeness; they were not interested in *illusion*, but in *accuracy*. Their conception of a good likeness was not a photographic portrait, but, to use the apt simile of Gilbert Dagron, it was more akin to those identikit drawings of suspected felons that police artists produce today from the descriptions of eyewitnesses.[6] The true portrait of the saint was a set of features forming the underdrawing of a painting or mosaic, which could be finished with modeling and with a background in a variety of formal modes, from the relatively illusionistic to the abstract.[7]

The role of modeling, perspective, motion, frontality, and other formal elements, there-fore, was not to create the kind of illusion that a modern viewer might expect in a photo-graphic portait, but to distinguish between classes of saints according to their *natures*. These formal distinctions were not *absolute*, but *relative*. In other words, *within* the stylistic range of a given artist and period, some groups of saints would be given a greater three-dimension-ality as a sign of their corporality, and some less. By way of example we may look once again at the twelfth-century frescoes of Nerezi (Figs. 1 and 2). Here we find a consistent formal differentiation between the military and the monastic saints: soldiers move their bodies more freely in space (Fig. 1); monks have less bodily presence and are more constrained in their movements (Fig. 2). The monks are portrayed in stiff, column-like poses; many of them are disciplined by a tight frontality, like the saint in the center of Figure 2, and their gestures tend to be repetitive and shallow, being for the most part confined to the front plane of the picture. The military saints, on the other hand, show much more motion, and even an exaggerated contrapposto. In the group in Figure 1, for example, Saint Procopius stands in a swaying posture, with his weight supported on his right leg; he turns his body sharply, so that his head

[3] On the portrait types, see L. Mavrodinova, "Saint Théodore, évolution et particularités de son type iconographique dans la peinture médiévale," *Bulletin de l'Institut des Arts. Académie Bulgare des Sciences*, XIII, 1969, 33–52.

[4] Th. Chatzidakis-Bacharas, *Les peintures murales de Hosios Loukas. Les chapelles occidentales*, Athens, 1982, 69–70, figs. 4–5.

[5] For a collection of such stories, see A. Kazhdan and H. Maguire, "Byzantine Hagiographical Texts as Sources on Art," *Dumbarton Oaks Papers*, XLV, 1991, 4–7.

[6] G. Dagron "Le culte des images dans le monde byzantin," *Histoire vécue du peuple chrétien*, ed. J. Delumeau, I, Toulouse, 1979, 133–60, esp. 146 (reprinted in *La romanité chrétienne en Orient*, London, 1984, no. 11).

[7] Kazhdan and Maguire (as in note 5), 7–9.

and torso face in different directions. He holds his round shield under his left arm in front of his chest, and parallel with the front plane; at the same time, he draws his right arm, which is strongly foreshortened, back into the picture space behind his body, as if he were intending to hurl his spear over the head of the spectator. This man of action, moving in space, contrasts strikingly with the more rigid portraits of the monks, whose freedom of movement, both laterally and in depth, is much more severely restricted (Fig. 2).

These formal distinctions are not confined to the frescoes of Nerezi, for other Byzantine paintings, executed at different periods and in different styles, show a similar formal differentiation of monks and soldiers relative to each other. We may contrast, for instance, two early fourteenth-century frescoes in the church of Sveti Nikita at Čučer, in Macedonia. One shows the warrior Saint Niketas, almost a swaggering figure, with his torso twisted in a vigorous contrapposto, his right arm akimbo, his well-rounded chest thrust toward the viewer (Fig. 5). The other portrays the ascetics Saint Paul of Thebes and Saint Anthony in more rigid postures, virtually without contrapposto (Fig. 6). Their bodies are flattened against the front plane of the image, so that their costumes have the quality of shadows cast against the wall. While the overall style of these fourteenth-century paintings is more naturalistic than that of the earlier frescoes at Nerezi, the artist has preserved the formal distinctions between the two classes of saints.

The formal idioms chosen in these churches for monks and soldiers corresponded to ideal images expressed in Byzantine writing, in hagiography, in dedicatory inscriptions, and in poems attached to icons. In their lives, ascetic monks were compared to living "monuments," or "columns," of virtue.[8] They had human feelings, but they overcame their emotions by means of the greatness of their minds.[9] As an example of the inflexibility of monastic saints, we may take a touching scene which is described in the life of Saint Nikon of Sparta, a tenth-century healing abbot. As a young man, says the hagiographer, Saint Nikon is leaving his family for the last time, setting off for the life of the wandering ascetic. Miraculously, he has crossed a swollen river, leaving his pursuing father and brothers stranded on the far bank. From across the raging water, Saint Nikon hears his aged father lamenting his son's departure. The saint, his biographer explains, being human, loved his father. On hearing the old man's pleas, Nikon "turned himself a little" toward his father and brothers, so that they could see his face which, by now, was withered through asceticism: "Facing them he bent his head three times toward the ground, then took his face away and gave them his back, taking up his journey."[10] It was a highly charged moment, but it has the visual formality of a liturgy. This slight concession to his distraught family was the expected deportment of the monastic holy man.

The monastic saint, therefore, was restricted in his emotions and in his movements. But he restricted himself in other ways too; he wasted his body through fasting and privation, so that it became incorporeal. Once again, the biographer of Saint Nikon says of his hero: "One

[8] *The Life of Saint Nikon*, ed. and trans., D. F. Sullivan, Brookline, Mass., 1987, 156, par. 45, lines 6–7.

[9] Ibid., 64, par. 14, lines 13–14.

[10] Ibid., 66–74, pars. 15–16. In this quotation and in those that follow I have used Sullivan's translation with a few modifications.

would have said that the shadow of a statue was to be seen in him, but not a man in a body."[11]
Elsewhere we learn: "His body was so wasted away and fatigued from toil that he differed
not from a shadow."[12] But privation in the material world brought a new freedom. Saint
Nikon's life was said to be "on the boundary between human nature and the angelic and
disembodied." The saint, "while living in the flesh, on account of his likeness to disembodied
powers, was not weighed down by the appendage of the body; but his life was upwards,
walking on air together with the powers of heaven."[13] He was even able to put his powers of
levitation to practical use, and travel between Corinth and Argos flying through the air.[14]
Saint Luke of Stiris, another tenth-century monastic saint, used to levitate himself a cubit
from the ground whenever he prayed.[15]

Such were the monks; rigid, wasted, and disembodied. The soldier martyrs were differ-
ent. A story in the Miracles of Saint George provides interesting insights into Byzantine
reactions to icons of these protectors. A group of Saracen soldiers insults Saint George by
going into his church in order to drink, sleep, and even play dice. The Saracens have with
them some Christian prisoners, one of whom warns them that the saint is able to repay such
behavior. But the Saracens only laugh, and ask their prisoner to point out Saint George's
portrait from among the holy images set above them in the church. The Christian indicates
the mosaic of the martyr with his finger; according to the text, the saint in the image is "girt
about with brightness, and a military corselet, wearing bronze leg-coverings, holding a war
spear in his hand, and looking in a terrifying manner upon those who gazed straight at him."
The fearsome character of this portrait, however, does not deter one of the Saracen soldiers
from hurling a missile at it; whereupon the weapon is returned to the attacker in such a
manner that it strikes him in the heart. The saint's active participation in this miracle is
proved by the icon itself, which is seen by the other soldiers to stretch out its hand.[16]

This story, while it belongs to a familiar class of legends concerning images that respond
to attacks by infidels or iconoclasts, is interesting for its stress on the physically active role of
the image; it wears its armor and carries its weapons in such a way as to look terrifying to its
beholders; it even seems to be extending its hand. The Byzantines looked to the soldier mar-
tyrs for strength to help them through life, and the images of these saints had to look the part.
Manuel Philes, a fourteenth-century poet, describing an icon of the two saints Theodore in
their armor, said that Hercules himself would not be a match for them.[17]

A second set of formal antitheses, of corporality and insubstantiality, of motion and
immobility, can be found in the bemas of later Byzantine churches. From the twelfth century
onwards it is common to find on the lower wall of the apse two painted liturgies, one above

[11] Ibid., 48, par. 9, lines 8–10.

[12] Ibid., 78, par. 18, lines 4–6.

[13] Ibid., 56, par. 11, lines 5–14.

[14] Ibid., 106, par. 29, lines 33–6.

[15] *Vita*, ed. G. Kremos, *Phōkika*, I, Athens, 1874, 28; cited by C. L. Connor "The Crypt at Hosios Loukas and its Fres-
coes," Ph.D. diss., New York University, 1987, 88.

[16] *Miracula S. Georgii*, ed. J. B. Aufhauser, Leipzig, 1913, 8–12.

[17] *Manuelis Philae Carmina*, ed. E. Miller, I, Paris, 1855–57, 80, no. 171, line 4.

the other, as can be seen in the frescoes at Nerezi (Figs. 7–10). The upper liturgy is the Communion of the apostles. It shows a double figure of Christ standing on either side of a central altar and distributing the bread and the wine to his apostles, who approach in two files from the north and the south as communicants (Figs. 7 and 8). The lower liturgy is that of the holy bishops, also shown in two files, converging on a central altar (Fig. 9). The number of bishops varies, but generally includes the three Hierarchs: Saints Gregory of Nazianzus, Basil of Caesarea, and John Chrysostom.[18] Each bishop holds a liturgical roll containing a text; like the apostles receiving the elements, they bow their heads and backs toward the center of the apse. The two scenes, then, are broadly similar in composition. In their formal characteristics, however, they are radically different. All of the bishops stand in identical poses—their backs are bowed to the same degree, their heads are inclined at the same angle, their scrolls are held in virtually the same way (Fig. 9). By contrast, the pose of each of the apostles is varied. On the south side, for example, the first, Saint Paul, bows more deeply to receive the bread from the hands of Christ, while the second apostle bows only slightly (Fig. 8). On the north side, two of the apostles turn to each other in an embrace (Fig. 10); the one on the left, Saint Luke, runs forward impetuously, while the apostle on the right, Saint Andrew, in effect shows his back to his master. The bishops and apostles are not only contrasting in their relative degrees of motion, but also in the extent of their modeling and corporality. The bishops wear white vestments covered with black crosses—the polystavrion and the omophorion (Fig. 9). Most of the crosses are not foreshortened, with the resulting effect that the garment is reduced to a flat two dimensional grid, affixed to the surface of the wall. By contrast, the apostles appear more substantial (Fig. 8); their bodies twist and turn in space, while they are swathed in ample folds of cloth which are relatively well modelled with light and shade. The costumes of the two groups of saints complement their formal characteristics; the vestments of the bishops are comparatively heavy in appearance and pleatless, while the classicizing robes of the apostles are thinner and more revealing of their moving bodies beneath.

We now look at the apse of a fourteenth-century building, Sveti Djordje at Staro Nagoričino in Macedonia (Fig. 11). This church was decorated one hundred and fifty years later than Nerezi, at a time when Byzantine artists were working in a more classical style, with a stronger emphasis on the construction of illusions of space. Even so, the same formal distinctions were made between the two liturgies. The stances of the bishops are, with only one exception, identical; one bishop alone, Saint Cyril of Alexandria, breaks the regular sequence of bowed figures by looking upward to Christ. By contrast, the poses of the apostles are extremely varied—some have their hands covered, others uncovered; some have their hands raised, others lowered; some have their hands crossed, others spread apart; some have their backs bent, others straight; some look forward, and others behind. In addition the bodies of the apostles are well modelled—their draperies even have a somewhat "inflated" appearance. The vestments of the bishops, in comparison, are flat and two dimensional. And here, in these

[18] On the iconography of the two liturgies, see C. Walter, *Art and Ritual of the Byzantine Church*, London, 1982, 184–214.

early fourteenth-century frescoes, there is an additional element of contrast; the apostles are given an illusionistic space in which to move, a space created by the green ground on which they stand and the architectural backdrop of buildings solidly constructed in oblique perspective. The bishops, on the other hand, are simply silhouetted against fields of green and blue.

The same formal distinction, between apostles and other classes of saints, can be found in other churches. It was noted, for example, by Otto Demus in his study of the late twelfth-century mosaics in the apse of the cathedral of Monreale, in Sicily. Here a choir of holy bishops, deacons, monks, and virgins, in the lower zone of the north and south walls, is juxtaposed with a grouping of the twelve apostles, in the upper zone. The saints in the lower zone stand in completely frontal postures, while the apostles above are represented in much freer attitudes, turning either toward each other, or to the enthroned Virgin and Child in the center of the apse.[19]

More curious in its effect than the mosaics of Monreale is an unusual icon from Kastoria, which dates to the first half of the thirteenth century (Fig. 12).[20] It portrays the Dormition, with the mourning apostles gathered around the deathbed of the Virgin, and with Christ at the center receiving her soul. As became the custom in later Byzantine painting, the scene also shows three bishops flanking Christ, who were believed to have been present at the funeral. They include Dionysios the Areopagite, who was thought on the evidence of his own writings to have been an eyewitness of the scene,[21] and James the Brother of the Lord, the first bishop of Jerusalem, who was also believed to have been present at the Dormition and to have written an account of the event.[22] But in this icon the role of the bishops is very different from that of the apostles. Whereas the apostles show their grief in their tensely furrowed brows and lined cheeks, the expressions on the faces of the saintly bishops are impassive and unmoved. In their flat white garments the bishops appear as disembodied presences, as floating spectators rather than fully engaged participants in the drama.

Similar distinctions of form can be seen in individual icons of saintly bishops and of apostles, such as the well-known mosaic icon of Saint John Chrysostom at Dumbarton Oaks, which dates to the early fourteenth century (Fig. 13). Its formal qualities are best described in the words of Byzantine poets, who composed epigrams addressed to icons of this saint. Here, for example, is a description attributed to the fourteenth-century poet Manuel Philes, which emphasizes the ascetic's lack of substance: "O painter, your hand has delineated the shadow of a shadow. For the body of the Chysostomos was a shadow, thinned out from fasting as if it were fleshless."[23] Another poem attributed to the same poet reads: "There is no softness and weight of luxury in you, father. Nor is there any excess of body, water, or flesh.

[19] O. Demus, *The Mosaics of Norman Sicily*, London, 1949, 230–31, pl. 64.

[20] *Holy Image, Holy Space: Icons and Frescoes from Greece*, exhib. cat., Walters Art Gallery, Baltimore, 1988, 176, no. 12.

[21] L. Wratislaw-Mitrovic and N. Okunev, "La Dormition de la Sainte Vierge dans la peinture médiévale orthodoxe," *Byzantinoslavica*, III, 1931, 134–74, esp. 139.

[22] M. Jugie, *La mort et l'assomption de la Sainte Vierge. Étude historico-doctrinale*, Studi e Testi CXIV, Rome, 1944, 121.

[23] Miller (as in note 17), 33, no. 71.

For you have thinned out physical thickness and severely stripped it down with an unyielding way of life."[24] Similar epigrams described icons of Saints Basil and Gregory of Nazianzus who, like Saint John Chrysostom, were depicted among the bishops officiating in the apses of churches. For example, a poem from a collection composed at the turn of the ninth and the tenth centuries describes an image of Saint Basil as "a shadow of flesh."[25]

A striking contrast is provided by another mosaic icon of the Palaeologan period, which is preserved in the Great Lavra on Mount Athos (Fig. 14). It portrays Saint John the Theologian. Unlike Saint John Chrysostom (Fig. 13), Saint John the Theologian has a well-rounded body, with carefully modelled drapery folds. He is turned to the left in a hunched pose, which is very different from the straight-backed rigidity of Saint John Chrysostom. The posture of Saint John the Theologian is a reference to his role at the Crucifixion of Christ; in Byzantine Crucifixion scenes, such as an early fourteenth-century icon from Ohrid (Fig. 15), a younger Saint John was commonly shown with his head bowed in sorrow, and his right hand raised and bent under his chin in a gesture of weeping. Thus, even as he writes his Gospel, John echoes his participation in the crucial event of Christ's earthly life. The fourteenth-century poet Manuel Philes described an icon of Saint John that must have been similar to the one in the Great Lavra. He says of it: "The son of Zebedee is bent to the ground, for he carries on his shoulders the yoke of the Lord."[26] It is as if the pose of Saint John carries the weight of the crossbar of Christ's death.

From this example it can seen that the formal distinction between the two groups of saints, bishops and apostles, meant more than the difference between ascetic and non-ascetic saints. It was also a sign that the apostles participated in the historical events of Christ's life on earth; that is, they bear witness to his incarnation. Another epigram attributed to Manuel Philes specifically associates the corporeal form of an icon with the incarnation of Christ. Describing the anthropomorphic image (or symbol) of the Evangelist Saint Matthew, the poet wrote: "Since you do not possess the incorporeal nature of angels, you carry the form of a corporeal evangelist . . . for you record for us the incarnate Logos."[27] Thus the apostles and the evangelists (whom Byzantine artists included with the apostles) were depicted in a more corporeal manner in art, because they bore witness to Christ in his human nature. Some of the most substantial and three-dimensional images in Byzantine painting are portraits of evangelists, such as the Evangelist Saint John from the famous tenth-century Gospels in the Stauronikita Monastery, on Mount Athos (Fig. 16).[28] On the other hand, we have seen that holy bishops and deacons, as well as monastic saints, were not completely subject to the laws of physical nature. To quote from a Byzantine epigram describing an icon of Saint Stephen, these saints had a "nature above nature."[29] Thus, paradoxically, the apostles were depicted as

[24] Ibid., no. 72.

[25] R. Browning, ed., "An Unpublished Corpus of Byzantine Poems," *Byzantion*, XXXIII, 1963, 298, no. 12; B. Baldwin, "The Language and Style of Some Anonymous Byzantine Epigrams," *Byzantion*, LII, 1982, 13, no. 12.

[26] Miller (as in note 17), 20, no. 36.

[27] Ibid., 19, no. 32. The poem could have been composed for a manuscript; see R. Nelson, *The Iconography of Preface and Miniature in the Byzantine Gospel Book*, New York, 1980, 33.

[28] MS. 43, fol. 13r.

[29] S. P. Lampros, ed., "O Markianos kōdix 524," *Neos Ellēnomnēmōn*, VIII, 1911, 183, no. 360, line 2.

more corporeal because they participated in the life of Christ as a man; the monks and holy clergy were disembodied because they had a special closeness to Christ as God. If the page of the Stauronikita Gospels bearing Saint John's portrait is turned, we discover overleaf a small icon of the monk Saint Euthemius (Fig. 17). He is depicted frontally against a flat gold background, his palms raised on behalf of the viewer in a symmetrical posture of prayer. This image, tight and severe, is strikingly different from that of the voluminously draped evangelist in his spacious antique setting.[30]

The logic of the forms is expressed with particular clarity in the mosaics of the katholikon of Hosios Loukas (Saint Luke of Stiris). The logic is clear precisely because the overall style of these mosaics is relatively unclassical and schematic—the distinctions are drawn more sharply. The key mosaic in the church is the portrait of Holy Luke (Fig. 18), the monastery's founder, the miraculous doctor, and the center of a healing cult. The relics of the saint were directly underneath this image, in the crypt of the church, where they worked many miraculous cures.[31] The image is typical of the portraits of monastic saints in this church in being almost entirely frontal. There is a marked bilateral symmetry governing all aspects of the icon, from the position of the upraised hands to the folds of the cloak. Only in the direction of Saint Luke's eyes, turned to the left, is there a hint of movement. A similar rigidity of form is maintained in the mosaics of other monastic saints who are represented on the walls and arches at Hosios Loukas.[32] But the individual portraits of the apostles, on the arches between the vaults in the narthex, are quite different. As can be seen from the mosaic of Saint Paul (Fig. 19), they are shown in three-quarter view, in motion. Their garments are less symmetrical, conforming to the movement of the body. The focus of the apostles' motion is Christ, whose image appears above the central doorway, leading from the narthex into the nave;[33] the apostles are depicted in the action of turning toward their master. At the same time, they are integrated into the historical scenes of Christ's life, which are depicted between them, in the niches of the narthex. Thus, the portrait of Thomas flanks the mosaic in the southern niche, in which he is shown putting his finger into the wound in Christ's side (Fig. 20). The apostle portraits here bear witness to the incarnation, and their formal character proves it.

The distinction goes beyond the abstractions of theology, because it also concerns the practical functions of the images in society. Prayer to Christ was the more effective on account of his humanity—his ability to sympathize with human troubles and weaknesses. Since it was desirable to have images in church which reinforced that idea, those who had witnessed Christ's life on earth were endowed with an appropriate degree of movement and corporality. But in the case of monastic and clerical saints, it was not their *humanity* that made them effective as helpers, but their *super*human qualities. Accordingly, their images were characterized by immobility and lack of substance which proved that they were closer than ordinary

[30] I would like to thank Kathleen Corrigan and Nancy Ševčenko for bringing this comparison to my attention.

[31] On the cult, see Connor (as in note 15), 62–88.

[32] See, for example, E. Stikas, *To oikodomikon chronikon tēs Monēs Osiou Louka Phōkidos*, Athens, 1970, pls. 28, 32–7.

[33] Ibid., pl. 12.

mortals to God. In functional terms, their disembodiment was like a badge—a sign of their special status. Indeed, I could go further in the case of these images, and say that their formal character is the *most* important conveyer of their message. It was not Holy Luke's monastic habit that caused him to heal, nor even his gesture of prayer; there were many praying monks who were not healers.[34] Rather, it was his special status as a holy man that enabled Luke to cure people, and this status was defined by the formal features of his portrait in relation to other images in the same church. This is what gave to his icon its special power in the eyes of the Byzantine beholder. The formal qualities of the portrait—its bilateral symmetry, its frontality, its lack of modeling—are not simply to be read as the generic mode of icons; on the contrary, they indicate that this is a particular type of holy image, occupying a particular place within a logical system of visual communication, and serving particular social needs. It is not important whether these formal features are to be named "style" or "iconography" or something else; but it is important that historians should not ignore them.

[34] A gesture of prayer similar to the one made by Holy Luke in his image was adopted by invalids seeking cures. The life of Nikon describes a monk standing before an icon of that saint and "raising his hands on high" as he prayed for a release from his blindness; Sullivan (as in note 8), 220, par. 64, lines 19–20.

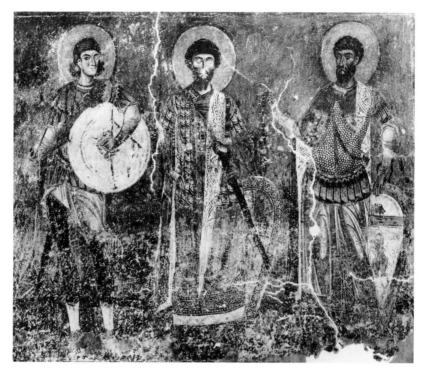

1. Soldier saints: Procopius, Theodore Stratelates, and Theodore Tiron, wall painting. Nerezi, Sveti Panteleimon (photo: Dušan Tasić)

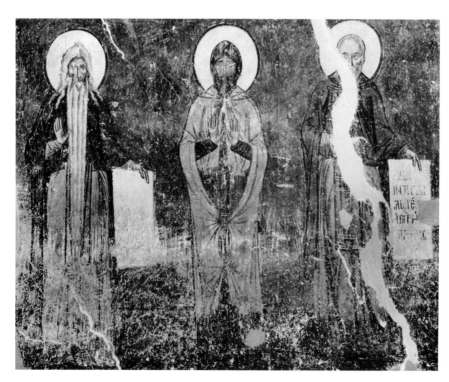

2. Monastic saints, wall painting. Nerezi, Sveti Panteleimon (photo: Dušan Tasić)

3. (top left) Saint Theodore Tiron, mosaic. Hosios Loukas, katholikon (after E. G. Stikas, *To oikodomikon chronikon tēs Monēs Osiou Louka Phokidos*, Athens, 1970, pl. 42b)

4. (top right) Saint Theodore Stratelates, wall painting. Hosios Loukas, katholikon (photo: Carolyn Connor)

5. (bottom left) Saint Niketas, wall painting. Čučer, Sveti Nikita (photo: Dumbarton Oaks)

6. (bottom right) Saints Paul of Thebes and Anthony, wall painting. Čučer, Sveti Nikita (photo: Dumbarton Oaks)

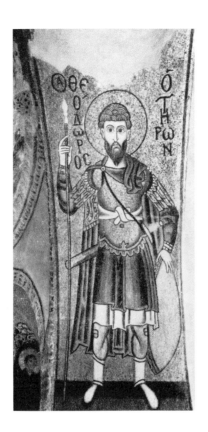

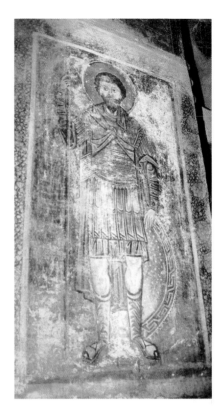

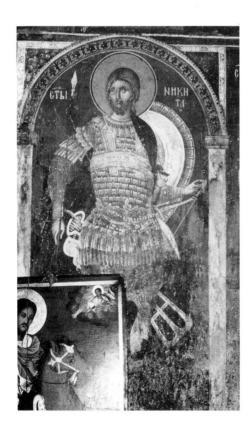

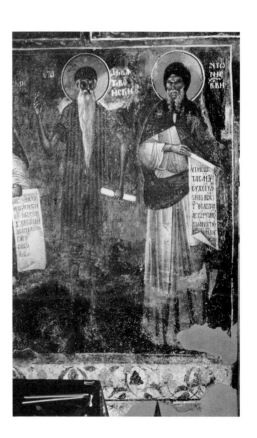

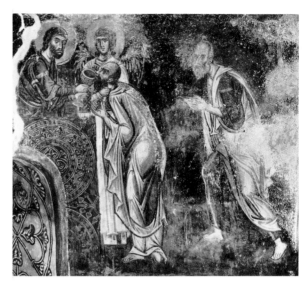

8. Liturgy of the Apostles, detail, wall painting. Nerezi, Sveti
Panteleimon (photo: Dušan Tasić)

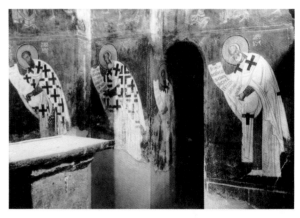

7. Wall paintings in apse. Nerezi, Sveti Panteleimon (photo:
Bildarchiv Foto Marburg)

9. Liturgy of the Holy Bishops, wall painting. Nerezi, Sveti
Panteleimon (photo: Bildarchiv Foto Marburg)

10. Liturgy of the Apostles, detail, wall painting.
Nerezi, Sveti Panteleimon (photo: Dušan Tasić)

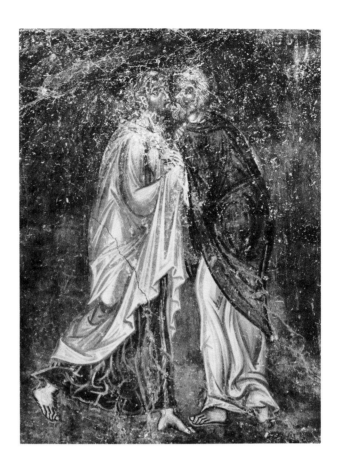

11. Liturgies of the Apostles and the Holy
Bishops, wall painting. Staro Nagoričino,
Sveti Djordje (photo: Bildarchiv Foto
Marburg)

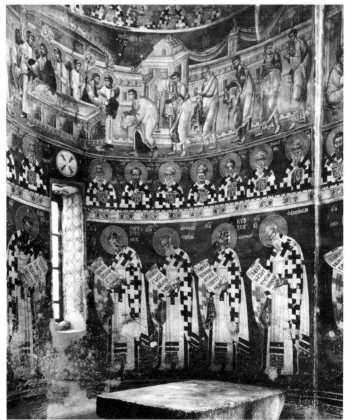

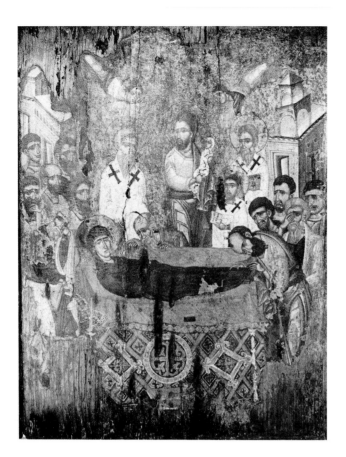

12. The Dormition, icon. Kastoria (photo: Thanasis Papazotos)

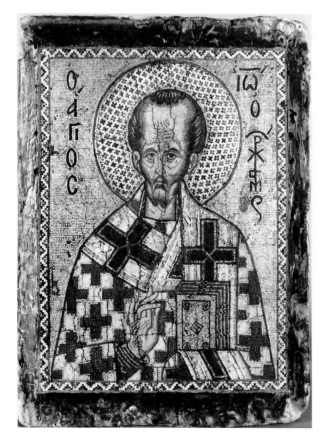

13. Saint John Chrysostom, mosaic icon. Washington, D.C., Dumbarton Oaks (photo: Dumbarton Oaks)

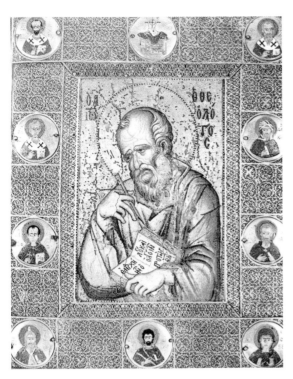

14. Saint John the Theologian, mosaic icon. Mount Athos, Monastery of the Great Lavra (after S. Kadas, *Mount Athos*, Athens, 1979, fig. 97)

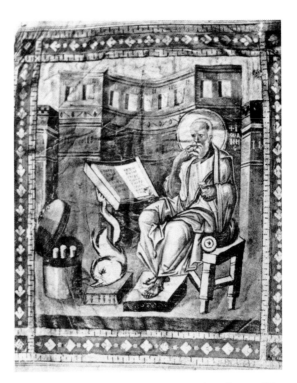

16. Saint John the Evangelist. Mount Athos, Stauronikita Monastery, ms. 43, fol. 13r (after K. Weitzmann, *Die byzantinische Buchmalerei des 9. und 10. Jahrhunderts*, Berlin, 1935, fig. 172)

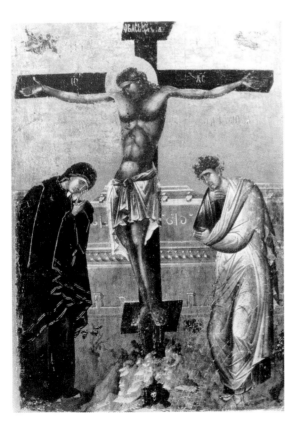

15. The Crucifixion, icon. Ohrid, National Museum (after K. Weitzmann et al., *Le grand livre des icônes*, Paris, 1978, pl. 149)

17. Saint Euthymius. Mount Athos, Stauronikita Monastery, ms. 43, fol. 13v (photo: Patriarchal Institute for Patristic Studies, Thessaloniki)

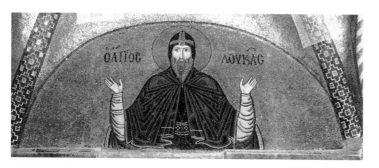

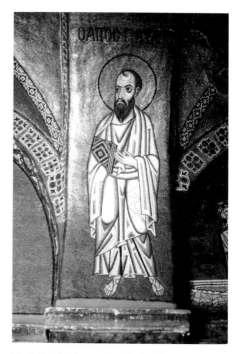

18. Holy Luke, mosaic. Hosios Loukas, katholikon (photo: Carolyn Connor)

19. Saint Paul, mosaic. Hosios Loukas, katholikon (photo: author)

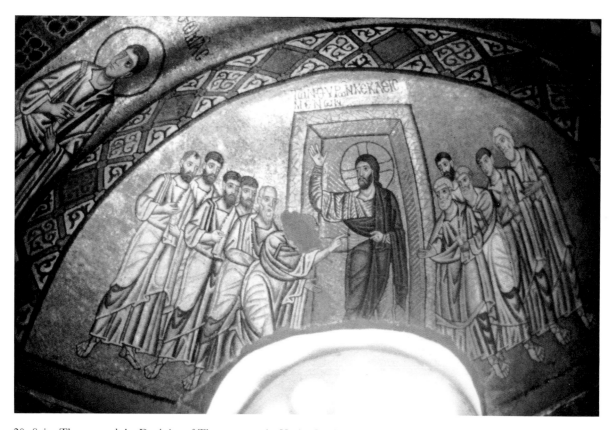

20. Saint Thomas and the Doubting of Thomas, mosaic. Hosios Loukas, katholikon (photo: author)

Diagrams of the Medieval Brain:
A Study in Cerebral Localization

·

YNEZ VIOLÉ O'NEILL

> Tell me where is fancy bred,
> Or in the heart or in the head?

SUNG JUST AS Bassanio is about to make the most important choice of his life, this couplet in the *Merchant of Venice* seems to suggest that the bard and other Tudor laymen were confused about the site of imagination.[1] Contemporary physicians, surgeons, and most artists had no such problem. Few if any of them doubted that fantasy or imagination was localized in the front and cognition or reason in the middle, and that memories were stored in the back of the head (Fig. 1).

For centuries medical practitioners as well as philosophers, theologians, and even poets explained thought as a regular physiological function. They believed that sensations were apprehended, digested into ideas, and stored as memories in a regular progression through the head from front to back just as nutriments were processed daily through the gastrointestinal tract from top to bottom. The three major stages of the intellectual process were believed to take place in chambers called cells or ventricles (that is, "little bellys"), which, though located in the head, corresponded in the nutritive process to the "organs of digestion": the stomach and the large and small intestines.

Although medieval physicians and surgeons knew where the principal organs of the nutritive process were located, they were less certain about the precise location of the ideation cells in the head. Were these "organs of thought" lodged under the main part of the brain where we moderns now find those cavities that we identify as the cerebral ventricular system, which are located in the lower and inner parts of the cerebrum? Or were they perhaps situated closer to the crown of the head, at its vertex, in the membranes that cover the brain and which we know as the cerebral meninges?

Traditionally, most scholars have believed that all medieval thinkers placed the cells of ideation in the cerebral ventricular system. As Walter Pagel, an eminent medical historian, asserted in 1957, the most characteristic feature in medieval accounts of cerebral anatomy and physiology was "the attention given to the localization of mental faculties in the ventricles

[1] *Merchant of Venice*, act 3, sc. 2, lines 62–64.

of the brain."[2] Despite its general acceptance, certain essential elements of this thesis have recently been challenged.[3] Our reappraisal stems from a fresh appreciation of the role that medieval graphic (i.e., visual) data played in the development of the medical sciences. One example of the visual genre being reconsidered here, the cellular brain diagram, is held in the collection of the Countway Library, Boston (Fig. 2) and will be included in the Index of Medieval Medical Images (IMMI), a national database that will soon be available on-line.[4]

This discussion will focus on our revision of the traditional localization doctrine. I shall show how it enables us better to interpret a most curious twelfth-century diagram (Fig. 3) along with a thirteenth-century copy (Fig. 4), whose meaning and significance have long eluded medical historians. These two drawings represent the head, the eyes and the nose at least in the thirteenth-century copy being obvious. If the deeper structures, those within the cranium, are not immediately recognizable, neither have they been to medical historians throughout the years.

Let me briefly trace the development of the localization doctrine and identify the anatomical structures that played a role in it. The first clear reference to any of the skull's contents is a brief description of one of the meningeal layers, emphasizing its undulating surface as it follows what we would call the cerebral convolutions. This account is found in an Egyptian papyrus containing a series of surgical case histories originally compiled about 3000 B.C., which survives in a copy made about 1600 B.C.[5] There is, however, no indication that the ancient Egyptians had any concept of the brain's function in producing ideation. We owe this concept to Plato, who, like several of his Hellenic predecessors, supported the idea of the brain's primacy in mental activities and placed the immortal part of the soul there.[6] Aristotle, while discounting the brain's significance, provided its first anatomical description of any

[2] W. Pagel, "Medieval and Renaissance Contributions to Knowledge of the Brain and Its Functions," in *The History and Philosophy of Knowledge of the Brain and Its Functions*, ed. F. N. L. Poynter, Oxford, 1958, 97. Fifteen years later, E. Clarke and K. Dewhurst in their *Illustrated History of Brain Function*, Oxford, 1972, 10–48, interpreted the medieval drawings collected for their history of cerebral graphics according to the ventricular localization doctrine.

[3] In a paper delivered on 29 April, 1989 at the Annual Meeting of the American Association of the History of Medicine, I offered an opposing thesis in greater detail.

[4] Boston, Countway Library, Uncatalogued MS. [Miscellany, Mostly Religious], Italy, bound ca. 1490–1520. I am grateful to Richard Wolfe for this information. For more information on IMMI, see M. H. Infusino, "The Index of Medieval Medical Images (IMMI) Project and the Origins of the Kalamazoo Session on 'The Use of Computer Databases to Access Medieval Pictures and Diagrams,'" *Literary and Linguistic Computing*, VI, 1991, 3–5; and S. S. Layne, "MARC Format for Medieval Manuscript Images," *Rare Books and Manuscripts Librarianship*, VI, 1991, 39–52. We believe that the IMMI data-base (Index of Medieval Medical Images in North America, National Library of Medicine Grant Project G08 LM04868) will be on-line as part of the RLIN database in 1993. The present study was funded in part by the aforementioned grant.

[5] Case number six in the Edwin Smith Surgical Papyrus, published in *Facsimile and Hieroglyphic Transliteration*, ed. and trans. J. Henry Breasted, I, Chicago, 1930, 164–74.

[6] For references to Plato, the Hippocratics, and the pre-Socratics who recognized the brain's role in effecting sensory and cognitive activity, see D. H. M. Woollam, "Concepts of the Brain and Its Functions in Classical Antiquity," in Poynter (as in note 2), 5–18; E. Clarke and C. D. O'Malley, *The Human Brain and Spinal Cord*, Berkeley and Los Angeles, 1968, 4–7; E. Clarke and J. Stannard, "Aristotle on the Anatomy of the Brain," *Journal of the History of Medicine*, XVIII, 1963, 130, n. 2; and *Herophilus. The Art of Medicine in Early Alexandria*, ed., trans., and essays by H. von Staden, Cambridge, 1989, 248–49.

detail when he described it as bilateral and enclosed by two membranes.[7] Aristotle seems also to have been the first to remark upon a cerebral ventricle, declaring that "in a great majority of animals, [the brain] has a small hollow in its center."[8] Though he seems to have been the first investigator to have identified the cerebral meninges and the cerebral ventricles, Aristotle probably never examined a human brain. Apparently, he based most of his observations on the brain of a turtle, a fact that may account for his misguided assertion that, in proportion to body size, man has the largest brain of all animals, and that woman's brain is slightly smaller.[9]

The culmination of the classical period of brain investigation was reached at Alexandria, the center of Hellenistic science in the third century B.C., when the Ptolemaic dynasty not only permitted but sponsored the intensive study of cerebral anatomy, through human dissection and perhaps even vivisection of convicted criminals. In the course of these investigations, the structures that were only anatomical details to Aristotle became central to competing physiologies of thought: one emphasizing the ventricles, the other the meninges. We have only fragments of the work of two Alexandrian anatomical investigators, but we know that Herophilus of Chalcedon subscribed to the idea of the brain as the central organ of intelligence and described a cerebral ventricle in which he placed the major controlling faculty of the body.[10] Since he located this common ventricle at the base of the brain near the anterior face of the cerebellum, it has been difficult for modern investigators to refrain from projecting modern neurophysiological findings on the Herophilian fragments.[11] Herophilus's slightly younger contemporary Erasistratus paid special attention to the convolutions of the human brain, deciding that their greater complexity was related to higher intelligence, and he located the command center of the body in the cerebral meninges whence, according to one report, he believed the nerves to originate.[12]

The extension of Roman power and a new spiritualistic emphasis of religion and philosophy seem to have brought human dissection to an early end even in Alexandria. Only some four hundred years later did Galen, the Greek physician who lived in Rome during the reign of Marcus Aurelius, return to investigation of the brain. Though he was unable to use human material for his studies, Galen endeavored to demonstrate and elaborate upon the work of the Alexandrian anatomists. While he accepted many of their findings, Galen contended that the soul or the mind was lodged neither in the ventricles, as Herophilus had believed, nor in the meninges, as Erastistratus had suggested, but in the substance of the brain.[13] During

[7] Aristotle, *Historia animalium*, 494b, 29–30.

[8] Ibid., 495a 6, and compare with Aristotle, *De partibus animalium*, 656b 26.

[9] Aristotle, *De partibus animalium*, 653a 26–27; and Clarke and Stannard (as in note 6), 140–43.

[10] Von Staden (as in note 6), 225, 314–15.

[11] Ibid., 247–48.

[12] A collection of the fragments concerning neuroanatomy and physiology surviving from Erasistratus's writings are in C. R. S. Harris, *The Heart and the Vascular System in Ancient Greek Medicine*, Oxford, 1973, 229–33. For passages from the writings of ancient authors who believed Erasistratus placed the control center of the body in the meninges, see von Staden (as in note 6), 313–17.

[13] Clarke and O'Malley (as in note 6), 460–63.

Galen's lifetime, therefore, in the second half of the second century A.D., a consensus had been reached that the body's command center was not located in the thorax or in the heart, but beneath the skull. There was no agreement, however, where precisely in the head this hegemonic center was located, since three possible sites had been proposed: the ventricles, the meninges, and the brain substance.

It is believed that from the time of Galen's death in the first decade of the third century until well into the Middle Ages there was no further practical study of the brain.[14] Classical anatomical studies, however, became progressively refined in an effort to fix the command center as well as each of the major faculties of the mind—fantasy, cognition, and memory—in a specific cerebral cavity. In terms of Shakespeare's couplet, fancy was believed bred not only in the head, but in its forward chamber. The development and elaboration of this system of beliefs, traditionally called the cell doctrine of brain function, must concern us now.[15] Its origins are difficult to determine. The Byzantine physician Posidonios, who may have observed patients with head injuries, considered that lesions of the front of the brain interfered with the appreciation of sensations, whereas those of the posterior resulted in memory defect. He decided further that damage to the brain's middle ventricle produced a disturbance of reason, and therefore we find in his writings, for the first time, localization of a single mental function in a particular cerebral cavity.[16] Nemesios, bishop of Emesa and a younger contemporary of Posidonios, allegedly suggested that all mental faculties were placed in the cerebral ventricles, with each ventricle responsible for a specific activity. Accordingly, the anterior ventricle was responsible for the apprehension of sensations and for imagination, the middle ventricle for cognition and reason, and the posterior ventricle for memory. Nemesios is rather vague on these matters, but later commentators certainly asserted that he, and most of his successors, believed that the faculties of the mind were contained within what we know as the ventricular system of the brain.[17]

[14] The traditional date for Galen's death, 199–200 A.D., was challenged by V. Nutton, "Galen in the Eyes of His Contemporaries," *Bulletin of the History of Medicine*, LVIII, 1984, 315–24, who convincingly argued that the classical anatomist died sometime after 210 A.D.

[15] Clarke and Dewhurst (as in note 2).

[16] Only fragments of Posidonios's works are extant. His etiological description of mental diseases, where he localizes reason in the middle ventricle, was quoted by Aetios of Amida, a medical encyclopedist who flourished under the emperor Justinian I (527–565). The Greek text of this passage is cited by W. Sudhoff, *Die Lehre von den Hirnventrikeln in textlicher und graphischer Tradition des Altertums und Mittelalters*, Inaugural Dissertation, Leipzig, 1913; reprinted in *Archiv für Geschichte der Medizin*, VII, 1913, 157. Citations to this work will be to the copy published in the *Archiv* since it is more easily accessible.

[17] An English translation from the Greek text of Nemesios's treatise is in *Cyril of Jerusalem and Nemesius of Emesa*, ed. W. Telfer, Library of Christian Classics, IV, Philadelphia, 1955, where ventricular localization is mentioned on pp. 341–42. Clarke and O'Malley (as in note 6), 463–65, also cite ancillary passages from Telfer's edition. Medieval thinkers used an edition of Nemesios's treatise translated from Greek to Latin during the eleventh century by Alphanus, bishop of Salerno. A modern edition of Alphanus's translation is *Nemesii episcopi Premnon Physicon sive Liber*, ed. K. Burkhard, Leipzig, 1917. In Burkhard's edition, Nemesios's views on ventricular localization appear on p. 89. Although Sudhoff (as in note 16), 157, doubted that Nemesios localized mental faculties in the cerebral ventricles, R. K. French, *Robert Whytt, The Soul and Medicine*, London, 1969, 109, attributes the formulation of the ventricular localization doctrine to Nemesios, as do Clarke and O'Malley (as in note 6), 463, and Clarke and Dewhurst (as in note 2), 10.

Nemesios's ideas about localization of the mental faculties may have been available in Latin to Salernitans as early as the middle of the second half of the eleventh century, but ultramontane discussions of the subject seem to have begun with Adelard of Bath, who early in his career identified the three most important organs of the human body as the head, the heart, and the liver, and then maintained that certain parts of the head regulated particular mental faculties: the prow, imagination; the middle, reason; and the stern, memory.[18] A little later, Adelard, while erroneously citing Aristotle as his authority, fixed the mental faculties more precisely in the brain. Moreover, he placed each of these faculties in a particular chamber he termed a "cell."[19] About 1125, William of Conches, in his *Philosophia mundi*, presented a variation of this schema, assigning the faculties of fantasy, imagination, and vision to the cell in the prow of the head; logistikon, or reason, which he defined as the power of discernment, to the middle cell; and memory, or the retentive virtue, to the cell in the head's occiput.[20] An apparently original feature of William's account was his assignment of qualities

[18] " . . . [Anima] verum aliud in capite, aliud in corde, aliud etiam hepate operatur, ipsius etiam capitis partes diversas diversis officiis dedicavit—in porta [sic] enim imaginatur, in medio ratione utitur, in puppi, id est occipitio, memoriam abscondit" (*Des Adelard von Bath traktat De eodem et diverso*, ed. H. Willner, Beiträge zur Geschichte der Philosophie des Mittelalters, IV, Munster, 1903, 32–33). H. Telle, in her edition of the fourth book of William of Conches's *Philosophia*, in *Willhelm von Conches, Philosophia*, ed. G. Maurach, Pretoria, 1980, 226–27, n. 86, noted the same metaphorical language in Constantine's translation of Ali ibn Abbas's *al-Maliki*, which is generally known as the *Pantegni*, or *Pantechni*; see Constantinus Africanus, "De communibus medico cognitu necessariis locis," *Operum reliqua*, Basel, 1536–39, 10–11, 91. The pertinent text in the last reference contains a large lacuna as it reads "Locus enim imaginationis ventriculi sunt in puppi cerebri" The comparable passage as it appears in an earlier printed edition, *Opera Isaac*, Lyon, 1515, fol. 16v (where the *Pantegni* appears as the seventh work, foliated separately), makes more sense and clearly displays Constantine's ship imagery (though this version has other problems of its own—omitting localization of memory, etc.). It reads: "Locus enim imaginationis in prora est cerebri. Locus vero intellectus sive rationes ventriculi sunt puppis cerebri."

[19] "Cum enim de comitantibus cerebrum sermo nobis sit, elice, si vales, qua ratione loca phantasiae, rationis et memoriae a philosophis deprehensa sint. Nam et Aristoteles in Physicis et alii in tractatibus aliis sic discernunt, ut phantasiam exerceri dicant in parte cerebri anteriore, rationem in medio, memoriam in occipitio. Inde et tribus illis cellis nomina imposuerunt phantasticam, rationalem, et memorialem" (*Die Quaestiones Naturales des Adelardus von Bath*, ed. M. Muller, Beiträge zur Geschichte der Philosophie des Mittelalters, XXXI, Munster, 1934, 22; and *"Quaestiones Naturales" di Adelardo di Bath*, ed. S. Balossi, A. di Giovanni, and B. Ferrari, Scientia Veterum, LXXXVI, Rapallo, 1965, 47). It is interesting to note that Adelard preferred the Nemesian schema of faculty localization to one advanced by Augustine of Hippo. In 401 or shortly after, Augustine asserted that observation of head injuries demonstrated that sensation derived from the front ventricle and motion from the rear, and that memory thrived in the middle cerebral ventricle. Augustine, *De genesi ad litteram*, lib. vii, cap. 18, in *PL* 34, col. 364.

[20] "Sub craneo duae pelliculae sunt, miningae dictae, quarum exterior, durior est; duraque mater dicitur: propinquior vero cerebro, ne laedat ipsum, tenuior, dicturque pia mater. Sub istis est cerebrum Sed in capite sunt tres cellulae, in prora, [in medio], in puppi in posteriori parte. Prima vero cellula est calida et sicca, et dicitur phantastica, id est visualis vel imaginativa, quia in ea vis videndi est et intelligendi, sed ideo calida et sicca est, ut formas rerum et colores attrahat. Medio vero dicitur logistikon, id est rationalis; quia in ea est vis discernendi Est calida et humida ut melius discernendo, proprietatibus rerum se conformet. Tertia vero memorialis dicitur quia in ea est vis retinendi aliquid in memoria. Ista est frigida et sicca ut melius retineat." *Philosophia mundi* was printed three times in the sixteenth century, but in none of these editions was the author correctly identified. The first edition, printed as *Philosophicarum et astronomicarum*, Basel, 1531, was ascribed to William of Hirsau. In subsequent recensions, Bede and Honorius Augustodunensis were identified as its authors. These were both published by Migne; see Bede, Περὶ διδάξεων sive elementorum philosophiae libri quattuor, in *PL* 90, col. 1127–78, and Honorius, *De philosophia mundi libri IIII*, in *PL* 172, cols. 39–102. Because the version attributed to Honorius has been considered to be the best of the editions, most of the passages cited above were drawn from its col. 95. Careful reading reveals that it contains a lacuna, indicated by brackets, which was supplied by consulting the Basel edition, p. 75, as well as the Bede recension, col. 1174. Telle (as in note 18), 106, agrees with this emendation.

to the individual cells, which he placed in the head but not specifically in the brain. According to William, two qualities characterized each cell, effecting its operative virtue. Finding these qualities in the traditional explanation of nutrition, which he applied to the cognitive process, he devised a qualitative explanation of mental function.[21] Thus, the cell of fantasy, like the humoral conception of "appetite," was hot and dry because the faculties of seeing and understanding used these qualities to draw in forms and colors. The middle cell was hot and moist because the power of cogitation, like digestion, needed these qualities to boil, or "cook up," perceptions into ideas. The rear cell was cold and dry because the seat of memory, like a refrigerator, needed these qualities to preserve memories, like kitchen leftovers. But, to return to the main question, at what level in the head were these chambers, or cells, placed by twelfth-century anatomists? Did they float underneath the brain, at the base of the cerebral cortex in the cerebrospinal fluid that we know fills the ventricular system? Were they embedded in the middle of the gray matter of the brain itself? Or were they enfolded in the convolutions of the meninges, those intriguing membranes that envelop and enclose the brain?

We know now that the cerebral meninges consist of three membranes—the dura mater, the pia mater, and the arachnoid—whereas medieval thinkers believed there were only two, counting the pia mater and the arachnoid as one and the dura mater as the other. The medieval names for these structures, that is, pia and dura mater, derive from Constantine the African's literal Latin rendering of an Arabic metaphor that emphasized the meninge's swaddling function: the inner membrane, the pia, being the embracing "tender mother," and the dura, the "harsher mother," protecting the brain from the skull's hardness. Modern anatomists still refer to the pia and dura mater by the names Constantine gave them.[22]

In his second account of cerebral form and function, which he completed shortly before 1150, William of Conches not only joined his illustrious predecessors in assigning a special function to the meninges, but substantiated his unusual neurological theory by claiming a rather fanciful etymological derivation for the "maternal membranes." William suggested that all of the nerves of the human body derive from the meninges, whence these membranes are called "maters," or mothers. The sensory nerves originating in the pia mater stretch out anteriorly toward "the windows of sense," while the nerves of voluntary motion, which are derived from the dura mater, extend posteriorly.[23] This concept was soon elaborated in

[21] William could have learned of the qualities associated with the operations of nutrition from several sources, including Johannitius's *Isagogue* or Nemesios's *Premnon Physicon*. Both authors explained that nutrition was accomplished by four natural corporeal powers, each of which was characterized by a complex quality: appetite was hot and dry; digestion, hot and moist; retention, cold and dry; expulsion, cold and moist. See G. Maurach, "Johannicius and Techne Galieni," *Sudhoff's Archiv*, LXII, 1978, 154; "La Isagoge de Ioanitius," ed. and trans. D. Garcia and J.-L. Vidal, *Asclepio*, XXVI/XXVII, 1974/75, 321; *Nemesii episcopi Premnon Physicon* (as in note 17), 143; *Cyril of Jerusalem and Nemesius of Emesa* (as in note 17), 362–63. His assignment of qualities characteristic of a specific alimentary process to each of the cognitive cells and his assertion that each complex quality served to effect the cell's mental faculty, however, appears to have no precedent, as was demonstrated by Y. Violé O'Neill, "William of Conches' Descriptions of the Brain," *Clio Medica*, III, 1968, 207–8.

[22] On the process by which these terms developed, see G. Strohmaier, "Dura Mater, Pia Mater, Die Geschichte zweier anatomisher Termini," *Medizinhistorisches Journal*, V, 1970, 201–16.

[23] "Sub cranio duae sunt pelliculae quae a physicis meningae dicte sunt; quarum propinquior cranio est durior & siccior; ista a physicis dura mater dicitur: quae propinquior est cerebro ne ipsum laedat est tenuior, atque pia mater dicitur. Ex his omnibus nervi humani corporis oriuntur, unde & matres dicuntur: sed qui ex pia matre nascuntur, illi quidem sunt instru-

certain Latin anatomical texts from the second half of the twelfth century attributed to Salernitan masters. There are three versions of these texts, which may comprise the lectures of one or several Salernitans named Richard or Nicolaus. The version attributed to Master Nicolaus, after discussing the brain's composition in classical terms, makes an extraordinary statement about the form and function of the meninges: "Three cells are set off. Indeed two membranes, that is to say the pia mater and the dura mater, are connected to each other in two places. In the front part of the head they constitute the cell of fantasy. In the middle of the head, [they constitute] the cell of logic. In the posterior of the head, they constitute the cell of memory."[24] This extraordinary passage has, as far as I know, never been correctly interpreted or discussed. What makes it extraordinary is not Nicolaus's assignment of the mental faculties but his localization of the three chambers. In his schema the three cells that medieval anatomists and philosophers believed to be the site of fantasy, cognition, and memory are found not beneath the cerebral cortex, but above it, in the brain's ambient membranes. While discussing neural function, moreover, Nicolaus amplified his theory of meningeal localization by explaining that the sensory nerves derive from the cell of fantasy and the motor nerves from the chamber of memory, which he described as the "thesaurus memoriae."[25] Nicolaus was not alone in his advocacy of this strange doctrine. Another twelfth-century anatomical text attributed to Richard the Salernitan tells us "the two meninges make three folds, connected to each other, in which there are three cells, fantasy, logistic, and memory."[26] Still more ornate is the account believed to have been written also by a Richard, who may have been English: "Therefore there are two mothers, which are called meninge or vulgarly webs, which knotted, make three foldings by which together, in a wonderful fashion of nature, cells are distinguished, namely the anterior, posterior and middle."[27] Richard assured us, moreover, that he was describing human, not animal, cerebral anatomy: "And note that this is the

menta sensuum & ad proram capitis tendentes, ibi tumorem faciunt. Ex dura matre nascuntur illi qui sunt instrumenta voluntarii motus, qui ad puppim capitis tendunt, atquae ibi tumorem quendam faciunt. Sed quomodo praedicti ad fenestras sensuum tendunt & quomodo alii ad membra quae voluntariem moventur . . . " (William of Conches, *Dialogus de substantiis physicis ante annos ducentos confectus a Vuilhelmo Aneponymo Philosopho*, Strasbourg, 1567, 275). This work is also known as the *Dragmaticon*.

[24] "Tribus cellulis distinctum est. Duae enim pelliculae, scilicet pia mater et dura mater in duobus locis se conectunt [in margin: De tribus celulis capitis, scilicet phantastica, logistica, et memoralis]. In anteriore parte constituunt cellulam fantasticam. In medio capitis cellulam logisticam. In posteriori parte capitis constituunt cellulam memorialem." This Latin text of the *Anatomia Nicolai* was prepared by F. Redeker in his *Die "Anatomia magistri Nicolai phisici" und ihr Verhältnis zur Anatomia Chophonis und Richardi*, Inaugural Dissertation, Borna-Leipzig, 1917. The passage cited is on pp. 37–38. Although G. W. Corner in his *Anatomical Texts of the Early Middle Ages*, Carnegie Institution of Washington Publication No. 364, Washington, D.C., 1927, based his English translation on Redeker's Latin text, his rendering (p. 71) is defective since any mention of the meninges is omitted. For Nicolaus's theory of the origination of the nerves, and a description of the posterior cell as the "thesaurus memoriae," see *Anatomia Nicolai* (Redeker), 38–39; and Corner, *Anatomical Texts*, 72.

[25] *Anatomia Nicolai* (Redeker) (as in note 24), 39–40; and Corner (as in note 24), 72–73.

[26] "Due enim miringe faciunt tres plicaturas inter se denexas in quibus tres sunt cellule, fantastica, logistica, et memoriam" (*Anatomia Richardi Salernitani*, in *Die medizinischen Handschriften der kgl. Universitätsbibliothek in Würzburg*, ed. I. Schwarz, Würzburg, 1907, 82).

[27] "Due igitur matres, que dicuntur miringe vel tele vulgariter, faciunt devexas [*sic*—we read 'denexas' from 'de' + 'necto'] tres plicaturas, quibus ad invicem tres mira nature arte discriminantur cellule (scilicet) anterior, posterior, et media" (*Anatomia magistri Ricardi*, in K. Sudhoff, "Der 'Micrologus' Text der 'Anatomia' Richards des Englanders," *Archiv für Geschichte der Medizin*, xix, 1927, 213–14, ll. 51ff.).

anatomy of the human brain and of its cells, not of brutes, because they are not believed to possess all the cells, because they do not have the middle one"[28] As early as the end of the twelfth century, then, the idea that mental activity was localized in the meninges had taken hold. During the thirteenth century, it became widely diffused through the works of the encyclopedists Bartholomew the Englishman and Vincent of Beauvais.[29] Once the meningeal localization of medieval thinkers is understood, it becomes possible to unlock the mystery of one of the most puzzling of medieval anatomical drawings.

In the early part of this century, scholars interpreted the diagram (Fig. 4) depicting the brain and eyes in the well-known thirteenth-century manuscript Ashmole ms. 399 of the Bodleian Library, Oxford, as follows:

> The cranial cavity itself is delimited by a striped covering running at an angle, which represents the epicraneum, craneum, dura and pia mater. Within it, or behind it, are indicated different rhombic brain cells; there are four of them, if we disregard the striped transverse ridge, which is probably supposed to indicate the region of the hind brain. As is shown by other illustrations of the Codex, the stripes bordered by simple lines were meant for legends, which are not entered on all figures and also not on our brain diagram. What is to be interpreted as the anterior ventricle, middle ventricle and posterior ventricle or as lateral ventricles cannot be determined from this illustration.[30]

With the help of these newly interpreted texts, and a fresh appreciation of their contexts, it is now possible to interpret this drawing differently and more fully. Our advantage over earlier scholars is that the diagram has been shown to comprise an intrinsic part of a medieval anatomical series formerly mistakenly termed the "Fünfbilderserie" (five-picture series). We know now that the illustrated anatomical manual is composed of not five but nine drawings, and that the brain-and-eye diagram is the final illustration in the nine-part series.[31] The only known copy of the manual preserved in its integrity has been found in a twelfth-century manuscript in Gonville and Caius College, Cambridge. Conveniently, unlike its Oxford counterpart, the Cambridge copy of the brain-and-eye diagram (Fig. 3) is furnished with captions, which permit us tentatively to identify at least two of the cerebral cells.[32] Beginning at the top of the sheet, we see at the ends of the striped bar two identical figures that form bisected diamonds: white triangles surmounting red ones. The caption written round the apex of the white triangle on the left seems to read "thesaurus cerebri"

[28] "[E]t nota quo hec est anatomia cerebri humani et cellularum eius, non brutorum, quia non creduntur omnes cellulas habere, quia nec mediam" (ibid., 217, ll. 150–53).

[29] Bartholomaeus Anglicus, *De rerum proprietatibus*, bk. V, chap. 3, Frankfurt, 1601, 125; reprint, Frankfurt, 1964 (same book, chapter, and page); *De rerum proprietatibus*, bk. V, chap. 3, trans. J. Trevisa, ed. M. C. Seymour, I, Oxford, 1975, 174, ll. 25–26; Vincent of Beauvais, *Speculum maius*, in the imprint entitled *Bibliotheca mundi, Speculum naturale*, bk. XXVIII, chap. 41, Douai, 1624, col. 2020.

[30] Sudhoff (as in note 16), 183.

[31] For the demonstration of this finding, see Y. Violé O'Neill, "The Fünfbilderserie—A Bridge to the Unknown," *Bulletin of the History of Medicine*, LI, 1977, 538–49.

[32] Gonville and Caius College, ms. 190/223, fol. 6r. A black and white reproduction of this drawing is in Clarke and Dewhurst (as in note 2), 40, fig. 60.

(treasure house of the brain), which closely resembles the term "thesaurus memoriae" Nicolaus used to designate the posterior cell. The red triangle bears a caption reading "the same," and this legend is then repeated twice, once on the white and once on the red half of the twin bisected diamond figure at the right end of the striped bar. Thus the diamond on the left seems to represent the posterior cell. But why are there two of these diamonds? Moving down the sheet, we see two blue diamonds placed between the striped bar and the chevron, separated by green struts that link the bar to the chevron. The legend written around the blue diamond on the right reads "cerebri habitatio et locus rationis" (the dwelling place of the brain and the place of reason). This rhombus clearly represents the middle cell. Again, however, it has a twin. Since the rhombi exist as mirror-images on each side of the diagram, it is as if they had been split in half. The large inverted chevron contains many captions, though some defy interpretation. The word "nervus" (nerve) appears repeatedly in the white border of the central red section. On the chevron's upper left side, a caption reads "nervus auditus" (auditory nerve). On its lower left side, another legend seems to read "nervus immobilis" (immobile nerve). The long white strips reaching to the eyes read "nervus apticus [or opticus]" (open [or optic] nerve). While we cannot attempt to solve all the problems posed by this intriguing diagram, we are able now to suggest a general explanation using our knowledge that a meningeal localization doctrine was held by contemporaries of the artist.

Let us imagine, as perhaps the artist did, a brain dissection performed like the one illustrated in the fourteenth-century work of Guido da Vigevano.[33] Starting at the crown of the head, as all anatomists did until Varolio in 1573,[34] the cranium is cut along its circumference and removed. The dura mater is sectioned both from ear to ear and from the center of the forehead to the back of the head and retracted, a procedure similar to those depicted in the dissection sequences published by Johannes Dryander (Eichmann) of Marburg and Walther Ryff of Strasbourg in the first half of the sixteenth century (Fig. 5).[35] The so-called pia mater would be similarly bisected and partially retracted. Our artist may have conceptualized the cerebral cells folded in the meninges and positioned along the head's median plane just as Leonardo depicted them in 1490,[36] but unlike Leonardo this artist imagined the cells not as spheres, but as polyhedrons, as they are drawn into a sketch dating from 1441 now in the

[33] A. M. Cetto, "Anatomical Dissection in Pictorial Representation," *Ciba Symposium* (Basel), v, 1957, 126, provides a precedent for this procedure. Discussing the Guido da Vigevano illustration, she suggested "the artist prefers to present a picture which seems to say: 'Imagine you have a man before you. At the point I am showing you, anatomists open up the skull of dead persons, using the same instruments as I show here.'"

[34] Clarke and Dewhurst (as in note 2), 64.

[35] Johannes Dryander (Eichmann), *Anatomia capitis humani*, Marburg, 1536, and *Anatomia hoc est corporis humani dissectionis pars prior*, Marburg, 1537; and Walther Ryff, *Omnium humani corporis partium descriptio*, Strasbourg, 1541. Modern discussions of this dissection technique are C. Singer, "Brain Dissection before Vesalius," *Journal of the History of Medicine*, xi, 1956, 261–74; and W. C. Hanigan, W. Ragen, and R. Foster, "Dryander of Marburg and the First Textbook of Neuroanatomy," *Neurosurgery*, xxvi, 1990, 489–98. Charles Singer maintained that this technique of anatomization of the brain was known in Paris by 1517. It would seem that the origins of this technique are much older than Singer imagined.

[36] See Leonardo's sketch of the open cranium as seen from above as reproduced in C. D. O'Malley and J. B. de C. M. Saunders, *Leonardo da Vinci on the Human Body*, New York, 1952, no. 142, 330–31, fig. 6; and Clarke and Dewhurst (as in note 2), 32, fig. 43.

Hof- und Staatsbibliothek in Munich.[37] Observation of the unossified spots in the cranium of a young infant could have served as empirical models for the shapes of the cerebral cells. In the skull of a human newborn, the anterior fontanelle roughly forms a rhomboid, while the posterior, the mastoid, and even Gerdy's fontanelle, which occasionally occurs in infants, can be described as roughly triangular in shape (Fig. 6).[38]

With our information about fourteenth-century cranial dissection and the doctrine that placed the cells in the meninges and positioned them at the crown of the head, some of the Cambridge diagram's eccentricities become explicable (see Fig. 3). Let us suppose that the posterior cell was enfolded in the dura mater and positioned at the head's vertex. During our hypothetical dissection, it would be split twice by the two sectionings, and, with the retraction of the dura mater, it would lie in four quarters at the dura's extremities, as the artist was attempting to show in our diagram. If the middle cell is imagined as positioned a bit forward along the forehead-to-occiput line, it would also be bisected—though only once—by this sagittal cut, and its two halves would appear as the rhomboids that lie outside the two green bands, the latter representing the two connections between the meninges Nicolaus described in the account cited above. Nicolaus told us also that the nerves of sensation originate in the pia mater. Since the captions on the borders of the red chevron refer exclusively to sensory nerves, we may conclude that the chevron represents the pia mater and that the triangles at its extremities are the anterior cell bisected once again by the sagittal cut.

An English drawing of 1410 (Fig. 7) shows the cranium and its underlying cerebral membranes reversed. Why? We believe that, like the artist responsible for the Cambridge diagram some three centuries earlier, the artist imagined a dissection with the skull opened and the meninges retracted. Geometric figures containing the mental faculties are arranged along the head's median plane. The chambers of fantasy and memory are depicted as rhomboids; those of cognition and judgment as circles; and imagination is localized in a rectangle. An accompanying caption recapitulates the qualities similar to those that William of Conches associated with the cognitive process: "the forthyr parte of ye brayn is hoot and drye the medyl parte hoot and moyste, and hyndryr parte colde and moyste"[39]

By this mutual clarification of neglected twelfth-century texts and misinterpreted medical iconography, I contend that we can establish the existence of a previously unrecognized medieval doctrine of meningeal localization of the mind's faculties, which placed imagination, reason, and memory not in the modern ventricles under the cerebrum, but in the folds of the membranes that cradle the brain matter. Thus Holofernes, the absurdly pedantic schoolmaster in Shakespeare's *Love's Labour Lost*, echoed, probably unknowingly, this meningeal localization doctrine when he explained that his ridiculously bookish bilingual puns were

[37] Munich, Hof- und Staatsbibliothek, Cod. Lat. 5961, as reproduced in Clarke and Dewhurst (as in note 2), 22, fig. 25.

[38] The shapes of the fontanelles in the skulls of neonates are clearly illustrated in E. Permkopf, *Atlas of Topographical and Applied Human Anatomy*, I, Philadelphia and London, 1963, 21, figs. 19 and 20; and F. H. Netter, *The Ciba Collection of Medical Illustrations*, I, pt. 1, West Caldwell, N. J., 1983, 10, pl. 8.

[39] Cambridge, Trinity College, MS. 1144 (0.2.40), fol. 57v, as cited by Clarke and Dewhurst (as in note 2), 21, fig. 24, and 46, n. 34.

"begot in the ventricle of memory, nourished in the womb of the pia mater and delivered upon the mellowing of occasion."[40] I hope this also somewhat bookish account has nourished ideas in the womb of the reader's pia mater and whetted his or her appetite to decode the mysteries of medieval medical images.

[40] *Love's Labour Lost*, act 4, sc. 2, line 62.

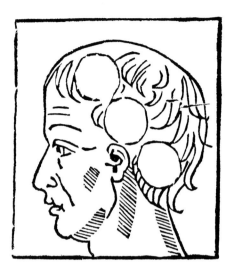

Tractatus de Fractura Calue fiue
Cranei a Carpo editus.

1. Diagram of the head with the sites of imagination, reason and memory, from Jacopo Berengario da Carpi, *Tractatus de fractura calve, sive cranei a Carpo editus*, Bologna, 1518, leaf 1

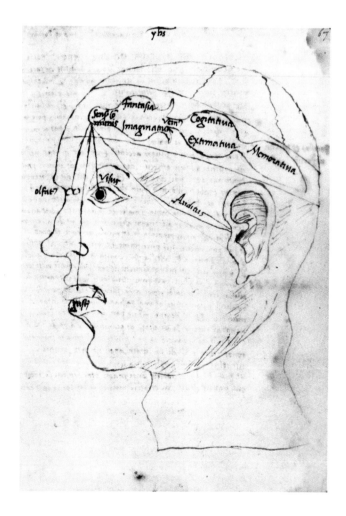

2. Cellular brain diagram. Boston, Countway Library, uncatalogued MS. [Miscellany, Mostly Religious], Italy, bound ca. 1490–1520 (photo: Richard Wolfe, Boston Medical Library)

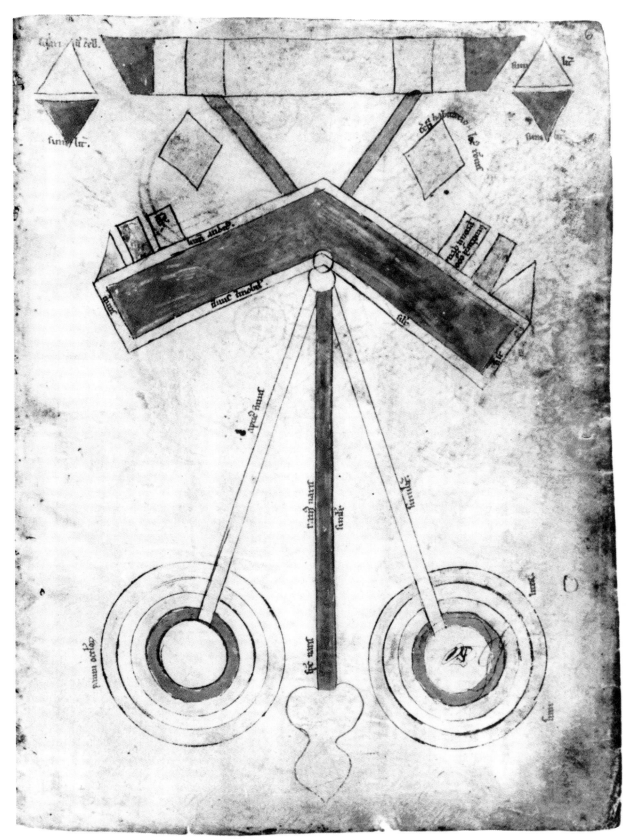

3. Diagram of the brain, twelfth century. Cambridge, Gonville and Caius College, MS. 190/223, fol. 6r (photo: courtesy of the Master and Fellows of Gonville and Caius College)

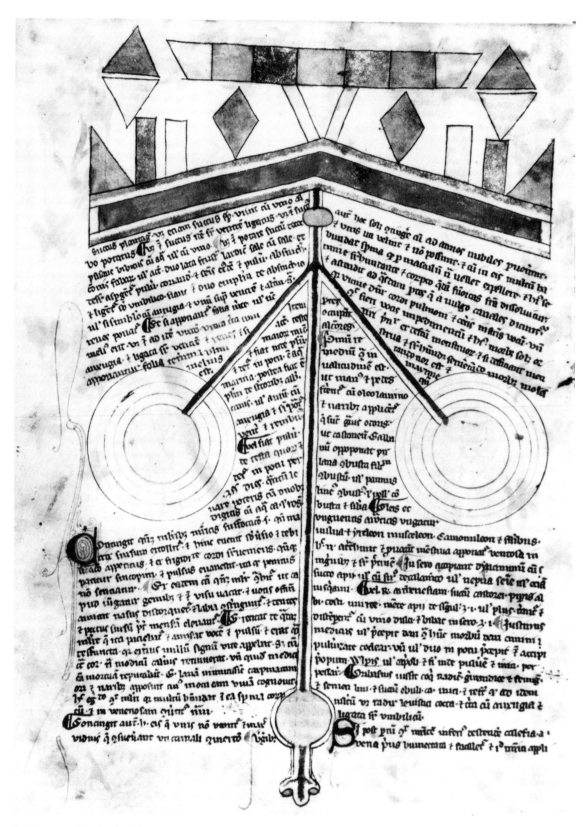

4. Diagram of the brain, thirteenth century. Oxford, Bodleian Library, MS. Ashmole 399, fol. 22v (photo: Bodleian Library)

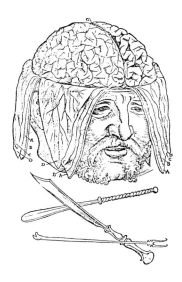

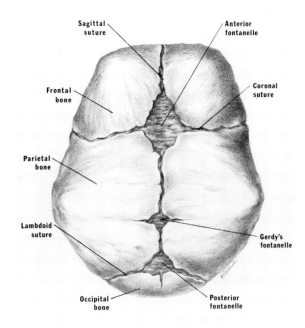

5. (top left) Dissection sequence, from Walther Ryff,
Omnium humani corporis partium descriptio, Strasbourg,
1541, leaf 14

6. (top right) Skull of a human newborn (redrawn by
Erica Himmel from illustrations in E. Permkopf, *Atlas of
Topographical and Applied Human Anatomy*, I,
Philadelphia and London, 1963, fig. 20; and F. H. Netter,
The Ciba Collection of Medical Illustrations, I, part 1,
West Caldwell, N.J., 1983, pl. 8)

7. (right) Cranium and underlying cerebral membranes,
1410, drawing. Cambridge, Trinity College, MS. O.2.40,
fol. 57v (photo: courtesy of the Master and Fellows of
Trinity College)

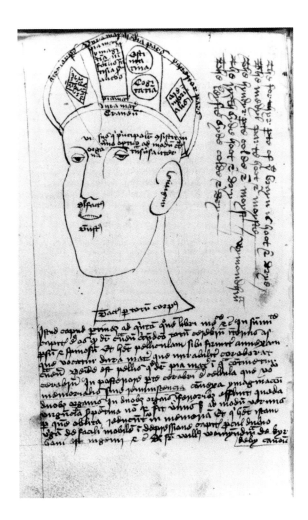

Gendering Jesus Crucified

•

RICHARD C. TREXLER

> We are more moved by seeing Christ hanging on
> the cross than by reading that he was crucified.[1]

UNLIKE the reproductive organs of many other divinities, the penis and testicles of
Jesus Christ have only recently been suspected of having much meaning. That is true
even in the context of the Crucifixion, where the very fact that Jesus hung naked before the
crowd capped his humiliation. Perhaps there's the rub. Whereas historically the actual im-
portance of the divine genitalia lay in their perception by those who gazed upon or thought
about them, in our time penile significance is looked for, if at all, away from that madding
crowd of devotees and ridiculers. Repeated calls in the last generation to pay attention to
historical peoples' responses to devotional images have largely fallen on deaf ears.[2] I believe
that the primary meanings of devotional objects, whether of flesh and blood or artificial, are
those that move people to devotion and, in the contemplative regimes of traditional Chris-
tianity, to tears.[3]

Historians of course are often ready to tell us what "people" thought (not did), but on
examination, these thoughts often turn out to be little more than the historians' own, pro-
jected back onto past intellectuals and thence according to the trickle-down theory, unto sim-
ple folk. Thus in his pathfinding *Sexuality of Christ*, Leo Steinberg laudably unveiled Jesus'
penis for serious study, but then indicated that these genitalia did not *affect* medieval and

[1] Johannes Molanus, cited in D. Freedberg, "Johannes Molanus on Provocative Paintings. *De Historia Sanctarum
imaginum et picturarum*, Book II, Chapter 42," *Journal of the Warburg and Courtauld Institutes*, xxxiv, 1971, 234. My
thanks to Caroline Bynum Walker, James A. Boon, William A. Christian, Jr., Klaus Schreiner, and Jean Wirth for their
input on this subject, and Lyn Blanchfield for reading a draft.

[2] D. Freedberg, *The Power of Images. Studies in the History and Theory of Response*, Chicago, 1989; and M. Camille,
The Gothic Idol: Ideology and Image-making in Medieval Art, Cambridge, 1989, are recent exceptions. See also R. Trexler,
"Florentine Religious Experience: the Sacred Image," in *Church and Community, 1200–1600. Studies in the History of
Florence and New Spain*, Rome, 1987, 37–74; and W. Christian, Jr., *Moving Crucifixes in Modern Spain*, Princeton, 1992.

[3] It follows that a "devotional object" is one to which we pray, at the time we do, irrespective of the artist's original intent.
On contemplative regimes, see J. H. Marrow, *Passion Iconography in Northern European Art of the Late Middle Ages and
Early Renaissance. A Study of the Transformation of Sacred Metaphor into Descriptive Narrative*, Kortrijk, 1979;
W. Christian, Jr., "Provoked Religious Weeping in Early Modern Spain," in *Religious Organization and Religious Expe-
rience*, ed. J. Davis, London, 1982, 97–114. One man's contemplation of Jesus' body parts, though not including his genita-
lia, is in R. Trexler, "In Search of Father. The Experience of Abandonment in the Recollections of Giovanni di Pagolo Mo-
relli," *History of Childhood Quarterly*, iii, 1975, 225–52.

Renaissance painters: the latter *only thought* of them as a sign of Jesus' humanity.[4] In her equally important *Holy Feast and Holy Fast*, and especially in her review of Steinberg's *Sexuality*, Caroline Bynum, in this at one with Steinberg, warned that medieval people did not assign sexual meanings to things as do we moderns: the Christic penis, for example, referred to Jesus' circumcision rather than being a sexual object.[5] Jean Wirth capped off this assignment of potential genital sensualities to the fleshless spheres by claiming that the Middle Ages considered (male *and* female?) generative organs to be "ridiculous and ugly."[6] So away with those legions of Boccaccesque men and women who, on reaching their erotic goal, are known to have cried *Che bella*! Obviously, historians are still far from considering audience reactions to cultural artifacts as an integral part of their meaning. And as regards the Christian divinities' sexuality, the task of integrating viewers has scarcely begun.

In this paper I shall concentrate on how certain thinkers assumed that devotees, in the *imitatio* of Christ's Passion, responded to seeing or sensing his genitalia. I shall argue that not completely unlike other gods, Jesus, whether in his image or in the vision made of him in imitation, might physically seduce his devotees and even those who ridiculed him. The goal of maintaining decorum in the presence of such representations was, therefore, important to moralists and, I shall argue, their opposition to representing Jesus naked had broad political and social roots.

On the basis of contemporary moralists' evidence, how *did* people in traditional Europe react to Jesus on the Cross? And how did they imagine people would act if they saw him naked, as the Bible said he had been—to the discomfort of all those who wished to cover him? Let it first be said that Jesus' whole crucified body was conventionally perceived by medieval men as a volume to be penetrated by audience. Thus in a dream Rupert von Deutz (d. 1129/30) envisioned himself French-kissing the crucified Jesus;[7] Peter of Blois (d. 1200) opined that Jesus' side wound, or "corporal opening", allowed one to peer in at the divine entrails; and Battista Varani (1458–1527) actually wanted to "enter the vase itself" so as to locate the Christic heart.[8] The women did not lag behind: they in fact led in the development of the cult of the externalized (fetched from the inside) Sacred Heart and the devotional theme of exchanging hearts with Jesus through such corporal intrusiveness.[9] Long before modern psychoanalytic insights, the genital implications of such penetrations were clear among late

[4] L. Steinberg, *The Sexuality of Christ in Renaissance Art and in Modern Oblivion*, New York, 1983.

[5] C. Walker Bynum, *Holy Feast and Holy Fast*, Berkeley, 1987, and especially the concluding section of "The Body of Christ in the Later Middle Ages: A Reply to Leo Steinberg," *Renaissance Quarterly*, XXXIX, 1986, 399–439.

[6] J. Wirth, "Sur l'évolution du crucifix à la fin du Moyen Age," *Les ateliers des interprètes. Revue européene pour étudiants en histoire de l'art*, II, 1989, 177; see also his *L'Image médiévale*, Paris, 1989.

[7] "Quod cum festinus introissem, apprehendi quem diligit anima mea, tenui illum, amplexatus sum eum, diutius exosculatus sum eum. Sensi quam gratanter hunc gestum dilectionis admitteret, cum inter osculandum suum ipse os aperiret, ut profundius oscularer" (Rupert von Deutz, *De gloria et honore filii hominis super Mattheum*, ed. H. Haacke, *Corpus Christianorum. Continuatio Mediaevalis* 29, Turnhout, 1979, 383).

[8] Cited in Wirth, *Image* (as in note 6), 323; see also Wirth's "La naissance de Jésus dans le coeur: étude iconographique," *Publications du Centre européen d'études bourguignonnes (XIVᵉ–XVIᵉ s.)*, XXIX, 1989, 149–58.

[9] M. Carroll has studied the erotic roots of the cult of the Sacred Heart, *Catholic Cults and Devotions. A Psychological Inquiry*, Kingston, 1989, 138–43; also A. Vauchez, *Le sainteté en occident aux derniers siècles du Moyen Age d'après les procès de canonisation et les documents hagiographiques*, Rome, 1981, 517–18.

fifteenth-century German printmakers, who might, for instance, provocatively place the cru-
cified Jesus' pierced, externalized heart over the space where his genitals belonged.[10]

Few can ignore the massive evidence of medieval and early modern women's erotic
involvement with the body of Christ—medieval Swabian women claimed they had had sex
with Jesus or had brought themselves to orgasm with his body;[11] the Englishwoman Mar-
gery Kempe (1373–ca. 1439) saw dangling genitals before her when faced with the Host;[12]
Alexander Pope's Heloise (ca. 1715) had an orgasm on seeing the erect Abelard in place of
the Jesus hanging before her.[13] Yet the crucifix was not always merely male, nor was its
manipulation purely imaginary. A second fundamental element of late medieval and early
modern interaction with crucifixes is evidence that devotees might manipulate the male gen-
der of crucifixes—the opposite, say, of women taking on the male bodily features of Jesus
through contemplating him on the Cross.[14]

One sign of this process of gender manipulation, which appears interesting enough in
itself, was that the wound in Jesus' side often came to look more and more like a vagina.[15]
But more important to this paper is evidence that to devotional ends, male images were
rendered effeminate, or even female. It is well known that Sebastian and John the Evangelist
took on strongly androgynous features in the late Middle Ages, but it is less familiar that
certainly by the fifteenth century, and as cult required, Jesus Crucified in parts of northern
Europe was changed into and clothed as the female transvestite Saint Wilgeforte (also called
Kümmernis) and then changed back again to Jesus.[16] By the end of the sixteenth century,
and continuing until the present day, Spaniards and Latin Americans have sometimes
adorned the male Jesus on the Cross with what we today call slips. This regendering deserves
our attention.[17]

[10] Wirth, *Image* (as in note 6), 323.

[11] H. Grundmann, *Religiöse Bewegungen im Mittelalter*, Berlin, 1935, 412–14.

[12] *The Book of Margery Kempe*, London, 1985, chaps. 35, 59, 79; see the suggestive article by S. Beckwith, "A Very
Material Mysticism: The Medieval Mysticism of Margery Kempe," in *Medieval Literature. Criticism, Ideology and
History*, ed. D. Aers, Brighton, 1986, 34–57.

[13] Although he had been castrated! See the marvelous verse cited by G. Wills, "The Phallic Pulpit," *New York Review of
Books*, 21 December 1989, 21–22.

[14] As suggested by Beckwith (as in note 12); her evidence is from A. Vauchez (as in note 9), 517–18. See also C. Bynum's
documentation of twelfth-century abbots calling themselves mothers, which she traces to larger gender conventions in the
period's social relations, *Jesus as Mother*, Berkeley, 1982, 135–46.

[15] Most striking in the breviary of Bonne of Luxemburg, reproduced in Wirth, *Image* (as in note 6), 329.

[16] G. Schnürer documented three eighteenth- and nineteenth-century cases in small Swiss villages where statues went
from male to female, "Die Kümmernis- und Volto santo-Bilder in der Schweiz," *Freiburger Geschichtsblätter*, x, 1903,
112f., 125f., 149; and the standard work of G. Schnürer and J. Ritz, *Sankt Kümmernis und Volto Santo*, Düsseldorf, 1934,
with excellent illustrations. But the practice was doubtless common in the late Middle Ages for Wilgeforte, as it was for
other worthies, for which, see R. Trexler, "Habiller et déshabiller les images: esquisse d'une analyse," in *L'Image et la
production du sacré*, ed. F. Dunand, J.-M. Speiser, and J. Wirth, Paris, 1991, 195–231.

[17] The role of the different sexes in fashioning Jesus in this way remains to be determined. One of the oldest such loin-
cloths or "slip-perizoniums", from late sixteenth- or seventeenth-century Mallorca, is shown in G. Llompart, *Religiosidad
popular. Folklore der Mallorca, Folklore de Europa*, Palma de Mallorca, 1982, 190. In a personal communication, William
Christian suggested that post-Tridentine insistence on Crucifix-worship to the detriment of Mary-worship may help ex-
plain the Crucified's taking on such female characteristics. See further below, note 68.

Jesus' body thus was more than a vehicle for expressing female as well as male gender qualities, as Bynum rightly insisted in her critique of Steinberg's exclusive emphasis on the salvific penis;[18] crucifixes might be manipulated to represent the one or the other sex. In her study of certain Hindu devotions, Wendy Doniger showed that the object of prayer always has to be heterosexually gendered in relation to the sex of the orant, at times switching gender to facilitate that relation.[19] Here is something to examine for the comprehension of Christian devotion as well: at the very least, the gender relation between orant and object needs to be considered as a fundamental factor of worship, rather than ignored, as if to say that the Crucified, this fetish of a decisively patriarchal ecclesiastical structure, stands in no such gender relation to his supplicant.

These two facts—that Jesus was experienced as a volume to be penetrated, and that his crucifix could be physically manipulated to change gender or even sex—attain their full meaning only when we know something about the devotees and, perhaps most fundamentally, their sex. If we wish to evaluate the change in the Crucified from clothed to bare-chested,[20] or in the late Middle Ages toward transparent loincloths or perizoniums with no signs of male genitalia (hardly a genderless representation!),[21] or in the Italian Renaissance to the increasingly creamy flesh of the crucified Jesus, we must know what role devotees of each sex played in them. The same applies, finally, to our particular interest here—to the genitalia of the man/god.

Around the year 1500, scholars, even from the pulpit, raised the question whether Jesus' penis had been visible while he hung on the Cross. The counterreaction was predictable: moralists asserted that such things should not be discussed, especially in the presence of women, whose so-called shame was pleaded.[22] This leads me to ask if women's reactions were also used *to justify* opposition to *pictures* of Jesus crucified. My evidence encourages me to answer in the negative. Over the course of Christian history, mostly only males' reactions to an eventually palpable Christic penis are found to be worthy of analysis. In male discourse, the male's fear of the sight of a naked Jesus explains why, in all of Christian art, Jesus was rarely shown naked.[23] I now wish to describe this fear, but I also wish to defend the hypothesis that, in fact, the authorities were concerned about both male and female reactions to the naked Christic penis, worrying that, at its sight, certain women and men would be tempted to escape the control of their masters.

[18] Bynum, "Body of Christ" (as in note 5).

[19] W. Doniger O'Flaherty, *Women, Androgynes, and Other Mythical Beasts*, Chicago, 1980, 87–93.

[20] Best traced by P. Thoby, *Le Crucifix des origines au Concile de Trente*, Nantes, 1959.

[21] This is the subject of Wirth's "Sur l'évolution" (as in note 6). The author argues that Jesus without genitalia was understood by average people as a statement about an ideal, virginal clergy.

[22] In 1499 this was Wimpfeling's and Nicholas Besler's opinion, G. Knod, "Jacob Wimpfeling und Daniel Zanckenried. Ein Streit über die Passion Christi," *Archiv für Literaturgeschichte*, XIV, 1886, 5–8. It was also Johannes von Paltz's view in his 1502 *Coelifodina* (Erfurt) as it had been that of his teacher Johannes von Dorsten; see Paltz, *Werke*, I, Berlin, 1983, 51–53. My thanks to Craig Harbison and Klaus Schreiner for help in this area.

[23] The only medieval Crucifixion I have found with a penis clearly visible (through a transparent perizonium) is part of the *Sendlinger Altarpiece* (1407), once in the Frauenkirche in Munich; the painting is today in the diocesan museum in Freising. Clement of Alexandria early objected to showing erections in paintings; cited in Freedberg (as in note 1), 245.

One of the earliest and most influential studies of nakedness in the Christian era was undertaken by Augustine of Hippo in his *City of God* where he explained the corporeal impact upon Adam (not Eve) of the Fall. On viewing Eve, Augustine indicated, Adam had an involuntary erection. To Augustine's mind, we have here a fundamental characteristic of postlapsarian males: on being stimulated by desirable objects of either sex, their penises become erect, or remain flaccid, independent of their wishes. The penis does not obey reason, will, or the collective sense of propriety. Moreover, because males are ashamed that the penis disobeys, even the most barbaric among them put on clothes to conceal involuntary erections or flaccidity.[24] Thus shame comes after and not before penile behavior; it is an effect and not a cause. It need hardly be pointed out that Augustine failed to praise women for not showing corporeal signs of sensate disobedience. It is as if, missing an apposite, visible body part, women do not respond to sensual stimuli.

Generally speaking, traditional Europeans followed the Bible in assuming that Jesus was hung naked on the Cross—"that horrific nakedness of the shamed," Jacob Wimpfeling called it—so as to humiliate decisively a male too weak to resist such treatment.[25] Why then was he practically never represented in that state? This question is the more important for any Christian theory of devotion because a covered Jesus, not being fully humiliated, obviously derailed devotees' *imitatio Christi*. No encyclopedic survey of medieval tractates' discussions of sexual matters exists, but on the evidence of Augustine, one hypothesis explaining Christianity's historic unwillingness to show not only naked females, but naked adult males, especially Jesus on the Cross, is that male viewers might have had an erection, as Pope's Heloise had an orgasm, if they saw the salvific genitalia: a loincloth reduced the likelihood of this happening. A church based on that icon did not wish to have its faithful interacting sexually, if necrophilically, with a naked image, a danger represented by the Rohan Master (ca. 1420–1430), who showed the Crucified ejaculating blood, while opposite, two lovers engage (Fig. 1). In short, a Jesus covered at the crotch might help prevent the seduction of the faithful.[26]

There were other ways to mitigate the threat of seduction. One way to prevent images from arousing viewers during the Middle Ages—those of the androgyne Saint Sebastian, for

[24] On "illa qua obscenae partes corporis excitantur" and "quidam barbari," see Augustine of Hippo, *The City of God Against the Pagans*, IV, Cambridge, Mass., 1966, bk. XIV, chaps. 16, 17. See also P. Brown, *The Body and Society*, New York, 1988, 416–17; G. Wills (as in note 13); and U. Ranke-Heinemann, *Eunuchs for the Kingdom of Heaven. Women, Sexuality and the Catholic Church*, New York, 1990, 90–93.

[25] The fourteenth-century Ps.-Bonaventure was especially graphic in making this point. Thus on the way to Crucifixion, among a whole list of humiliations, "gli hanno tolto il mantello e legata alta la tunica ai fianchi, senza alcun rispetto," *Anonimo francescano del '300. Meditazioni sulla vita di Cristo*, Rome, 1982, 127–28 (chap. 75). For "illa horrenda nuditas verendorum," see Knod (as in note 22), 5. To the Crucifixion may be added the story of the naked Jesus' flagellation: significantly, its Old Testamental complement or type was Job being ridiculed and beaten up by his wife; see, for example, the complementary pictures in *Heilsspiegel. Die Bilder des mittelalterlichen Erbauungsbuches Speculum humanae salvationis*, ed. H. Appuhn, Dortmund, 1981, 42–43.

[26] The Rohan Master presumably meant to refer to Jesus' circumcision, but, in fact, the painting looks like the result of a castration, which is what the Israelite Phinehas, after having speared the pair's genitalia, inflicts on the lovers; *The Rohan Master. A Book of Hours*, ed. M. Thomas, New York, 1973, pl. 127; and A. Edwardes, *Erotica Judaica. A Sexual History of the Jews*, New York, 1967, 17f.

example—was to show their flesh mutilated.[27] That was a tall order, since Jesus, still in the prime of life, had a "beau corps bien formé," as one Roman soldier in a sixteenth-century play observed on seeing Jesus in the buff. Though little is known in particular about medieval imaginings regarding the condition of Jesus' genitals, the body as a whole was considered perfect in every respect, white and lithe, in short, ultimately seductive.[28]

Representing the bare-chested Jesus in the mutilated state of the Passion, while rendering him sensually undesirable to the hardened contemplative, could not hide what could be expected of any male on the point of expiring on a cross: an erection, followed by an ejaculation. This embarrassingly public and uncontrollable *motus corporis* might be anticipated to stimulate male viewers to an erection.[29] Neither was the power of Jesus' agonized ejaculation totally ignored in the Middle Ages. According to Duerr, the first crop of henbane, the poisonous herb favored for medieval witches' ointment, was held to have sprung up where the divine semen had fallen.[30] Again, a loincloth concealed such activity.

The fear of such a thanatologic erection may explain why medieval stories recounted that on the Cross, Jesus covered his genitals with his right hand until it was nailed to the wood, then with his left hand, so it may explain why in many *pietàs* his corpse is shown with his rigid hands over his genitalia.[31] Fear of a visible erection—and no vague reference to an otherwise ill-defined "shame"—may also lie behind at least three different legends—the Ps.-Anselm, a Revelation of Bridget of Sweden, and the *Meditations* of the so-called Ps.-Bonaventure—to the effect that either Jesus covered his genitalia himself, or Mary or the Magdalen did so with a veil after seeing him hanging naked.[32]

[27] For a case where a Saint Sebastian by Fra Bartolomeo was removed because it excited nuns, see Freedberg (as in note 2), 346; and *Le opere di Giorgio Vasari*, ed. G. Milanesi, Florence, 1906, IV, 188. Ordered to create a Virgin Mary that would not be alluring, Toto del Nunziata, in good Wilgefortian manner, put a beard on her: Vasari-Milanesi, VI, 536 and Freedberg (as in note 2), 322, and, in general, his chap. 14; also Wills (as in note 13), 22.

[28] The play line is from J.-C. Bologne, *Histoire de la Pudeur*, Paris, 1986, 224. Statements about the quality of Jesus' body occur regularly in devotional literature. The Ps.-Anselm called it "delicata enim et naturalis ingenuitas et formosa membrorum principalium," *Dialogus beatae Mariae et Anselmi de passione domini*, PL 159, Paris, 1854, 279–80. A medieval English nun spoke of "his beauty, loving face, and white flesh beneath his clothes," cited in H. P. Duerr, *Traumzeit. Über die Grenze zwischen Wildnis und Zivilisation*, Frankfurt am Main, 1985, 312–13. Margery Kempe: "the handsomest man that ever might be seen or imagined," *Book*, 249 (chap. 85). Ps.-Bonaventure: "nudo di fronte a tutti, giovane dal corpor armonioso e riservato, lui, il più bello degli uomini"; *Anonimo francescano* (as in note 25), 132 (chap. 78). Brunelleschi is said to have criticized Donatello's crucifix: "che egli avesse messo in croce un contadino, e non un corpore simile a Gesù Cristo, il quale fu delicatissimo [!] ed in tutte le parti il più perfetto uomo che nascesse giammai," Vasari-Milanesi (as in note 27), II, 398. Wirth brought together some hints in literature and art that Jesus' penis was thought of as modest in size; Wirth (as in note 6), 169, 170, 173. But the whole subject of Jesus' body needs serious study.

[29] Steinberg (as in note 4), illustrates dead Jesuses or Men of Sorrows with erections. Describing the phenomenon, H. P. Duerr said the shame of long erections (up to seventeen hours!) was the reason men were "never" hung naked. He cited a German case of 1547 in which a hangman castrated a corpse so no one would see his genitalia, *Nacktheit und Scham*, Frankfurt am Main, 1988, 270–72.

[30] On this *Bilsenkraut*, see Duerr (as in note 29), 271, who does not document his statement.

[31] S. Axters, *Geschiedenis van de Vroomheid in de Nederlanden*, Antwerp, 1960, IV, 264–65. Note that such actions presume a naked Crucifixion, not one with a perizonium. On Julius Caesar doing the same before falling from Brutus's thrust, see J. Döpler, *Theatri poenarum suppliciorum et executionum criminalium, oder Schauplatzes der Leibes- und Lebenstrafen*, Sondershausen, 1693, 1047.

[32] For Ps.-Anselm, see the *Dialogus beatae Mariae* (as in note 28), 282, and Bologne (as in note 28), 282; for Bridget, see P. Fehl, "The Naked Christ in Santa Maria Novella in Florence: Reflections on an Exhibition and the Consequences,"

In Augustine's age, as now, people presumably used images for sexual gratification; demonstrable evidence remains to be discovered that medieval males had intercourse with representations of Jesus, but it will probably turn up in judicial sentences of those who insulted Jesus on the Cross.[33] The conviction that males can seduce other males—and this political formulation inevitably becomes part of our discourse—remains strong a thousand years after the church father. Directing himself exactly to the problem of the *imitatio Christi*, Jacob Wimpfeling in the first years of the sixteenth century blared: "In order to stimulate feelings, it is not necessary that hanging on the Cross, Christ naked all over without a covering expose the most abstruse and secret parts of his body for human eyes to see."[34] A half century later, alarm that the tortured adult Jesus might actually face Christians "as naked as the day he was born" emerges in Giovanni Andrea Gilio da Fabriano's *Degli errori de' pittori circa l'istorie* (1563).

Gilio maintained, in part because Christians needed to gaze upon and contemplate holy persons so as to imitate their lives, that sacred figures should as a rule be shown in their physical condition at the time of the events represented.[35] That is, the viewing of actual history, including the brutality of Jesus' Passion, would produce pious sentiment. Thus Gilio would have approved of Grünewald's *Isenheim Altarpiece*'s Crucifixion, with its body replete with wounds and scars: from scenes of extreme cruelty could be "learned just how acerbic was the pain, the jokes, the afflictions" suffered by the martyrs.[36]

Gilio's general rule did not, however, extend to showing male genitalia. He limited his previous generalization by stating: "But I will say that some fictions have been invented for reasons of decency which are praiseworthy, and they ought not in any way be abandoned. These are to cover the shamed part of sacred figures with some nice cloth."[37] Now, as an interlocutor in Gilio's dialogue points out, while the Bible says that on the last day everyone will arise *tutti nudi*, this does not mean that artists should represent people in this way. Gilio was not bothered: "I praise the fiction," he proclaimed;[38] historical accuracy extends to everything but nakedness, he insisted. In their imitations of Christ, therefore, people like Margery Kempe would have to do without visual aids and "use the imagination," as the Ps.-Bonaventure recommended. They would have to summon up the naked Jesus on their own, which,

Storia dell'arte, XLV, 1982, 163; and M. Brisson, "An Unpublished Detail of the Iconography of the Passion in *Le Chastel Perrileux*," *Journal of the Warburg and Courtauld Institutes*, XXX, 1967, 398; for Ps.-Bonaventure, see *Anonimo francescano* (as in note 25), 135 (chap. 79), and Steinberg (as in note 4), 31–32.

[33] For the Testard accusation against the marquis de Sade to this effect, see *Der Spiegel*, 4 June 1990, 199.

[34] Knod (as in note 22), 9.

[35] Giovanni Andrea Gilio da Fabriano, *Degli errori de' pittori circa l'istorie*, in *Trattati d'arte del cinquecento*, II, Bari, 1961, 31–32.

[36] Ibid., 40. I am not suggesting that Grünewald's terribly mutilated Christ could not itself provide a sadomasochistic pleasure. Thus Netherlandish accounts feature Christ being burned in the loins and private parts, while people delight in bursting the blisters that form there, Marrow (as in note 3), 118.

[37] "Ma ben dirò che sono state trovate alcune finzioni per cagione de l'onestà le quali sono lodevoli, e queste lasciare in verun modo non si deono. E queste sono il celare con qualche bel garbo le parti vergognose de le sacre figure," Gilio (as in note 35), 77.

[38] Ibid., 78.

Gilio assured us indirectly, would take little enough imagination: "It seems to me that there is no great secret of nature or art in those few shameful parts."[39]

The reasons Gilio gave for his antinakedness rule are varied. Of course, shame and decency forbid nakedness: "rather than deriving pleasure from [Michelangelo's naked works, for example] the majority of viewers are outraged."[40] But being aware of Augustine's psychology—that male shame originates in a body motion, and not vice versa—we may suspect that such cries of shame are used to neutralize references to such a *motus corporis*, of which more below. Gilio also protested that the persons represented, who might be too ashamed even to look at their own genitalia, would be offended by others looking at them. "If we bear that reverence for saints whose sanctity stems from thus abhorring," why then would painters violate those saints' own wishes, Gilio asks.[41]

Gilio further argued that nakedness is in conflict with Church power. Thus figures of Jesus should never be naked, "whether they be of his childhood, baptism, flagellation, crucifixion, resurrection or whatever";[42] if holy figures are shown naked, the "purity, chastity, and reverence" of religion, which make up the force that engenders decorum and devotion among the people, would be lost. Not surprisingly, Gilio equated "religion" with the Christian Church, and the covered Christ as standing for it.[43] He implied that a naked Christ would indicate that the Church was impure, and encourage people to be indecorous toward it. The inherent conflict between history—Jesus' nakedness—and Christian order comes to the fore, and the latter wins. The fear that devotees might be moved to individual "indecent" acts by the state of the image is supplanted by the fear that social groups might attack an undressed Church. Again, the question of Christ's nakedness reveals itself to be in part a discourse about political power, this time the Church's.

Political fears of this type reached their natural conclusion in the thought of the northerner Johannes Molanus, a contemporary of Gilio. "Christ *was* crucified naked," he volunteered, "but I think it is pious to *believe* that his shameful organs were [then] veiled for decency."[44] Here the plot thickens: Christians are inhibited from the *imitatio* and *contemplatio Christi* not because their faces redden at nakedness but because that redness appears epiphenomenal, and related to a more fundamental concern for social order. Christians are actually in a better state of grace if they believe the inverse of biblical fact: that Jesus' humiliation was not, after all, as complete as it might seem to have been.

A final reason Gilio gave for covering Jesus takes us back to Augustine, to the danger of an audience *motus corporis* in reaction to such nakedness. For instance, by suppressing

[39] See this Gilio text (as in note 46). "Metti in moto l'immaginazione, e puoi vedere . . . chi spoglia Gesú," *Anonimo francescano* (as in note 25), 135 (chap. 79).

[40] "La maggior parte de'riguardanti se ne scandelezzino anzi che diletto ne piglino," Gilio (as in note 35), 77.

[41] "Se dunque portiamo quella riverenza ai santi per la santità loro che ciò aborrisce . . . ," ibid., 78.

[42] "Da la fanciullezza, dal battesimo, da la flagellazione e crucifissione e resurrezzione in poi, non mai," ibid., 79.

[43] "E questo per onestà la quale deve tenere il primo luogo nè le figure sacre. Per mostrare l'istorico la purità la castità e la riverenza de la religione, deve fare con la penna e con le parole l'orecchie caste de chi legge, et i pittori col pennello e coi colori gli occhi casti di chi mira: dal che ne nasce il decoro de la pittura, la lode de l'artefice e la devozione de' popoli," ibid.

[44] My italics, cited in Bologne (as in note 28), 281; see the further text in Freedberg (as in note 1), 238–45.

saints' nakedness, the painter removes "occasions for laughter, ridicule, *and scandal*."[45] The artist who uses "such diligence to thrust these parts before viewers' eyes" does so "for no other reason than to provoke a few poorly educated youths to laughter by a thousand indecent and vain discourses."[46] Perhaps Gilio had some contemporary Passion play in mind. "Ho, villains," cried the barker advertising one such play in France, "come to the festival. Neither ass nor head will there be, that will remain concealed from you."[47]

Even if we reject Gilio's questioning of the motives of contemporary artists, his reading, as opposed to those that deduce art only from formal intellectual inspirations has the distinct merit of deriving the image of Jesus on the Cross from artists' desire to affect viewers—a particular group of viewers to boot: young males. Youths more than mature men respond to such nakedness, he assumed, and they ridicule it. Such youths included Canaan, the son of Noah, Gilio suggested: before the other two sons, while avoiding looking at his genitals, covered their naked father, Canaan laughingly made fun of him. But was ridicule all "that his younger son had done to [Noah]" (Genesis 9.24)? Surely not. The "sexual perversion" to which the Revised Standard Version of the Bible refers seems to indicate that the excited young Canaan had an erection, then fellated the stuporous father's bulging penis.[48] As Europeans traditionally identified sexual roles, the helpless father Noah was the negative passive agent (*patiens*) and his son the relatively positive active sodomite. A serious matter: something both generationally and canonically *contra naturam*. It remains to be pointed out that the image of the drunken Noah was the primary Old Testamental complement or type of the Crucifixion of Christ.[49]

Thus for Gilio, youth, the most sexually licentious part of the male population, would react most—if with calculated ridicule—to a naked Jesus. We are on the brink of reencountering Augustine's justification for covering the Savior, now linked to a particular male age group. Gilio's wariness was not otherwise unknown in his own time—as in earlier centuries, the term "idol" could still refer to any *naked* statue, such as one of a Roman emperor. In the 1420s the Rohan Master showed two Israelites embracing passionately and uncontrollably after they both had gazed upon such a "decently" fig-leafed "idol".[50]

[45] My italics; Gilio (as in note 35), 78.

[46] "Perché non mi pare che in quelle poche parti vergognose sia tal secreto di natura nascosto . . . Tanta diligenza à metterle avanti agli occhi de' riguardanti . . . " That is really done "non per altro che per far ridere, con mille discorsi disonesti e vani, i poco accorti giovini," ibid., 80.

[47] "ça vilains, venez à la fête. / Il n'y aura ni cul ni tête / Qui vous demeure ja couvert," cited in Bologne (as in note 28), 222.

[48] Ibid., 79. See Thomas (as in note 26), pl. 28. For Noah and Canaan on homosexuality, begin with *The Interpreter's Bible*, I, New York, 1952, 556. In his summary of possible interpretations of this passage, Pierre Bayle omitted fellation, but included castration, *The Dictionary History and Critical*, II, London, 1735, 431–32 (s.v. "Cham"). See the Jewish commentaries in Edwardes (as in note 26), 45.

[49] Besides the many "type books" showing both scenes, see Knod (as in note 22), 8, 11, and 15, where Augustine's association of the two stories is referred to, in part to shore up the view that Mary did cover Jesus on the Cross; also Johannes von Paltz (as in note 22), 51. In his *De doctrina christiana*, Augustine made Noah's uncovering and recovering the prefigurement or type of the treatment of Jesus on the Cross; Wimpfeling, cited in Knod (as in note 22), 15. See also above, note 25, where Jesus is imagined as a man assaulted by women.

[50] See Thomas (as in note 26), pl. 123. P. Brown said that early Roman emperors showed their unchallenged power by posing in the nude (as in note 24), 438. Note that Wimpfeling denounced the idea of a naked Jesus because that would have

It is not surprising, therefore, that Gilio, in defending clothing for holy images, also referred to the pre-Christian experience of nakedness. He cited Pliny's story of Pheidias's *Venus*, which was so beautiful that certain sexually aroused "lussuriosissimi giovini" ejaculated their sperm onto the statue. No wonder, Gilio intimated in commenting on this heterosexual image, that Mary had never been represented naked in art.[51] Switching to a homosexual paradigm, he cited the story of Noah, mentioned above, to drive home the evil of fathers, living or dead, appearing naked before their issue.

Recent art-historical work has begun to evaluate the fact that European paintings of females often sought to accommodate the male gaze and emotions—and those of males, the female gaze. But few scholars have raised the problem of the male gazing sensually at the male form.[52] Jesus is especially interesting in this regard: in art only the *infant* Jesus is often shown with uncovered genitalia, and Gilio had no serious objection to such *piccioli fanciulletti* being painted naked. Why? Because given the infants' innocence, male devotees are not scandalized on seeing them naked, and thus "will not fall [into sin with them] by natural instinct" (non potendoci per naturale istinto cadere).[53] I take this to mean that male adults who gaze on very young boys will not have an erection.[54]

In short, though these sources speak far from frankly, it appears that from early Christianity onward a powerful reason for keeping the crucified Jesus covered at the crotch was the danger that he would seduce other males, yea even in death—if not with his *beau corps bien formé*, then with his dying penis.[55] Making no pretense at accounting for the historical specificities of such seduction, I aim only to open up the possibility that seduction was part of this nonhistorical god's armor across the ages. Perhaps it was, therefore, not completely fortuitous that Panurge was in Christ's Passion cortège when he had his enormous erection, which led to such disorder that the audience and actors fell into a sexual frenzy seeking to fellate him.[56] Before the advent of modern communications, sacred images, like today's holy

made him comparable to Priapus, in whose rites "pudenda gentiles populo denudabant," Knod (as in note 22), 14. See further, Camille (as in note 2), 87–101.

[51] Clearly, he assumed Mary, too, had a beautiful body. "Lussuriosissimi giovini, de la cui libidine restò macchiata. I pittori che furono avanti Michelagnolo non fecero mai la figura de la gloriosa Vergine nuda . . . ," Gilio (as in note 35), 79. Significantly, contemporaries labeled such a male loss of penile control as "effeminization of the soul": "Quod si gentiles ipsi philosophi . . . picturas nudarum mulierum prohibuere, quod earum aspectu animi effeminarentur, prava foverentur desideria et ad scelera proniores redderentur . . . ," (the theologian Antonio Possevino [fl. 1595], cited ibid., 602).

[52] In a book on responses, Freedberg (as in note 2) seems to avoid all references to one such type of response, namely homoeroticism. See, however, J. Saslow, *Ganymede in the Renaissance. Homosexuality in Art and Society*, New Haven, 1986; and in general N. Bryson, *Vision and Painting: The Logic of the Gaze*, London, 1983.

[53] Gilio (as in note 35), 78. Erasmus and other writers, however, felt that children might be corrupted by naked infant Jesuses; Freedberg (as in note 1), 240.

[54] This may concur with Florentine practice. Michael J. Rocke found male passives were rarely below the age of puberty, "Male Homosexuality and its Regulation in Late Medieval Florence," Ph.D. diss., State University of New York, Binghamton, 1989.

[55] One early text even implies a homoerotic relation between Jesus and his apostles, S. Levin, "The Early History of Christianity, in Light of the 'Secret Gospel' of Mark," in *Aufstieg und Niedergang der römischen Welt*, ed. W. Haase and H. Temporini, part II: Principate, 25.6, Berlin, 1988, 4270–4292; further in J. Boswell, *Christianity, Social Tolerance, and Homosexuality*, Chicago, 1980, 225.

[56] "Tant joueurs que spectateurs, entrer en tentation si terrificque qu'il ne y eut ange, homme, diable ne diablesse qui ne voulust biscoter," cited in N. Zemon Davis, *Fiction in the Archives*, Stanford, 1987, 31 (*Tiers Livre*, chap. 27).

cards, were probably the most available for erotic ends. Just as importantly, the passive male's seduction of other males is not devoid of political meaning.

Seduction by the gods, whether in medieval times or in antiquity, could not be excluded simply by covering the genitalia. As Steinberg has noted, the perizonium itself could draw attention to the genitalia, suggesting that activity continued beneath it, as in the flying bannerlike perizoniums of Lucas Cranach. Other parts of the body of the Savior might be rendered corporeally erotic, even strikingly unmutilated. As mentioned earlier, the social context for the Crucified's being regularly bare-chested by the twelfth century, and the social and psychological effects of that undressing, remain to be determined. But the growing eroticism of the Christic torso in some Renaissance art, with its understatement of Jesus' suffering,[57] appears to have had important effects on devotion—and this was the thrust of Gilio's treatise. Although this is not the place to enter into the matter, it should be said that several Jesuses of this new age, whether from their shiny skin surface or from their exposed, if not erect penises, seem almost to be pathics dutifully prepared to receive sexual service. Perhaps these motifs are best combined in the supremely seductive hanging Jesus of Laurent de La Hyre, where the Magdalen appears to dwell not just on the Savior's pearly skin, but also on his active erogenous zone, which threatens to cast off the veil (Fig. 2). Besides the penis remaining a part of the dynamic between Jesus and the orant, therefore, the skins of the figures as well help to transmit conventional gender relations between object and orants.

The demand that young men and, even more, women not hear about or see penises worked to preserve adult males' property rights and influence over these dependents. If such *lussuriosissimi* types knew the joys of seeing male genitalia, the patriarchs might be cuckolded and lose their property rights. This was the social and political foundation of the oft-described "shame" of dependents. Although I cannot develop this train of thought fully here, I do not wish to end this paper with the idea that a so-called covered, suffering Christ, like that of the *Isenheim Altarpiece*, obviates the danger of eroticism and the intrusion of gender ambiguities. It does not. Gender is there; only it emerges later, on Jesus' road to heaven.

There is literary authority for this view. The Bible says that we will all be bodily resurrected in a naked state, and Augustine determined, against those who claimed that women would be resurrected in more perfect male bodies, that we would reassume the sex we had on earth.[58] Heaven *does* have gender, and as for age—with all *its* indirect gender implications—everyone, including Jesus himself, would have the Savior's corporeally perfect, and thus endlessly seductive, thirty-three years.[59]

[57] Among many others, I am thinking of Francesco di Giorgio Martini's *Jesus Stripped at Calvary*, Borgognone's *Cristo Risorto*, and many paintings of Pontormo and Rosso. Among the sculptures are Michelangelo's wooden Crucifix and his *Cristo Risorto*, Cellini's marble Crucifix, etc. Included in this phenomenon should be the increasingly effeminate representations of John the Evangelist, the "friend of Christ," often at the side of the Cross.

[58] See the discussion in Gilio (as in note 35), 66, and the references, 597–98. The apocryphal Gospel of Thomas had said that "every woman who will make herself male will enter the kingdom of heaven," see W. Thompson, *The Time Falling Bodies Take to Light. Mythology, Sexuality, and the Origins of Culture*, New York, 1981, 252.

[59] Gilio (as in note 35), 66. There is apparently no modern literature on sex and gender in the Christian beyond.

Thus in heaven, body is back; and such ruminations left a visual track behind them. I can only mention in passing the topos of a newly beauteous Jesus releasing souls from hell,[60] before going on to discuss the Resurrected Jesus, where gender mutations abound. In the *Isenheim Altarpiece* (Fig. 3), Jesus' awful wounds have healed in the very earth. If saying that the body has been regendered is problematic, I shall use the word rejuvenated. Now it is soft and creamy, and Jesus' hair, no longer its earlier Mediterranean black, has turned a remarkably northern, or, may I say, feminine, blond. *Che bella!*

In an earlier work I noted that Florentines habitually categorized certain figures according to their use or emotional impact: some figures, for instance, were said to "give peace." I also showed that once a painting had performed a miracle, its owners retrofitted it with objects known to "maintain devotion": a sky full of stars, or *cielo*, a crown, etc. I urged historians to try to discover or reconstruct the iconography of this "technology of devotion" that contemporaries used to manipulate their sentiments.[61]

I do not expect tomorrow to fall upon a case in which Jesus' exciting genitalia performed miracles. But in the spirit of Augustine, Margery Kempe, and Ganymede himself, I would argue that Jesus' very gender, no mere symbol of some ideologically sexless "humanity", is part of a technology of seduction. Keeping in mind that in the Middle Ages patriarchy allowed women much sooner than men to be humiliated in their bodies,[62] I believe that we should look at the impact that the effeminized—or dependent—masculinity of the humiliated Jesus Crucified had, and still has, on Christians' actions. Devotees' deep-rooted practice of affixing real loin-cloths to crucifixes already fitted with artificial ones is a place to start.

Torturing the helpless Jesus did not render him genderless. Rather, as Simone de Beauvoir and many Christian women know—this paper does not pretend to do justice to the subject of the Crucified Jesus' impact on women—torture rendered Jesus like unto a suffering woman (for example, Wilgeforte), to be worshipped by women,[63] or like unto a powerless man, to be venerated by other powerless males in early modern Europe: "I see the god on earth," yelled a sixteenth-century French burgher on encountering the man who had played Christ in his sarcophagus in a Passion play the previous day. "Did you keep your shameful member stiff while playing God?"[64]

[60] A particularly striking painting is in the Landesgalerie, Hannover, a *Jesus in der Vorhölle* of ca. 1420 that once belonged to the Cistercian nuns of Osterode. Jesus is tall and of magnificent bearing. His hair is blond, right down to his upper-class goatee. His skin is very white, while his wounds are indicated only by mere circles. This is a good *Fürst der Welt!*

[61] R. Trexler, *Public Life in Renaissance Florence*, New York, 1980, 113–15.

[62] See my "Correre la Terra. Collective Insults in Late Medieval and Renaissance Europe," *Mélanges de l'École française de Rome. Moyen Age, Temps Modernes*, xcvi, 1984, 845–902.

[63] Beckwith (as in note 12) cites de Beauvoir, *The Second Sex*, New York, 1976, 686: "In the humiliation of God, she sees the dethronement of man, inert, passive, covered with wounds, the crucified is the reverse image of the white, bloodstained martyr exposed to wild beasts, to daggers, to males, with whom the girl has so often identified herself; she is overwhelmed to see that man, man-God has assumed her role. She it is who is hanging on the tree, promised the splendour of the resurrection." If I understand rightly, Beckwith, with great insight, saw female mystics transforming the Crucified into female gender by a process of "feminization." Jesus is "passive, and his body becomes the site onto which desire is projected" (as in note 12), 47–48.

[64] Davis (as in note 56), 31 (1530).

It remains to be proved, of course, that young men in medieval Europe were, in fact, sexually aroused by Jesuses. Indeed, it remains an open question if even the patriarchs of medieval culture revered a male like Jesus, who proved to be not a man, but a worm, to cite the usual simile.[65] In a profound remark addressing the threat of imitating Jesus, Johannes von Paltz mused: "I do not know how a preacher can say [that Jesus was naked] without being ashamed. For it seems such a preacher is undressing the lord in front of the whole audience."[66] For a preacher to bruit it about that Jesus was naked, said Jacob Wimpfeling, "doesn't move one to devotion, but rather to a certain *vilitas* or disrespect for our lord Jesus."[67]

And, in fact, confraternal male devotion to Christ in passion appears to be largely an early modern, non-elite avocation.[68] But whatever may result from a serious study of the relationship between the different sexes and people of various ages and this humiliated half-man/god, we can be sure that the meaning of those Jesuses on the Cross lies less in the intentions of the image-makers than in the sense of self with which male, and female, devotees and ridiculers felt themselves attached to the figure, and who thus, so to speak, refused his application for godhood.

[65] And a circumcised one at that. "Ego autem sum vermis, et non homo; opprobrium hominum, et abiectio plebis. Omnes videntes me deriserunt me" (Ps. 21.7–8). This simile is regularly encountered in the sources in Marrow (as in note 3).

[66] What follows is still more impressive: "Et nescio, quomodo praedicator hoc posset dicere absque verecundia. Videtur talis praedicator denudare et dominum coram multitudine populi, quae vix illam denudationem videre potest. Et si dicitur: Si praedicator propter hoc, quod refert denudationem, dicitur denudare Christum, tunc similiter si refert passionem Christi, dicetur eum crucifigere, respondetur concedendo: Sed hoc non offendit, cum hoc certum sit et dominus iusserit celebrationem fieri in sui memoriam dicens: Hoc facite in meam commemorationem sic et hic praedicationem. Sed quia denudatio incerta est et non omnes hoc dicunt, igitur etc," Johannes von Paltz (as in note 22), 52.

[67] "Et profecto moleste tuli quod Christo fuit tributa illa horrenda nuditas verendorum coram virginibus et matronis et quidem multis, quod non michi ad devocionem sed pocius ad quandam vilitatem aut despectum domini Jhesu (ni fallor) deservire visum fuit," Knod (as in note 22), 5, and similar text, 7.

[68] William Christian noted the increasing devotion to the Crucified in early modern male confraternities, *Local Religion in Sixteenth-Century Spain*, Princeton, 1981, chap. 6.

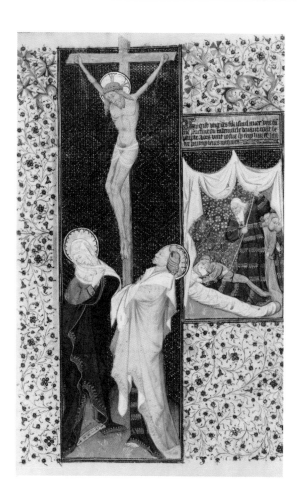

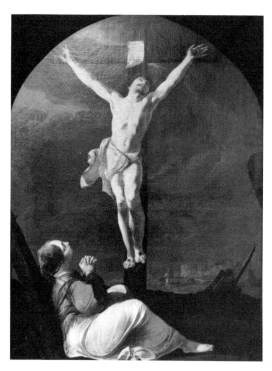

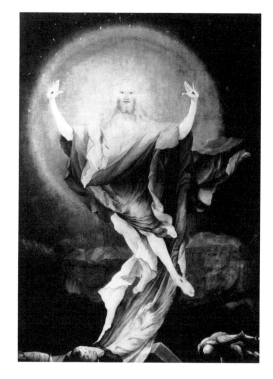

1. (left) The Master of Rohan, Crucifixion and Phinehas Punishing the Lovers, from Book of Hours, 1420–30. Paris, Bibl. Nat., MS. lat. 9471, fol. 237 (photo: Bibliothèque Nationale)

2. (bottom left) Laurent de La Hyre, Mary Magdalen at the Foot of the Cross, ca. 1630, oil on canvas. Saint-Denis, Musée d'Art et d'Histoire (photo: Musée d'Art et d'Histoire)

3. (bottom right) Matthias Grünewald, Resurrection, from the *Isenheim Altarpiece*, ca. 1512–16, oil on wood. Colmar, Unterlinden Museum (photo: Giraudon/Art Resource)

Medieval Pictorial Systems

•

WOLFGANG KEMP

BETWEEN the ivory panels of Milan Cathedral (Figs. 1 and 2) and the Marburg tapestry of the Prodigal Son (Fig. 3), lies an entire millenium of Christian art, which could be called the millenium of multiple images, in contrast to the epoch which began at the time the tapestry was created (ca. 1425) when creative energies were directed toward the making of individual pictures.[1]

There is a coherence between these two works, despite the differences in style and media. A fifth-century viewer would have had as little difficulty reading the tapestry as the late medieval person would have had with the ivory bookcover. For the first and greatest problem confronting the observer within the framework of Western representational practice, is not an issue here: the differences in the disposition of pictorial information and in its composition can be ignored. In both cases we are presented with a complex structure, whose composite character remains as evident at the material level (both works are pieced together) as at the compositional level. The pictorial fields are clearly distinguished from one another by their framework, their contrasting directionality and through variations in proportion and articulation. However, the fundamentally additive character includes a further and much more thoroughgoing similarity: in both works, two very distinct representational modes are deployed, the symbolic and the narrative. The appropriateness of applying these terms, particularly with regard to the tapestry, needs further elucidation. In the case of the ivories, there is no uncertainty (Figs. 1 and 2). We have a symbolic center in the multi-framed metasymbol of the Cross and Lamb, respectively, and we have four satellite symbols placed in their characteristic corner positions, which relate to the symbolic central field by means of their accentuation (the wreath) as well as through their differing proportions and abbreviation as busts which sets them apart from the narrative fields. Although reduced to essentials, the narratives correspond to the full-blown concept of a Christian history painting. One thousand years later in the tapestry things have changed little (Fig. 3). However, there the contrast between narrative and symbolic is realized in a different way. By this I do not mean simply that the relationship between border and filling is reversed; that is, Milan's symbolic center and narrative border vs. Marburg's symbolic border and narrative center. These two variants will be

[1] On the ivories, see G. Stuhlfauth, *Die altchristliche Elfenbeinplastik*, Freiburg, Leipzig, 1896, 66ff.; F. Volbach, *Elfenbeinarbeiten der Spätantike und des frühen Mittelalters*, 3rd. ed., Mainz, 1976, no. 119; P. Metz, *Elfenbein der Spätantike*, Munich, 1962, 24–25. On the tapestry, see M. Lemberg, *Der Marburger Bildteppich vom verlorenen Sohn*, Marburg, 1986; and W. Kemp, *Sermo corporeus. Die Erzählung der mittelalterlichen Glasfenster*, Munich, 1987, 48ff.

treated without distinction here; the pictorial system does not accord a status to their difference. The difficulty arises with the syncretistic character of the textile border. There, in a continuous sequence the life of a nobleman is depicted from the "cradle to the grave," in the narrative mode of presentation and in clear distinction to the symbolic mode of the eucharistic emblems in the corners. These differing modes of allegorical presentation, however, do not affect the nature of the relationship between center and periphery. The framed story of the life of the Prodigal Son, who appears here as a nobleman, forms the smaller cycle, while the enframing "story" forms the points of reference for it and makes up the greater cycle, which appropriately uses the four sides to represent the four ages of man, thus interpreting life according to its ideal regularity. In other words, difficulties may arise if we equate the difference between the two modes to one between symbol/sign and story. In another context, I have presented more than a few examples from medieval art that demonstrate how a second narrative can step into the symbolic line of argumentation and react with the first in a similar way, and I do not mean simply typologically.[2] The function of one register may be taken over by genuine pictorial symbols, or by rows of symbols in narrative form or by actual narratives. What term should be used for this? Symbolic-representative (*symbolisch-zeichenhaft*) does not capture all that we mean. Instead, I suggest that we talk of narrative order and of thematic order, and reserve the concept of systematic order of the pictorial system for the interaction of the two registers.[3]

This last suggestion calls for further remark. In the Marburg tapestry, as in the Milan diptych, the four corner fields of the frame are anchored by signs, but to different effect. The ivory emphasizes the symbols through the attribute of the circle or wreath, so that they are distinguished from the narrative fields by their format, i.e. circle = symbol, rectangle = story. The centerpiece departs from this schema, insofar as both elementary forms interpenetrate each other in it. Herein lies the key to understanding the two figures to which the symbolic and narrative modes converge: the quincunx, which is constituted by the diagonal disposition of the medallions, and the cross yielded by the horizontals and verticals of the narrative fields. These two syntagmata spring from the two-fold formal encoding of the center like a sort of duck-rabbit figure. But this is to address only the first level of their functioning, namely, their capacity to associate and distinguish elements. Yet these syntagmata are also intrinsically meaningful as figures. Again, the centerpiece makes this point. The represented Cross gives form and theme to the narrative of the life and works of Christ; its four arms and the four rivers of Paradise that emerge from its foot motivate the second ordering based on the quadruple, implying a host of other four-fold groupings: the four Evangelists (represented in both reliefs by their busts and symbols), the four seasons of the year, the four elements, the

[2] Kemp (as in note 1), 56–57.

[3] A similar conceptualization is reached by W. Haug, *Das Mosaik von Otranto*, Wiesbaden, 1977, 82. On the possibilities of pictorial ordering in medieval art and their conceptualization, see also E. J. Beer, "Darstellungmöglichkeiten des Allegorischen in der Kunst des Mittelalters," *Sitzungsberichte der Kunstgeschichtlichen Gesellschaft zu Berlin*, XXXIII, 1984–85, 5ff. See also F. v. Juraschek, "Sinndeutende Kompositionsweisen der Illustrationen zur Apokalypse im Frühmittelalter," in *Arte del primo millenio*, Virlongo, 1954, 187ff.; and M. H. Caviness, "Images of Divine Order and the Third Mode of Seeing," *Gesta*, XXII, 1983, 99ff.

four directions, the four winds, the four horsemen of the Apocalypse, and so forth. It comes as no surprise that this number governs also the narrative sector: the narrative cycle has sixteen panels (i.e. four times four scenes).[4] Thus, we must understand the four-fold order (or, for that matter, the quincunx) not simply as a naked configuration but also as a figure, as ideogram, or, to borrow a concept from linguistics, as paradigmatic order. In any case, it is a figure that has a totalizing effect and which brings into play the principle of analogy and metaphor, while the axially-emphasized figure of the Cross and every narrative picture series rests on the principles of contiguity and metonymy. In brief: we are basically dealing with a three-part model, which, beyond its narrative and thematic modes of expression, and its primary, but not signifying articulation into frame and filling, has the possibility of an additional figurative structuring, which serves to relate the modes but can also be meaningful in and of itself.

Two diametrically opposite explanatory models are possible regarding the ultimate origin and the historical necessity of such pictorial systems. On the one hand it might be claimed that this triple order is the product of a concrete historical situation, while on the other it might be claimed that, historical considerations are negligible and that the order is inherent in the nature of the material. The distinction between thematic and narrative order is reminiscent of Jurij Lotman's typology of cultures. His theory operates with two groups of "subtexts" in developed cultures (culture itself is for Lotman the main text): subtexts that model the larger structures of the world, and subtexts, that "describe the place, position, and activities of people in their surrounding world."[5] The first group answers the question, "How is everything ordered?" Its status is paradigmatic, its formal quality is its static character and a spatial construction which articulates a system of values: binary oppositions like above/below, right/left, center/periphery, inside/outside, order/chaos are worked into a totalizing structure. The second group of subtexts asks, "What happened and how did it happen?" and, "What did the characters do?" Its disposition is syntagmatic, its mode narrative, it describes the movements of human beings through a symbolic field which has been established and marked according to the rules of the first subtext.

Lotman has worked on this concept over the years and has changed it not always for the better. But already the first outline, here extremely condensed, reveals its potential and raises some questions. Especially important for our discussion are Lotman's statements about the

[4] There is already a field of study that treats this four-fold ordering as a matrix of a Christian conception of the world. Among relevant studies I list only a selection: O. K. Werckmeister, "Die Bedeutung der 'Chi'-Initialseite im Book of Kells," in *Das erste Jahrtausend. Kunst und Kultur im werdenden Abendland an Rhein und Ruhr*, ed. V. H. Elbern, Düsseldorf, 1964, II, 687ff; idem, *Irisch-Northumbrische Buchmalerei des 8. Jahrhunderts und monastische Spiritualität*, Berlin, 1967, 120ff.; F. Rademacher, *Der thronende Christus der Chorschranken aus Gustorf. Eine ikonographische Untersuchung*, Cologne and Graz, 1964; A. C. Esmeijer, *Divina Quaternitas*, Diss. Utrecht, 1973; V. H. Elbern, "Bildstruktur—Sinnzeichen—Bildaussage. Zusammenfassende Studie zur unfigürlichen Ikonographie im frühen Mittelalter," *Arte medievale*, I, 1983, 17ff.

[5] J. Lotman, "On the Metalanguage of a Typological Description of Culture," *Semiotica*, XIV, 1975, 102. For Lotman's conception of culture as text see his and Uspenskij's contributions to *Semiotica e cultura*, Milan and Naples, 1975; and J. Lotman, *Tipologia della cultura*, Milan, 1975. For a critical reassessment of this theory and a bibliography see *Semiosis. Semiotics and the History of Culture. Festschrift Lotman*, Chicago, 1984.

coexistence or cooperation of the two "texts." When Lotman calls the first group primary and the second secondary, he gives the impression that the secondary text, as a derivative quantity, translates the givens of the primary text. In this case the latter would function as a cultural model, the former as its hypostasis. Our examples, on the contrary, show that *both* classes of subtexts can materialize in concrete forms and that both are capable of articulating axiological qualities. It goes without saying that Lotman's topology of values is found more often in the context of thematic statements, but a narrative sequence also has its directional sense as narration and can constitute itself as paradigmatic narrative, without being dependent on the support of a thematic text (about which later). And when both modes or texts not only appear but work together, we encounter a third position, which Lotman's theory does not take into account: then the figurative or systematic content of their constellation has to be realized. This leads us to the conclusion that not so much a typology of modes or "texts" but a typology of their relationship is needed and that this kind of material requires a historical and not a semiotic or structuralist analysis.

Historians, however, have paid too little attention to such questions and have pointed to analogous pagan works of art as the definitive source for later Christian compositions: to votive reliefs of Heracles and his deeds,[6] to the so-called *Tabulae Iliacae* (Fig. 4),[7] and to a great many Mithraic altarpieces (Fig. 5),[8] all of which have in common the contiguity of the two orders: an iconic center surrounded by what Schweitzer has called a *Legendenrahmen*, a frame of narrow bands subdivided into small narrative panels. Given the unquestionable attraction of the Mithras cult for early Christianity, its foremost art form becomes an ideal candidate for providing Christian art with an equally flexible and comprehensive pictorial system. In my view the analogies work only on a superficial level. To begin with, the status and function of the framing devices and the relationship between center and periphery are far from clear. Scholars remain embroiled in a heated debate about questions of identification, compositional logic, and overall meaning. For our concerns it must be especially noted that the *Legendenrahmen* does not follow the principles of sequential or thematic order. It encompasses pictorial elements of widely differing types: cosmological symbols, scenes from the life of Mithras, secret signs referring to the established rules of the cult or to the special code of the community.

A reception of the Mithraic images, which was based on oral and ritual transmission, was not bound to proceed along a linear continuum. In contrast most Christian monuments were based on canonic texts, not on secret doctrines and pictorial representations alone.[9] The

[6] B. Schweitzer, "Dea Nemesis Regina," *Jahrbuch des Deutschen Archäologischen Instituts*, XLVI, 1934, 175ff.

[7] A. Sadurska, *Les tables iliaques*, Warsaw, 1964.

[8] Among the relevant studies are F. Saxl, *Mithras. Typengeschichtliche Untersuchungen*, Berlin, 1931, 28ff., 37ff., 81; H. Lavagne, "Les reliefs à scènes multiples en Italie," in *Mélanges de philosophie, de littérature et d'histoire ancienne offertes à P. Boyancé*, Rome, 1974, 481ff.; R. L. Gordon, "Paneled Complications," *Journal of Mithraic Studies*, III, 1980, 200ff.; S. R. Zwirn, "The Intention of Biographical Narration on Mithraic Cult Images," *Word and Image*, V, 1989, 2ff.

[9] Without wanting to enter the "orality-literacy debate" here, the sheer number of Father Ong's famous characteristics of orally based thought and expression may indicate the direction which a pertinent interpretation should take: "additive rather than subordinative," "aggregative rather than analytic," "redundant" or "copious," see W. Ong, *Orality and Literacy. The Technologizing of the Word*, London and New York, 1982, 36ff.

unidirectional disposition of writing and the authority of the Bible as a collection of historic books favored a more compelling ordering at least of the narrative panels—sequence and logic were thus strengthened even in aggregative compositions. In addition to this, the very symbols or representatives of Scripture, like the Evangelists and their beasts, could be used as cornerstones and keys of complex and mixed structures, and so could exchange meaning and function and switch from the narrative to the thematic order. This leads me to the next question and the interim finding that neither the art-historical nor the text-theoretical approach is adequate to the object of investigation. Neither of them is capable of explaining the necessity of the combination in view of the question which appears to me to be of great importance, regarding the nature of the specific attractions of a narrative and thematic order for a Christianized visual and textual culture.

The proposition that the Christian religion is based on a great story, namely, on the new unity which the Christian viewpoint forges between the Old and New Testaments, and that pictorial narrative is thus its legitimate expression, should not meet with opposition, but it must be formulated more specifically in order to be reconsidered productively. What is the nature of the biblical story? Consider the thesis of a narratalogically oriented exegete: for Herbert Schneidau, the Bible means "the birth of a new kind of historicized fiction, moving steadily away from the motives and habits of the world of legend and myth."[10] It rebels "against the pagan world view, which is locked into an eternal cyclical movement." For that reason, prose "could transform storytelling from ritual rehearsal to the delineation of the wayward paths of human freedom, the quirks and contradictions of men and women seen as moral agents and complex centers of motive and feeling,"[11] resulting in the "avoidance of the epic," which Schneidau and Talmon bring into functional connection with cosmology, analogic thinking, and ritual. "The recitation of the epics was tantamount to a re-enactment of cosmic events in the manner of sympathetic magic."[12] For Schneidau, pagan culture is identical to a "world of linked analogies and correspondences."

> A cosmology of hierarchical continuities, as in mythological thought, exhibits strong metaphorical tendencies. The enmeshing and interlocking of structures are coherently expressed in poetic evocation of transferable, substitutable qualities and names. In this world movement tends to round itself into totalization, impelled by the principle of closure.[13]

Biblical narration sets the figure of metonymy against metaphor, bringing elements into contact rather than into a comparison. In Schneidau's compelling formulation: "Where myth is hypotactic metaphors, the Bible is paratactic metonymies."[14] "That is, where myth involves a set of equivalences arranged in some system of subordination, the Bible offers a series of

[10] H. Schneidau, *Sacred Discontent: The Bible and Western Tradition*, Berkeley, 1977, 215. Regarding the entire discussion, I follow the summary representation of R. Alter, *The Art of Biblical Narrative*, New York, 1981, 25ff.

[11] Alter (as in note 10), 80.

[12] S. Talmon, "The 'Comparative Method' in Biblical Interpretation—Principles and Problems," in *International Organization for the Study of the Old Testament, Göttingen Congress Volume, 1977* (Supplement to *Vetus Testamentum*, xxix), Leiden, 1978, 354.

[13] Schneidau (as in note 10), 292.

[14] Ibid., 292.

contiguous terms arranged in sequence without a clear definition of the link between one term and the next."[15]

This narratological insight can be readily harmonized with the basic Christian understanding of time and history, which regards its material as linear and not cyclical.[16] It has been given a beginning (*In principio . . .*) and an end; it is accentuated through the *kairoi* of the divine sequence of events and extended through the ages, the *chronoi* of profane history. Views differ on whether or not it is a continuous or spasmodic history, but it is genuine historical time. In opposition to the pagan myth of the eternal return and in continuation of the Judaic tradition, this "historicist theodicy" "is based on unique, unrepeatable events, starting with the Yahweh-Israel covenant and culminating in the Crucifixion—events that occurred in time and permanently altered not only the structure of the cosmos but also the manner of its movement."[17]

The dimension of linear time is so to speak sanctioned; even God, Christ, needed it, when he took on an historical, human existence. Christianity's "central doctrine of the Crucifixion was regarded as a unique event in time not subject to repetition and so implied that time must be linear and not cyclic."[18] In the words of Augustine, "Christ died, once and for all, for our sins."[19] The absolution of original sin on the Cross, that unique and unrepeatable process, is yet incapable of one thing: "cancelling the historical fact of original sin from the world and dissolving the breach between God and man resulting from it."[20] Insofar as the Crucifixion itself takes place in the medium of time, it legitimizes the medium of time as a Christian dimension by delivering proof that the New Testament God "assumed an historically-conditioned, human existence."[21]

Among the church fathers it was mainly Saint Augustine who threw this unique linear conception of time and history into relief by comparing it with the type of cyclical thinking to which the pagan world and the great philosophical tradition had subscribed. "In the twelfth book of the *City of God*, Augustine refers to classical notions of recurrence and contrasts them to the 'straight path' of Christian time. 'These are the arguments by which the wicked endeavour to turn our simple piety from the straight path and make us walk in circles with them.'"[22] Augustine here is alluding to Psalm 11:9, "in circuitu impii ambulant," but at the same time he is changing the argument from, "a metaphor for the confusion of false doctrine"

[15] Alter (as in note 10), 26.

[16] A good introduction to the fundamental studies on the Christian conception of time is found in F. Masciandro, *La problematica del tempo nella 'Commedia'*, Ravenna, 1976, 14. A problematization is found in W. Pannenberg, "Weltgeschichte und Heilsgeschichte," in *Geschichte—Ereignis und Erzählung*, ed. R. Koselleck and W.-D. Stempel, Munich, 1973, 307ff.

[17] N. M. Farriss, "Remembering the Future, Anticipating the Past; History, Time, and Cosmology among the Maya of Yucatan," *Comparative Studies of Society and History*, XXIX, 1987, 568.

[18] G. J. Whitrow, *The Nature of Time*, New York, 1972, 14, cited by R. Edwards, "Techniques of Transcendence in Medieval Drama," in *The Drama of the Middle Ages*, ed. C. Davidson et al., New York, 1982, 114f.

[19] Augustine, *De Civitate Dei*, XII.13.

[20] Edwards (as in note 18), 26.

[21] M. Eliade, *Das Heilige und das Profane*, Reinsbek, 1957, 66.

[22] A. Higgins, "Medieval Notions of the Structure of Time," *Journal of Medieval and Renaissance Studies*, XIX, 1989, 231.

into "a model of pagan notions of temporal structure," especially the Platonic ideas of eternal return. "The theory of repetition, however, is objectionable to Christians not primarily because they reject the idea of recursiveness in itself, but because the repetition *ad infinitum* contradicts the biblical and patristic position that the *saeculum* was created from nothing and will end, and that human history is no less than 'a continuous and progressive revelation of the Providential design.'"[23]

One could understand all this as a complete justification of the narrative cycle as the form of expression of Christian art and also appeal to it as an explanatory basis for individual phenomena, like the frequent occurrence of hard, paratactic accretions in narrative cycles. At the same time, these general considerations regarding Christian notions of time and narrative open a perspective for understanding the counterpart, that is, the thematic, axiological "subtext," and the possibility, even the necessity, of combining narration and axiology. It was, at the very latest, in that moment when Christianity had to constitute the state cult and the ruling world view, that the one-sidedness of its central texts as historical narratives came to light and demanded closure. On this point, one must concur with Lotman. Every culture needs to know how everything is ordered, and how everything came to be. Christianity's deficits are, as we have seen, already immanent in a new kind of storytelling which is not in itself transparent to the "whole," and does not, cannot, attempt totalization. In addition, its deficits have to do with the quantitative occurrence of pertinent information about the "whole": one can readily establish that the first two chapters of Genesis and the twenty-two chapters of the Apocalypse threaten to sink down into the "mare historiarum" of the other biblical stories, at least quantitatively.

Restoring this deficit has become the incompletable task of all branches of Christian exegesis and Christian self-representation. One need only think first of all of the liturgy, which has to reinterpret a linear material in a circular way and to reinterpret a history as a cosmogony, the main example for this being the liturgical year with its fixed and moveable feasts, its reconciliation of the Western solar and the Hebrew lunar calendar, its coordination of natural cycles and the progressive cursus of *Heilsgeschichte*. Then think of theology, which recognized from the beginning the potency *and* the deficiency of its textual foundation: it developed a genuinely historical interpretative method in typology and it satisfied the axiological demand with symbolism, which can puncture the narrative at any point and elevate it to the most general level. A division of labor developed out of this double strategy in the late Middle Ages, when theology as philosophy threw itself wholly on the side of explaining the world, not without, let it be noted parenthetically, laying about itself certain meta-narratives as a protective, invisible frame. Let us consider further Christian church building, in which the cyclically organized time of the liturgy and liturgical drama find a space for action, triply encoded in a manner not much different from our mixed cycles: cosmically *qua* image, symbolically *qua* figure, and, *qua* spatial aggregate, making succession possible, marking out a spatio-temporal unity. And if we think finally of artworks of the medieval period, their aggregate character is the first thing that strikes us, as well as the tendency to create complex

[23] Ibid., 231.

works and ensembles out of many pictures and out of pictures of completely different iconic status. We note further, the drive toward totality, toward system, toward ideograms, which often stands in evident contrast to the compositional principles of a period. The thematic and the narrative are bound up in a continually self-renewing compulsory partnership, which lends itself well to the art of a religion based equally on immanence and transcendence, and which has been directed by stories from historical time in developing its universal doctrine. The pictorial arts are obviously particularly suited to illustrate the need and the necessity of this bond, of this law of complementarity, since they are charged to give both narration and explication for didactic reasons. Unlike theology, they are not inclined to consider the text, the "historiae fundamentum," as a given to be replaced by speculation—a tendency against which Saint Augustine warned: "ne subtracto fundamento rei gestae, quasi in aere quaeratis aedificare."[24] Art has rarely built castles in the air in this sense.

I now return to the two art works. One should guard against overtaxing the demonstrational value of these rather casually selected examples; nevertheless a difference is apparent. In front of the Marburg tapestry (Fig. 3), one has the impression that here a system has fallen apart, that the thematic order compels no formal composition. The corner accents seem detached; the "exemplary" border tends toward ornament. This observation concerns only the formal, not the conceptual quality of the two orders. Conceptually, the work ranks much higher than its rather naive style would lead one to think. This becomes clear when we turn to its narrative core. In it, the linearity of the narrative thread is intersected vertically in an oppositional schema, so that each episode appears mirrored *in bono* and *in malo*: the cordial leavetaking from the paternal home is aligned with the dismissal from the whorehouse, the confident departure on horseback finds its pendant in the desperate situation of the herdsman of unclean animals, and so forth. This form of narrating in opposites is of course no innovation of the Marburg tapestry.[25] Of interest here is the observation that in the framework of a two-place model, narrative order is strengthened through that element which the thematic order, or the interaction of both orders, has lost, namely the power to keep distant elements together. The narrative integrates this potential, that is, its own characteristic principles of metonymy and contiguity are joined by metaphor and analogy, which had formerly been part of the thematic order. This constitutes a breakdown in the system of poetics such as is only possible in the visual arts, and indicates two things: that narrative has liberated itself from the model of the Holy Text and found its own language and artistic form and that the drive for cooperation between historical and axiological subtext has given way. It gives way because the realms have developed into autonomous and specialized areas; narrative art on the one hand, philosophy and science on the other. The strength of the thematic order lay in having added the cosmological component which we discussed with regard to the quaternitas-

[24] Augustine, *PL* 38, col. 30. On the question of 'fundamentum' and theological superstructure see M. D. Chenu, *Nature, Man and Society in the Twelfth Century*, Chicago and London, 1957, 116ff.; and H. Lubac, *L'exégèse médiévale. Les quatres sens de l'Écriture*, I, Paris, 1959, 407ff.

[25] Kemp (as in note 1), 46ff. The first example that I could find for this mode of narration is the Window of the Prodigal Son in Bourges Cathedral from the beginning of the thirteenth century.

schema of the Milan ivory. When an age takes its conception of the world simply as a spatial projection and no longer as a figure, such an order must come to an end.

To give these considerations greater concreteness I want to examine the late twelfth-century ceiling of St. Martin in Zillis (Figs. 6–9).[26] Three pictorial orders familiar to us come together or overlay each other in Zillis (see Fig. 7). First there are the forty-eight border fields, the "sea pieces," which surround "the firmament of the salvation story," in the words of Walter Myss. Then comes the historical-linear sequence of one-hundred and five fields of the inner cycle, which extends from the Annunciation to the Crowning with Thorns, with details from the life of Saint Martin as a short addendum. And finally there is the figure of the Cross, which is inscribed within the pattern of the panelled ceiling as a uniform, double ornamental band. Three orders and symbol systems are thus represented:

1. The spatial system of the *mundus* has the sea at the edge of the world and its monstrous sea-creatures, and the four trumpeting angels of the Apocalypse in the corner fields, here representing, as in many medieval schema-pictures, the four corners of the world and the four cardinal winds (Fig. 8).

The spatial pictorial order stands in an isomorphic relation to its *relatum*, which is more a consequence of the actualization of elementary spatial qualities than of their depiction. By this, I have in mind the "squareness" of the *mundus tetragonus*, with the corner fields as fixed points, its bounded character (the surrounding border fields), and also the quality of continual expansion—in contrast to the fields of the inner zone, the border squares have a uniform running stripe, the wavecrest of the stylized ocean—and the natural fixed directionality of space—the four picture rows on the border are each oriented to their compass direction and thus stand in clear contrast to the central pictorial events.

2. This inner cycle (Fig. 9) thus occupies the continent of the *mappa mundi* and conforms to geographical conceptions insofar as the story of salvation unfolds from east to west, from choir to entrance, from the east where everything begins, towards the west, whither one of the prominent heralds of the early church, Saint Martin, brought Christianity and where the end of time is to be awaited. This *mundus* is interpreted as *saeculum*, as a historical world activated by divine and human powers—in contrast to the abyss with its primitive beings of an animistic/diabolical nature—and as a linear consecutive pictorial order, which follows the linear schema of written texts, thus using an artificial form of disposition which cannot have recourse to a "natural" arrangement of spatial givens. This very cycle, with its extremely variable relationship of picture content to narrative unit—an event may be represented on one panel or just as easily extend itself across four—exemplifies what biblical narratology assumes about its subject: that history proceeds on its own course, paratactic, linear, following its own laws and standing in clear contrast to an ideogrammatic cosmology. That in Zillis

[26] On the ceiling in Zillis, see E. Poeschel, *Die romanischen Deckengemälde von Zillis*, Erlenbach and Zurich, 1941; W. Myss, *Bildwelt als Weltbild. Die romanische Bilderdecke von St. Martin zu Zillis*, Beuron, 1965; E. Murbach, *Die romanische Bilderdecke der Kirche St. Martin zu Zillis*, Zurich, 1967; F. W. Deichmann, "Kassettendecken," *Jahrbuch der Österreichischen Byzantinistik*, XXI, 1972, 83ff.; S. Brugger-Koch, *Die romanische Bilderdecke von St. Martin, Zillis (Graubünden). Stil und Ikonographie*, Ph.D. diss., Basel, 1981.

the story fails to end, to round itself out, but rather breaks off in the middle of narrating the Passion, may be regarded in this light as more than an arbitrary clumsiness.

3. The tension between cosmology and history is not really transcended by the monumental sign of the Cross that overlays both orders (Fig. 7). The Cross does not carve out highpoints, or fixed points, of the temporal or cosmic space; it does not even give the ceiling pattern direction or proportion due to the uneven segmentation of the longer cross arm. Its layout is of a purely geometrical nature, its form of a purely graphic nature. In pure form, it occupies the third discursive mode of the composition: the figure. It is difficult to concur in this instance with the current, cosmological interpretation of the *figura crucis*, which likes to see in it "the basic schema imposed by God on the cosmos, the law of the world's constitution."[27] What we do have, surely, is a combination of three orders, clearly defined among themselves; not until we have established this, can we speak of a totality of cosmos and history in the sign of salvation.

Such syntheses were probably common on medieval church ceilings. In St. Michael in Hildesheim an analogous conception of the world is yielded by a complex typology of inner and outer corner positions, occupied by Evangelists, their symbols, and the rivers of Paradise, while the central zone of the historical cursus, the historical line of connection between the Fall and the (reconstructed) theophany is drawn out in the form of the relatively novel pictorial formula of the Tree of Jesse. In St. Emmeram in Regensburg, whose paneling from the twelfth century is known only through written sources, a cycle divided itself through the western transept, nave and choir, representing the world-historical course of salvation in the three stages: prehistory, Christian time, and the end of time.[28] The formal material of the historiated ceiling, whose content was preponderantly typological, consisted of figures: quincunx (prehistory), cross in circle and square (Christian period), and concentric circles (the end of time)—history *more geometrico*, but probably designed with a cosmological intention as well. In the west choir, the four ancient world empires grouped themselves in four corner circles around "the great middle sphere" with the representation of the Ancient of Days, the Eternal who according to the titulus encompasses all things and measures to each its time. In the center of the choir ceiling, the Agnus Dei determines the four "states" of the *Ecclesia militans* represented in the outer circle, about which we can say with certainty only that here among others the four apocalyptic angels were illustrated, which may express spatially the universal claim of the Church, though perhaps also were meant to recall the origins of the entire cycle, the four world empires, as Bede interpreted them.

With the four world empires and the *Ecclesia militans*, we have come upon key terms which help us grasp that displacement of the ideogrammatically composed conception of the

[27] On the Cross as "supersymbol" see the literature cited in note 4 and B. Bronder, "Das Bild der Schöpfung und Neuschöpfung der Welt als 'orbis quadratis'," *Frühmittelalterliche Studien*, VI, 1972, 202–3.

[28] The best treatment is still to be found in J. A. Endres, "Romanische Deckenmalerein und ihre Tituli zu St. Emmeram in Regensburg," *Zeitschrift für christliche Kunst*, XV, 1902, cols. 205ff., 235ff., 275ff., 297ff. A more recent publication of the sources is M. Piendl, *Fontes monasterii S. Emmerami Ratisbonensis. Bau und kunstgeschichtliche Quellen*, Kallmütz, 1961.

world by a geographical layout which is so noticeable at Zillis. The twelfth century apparently ceased to understand the world merely as a formulaic totality, but rather grasped it as an extended quantity, which represented the Church's sphere of action. In this respect, the synthesis of *mundus, saeculum,* and *figura* is not unique to the ceiling composition of Zillis. If one is permitted to shift to a different medium, an instructive comparison can be made to the contemporary conception of history of Otto of Freising. Otto begins his universal chronicle, as did Orosius, with a description of the world, but then does not proceed to the "agenda" of history directly; rather, he prefaces his presentation with a carefully worked out model of a "parallelism of the cosmos and history." "The orderly development of the world does not simply follow temporal (*aetates*) and political principles (*regna*). With his doctrine of the (three-fold) east-west migration, Otto appends a spatial ordering to the temporal one, just as the geographical positions (the celestial directions) determined the world empires; and significantly the bishop also speaks here of *translationes,* in order to determine the coherence of ordering criteria."[29] Secular power, the sciences and philosophy, as well as piety, formerly had their home in the East and then migrated to the West: "omnis humana potentia seu scientia ab oriente incepit et in occidente terminatur, ut per hoc rerum volubilitas ac defectus ostendatur."[30] The consecutive clause means that the rule-governedness of the *translatio* or the historicization of space is not subject to some final and sacred cause, but serves only as the highest expression of that basic condition of every earthly thing after the Fall, which Otto designates as *mutabilitas, volubilitas rerum,* or *transitionis status.* This theology of history recognizes three phases: *stabilitas,* the order of the paradisical world, *mutabilitas,* or historical change, and again *stabilitas,* the definitive transcendence of temporality in the *civitas aeterna*—a sequence which connects this model with the ceiling programs of Hildesheim and Regensburg.

Belonging in closest proximity to the historiated ceiling of Zillis are some medieval maps, although not the Beatus-maps so frequently alluded to. The latter maps correspond only with respect to the schema of worlds, such as the sea and its inhabitants on the edge of the world, the squareness of the *mundus,* the four angels, etc. By contrast, maps such as those of Ebstorf and Hereford equal and exceed the complexity of Zillis, albeit originating from a later period (ca. 1235 and 1280 respectively), but inconceivable without older models (Figs. 10 and 11).[31] The relationship between these conceptions of the world and the pictorial world of Zillis can be reduced to a formula: historicization of cartography in Ebstorf and Hereford, cartography of history in Zillis. Regarding both formulations, it can be said that they are "pictures of the world which can be alike described as spatially-represented history and historically-represented space."[32] In the maps, as in Zillis, frame and filling, border program

[29] H. W. Goetz, *Das Geschichtsbild Ottos von Freising,* Cologne and Vienna, 1984, 159.

[30] Ibid., 60.

[31] On the maps, see especially A.-D. v. d. Brincken, "Mappa mundi und Chronographia," *Deutsches Archiv für Erforschung des Mittelalters,* XXIV, 1968, 118ff.; idem, " . . . ut describeretur universus orbis. Zur Universalkartographie des Mittelalters," *Miscellanea Medievale,* VII, 1970, 249ff.; U. Ruberg, "Mappae mundi des Mittelalters im Zusammenwirken von Text und Bild," in *Text und Bild. Aspekte des Zusammenwirkens zweier Kunste im Mittelalter und früher Neuzeit,* ed. C. Meier and U. Ruberg, Wiesbaden, 1980, 550–551; J.-G. Arentzen, *Imago Mundi Cartographica,* Munich, 1984.

[32] Arentzen (as in note 31), 164.

and central subject matter work together with a systematic intent. The peripheral indications on the far side of the edge of the world are preponderantly historical and narrative in nature: either pure legend as in Ebstorf (the creation myth among other things) (Fig. 11) or a mixture of pictorial narration and textual exegesis as in Hereford (Fig. 10). In the latter the terrestrial map is caught up in a representation of the end of the world. Its author and a profane scene appear in the lower corners. It is no surprise that precisely here we find the plea directed to all who "own this story [cest estoire], hear, read, or see it."[33] "Estoire" is the only designation the map uses to refer to itself: it identifies itself as a work to be understood only by other means as a history painting, not in the sense of an orderly chronicle, but rather as a many-sided "compendium of the knowledge of the world." Of course, this designation is meant to encompass the interior realm as well, the image of the oikoumene, which is in no way restricted to the purely geographical. On the contrary, "topographical information . . . remains secondary in comparison to a predominantly textual and pictorial content drawn from legend and history, natural history and ethnology."[34] The entries on the map are as a rule legitimized as sites of a Christian or extra-Christian event; the world-map "does not reproduce the measured surface of the earth, but is, rather, a pictura of the stage of world history, embedded in the story of salvation: starting from Paradise, the eye follows the circle and returns to Paradise."[35] This last observation applies to both maps, but especially to the Ebstorf map (Fig. 11), where at the very top, Paradise and a sort of counterpart scene are so placed to give them an unmistakable introductory function.

A final commonality between the maps and the ceiling should not be overlooked: both attempt to extend the complex interplay of space and time into a figure of totality. In Zillis, the monumental Cross is imposed on the dimensions of the mundane, in the Hereford map, the dialectic of center and edge is to be understood figuratively. In the center of the Hereford map, the crucified Christ is placed above the titulus of the Heavenly Jerusalem; on its edge, one reads in the markers which label the compass points, the capital letters M—O—R—S. But the border program does not get the last word here: as God of the Last Judgment, Christ appears at the top, displaying his wounds and surrounded by his arma. The perspective of the history of salvation, the decay of death and the overcoming of death, is revealed in this symbolic parallelism. The map in Ebstorf has in the center the Heavenly Jerusalem with the resurrected Christ as its central image, and, in the four compass points, Christ's head, hands, and feet, leading to various interpretations: Christ embraces and contains the world, the world is the body of Christ.[36] For our investigation it does not make much difference. We recognize here the same tendency towards a super-symbol as in Zillis.

Ultimately, the consideration of these maps brings us to a paradox. The geographical model had fewer problems with the narrative element and the saturation of the earth by history than with the making of an analogical picture of the world, to which the entire effort of Christian cosmology had to apply. But here we are already in the thirteenth century,

[33] Ibid., 225.
[34] V. d. Brincken (as in note 31), 128.
[35] Ibid., 186.
[36] For a discussion of these proposals, see Arentzen (as in note 31), 119.

which had other means in theory and practice of "placing man correctly against the over-whelming backdrop of the cosmos."[37] At the same time, the pictorial formula became available: for example, Vita icons, in the West as well as in the East, make use of them, as do thematic complexes, such as the Marburg tapestry. The Renaissance discovered the legitimization of such a pictorial system in the model of the antique, although without being any longer under the compulsion to force a historical conception of the world to conform to an axiological demand.[38] The comparison of Marcantonio Raimondi's master print "Quos Ego" with an antique *Tabula Iliaca* speaks for itself (Figs. 4 and 12). Henceforth, the door is open for use in book titles, broadsides, and devotional images.

[37] P. Brown, *The Making of Late Antiquity*, Cambridge, Mass., 1978, 100.

[38] For the reception of our pictorial scheme in Renaissance and Baroque art see Saxl (as in note 8), 81; and B. Schöller, *Kölner Druckgraphik der Gegenreformation*, Ph.D. diss., Marburg, 1990, 184ff.

1. Scenes from the Life of Christ, early fifth century,
ivory diptych. Milan, Museo del Duomo (photo: Hirmer
Fotoarchiv)

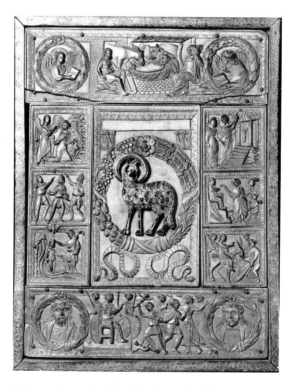

2. Scenes from the Life of Christ, early fifth century, ivory
diptych. Milan, Museo del Duomo (photo: Hirmer
Fotoarchiv)

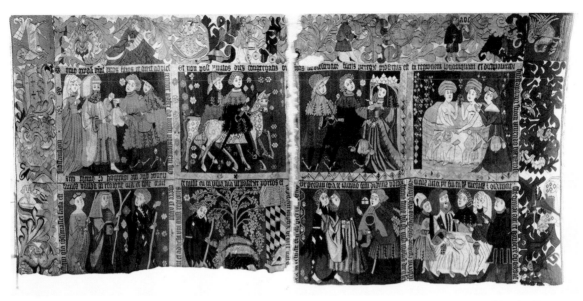

3. Scenes from the Prodigal Son, around 1425, embroidery. Marburg, Universitäts Museum (photo: Bildarchiv Foto Marburg)

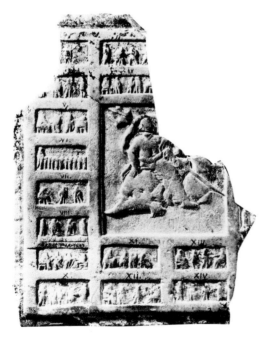

4. Tabula Odysseaca "Tomassetti," stone relief. Vatican, Museo Sacro (after A. Sadurska, *Les tables iliaques*, Warsaw, 1964, pl. 16)

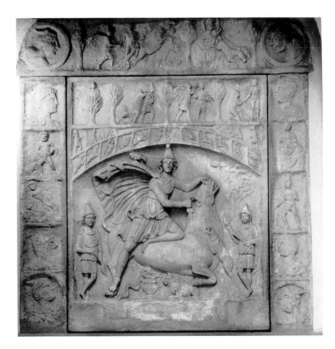

5. Mithraic relief. Wiesbaden, Städtisches Museum (photo: Bildarchiv Foto Marburg)

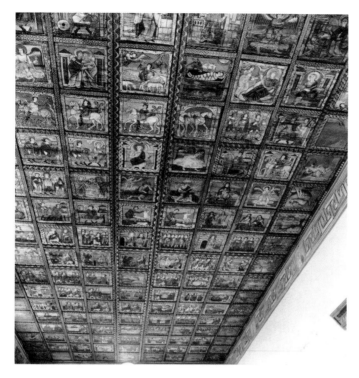

6. Ceiling painting, third quarter of twelfth century. Zillis, St. Martin (photo: Bildarchiv Foto Marburg)

Osten (Chor)

1	*2*	*3*	*4*	*5*	*6*	*7*	*8*	*9*
48	49	50	51	52	53	54	55	*10*
47	56	57	58	59	60	61	62	*11*
46	63	64	65	66	67	68	69	*12*
45	70	71	72	73	74	75	76	*13*
44	77	78	79	80	81	82	83	*14*
43	84	85	86	87	88	89	90	*15*
42	91	92	93	94	95	96	97	*16*
41	98	99	100	101	102	103	104	*17*
40	105	106	107	108	109	110	111	*18*
39	112	113	114	115	116	117	118	*19*
38	119	120	121	122	123	124	125	*20*
37	126	127	128	129	130	131	132	*21*
*36**	133	134	135	136	137	138	139	*22**
*35**	140	141	142	143	144	145	146	*23**
*34**	147	148	149	150	151	152	153	*24**
*33**	*32*	*31**	*30**	*29**	*28**	*27**	*26*	*25**

Süden (Fensterseite) — Norden (Kanzelseite)

Westen (Haupteingang)

7. Schematic rendering of ceiling painting. Zillis, St. Martin (after W. Myss, *Bildwelt als Weltbild. Die romanische Bilderdecke von St. Martin zu Zillis*, Beuron, 1965, fig. 3)

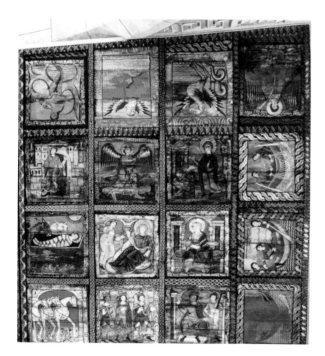

8. Ceiling painting, detail. Zillis, St. Martin (photo: Bildarchiv Foto Marburg)

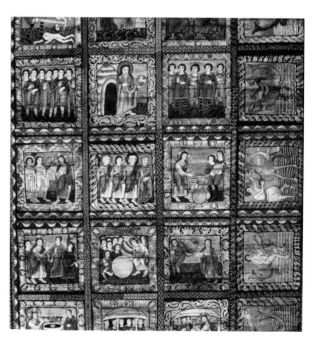

9. Ceiling painting, detail. Zillis, St. Martin (photo: Bildarchiv Foto Marburg)

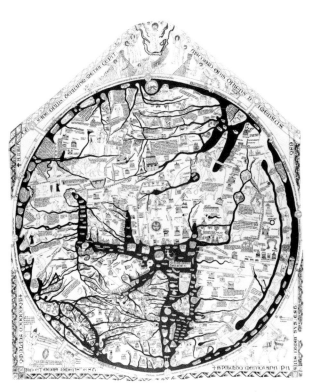

10. Hereford World Map, late thirteenth century. Hereford Cathedral (after B. Hahn-Woernle, *Die Ebstorfer Weltkarte*, Stuttgart, 1987, pl. 20)

11. Ebstorf World Map, around 1235. Ebstorf Cloister (after B. Hahn-Woernle, *Die Ebstorfer Weltkarte*, Stuttgart, 1987, pl. 24)

12. Marcantonio Raimondi, *Quos Ego*, engraving, after 1516

Piero della Francesca's Iconographic Innovations at Arezzo

•

MARILYN ARONBERG LAVIN

PIERO DELLA FRANCESCA'S fresco cycle of the True Cross in San Francesco in Arezzo, dating between 1452 and 1466, is extraordinary from many points of view (Fig. 1).[1] Although it enters into the visual history of this complex set of legendary episodes,[2] there are enough anomalies in Piero's version of the story to claim for it a special place. In this paper I will point out the iconographic innovations in the cycle and show their role in re-shaping the substance and the meaning of the story.[3] There are three monumental representations of the True Cross legend that predate Piero's—Agnolo Gaddi's in Santa Croce, Florence (1388–92), Cenni di Francesco di Ser Cenni's in the Chapel of the Cross, San Francesco, Volterra (1410), and Masolino's in Santo Stefano, Empoli (1424)—and they all place the opening scenes at the top of the right wall. This starting point, surprising in the light of Western reading conventions in fact, follows an Early Christian protocol, passed down from the Roman basilica of St. Peter's itself, where the opening scenes were on the upper tier of the

[1] Some of the observations made here are included in my recent book, *The Place of Narrative: Mural Decoration in Italian Churches, 431–1600 A.D.*, Chicago and London, 1990, not yet published at the time of the Princeton conference.

[2] I discuss the history of this subject matter in ibid., 99–118. The primary iconographical source is the *Legenda Aurea, Vulgo historia lombardica dicta*, ed. Th. Graesse, Leipzig, 1850; trans. and adapted as *The Golden Legend*, by G. Ryan and H. Ripperger, 1941; New York, 1969, compiled from a variety of Greek and Latin apocryphal texts by Jacobus de Voragine about 1265, and arranged according to the Church calendar. Events of the True Cross legend are described under entries for two feast days, the Invention of the Cross, May 3 (pp. 269–76) and the Exaltation of the Cross, Sept. 14 (pp. 543–50). The story, very briefly, follows the wood of the Cross from the time of Adam, when a tree branch is planted over his dead body, to the time of King Solomon, when the wood of the tree gives evidence of miraculous powers, is venerated by the Queen of Sheba and is buried by the king, to the time of Christ when it rises from the bottom of a lake and is used to fashion the Cross. Following Christ's Crucifixion, the Cross is hidden. Three centuries later, under the sign of the Cross, Constantine the Great wins the battle at the Milvian Bridge on the Tiber river, thereby gaining the imperial throne, and makes Christianity the official Roman religion. His mother, Saint Helena, travels to Jerusalem where, through a series of miracles, she finds the Cross relic itself. In the early seventh century, the Cross is stolen by King Chosroes of Persia, and then regained in battle by the emperor Heraclius who, after more miracles, restores the relic to Jerusalem.

[3] All the major monographs on Piero deal with the cycle: R. Longhi, *Piero della Francesca*, 1927; Milan, 1963, 75–86; B. Berenson, *Piero della Francesca or the Ineloquent in Art*, 1950; New York, 1954, 9ff.; K. Clark, *Piero della Francesca*, 1951; London, 1969, 21ff.; L. Venturi, *Piero della Francesca*, Geneva, 1954, 2–92; P. Hendy, *Piero della Francesca and the Early Renaissance*, New York, 1968, 81–91; C. Gilbert, *Change in Piero della Francesca*, Locust Valley, N.Y., 1968, 75–86; E. Battisti, *Piero della Francesca*, Milan, 1971, I, 132–279; II, 19–32; M. Salmi, *La pittura di Piero della Francesca*, Novara, 1979, 62–100.

Diagram A. Florence, Santa Croce, chancel. Disposition of the cycle of the True Cross, Agnolo Gaddi

wall to the right of the altar.[4] Gaddi, who painted the first rendition of the True Cross story on a monumental scale, was also the first artist to introduce scenes of Adam and his family (Fig. 2 and Diagram A). He organized the scenes in a continuous narrative (several moments

[4] This tradition is traced in Lavin (as in note 1), passim.

Diagram B. Arezzo, San Francesco, chancel. Disposition of the cycle of the True Cross, Piero della Francesca

in time within a single frame, set against a unified background), with the episode of Seth speaking to the archangel Michael above, and Adam's Funeral below.

Piero also followed the Early Christian protocol by starting his cycle in the right lunette and he used continuous narrative as well (Fig. 3 and Diagram B). His organization of the scenes, however, was entirely new. Instead of placing the episodes one above the other, he

spread them across the frontal plane, beginning in the right corner and moving toward the left. In the right corner, moreover, he introduced an episode, Adam Speaking to his Children, that had never been seen in painted versions of the legend and was to remain unique in the history of art. In a pose recalling images of the youthful Adam at the time of his creation, the old Adam reclines on the ground, supported by his wife, the equally aged Eve, who leans on a cane. At 930 years of age, Adam is dying; since his children know nothing of suffering and death, he lifts his hand in declamation to explain these mysteries to them. By introducing this scene, Piero gives the story a logical beginning, launching his cycle with a visual meditation on the solemn message that death is a necessary step toward salvation.[5]

Moving from right to left, the narrative next shows Seth speaking to the archangel in the background and then returns to the frontal plane where Adam's funeral takes place. The foreground alignment of isocephalic figures is clearly related to classical sarcophagi. As Seth plants a branch of the Tree of Life over Adam's diagonally placed body, the members of his extensive family (thirty sons and thirty daughters, according to the legend) mourn him in a variety of poses, the multifarious styles of their dress representing societal evolution during the near millennium of their father's life.

While the narrative thus progresses across the field in a linear manner, the true subject of the composition, the huge Tree of Life, stands in the center and fills the upper reaches of the lunette. Although now appearing lifeless and black, the tree was originally covered with masses of green leaves.[6] Decked in triumph, it is emblematic of a fundamental Christian tenet: the paradox of the Fortunate Fall, the *Felix Culpa* of Adam and Eve.[7] Because of the "happy fault," Adam dies, the root of the Cross is planted, and the scheme of man's salvation begins. In the first composition, Piero thus alerted the spectator to the fact that each parcel of the narrative is part of a larger mosaic of significant Christian ideas.

Two scenes from the story of Solomon and Sheba are depicted on the second tier of the right wall. In *The Golden Legend* as well as most of the earlier painted cycles, the duping of Solomon, the Old Testament king known for his wisdom, is a major factor. This conundrum involves Solomon's admiration for the beautiful tree that Seth planted, which he orders to be cut down for use in the palace he is building. As the workmen fulfill their duties, however, the log keeps changing size, and in desperation the king has it thrown across the Siloah pond to serve as a bridge. When Sheba comes on her visit to Solomon, she recognizes the log's holiness and worships it. Later she tells Solomon that a man who will end his kingdom will hang from this wood, and the frightened king, hoping to thwart Sheba's prediction, has the beam buried in a lake.

[5] Cf. the apocrypha called the *Vita Adae*, a legend joined to the Story of the Cross toward the end of the fourteenth century. J. H. Mozley, "Documents, The 'Vita Adae,'" *Journal of Theological Studies*, xxx, 1929, 121–49.

[6] The first to make this observation was E. Borsook, *The Mural Painters of Tuscany, from Cimabue to Andrea del Sarto*, Garden City, N.Y., 1960; Oxford, 1980, 97.

[7] The concept is expressed in the Exultet hymn, which reads in part, "O certe necessarium Adae peccatum, quod Christi morte deletum est! O felix culpa, quae talem ac tantum meruit habere redemptorum!" Cf. H. Weisinger, *Tragedy and the Paradox of the Fortunate Fall*, East Lansing, 1953.

Piero again followed his predecessors in locating the story of Solomon and Sheba on the second tier of the cycle, and, reversing his own reading order in the lunette above, also followed their left-right arrangement. On the left is the scene of Sheba Venerating the Wood (Fig. 4). Sheba and her entourage appear in a landscape of rolling hills. Two grooms, one dressed in gray and red and the other in red and gray, stand in mirror-image poses, guarding an outdoor sanctuary punctuated by two leafy trees. As Sheba kneels to venerate the log, her ladies in waiting gesture in amazement at her miraculous recognition of its holiness.

Rather than presenting next a scene of the Burial of the Wood, as found in other cycles, Piero introduced the Meeting of Solomon and Sheba (Fig. 5). He thus departed from the visual tradition and returned to the biblical sources for Sheba's visit (1 Kings 10, and 2 Chronicles 9), where she comes to test the wisdom of Solomon and is convinced. The encounter took on great significance in Christian theology because Christ himself interpreted it as a prefiguration of the pagan world's recognition of His own divine wisdom (Luke 11:31). Saint Ambrose carried the allusion further, saying: "The Church is a Queen and the meeting of Solomon and the Queen is a great symbol of Christ's marriage to the Church."[8] Piero showed the monarchs clasping hands within a loggia, mythologically grand in scale and decoration. As often observed, Sheba and her ladies-in-waiting are drawn from the same cartoon as the women in the adjacent Recognition scene, with the design reversed. With this ingenious technique not only did Piero weave the extraordinary meeting scene into the narrative, but he also emphasized its equally miraculous quality. The change of plot replaces Solomon's gullibility with handfasting, the sign of the symbolic marriage and equality among monarchs. At the same time, by making Sheba bow lower than Solomon, Piero underscored the king's superior wisdom. In this way he insured Solomon's proper role as an antetype of Christ.[9]

In its position on the second tier of the altar wall, Piero's Burial of the Wood (Fig. 6), though it retains its relation to the Sheba/Solomon episodes, is as far as possible from the figure of the noble king. In fact, besides having lost the usual courtly witnesses, the Burial scene offers a change of mood that I would classify as "comic relief." The burying action is carried out by three earnest but disheveled workmen, who labor together to upend a knotty plank into a pool of water with a rim painted a threatening color of red. In their sweaty struggle, the first shamelessly exposes his genitals. The second, hoisting the plank with the aid of a strut, bites his lower lip. The third, pushing forward and down with his bare hands, wears a mock heroic garland of leaves and berries suggesting drunkenness and lack of wit. In a story populated with great biblical and historical personalities, these men stand out as lowbrow ruffians. If, as is sometimes claimed, the visual configuration conjures thoughts of the Carrying of the Cross,[10] the reference is ironic since it demonstrates the innocence of the truly stupid. The compositional thrust from upper right to lower left directs the eye to the scene diagonally below on the opposite side of the window, which is next in a chronological sense.

[8] From a Homily on Luke 11, by Saint Ambrose, read during the first week of Lent as lesson ii: *The Hours of the Divine Office in English and Latin*, ed. L. J. Doyle et al., Collegeville, Minn., 1963, I, 1530.

[9] L. Réau, *Iconographie de l'art chrétien*, Paris, 1956, II, pt. 1, 186–87.

[10] See Gilbert's contributions and review of this subject (as in note 3), 77–82.

For the Passiontide scenes found in Gaddi's and Masolino's cycles—the Dredging of the Probatic Pool and the Fabrication of the Cross—Piero substituted an unprecedented Annunciation (Fig. 7), the relevance of which he justified under three rubrics.[11] The first is its relation to the opening episode, where Adam reveals the need for a savior; here Gabriel announces the Savior's birth. As Gabriel utters the word *Ave*, the palm frond he proffers to Mary acts as the key to paradise, unlocking the sin of *Eva*. With this same symbol Gabriel also forecasts Mary's own entry into paradise, thus revealing her not only as the Mother of God but also as coredemptress, her death and Assumption being the guarantee of humanity's salvation in the Cross.[12] The Assumption is actually represented on the Crucifix that in all probability originally hung in the chancel of the church.[13]

The second rubric, which I shall discuss below, is Mary's relation to Saint Helena. The third is Mary's relation to the church of San Francesco in Arezzo. Since Mary was the patron of Saint Francis and the Franciscan Order, worshippers who frequented this church on the Feast of the Annunciation were granted an indulgence of forty days. It is possible that a representation of the *Annunziata* was called for by the friars to make this remission visible.[14] Placing the Annunciation in this particular field, moreover, put the three-dimensional Crucifix over the altar in the "correct" chronological position in the narrative—as the nexus—following the last biblical scene and preceding the first scene of Christian history.

The next two episodes—the Dream of Constantine (Fig. 8) and the Victory of Constantine (Fig. 9)—are also extraordinary. They reintroduce Constantine the Great to the story of the Cross for the first time in more than three hundred years, and represent the scenes on a monumental scale previously unknown in the history of art. Medieval scenes of the Dream of Constantine show Constantine, while asleep on the eve of his battle with Maxentius, being informed by a mystic visitor of his coming victory under a cross.[15] Piero not only aggrandized the moment but infused it with a drama that is entirely new. In a blaze of light, an angel streaks in from on high holding a tiny golden cross (now seen only in infrared photographs). The power of the emblem is announced not as a physical presence but as radiance, the fall of the light that follows the angel's flight harmonizing with the descent of the Holy Spirit in the other Annunciation scene, again identified as Divine Illumination. The placement of the two stalwart guards augments the mystery. With one facing out and one facing in, they hide the lacings of Constantine's tent, so that the flaps seem miraculously suspended. The sleeping

[11] The most important study of this subject in this context is that by R. Kahnsitz, "Zur Verkündigung im Zyklus der Kreuzlegende bei Piero della Francesca," in *Schülerfestgabe für Herbert von Einem*, Bonn, 1965, 112–37, on which some of the ideas expressed below depend.

[12] Cf. O. von Simson, "'Compassio' and 'Co-redemptio' in Rogier van der Weyden's Descent from the Cross," *Art Bulletin*, xxxv, 1953, 9–16.

[13] E. Sandberg-Vavalà, *La croce dipinta Italiana*, Verona, 1929, 873–76, fig. 550.

[14] The indulgence was granted in 1298; cf. U. Pasqui, *Documenti per la storia della città di Arezzo (1180–1337)*, Florence, 1916, II, Item 684, 496–97, n. 1 (Arch. Capit. Sinossi Paci, no. 119). For the importance of the Annunciation in Aretine devotion in general, see M. J. Zucker, "Parri Spinelli's Lost 'Annunciation to the Virgin' and Other Aretine *Annunciations* of the Fourteenth and Fifteenth Centuries," *Art Bulletin*, lvii, 1975, 186–95.

[15] See the excellent discussion of representations of this legend in W. Voelkle, *The Stavelot Triptych: Mosan Art and the Legend of the True Cross*, New York, 1980; also A. and J. Stylianou, *In Hoc Vinces . . . , By this Conquer*, Nicosia, Cyprus, 1971.

emperor, lying at the foot of the tent pole, resembles nothing so much as the symbolic figure of the dead Adam, who is often represented in Crucifixion scenes lying at the foot of the Cross.[16] Seated on the platform of the bed, another servant stares out of the picture with a melancholy air; resting his head on his hand, he takes a pose commonly seen on antique sarcophagi and other deathbed scenes.[17] This motif joins the other innovations in the scene to raise it above the level of a narrative. The announcing angel not only brings news of the power behind Constantine's coming victory, but also reveals the concomitant death of paganism and the coming of a new age.

The Victory of Constantine takes up the whole lower tier of the right wall (Fig. 9). The only earlier representations of this historical event (which occurred in 312 A.D.), were small in scale and Gothic in style. On the Stavelot Triptych of the mid-twelfth century, for example, the battle is shown as an equestrian charge, with soldiers dressed like medieval crusaders dashing from the left with lowered lances, and the enemy fleeing off toward the right (Fig. 10). In Arezzo, with the exception of one nervous mount, the army proceeds calmly rightward toward the river Tiber. Astride a white steed at the water's edge, Constantine holds a tiny cross as talisman against the foe. His rival Maxentius scrambles up the opposite bank in the wake of his routed troops.[18] With the introduction of this scene, Piero added three novel visual elements: for the first time, two battles were represented in a cycle of the True Cross, the episode was depicted on a monumental scale and Constantine's victory was shown as a miracle. Bishop Eusebius (264?–349?), Constantine's biographer, had likened the emperor on the water's edge to a new Moses, bringing his people to the promised land of Christianity. For similar reasons, Saint Francis called himself a new Moses and likened his order to a new Exodus.[19] The parallel between Saint Francis and Constantine the Great as Christian heroes would not have been lost on the congregation at San Francesco in Arezzo.

Constantine's virile profile in the center of the Victory scene (Fig. 9) is often said to follow that of the emperor John VIII (Paleologus), as represented on Pisanello's famous medal made around the time of the Council of Ferrara and Florence in 1438/39.[20] Paleologus's plea for help in fighting the Turks heard at this council went unheeded, and fourteen years later, in 1453, the Eastern Empire fell.[21] Within a few years, the Turkish threat to

[16] A reproduction of the well-known Ottonian ivory Crucifixion with Adam in the Metropolitan Museum of Art, New York, is found in A. Goldschmidt and K. Weitzmann, *Die byzantinischen Elfenbeinskulpturen des X.–XIII. Jahrhunderts*, II, Berlin, 1934, pl. II, no. 6.

[17] For example, the scene of the Death of Saint Ambrose in the Branda Chapel, San Clemente, Rome, where, on the platform of the saint's bed, a mourning servant is seated in the same pose; reproduced in Lavin (as in note 1), fig. 146.

[18] Some details are now visible only in the early nineteenth-century watercolor copy by the German painter Johann Anton Ramboux in the Düsseldorf Kunstmuseum; Lavin (as in note 1), fig. 28.

[19] Cf. E. Becker, "Konstantin der Grosse, der 'neue Moses': Die Schlacht am Pons Milvius und die Katastrophe am Schilfmeer," *Zeitschrift für Kirchengeschichte*, XXXI, 1910, 161–71; *St. Francis of Assisi, Writings and Early Biographies, English Omnibus of the Sources for the Life of St. Francis*, ed. M. A. Habig, Chicago, 1973; 4th ed. Chicago, 1983, Celano I, 5, 232–33; and Major Life, chap. XIII, sec. 10, 735; also S. Clasen, "Franziskus, der neue Moses," *Wissenschaft und Weisheit*, XXIV, 1961, 200–208.

[20] See M. Vickers, "Some Preparatory Drawings for Pisanello's Medallion of John VIII Palaeologus," *Art Bulletin*, LX, 1978, 415–25, for a review of the material concerning this bronze medal and its many examples.

[21] D. M. Nicol, *The Life and Legend of Constantine Palaiologos, Last Emperor of the Romans*, New York, 1992.

Italy itself increased and there were many calls for renewed crusades. These events, which were concurrent with Piero's cycle, made visual allusions to them inevitable.[22] However, it should be emphasized that after Islam became a power in the ninth and tenth centuries, all True Cross cycles had undertones of crusade propaganda. The owner of the Stavelot Triptych, for example, promulgated both the Second and the Fourth Crusades.[23] Besides the resonance it had for Franciscan custodial rights over some of the sacred sites in Palestine, an allusion to a living Christian heir to the Roman Empire was most appropriate in a scene of imperial battle. Piero had used the same kind of historical allusion in his 1451 fresco in the Tempio Malatestiano in Rimini: for the representation of the fourth-century Gallic king, Saint Sigismund, he relied on a popular image of the contemporary Western emperor Sigismund.[24] In a Catholic place of worship, however, such political undertones could have only secondary meaning. It was the primary theological meaning of the cycle, I believe, that motivated the changes in iconography we are tracing, and I will return to it at the end of this paper.

When Constantine's mother, Saint Helena, arrives in Jerusalem, she learns that only one man knows where the Cross is hidden, a certain Judas who refuses to tell his secret. Helena has Judas thrown into a dry well; after seven days of torture, he recants and is drawn out. All earlier representations of this episode are small in scale.[25] Piero not only made it large, he also gave it a prominent place on the altar wall, on the second tier to the left of the window (Fig. 11). Furthermore, he introduced two major innovations to the theme. The first, in a comic vein, relies not on the legend illustrations, but on an unlikely source, Boccaccio's *Decameron*. In the hilarious story of Andreuccio da Perugia, the "hero" goes to Naples to buy a horse. After falling in a dung heap, he badly needs a bath. Tomb-robbers lead him to a well where there is usually a rope, a pulley, and a great bucket. Finding the bucket gone, they tie Andreuccio to the rope and let him down. Guards of the watch coming for water are terrified when, instead of a bucket, Andreuccio appears (Fig. 12). In Piero's version, the dandified boys pulling on the rope with a young man attached to it surely recalls this comic situation.[26] The painted scene thus joins its counterpart on the right side of the window in portraying ignorant innocence. In both cases, Giovanni da Piamonte, one of Piero's documented assistants, may have been chosen to do the actual painting for the purpose of portraying low-life types in a style similar to but cruder than Piero's.

[22] C. Ginzburg, *The Enigma of Piero: Piero della Francesca: The Baptism, The Arezzo Cycle, The Flagellation*, trans. M. Ryle and K. Soper, London, 1985, 27–51; originally published as *Indagini su Piero*, Turin, 1981, 15–62, is the most recent in a long line of authors (starting with J. Babelon, "Jean Paleologus et Ponce Pilate," *Gazette des Beaux-Arts*, 6th ser., iv, 1930, 365–75) who find the "Turkish question" one of the main issues of the cycle. See also Lavin (as in note 1), 346, n. 126.

[23] See discussion in Voelkle (as in note 15).

[24] M. A. Lavin, "Piero della Francesca's Fresco of Sigismondo Pandolfo Malatesta before St. Sigismund," *Art Bulletin*, lvi, 1974, 345–74; lvii, 1975, 307, 607; lix, 1977, 421–22.

[25] See the ninth-century Wessobrunner Betebuch manuscript (Stylianou, as in note 15, 179ff.) and a predella scene on the Saint Helen Altarpiece by Michele di Matteo, ca. 1430, Venice Academy, no. 195.

[26] See Giovanni Boccaccio, *Decamerone*, intro. V. Branca, Florence, 1966, I, 118, 124, ills.; see III, 966–68, for bibliography of manuscripts and illustrations. See also V. Branca, *Boccaccio medievale*, Florence, 1981, esp. 402–3.

A more serious note is also struck. An official hauls Judas up by his hair in the same manner as the angel who takes the prophet Habakkuk to a place he does not wish to go. Neither Habakkuk nor Judas yet understands that he is taken by force for a higher good.[27]

The Finding and Proofing of the Cross (Fig. 13), a two-part composition that fills the second tier on the left wall, has much in common with earlier representations, both large and small.[28] On the left, following Judas's directions, Helena finds the crosses. On the right the problem of distinguishing Christ's Cross from the others is resolved when the True Cross raises a dead youth on his bier. The urban setting of this portion of the register follows a version of the legend in which, after destroying a temple on this site, Helena erected a new basilica. The painted church facade behind the figures, which may refer to this future building, certainly is represented in a "future" style, perhaps a premonition of the facade of the new cathedral in Pienza being built at this very period.[29]

In the legend, at the moment the Cross is proofed, the vanquished Devil is heard to shout and cry out. This narrative detail integrates another new element into Piero's episodes: the image of the town of Arezzo, nestling in the saddle of the Tuscan hills, on the left side of the tier. The view of the town alludes to an important miracle Saint Francis performed at Arezzo during a time of bitter intestine fighting. As he approached the town, Francis was saddened to see many devils exulting at the success of their work. At his command, these devils, like the Devil in Jerusalem, fled shouting and crying out.[30]

The same allusion to the Devil overcome is the final element to give relevance to the image of the Annunciation in the cycle. Saint Ambrose, historically the first to report on Helena's finding of the Cross, described the moment when she draws near the relic's burial place. Helena speaks directly to the Devil, saying: "I see what you did, O Devil, in order that the sword by which you were destroyed might be walled up Why did you labor unless that you may be vanquished a second time? As Mary bore the Lord, I shall search for His Cross. As Christ had visited a woman in Mary, so the spirit visited a woman in Helena. Mary was visited to liberate Eve; Helena was visited that Emperors might be redeemed."[31] Thus Ambrose links not only Sheba to Mary and Mary to Eve, but, on this mystical level, he also links Helena to Mary.

In 612 A.D., King Chosroes of Persia stole the Cross and declared himself God. While Agnolo Gaddi included both episodes,[32] Piero omitted the theft and the blasphemy, proceeding directly to the remedy—the military victory won by the emperor Heraclius in 628 A.D.

[27] Habakkuk's transportation is described in *The Golden Legend* (as in note 2, 450; Feast of the Assumption).

[28] See, for example, Agnolo Gaddi's version of the scenes on the right wall, bottom tier of the chancel, in Santa Croce, Florence; Lavin (as in note 1), fig. 87.

[29] Designs for this church were in progress in 1459, when Piero was in Rome working at the Vatican; cf. L. Finelli, *L'umanesimo giovane: Bernardo Rossellino a Roma e Pienza*, Rome, 1984, and C. R. Mack, *Pienza: the Creation of a Renaissance City*, Ithaca, N.Y., 1987. He would have had contact there with Rossellino and may even have had a hand in designing the facade (rather than the other way around), since in Rossellino's oeuvre the design is unique.

[30] See the illustration of this scene in the fresco cycle in the Upper Church at Assisi; Lavin (as in note 1), fig. 159.

[31] *Oratio de Obitu Theodosii*, ed. Sister M. D. Mannix, Washington, D.C., 1925, 59ff., 77ff., delivered on 25 February 395 A.D.

[32] Lavin (as in note 1), figs. 81 and 82.

Rather than representing two knights in single combat clashing on a bridge, as in the story and in Gaddi's cycle, Piero all but filled the right wall lower tier with the clangorous melée of a mass conflict (Fig. 14). The similarity to late antique battles, pointed out by Clark,[33] is amplified by references to chronicles, like the astonishing illustrations of ca. 1350 to the history of Henry VII's Roman campaign.[34] At the same time, allusions to specific Roman monuments—the Arch of Constantine,[35] and the drawing of a famous equestrian statue perhaps representing Heraclius himself[36]—"authenticate" the scene and place it squarely in the official imperial realm in the early centuries of Christendom.

At the right end of the tier, Piero blended allusions to Chosroes's crimes into the Execution Scene. The star-studded canopy over the throne from which he has been removed refers to Chosroes's attempts to rule the workings of the universe. Even more poignant is the reference to the substance of his blasphemy, stated visually through his physiognomic identification with the lofty face of God-the-Father in the Annunciation on the nearby altar wall. Moreover, the evil Eastern king is judged by, in addition to his contemporaries, all future ages, represented by the members of the Bacci family, patrons of the cycle, who stand around the kneeling figure.[37]

The same telescoping of events into a single frame appears in the last scene of the cycle, the Exaltation of the Cross (Fig. 15), which skips up to the lunette at the top of the wall. The Emperor Heraclius, after his victory over Chosroes, attempts to enter Jerusalem in triumph, mounted and in regalia. He is blocked by an angel who has walled up the city gate, admonishing him for his pride. Heraclius then enters as a penitent to return the Cross to its rightful place. Both episodes are seen in Gaddi's cycle: Heraclius on his horse stopped at the gate and Heraclius walking with the Cross.[38] Piero's version, by contrast, shows one unified moment. Heraclius, without his ceremonial clothes, is dressed in simple garments, and he walks on the ground carrying a huge Cross above his head (this figure is badly damaged in the fresco). Unlike other renderings, where close-up views of the gate of Jerusalem are major elements of the scene, Piero sets his scene outside the town. In a deeply receding, almost empty landscape, Heraclius confronts a group of Jerusalemites who have come to meet him: several kneel; one doffs his hat; another rushes along the road. The innovation here is one of Piero's most ingenious. In classical Rome, when the emperor entered a town, citizens paid him homage by coming out to greet him. The farther the people traveled outside their city, the greater respect they showed the emperor.[39] By aggrandizing and isolating Heraclius's entry, and removing it

[33] Clark (as in note 3), 21ff.

[34] F.-J. Heyen, ed., *Kaiser Heinrichs Romfahrt*, Boppard am Rhein, 1965, fol. 10.

[35] As pointed out by A. Warburg, "Piero della Francescas Constantinschlacht in der Aquarell Kopie des Johann Anton Ramboux," *Gesammelte Schriften*, I, Leipzig and Berlin, 1932, 251–54.

[36] As pointed out by M. Vickers, "Theodosius, Justinian or Heraclius?" *Art Bulletin*, LVIII, 1976, 281–82.

[37] Cf. M. Salmi, "I Bacci di Arezzo nel secolo XV e la loro cappella nella chiesa di S. Francesco," *Rivista d'Arte*, IX, 1916–18, 224–37; and Ginzburg (as in note 22), passim.

[38] On the lowest tier of the left wall; Lavin (as in note 1), fig. 83. These events are described in the sixth lesson of the breviary reading for the Feast of the Exaltation of the Cross (14 September), and often illustrated in liturgical manuscripts; Lavin (as in note 1), 321, n. 34.

[39] Cf. E. H. Kantorowicz, "The 'King's Advent' and the Enigmatic Panels in the Doors of Santa Sabina," *Art Bulletin*, XXVI, 1944, 207–31; reprinted in *Selected Studies by Ernst H. Kantorowicz*, Locust Valley, N.Y., 1965, 37–75.

from town, Piero created an *adventus* scene in which deference for the emperor is transformed into adoration for the Cross. By focusing on the emperor of Holy Rome, simply dressed and barefoot, he made Heraclius's act into a prefiguration of discalced poverty, chief among Franciscan virtues.

Piero's innovations throughout the cycle all move the story toward dignity, logical cohesion, and a profound relationship to its Franciscan context. The result is a legend universalized: preparation for the Messiah in patriarchal times, official conversion of the pagans, establishment of the cult of relics, suppression of heresy, and the liberation and protection of the Holy Land. In changing the legend thus, Piero created what amounts to a new story—created, in fact, a "foundation myth" for the Christian State.

Piero's method of expressing more than the traditional narrative has been demonstrated through analysis of the subjects of individual scenes. This entry point, however, is only one of many that would bring about the same results. Indeed, most of my observations came originally from studying not the iconography of the episodes but the disposition of the scenes, that is, the conceptual planning of the narrative order.[40] Comparing Piero's order to that of Gaddi, we see immediately that Piero drastically rearranged the legend's chronology (Diagrams A and B). He also made sets of pairs across the space on every tier of all three walls. He was not alone in making changes in narrative order. In fact, he used a number of standard patterns of arrangement to effect his new organization. Nor was creating sets of pairs across the space Piero's innovation. Internal typology had been in use for more than a hundred years.[41] His cycle is novel only in the exaggeration of his rearrangement and in the consistency and coherence of his pairs, brought about I should emphasize, by the very iconographic changes that have been noted here.

The tension between the irregularity of the narrative order and the symmetrical pairing of the scenes underscores Piero's final point. He characterized the theme of *Gerusalemme liberata* with the rhythms of chivalric narration. At the same time, he expressed his conception of the Christian State's foundation by following Horace's definition of the epic mode: gravity, dignity, and harmonious decorum; variety without clutter; and seriousness blended with humor without disgrace.[42] By elevating the legend in both content and form, Piero showed that under the perpetual ministrations of the Franciscan Order the history of the Cross reveals the vesting of the Christian State with the guardianship of salvation's scheme, and he gave the people of Arezzo a cycle that was both timely and timeless.

[40] See Lavin (as in note 1), 167–94.

[41] Ibid., 30, 65, 116, 128, 149, 189, 198, 306 n. 1, 368 n. 67.

[42] Quintus Horatius Flaccus, *Ars Poetica*, ed. C. D. N. Costa, London and Boston, 1973, 113–34. In the fifteenth century, Horace was taught in schools with regularity (Aristotle's *Poetics* had not yet been recovered, although scholars gleaned what they could about it from the Horatian sources).

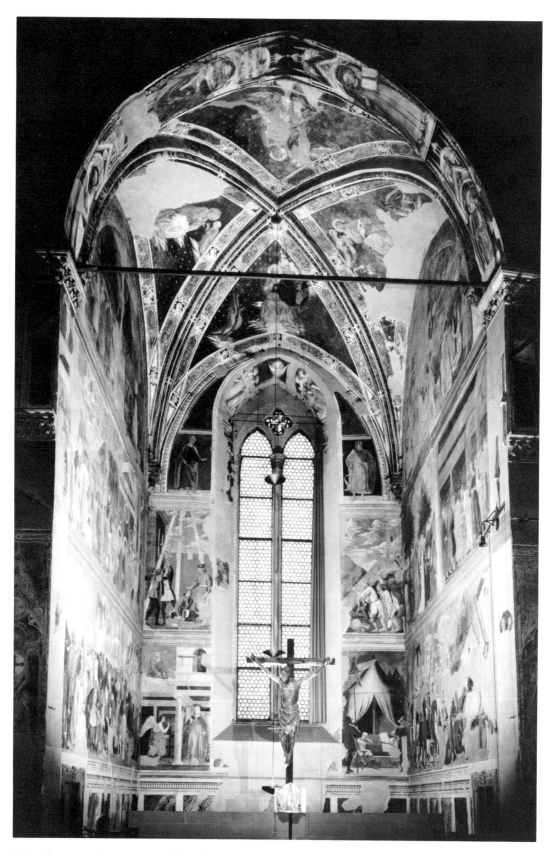

1. San Francesco, Arezzo, general view of chancel (photo: Alinari)

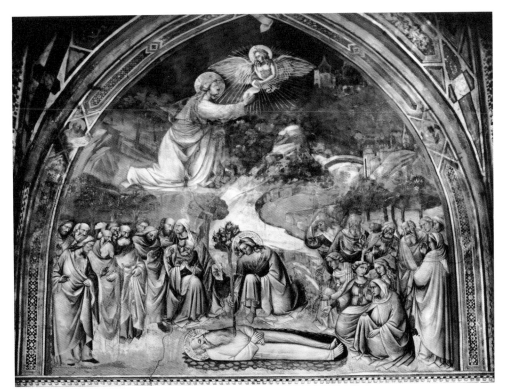

2. Agnolo Gaddi, Story of Adam's Death, 1388–92, Florence, Santa Croce, chancel, right lunette
(photo: Alinari)

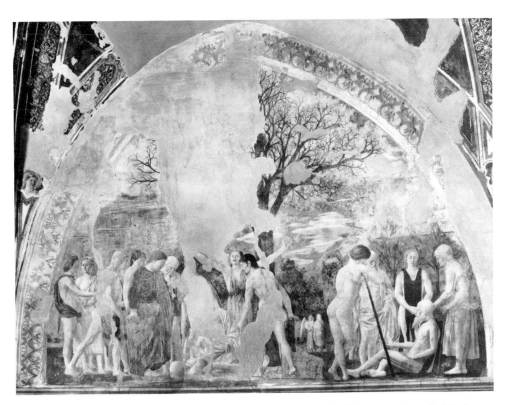

3. Piero della Francesca, Story of Adam's Death, 1452–66. Arezzo, San Francesco, chancel, right lunette
(photo: Soprintendenza per i Beni Artistici e Storici, Florence)

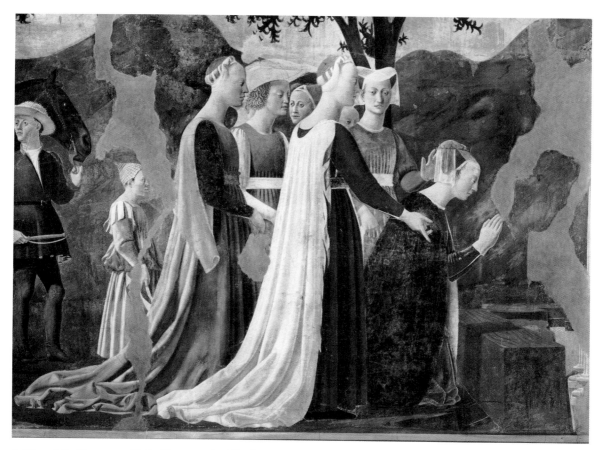

4. Piero della Francesca, Sheba Venerates the Wood, 1452–66. Arezzo, San Francesco, chancel, right wall, second tier left (photo: Soprintendenza per i Beni Artistici e Storici, Florence)

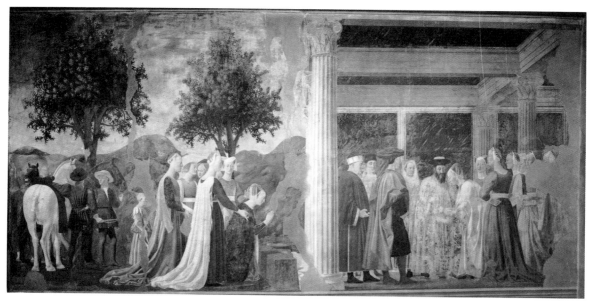

5. Piero della Francesca, The Meeting of Solomon and Sheba, 1452–66. Arezzo, San Francesco, chancel, right wall, second tier right (photo: Soprintendenza per i Beni Ambientali Architettonici, Artistici e Storici, Arezzo)

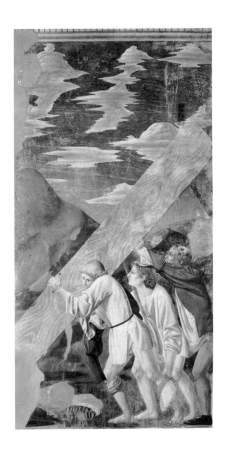

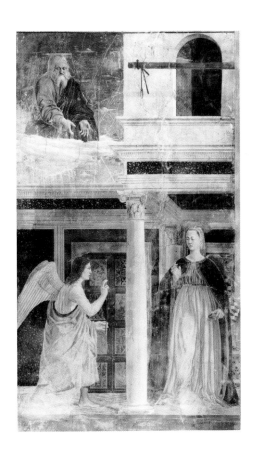

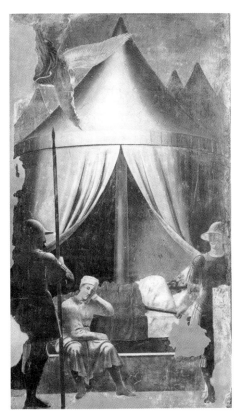

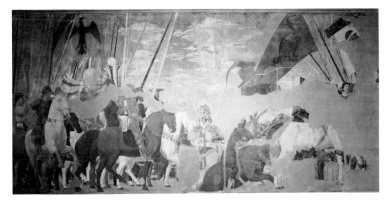

6. (top left) Piero della Francesca and assistant, Burial of the Wood, 1452–66. Arezzo, San Francesco, chancel, altar wall, second tier right (photo: Alinari)

7. (top right) Piero della Francesca, Annunciation, 1452–66. Arezzo, San Francesco, chancel, altar wall, third tier left (photo: Alinari)

8. (bottom left) Piero della Francesca, The Dream of Constantine, 1452–66. Arezzo, San Francesco, chancel, altar wall, third tier right (photo: Soprintendenza per i Beni Ambientali Architettonici, Artistici e Storici, Arezzo)

9. (bottom right) Piero della Francesca, The Victory of Constantine, 1452–66. Arezzo, San Francesco, chancel, right wall, third tier (photo: Soprintendenza per i Beni Ambientali Architettonici, Artistici e Storici, Arezzo)

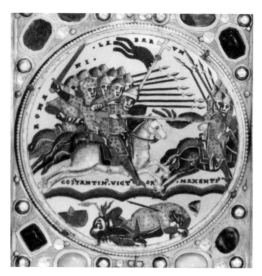

10. *Stavelot Triptych*, detail, The Battle of Constantine, 1130–58, gold and enamel. New York, Pierpont Morgan Library (photo: Pierpont Morgan Library)

12. Illustration of Boccaccio, *Decameron*, Story of Andreuccio, 1492, woodcut. Venice, Stampa di Gregori (photo: courtesy of Vittore Branca)

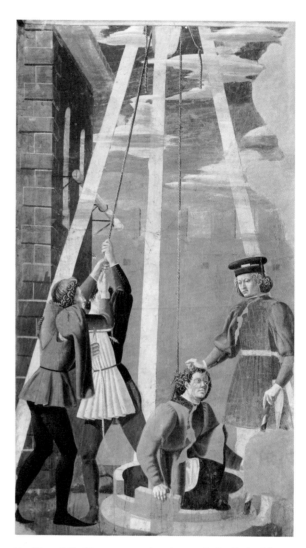

11. Piero della Francesca and assistant, Judas Raised from the Dry Well, 1452–66. Arezzo, San Francesco, chancel, altar wall left (photo: Alinari)

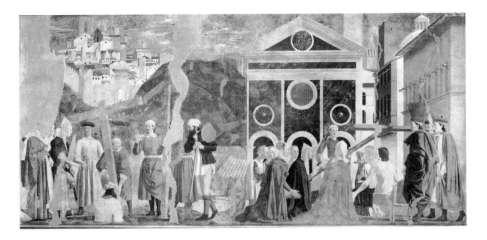

13. Piero della Francesca, The Finding and the Proofing of the Cross, 1452–66. Arezzo, San Francesco, chancel, left wall, second tier (photo: Soprintendenza per i Beni Artistici e Storici, Florence)

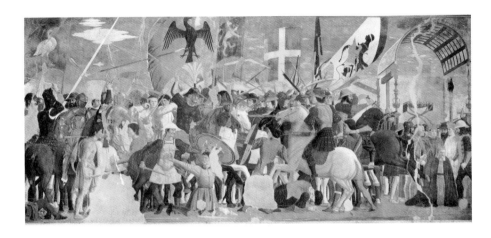

14. Piero della Francesca, The Battle of Heraclius, 1452–66. Arezzo, San Francesco, chancel, left wall, third tier (photo: Soprintendenza per i Beni Artistici e Storici, Florence)

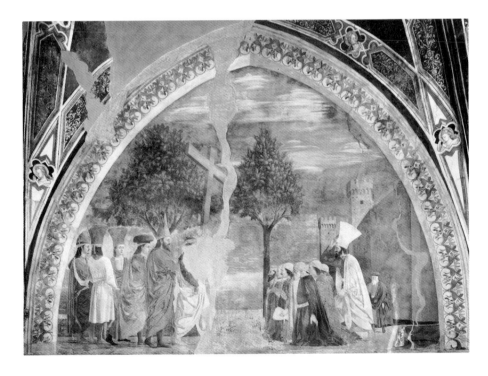

15. Piero della Francesca, The Exaltation of the Cross, 1452–66. Arezzo, San Francesco, chancel, left lunette (photo: Soprintendenza per i Beni Artistici e Storici, Florence)

Miracles Happen: Image and Experience in Jan van Eyck's *Madonna in a Church**

•

CRAIG HARBISON

AT TIMES the world in which Jan van Eyck lived was dominated by miraculous events. And images—panel paintings—often either stimulated or recorded these miracles. In June 1433 heavy rains were ruining the crops around Bologna in north Italy. A member of the city's Council of Elders suggested that a venerable image of the Madonna and Child be brought to town from its shrine on the Guardia hill in order to implore God for an end to the downpour. When the image reached the Porta Saragozza, the rain stopped. Subsequently, the bishop of Bologna, the Blessed Niccolò Albergati, did much to foster the cult of this miraculous image by ordering the procession of the image into the city repeated yearly, although never again with such dramatic effect.[1] I mention Albergati and the Bolognese icon partly because of the frequently magical quality of Renaissance religion,[2] and partly, of course, because of Albergati's connection with Jan van Eyck. It is remotely possible that artist and cleric discussed the behavior of such powerful religious images at the time the cardinal sat to have his portrait painted by the Fleming, an event that most likely took place in 1435 or 1438.[3]

Albergati is not the only possible source for van Eyck's knowledge of miraculous images or icons. We know that Italo-Byzantine panels were coming into northern Europe at this

* Much of the material in this essay is derived from a longer study of van Eyck's works published by Reaktion Books, London, 1991. My thanks to C. Anderson, H. Belting, M. Camille, B. Cassidy, H. Kessler, C. Purtle, H. Sarfatij, and J. Ziegler for helpful comments or information. My research was carried out with the help of a travel grant from the Research Council, University of Massachusetts, Amherst.

[1] For the Bolognese miracle, see, for instance, C. degli Esposti et al., *Bologna, alma mater studiorum*, trans. M. Vecchietti, Bologna, 1988, 193–94; and H. Belting, *Bild und Kult*, Munich, 1990, 384, 407–8 (and fig. 210); for Albergati, see P. de Toeth, *Il Beato Cardinale Niccolò Albergati e i suoi tempi*, I, Viterbo, 1934, esp. 282–87.

[2] For image miracles similar to that at Bologna, see R. Trexler, "Florentine Religious Experience: The Sacred Image," *Studies in the Renaissance*, XIX, 1972, 7–41.

[3] For a recent overview of critical opinion on van Eyck's Albergati portrait, see K. Demus, F. Klauner, and K. Schütz, eds., *Kunsthistorisches Museum, Katalog der Gemäldegalerie, flämische Malerei von Jan van Eyck bis Pieter Bruegel d. Ä.*, Vienna, 1981, 169–73. The identity of the sitter in the Vienna painting as Albergati is doubted by E. C. Hall, "Cardinal Albergati, St. Jerome and the Detroit St. Jerome," *Art Quarterly*, XXXIV, 1968, 2–34; and idem, "More About the Detroit van Eyck: The Astrolabe, the Congress of Arras and Cardinal Albergati," *Art Quarterly*, XXXVII, 1971, 181–201. E. Dhanens, *Hubert and Jan van Eyck*, New York, 1980, 282–91, accepts the date of 1438 recorded in the seventeenth century; see also the earlier discussion by M. Meiss, "'Niccolò Albergati' and the Chronology of Jan van Eyck's Portraits," *Burlington Magazine*, XCIV, 1952, 132–44.

time and were being treated with great veneration, copied and widely circulated.[4] Several of van Eyck's works from the late 1430s, both those lost and those still surviving, reflect this growing interest. For instance, the figural composition of his 1439 *Madonna by a Fountain* (Antwerp, Koninklijk Museum voor Schone Kunsten) is a precise copy of a Madonna *eleousa* type.[5] Van Eyck's small panel was itself copied, carefully and repeatedly, over the course of the century, suggesting that contemporaries thought that it too had spiritual as well as artistic power.[6]

Most of van Eyck's surviving works played a part in the spread of the cult of Mary. The worship of saints was centered on corporeal relics. Since the Virgin's body ascended into heaven, her continuing adoration on earth tended to focus on images, primarily statues, whether old or new.[7] An interesting example is the statue sometimes referred to as Our Lady of the Fountain. In 1403 when Philip the Bold, grandfather of van Eyck's patron, Duke Philip the Good, was fortifying the coast at Dunkerque, a small statue was discovered, and presumed to be of the Virgin.[8] It attracted great devotion and was given its name because of a nearby fountain of pure water; later it became known as Our Lady of the Dunes. Perhaps the story of its discovery helped inspire van Eyck's painting of the *Madonna by a Fountain*. These statues were often initially housed in small shrines, such as the one we see in Rogier van der Weyden's painting in Lugano (Fig. 1).[9] If they were successful miracle-workers, and many of them were, they were soon moved to large edifices, where more elaborate devotion grew up around them.

Three shrines in the area where van Eyck worked are particularly intriguing. Perhaps the most popular was at Boulogne on the coast, unfortunately destroyed in the French Revolution. Duke Philip the Good traveled to Boulogne to worship before the miraculous statue of the Virgin there at least thirteen times during his life, including trips in 1435, 1437, and 1438.[10] At Halle, just south of Brussels, an image of the Virgin had been worshiped since the thirteenth century. The confraternity that was founded in the fourteenth century to honor

[4] The icon brought to Cambrai from Rome in 1440 and in 1454 copied fifteen times for distribution in the Netherlands is discussed by E. Panofsky, *Early Netherlandish Painting*, Cambridge, 1953, 297; see also the earlier study of J. Dupont, "Hayne de Bruxelles et la copie de Notre-Dame de Grâces de Cambrai," *L'Amour de l'art*, XVI, 1935, 360–66.

[5] For the *eleousa* type of icon see the articles by K.-A. Wirth in *Reallexikon zur Deutschen Kunstgeschichte*, IV, Stuttgart, 1958, cols. 1297–1307; and by M. Restle in *Lexikon der Marienkunde*, I, Regensburg, 1967, cols. 1550–54. Dhanens (as in note 3), 295–301; L. Silver, "Fountain and Source: A Rediscovered Eyckian Icon," *Pantheon*, XLI, 1983, 95–104; and P. Vandenbroeck, *Catalogus Schilderijen 14e en 15e eeuw*, Koninklijk Museum voor Schone Kunsten, Antwerp, 1985, 174–78 (no. 411) all discuss the relation between van Eyck's *Madonna by a Fountain* and iconic prototypes. Dhanens, 292–94, also discusses van Eyck's icon-derived depictions of the *Holy Face* that survive in copies dated 1438 and 1440.

[6] See especially the article by Silver (as in note 5).

[7] This point is made by J. Sumption, *Pilgrimage: An Image of Medieval Religion*, London, 1975, 275–80. Certainly remainders of the Virgin's wardrobe (belts, veils, etc.) and her body (milk) were thought to exist and were greatly venerated as well.

[8] J. Toussaert, *Le sentiment religieux en Flandres au fin du Moyen Age*, Paris, 1963, 272.

[9] A recent treatment of this painting is C. Eisler, *The Thyssen-Bornemisza Collection: Early Netherlandish Painting*, London, 1989, 62–73, cat. no. 4.

[10] A. Benoit, "Les pèlerinages de Philippe le Bon à Notre-Dame de Boulogne," *Bulletin de la Société d'Études de la Provence de Cambrai*, XXXVII, 1937, 119–23.

this statue was approved and confirmed by Pope Eugenius IV in 1432.[11] Plenary indulgences were then granted to those who wore medals or carried images honoring Our Lady of Halle. The Church of Our Lady at Tongeren had several medieval statues of the Virgin around which devotion had developed. That did not stop the Confraternity of Our Lady in Tongeren from commissioning a new miracle-working statue in 1479 (Fig. 2), which has overshadowed the earlier ones and is still today the object of great veneration.[12]

These cults often involved account-keeping. Miracles were recorded in large ledgers so that pilgrims could be suitably impressed.[13] Histories of the Virgin's miracles were written.[14] Prayers said to images of the Virgin could affect the weather, save a child's life, or bring a child back to life. The most widespread result of the prayers was less spectacular, more internal or personal. The statue itself could seem to respond—nod, smile, or cry. Saint Catherine was said to have prayed repeatedly before an image of the Virgin (Fig. 3), and then to have been visited by the Virgin herself in the same form she had taken in the image.[15]

Popular prayers often repeated in fifteenth-century devotional books promised specific and varied visions of the Virgin. One of the chief devotional aims of fifteenth-century religious life was to have, through private prayer and meditation, a vision of the divine there and then.[16] Lay women and men in the fifteenth century did not focus on church ritual; they did not routinely observe the sacraments or their other parochial duties. Such things were at a low ebb in the Netherlands.[17] In a period that in many ways was anti-intellectual, lay people did not often concern themselves with the complexities of church doctrine.[18] Rather, they sought experiences that were direct and accessible, in part through the painted imagery which contemporaries created for them.

It should be stressed that, as it exists today, van Eyck's *Madonna in a Church* (Fig. 4) is a fragment, having lost its donor panel.[19] Directed as it is toward the right, the composition

[11] For the cult of the Virgin in Halle, see the publication of the Halle church: *Halle, 700 Jaar Mariastad*, Halle, n.d.; E. H. van Heurck, *Les drapelets de pèlerinages en Belgique et dans les pays voisins*, Antwerp, 1922, 171–78, discusses and reproduces the pilgrims' banners of Halle and other nearby sites; these are also mentioned by Toussaert (as in note 8), 267–68.

[12] *Onze Lieve Vrouw Oorzaak onzer Blijdschap, Causa Nostrae Laetitiae*, Tongeren, 1979, gives a history of the various cult statues at Tongeren.

[13] See, for instance, C. Zika, "Hosts, Processions and Pilgrimages: Controlling the Sacred in Fifteenth Century Germany," *Past and Present*, CXVIII, 1988, 25–64.

[14] See, for instance, the manuscript of the *Miracles de Notre Dame* by Jean Miélot made in Flanders at mid-century for presentation to Philip the Good (Oxford, Bodleian Library MS. Douce 374). Fol. 84v of this manuscript shows the Virgin miraculously catching a falling child on a contemporary Flemish street.

[15] C. Harbison, "Visions and Meditations in Early Flemish Painting," *Simiolus*, XV, 1985, 87–118, esp. 114.

[16] Harbison (as in note 15).

[17] Toussaert (as in note 8); Toussaert is referred to by J. Bossy, "The Counter-Reformation and the People of Catholic Europe," *Past and Present*, XLVII, 1970, 52–53.

[18] For the judgment that the period was anti-intellectual, see G. Constable, "Twelfth-Century Spirituality and the Later Middle Ages," *Medieval and Renaissance Studies*, V (Proceedings of the Southeastern Institute of Medieval and Renaissance Studies, Summer 1969), ed. O. B. Hardison, Jr., Chapel Hill, 1971, 27–60; also G. Leff, "The Fourteenth Century and the Decline of Scholasticism," *Past and Present*, IX, 1956, 30–41.

[19] The most important recent bibliography for van Eyck's painting includes the following: Panofsky (as in note 4), 144–48 and 193–94; E. Herzog, "Zur Kirchenmadonna van Eycks," *Berliner Museen*, VI, 1956, 2–16; Dhanens (as in note 3),

itself suggests the original presence of a donor there. This impression is confirmed by several later surviving copies with their donor panels intact (Figs. 5 and 6). Van Eyck's Virgin, then, is someone's vision. I believe this particular vision is related to the cult of miraculous Virgin statues that I have just described.[20] The image, which is the vivid answer to a pilgrim's prayer, not the visual expression of complex theological doctrine, offers the viewer the delicacy and immediacy of a common—and obsessive—contemporary experience. Such an interpretation of the work is indicated in a number of ways. Let me take the more precise and specific elements first.

In a niche in the rood screen in van Eyck's cathedral is a statue of the Virgin and Child flanked by two lit candles. Several observers have remarked how very like the gigantic foreground figure this small carving is.[21] Perhaps it is not accidental that there are just two pools of light on the floor, paralleling the two candles, leading us to conclude that the full-color Virgin may be a version of the cold stone statue come to life and grown large.[22] Marian cult statues were often adorned with large and ornate crowns. Great masking robes hid their often pathetic and primitive forms underneath. This is true for instance of the miracle-working statue of the Virgin at Halle as well as the 1479 statue at Tongeren (see Fig. 2). The Virgin's crown in van Eyck's work, in point of fact, is unnaturally large, like the ones added to cult statues. And, too, her robe is pulled up and tucked under her left forearm, a feature repeatedly found in earlier sculpture.[23]

In the fifteenth century pennants were also made for pilgrimage sites, and are best preserved today in later renditions.[24] One from Halle shows a gigantic robed and crowned statue of the Virgin floating in the sky above the large Halle church. Fifteenth-century pilgrimage medals show a schematic view of statue, architectural enclosure, and prayerful pilgrims (Fig. 7).[25] Such humble objects give us an idea of the visual culture from which van Eyck's finely calculated painting grew. They demonstrate that in the fifteenth century the visual combination of large Virgin Mary and ecclesiastical building was over and over again associated with a cult statue and its shrine.

316–28; C. J. Purtle, *The Marian Paintings of Jan van Eyck*, Princeton, 1982, 144–56; H. Belting and D. Eichberger, *Jan van Eyck als Erzähler*, Worms, 1983, esp. 146–50.

[20] There is an interesting general discussion of the relation of "image and pilgrimage" in D. Freedberg, *The Power of Images*, Chicago, 1989, 99–135.

[21] See, for instance, Purtle (as in note 19), 149–52.

[22] M. Camille, *The Gothic Idol: Ideology and Image-making in Medieval Art*, Cambridge, 1989, 233–35, discusses the earlier medieval tradition of the miraculous statue seeming to come to life. Camille makes the interesting point that in portrayals of these miracles, medieval artists wanted to make clear that the miraculous apparition was not to be confused with the statue itself; thus the statue is shown still in place while the larger vision of the Virgin appears before it. Van Eyck appears to have had a similar concern.

[23] See, for example, the thirteenth-century ivory statue from Tournai, reproduced in L. Fourez, *Tournai, Ville des Arts*, Tournai, 1978, 38.

[24] See van Heurck (as in note 11) and Toussaert (as in note 8), 267–68.

[25] For the type of pilgrim's medal illustrated in Figure 7, see R. M. van Heeringen, A. M. Koldeweij, and A. A. G. Gaalman, *Heiligen uit de modder, in Zeeland gevonden pelgrimstekens*, Zutphen, 1987, esp. 78–79. Thanks to Herbert Satfatij, Rijksdienst voor het Oudheidkundig Bodemonderzoek, Amersfoort, for this reference.

One detail in van Eyck's panel has never, to my knowledge, been commented upon. On the compound pier to the left of the Virgin (on the Virgin's own right), hangs a large, two-column prayer tablet. Although somewhat in the shadow, it is very much in the foreground of the work. And it does, I think, help us understand the mental process which van Eyck is visualizing. Both later copies of van Eyck's work (see Figs. 5 and 6) include this plaque and in fact give it more prominence. (They do not, on the other hand, imitate van Eyck's pools of light on the floor. Judging, therefore, from the reception of the work, it is the prayer plaque, not the light pools, that should lead to an understanding of the painting's proper religious frame of reference.) The importance of van Eyck's tablet is also suggested by the fact that it is the only noticeable detail in van Eyck's church interior that is not part of the building's structure or of the choir apparatus.

The physical movement of the pilgrim was inevitably meant to be accompanied by specified prayers. Tablets were hung in churches, at pilgrimage sites, with such prayers inscribed on them. Standing before these tablets saying these prayers brought remission of sins and even, the prayers promised, visions of the Virgin. Prayer tablets are found in Rogier van der Weyden's *Seven Sacraments Altarpiece* (Antwerp, Koninklijk Museum voor Schone Kunsten), where a pilgrim genuflects while saying the prayer,[26] and in many other fifteenth-century paintings.[27] In the panel attributed to the later fifteenth-century Master of the Saint Catherine Legend (see Fig. 3), Saint Catherine receives a miraculous visit from the Virgin and Child after saying a prayer inscribed on a nearby tablet.

The original frame of van Eyck's Berlin panel had, at the bottom, a motto extolling the Virgin: FLOS FLORIOLORUM APPELARIS. Running around the other sides was part of a medieval Nativity hymn, which can be translated as: "This mother is the daughter, this father is born, who has heard of such a thing, God born a man."[28] This was followed by ETCET, implying that the spectator was to continue intoning the entire prayerlike hymn. Some other artists at this time inscribed such hymns or prayers—I do not believe that the distinction was a significant one in this case—on the wings of devotional images.[29] The words were to be said in front of the painting, text and image reinforcing each other and creating the same devotional aura. In some cases, we know that prayers thus inscribed were indulgenced, granting them special potency.[30] In fact, the indulgence was at times dependent on saying the prayer in front of the image. I do not know if van Eyck's words were also indulgenced, but the thrust of the combination—inscribed frame and devotional image—is much the same. In any

[26] See Vandenbroeck (as in note 5), 154, with further reference to R. van de Ven, "Het boekbedrijf te Diest gedeurende de 15de en 16de eeuw," in *Handschriften uit Diestse kerken en kloosters* (Diestsche Cronycke, 6), Diest, 1983, 16.

[27] Examples include the center panel of Vrancke van der Stockt's *Cambrai Altarpiece* (Madrid, Prado, no. 1889) and the Campinesque *Annunciation in a Church* (also in the Prado, no. 1915). The large Einsiedeln *Madonna* engraving by the Master E. S., referred to below, has a prayer plaque attached to the outer wall of the shrine (Fig. 10).

[28] See, for instance, M. Meiss, "Light as Form and Symbol in Some Fifteenth-Century Paintings," *Art Bulletin*, xxvii, 1945, 175–81.

[29] Harbison (as in note 15), 102–5, figs. 21, 22, reproduces several of these works.

[30] S. Ringbom, "*Maria in Sole* and the Virgin of the Rosary," *Journal of the Warburg and Courtauld Institutes*, xxv, 1962, 326–30. For indulgenced images in general see also the article by O. Schmitt on "Ablass" in *Reallexikon zur Deutschen Kunstgeschichte*, i, Stuttgart, 1937, cols. 78–81.

case there exists what may be an indulgenced prayer tablet within the painting. The references to words here were clearly meant as an incantation, bringing the cult statue to life, if not also granting an indulgence to the spectator.

Probably the most vital part of a pilgrimage was the visual element itself—to see the holy spot, the venerated relic or image. For many, the notion of sight connected to pilgrimage really meant seeing the sights, in a tourist-like fashion. Proceeding through the landscape, the pilgrim stopped at whatever shrines he encountered along the way. This may help explain why one copy of van Eyck's work shows the donor kneeling in a landscape (see Fig. 6).[31] For others mental pilgrimages were possible: they could stay at home and imagine a pilgrimage journey.[32] Perhaps that is why, in another copy of van Eyck's work, the donor panel shows an abbot kneeling in prayer in his bedroom, fulfilling his pilgrimage while never leaving his comfortable fireside (see Fig. 5).[33] It is impossible to say whether the donor in the landscape or in the interior reflects van Eyck's original conception. Both possibilities cast further light on the pilgrimage theme as well as on the way artists increasingly made up different stories about the donors' lives.

The three greatest painters of the second quarter of the fifteenth century in the Netherlands all went on pilgrimages. Jan van Eyck was sent on a pilgrimage by and for the duke of Burgundy in 1426.[34] Robert Campin was sentenced to a pilgrimage to Provence as penance for adultery in 1432.[35] And in 1450 Rogier van der Weyden joined the throngs of northern European pilgrims, including a large contingent from the court of Burgundy, on a jubilee journey to Rome.[36] In the past, these trips have been studied for the impact they may have had on the painters' style. They demonstrate that artists were full participants in the contemporary fashion for pilgrimage. Their paintings show this as well. I have already mentioned the way Rogier van der Weyden's *Madonna in a Niche* (see Fig. 1) is, like many cult images, set into the side of an existing building to be worshipped by passing pilgrims. Later in the century, Hans Memling showed a prominent, and large, Bruges family spilling into a partially opened religious building to worship an image of the enthroned Virgin and Child

[31] For this work, see *Jan Gossaert genaamd Mabuse*, exhib. cat., Rotterdam, Boymans-van Beuningen Museum, 15 May–27 June 1965, 76–79, cat. no. 7.

[32] B. Dansette, "Les pèlerinages occidentaux en Terre Sainte: une pratique de la 'Devotio Moderne' à la fin du Moyen Age? Relation inédite d'un pèlerinage effectué en 1488," *Archivum Franciscanum Historicum*, LXXII, 1979, 106–33, 330–428. Mental pilgrimages are discussed in general terms by Sumption (as in note 7), 295–302.

[33] For this work, see in general, Vandenbroeck (as in note 5), 125–30.

[34] See, for instance, Dhanens (as in note 3).

[35] For Campin's judicial pilgrimage, the most careful discussion is found in P. H. Schabacker, "Notes on the Biography of Robert Campin," *Mededelingen van de Koninklijk Academie voor Wetenschappen, Letteren en Schone Kunsten van België, Klasse der Schone Kunsten*, XLI, 1980, 3–14. Stylistic evaluation of Campin's pilgrimage is provided by G. Troescher, "Die Pilgerfahrt des Robert Campin, altniederländische und südwestdeutsche Maler in Südostfrankreich," *Jahrbuch der Berliner Museen*, IX, 1967, 100–34; and C. Sterling, "Études Savoyardes I: Au temps de duc Amédée," *L'Oeil*, CLXXVIII, 1969, 2–13.

[36] For Rogier's jubilee year pilgrimage, see T. H. Feder, "A Re-examination Through Documents of the First Fifty Years of Roger van der Weyden's Life," *Art Bulletin*, XLVIII, 1966, 416–31, esp. 430. For a suggestion about the influence of this trip on Rogier's art, see P. H. Jolly, "Roger van der Weyden's Escorial and Philadelphia *Crucifixions* and Their Relation to Fra Angelico at San Marco," *Oud-Holland*, XCV, 1981, 113–26.

(Fig. 8). In the landscape at the sides can be traced the family's journey as they approached the shrine. Coincidentally, standing at the left in Memling's work is the patron of the donor, Saint James of Compostella, with his staff and hat covered with pilgrims' badges. There are many other fifteenth-century images similarly attentive to the pilgrim's experience.

Pilgrims bought badges at their journey's end. Into some of these medals were set small convex mirrors, the magic devices for capturing and taking home the rays emanating from a miraculous cult object.[37] Pilgrims holding up these mirrors before relics can be seen in fifteenth-century woodcuts.[38] Looking in such a mirror was also a perfect way to see a vast interior on a small surface; the curve of the mirror had the effect of drastically condensing the recorded space. Van Eyck's desire to depict a Gothic cathedral on a foot-high panel could have been stimulated by such pilgrims' mirrors. His painting, like the mirror, is a portable memory image, holding the vision on its compact light-filled surfaces forever.

In raising the issue of pilgrims' mirrors, I have entered the realm of what I would call the more intangible features of van Eyck's work, which might be related to what I believe is its theme—the adoration of a cult statue in the context of a pilgrim's journey. How does van Eyck's work stress the ideology of pilgrimage in more general, even elusive ways, especially as it might be espoused or promoted by one of the artist's upper-class patrons?

In the first place, we must take seriously the visual intrigue of the point of view the artist offered us. Unlike the frontality and symmetry of several of his other images of the Madonna and Child (such as the Lucca *Madonna* now in the Städelsches Kunstinstitut, Frankfurt), van Eyck in the Berlin panel presented an angled view. In part, I think this is related to the original diptych format of the work. But it also quite clearly has the result of stressing the forest-like effect of columns, along with the complex, beckoning light effects of the Gothic cathedral. The choir and its gallery and clerestory are raised to create further rhythmic and spatial variety, emphasizing the visual pull of the building. He is intent on representing a compelling physical experience and on heightening its visual appeal.

The light in van Eyck's paintings is invariably a crucial element.[39] Did van Eyck observe in the visible world the light he managed to portray with paint on a panel? The answer is clearly yes. Did he further try to adjust or change this light so that it would no longer be realistic, but deeply, specifically, and intentionally symbolic? The answer to this question is not so clear or easy.

[37] For pilgrims' medals with a place for a small mirror insert, see, for instance, G. Stam, "Souvenirs uit heilige plaatsen," in *Vroomheid per dozijn*, Rijksmuseum het Catharijneconvent, Utrecht, 1982, 7–11, esp. 10, fig. 6; and H. Schwartz, "The Mirror of the Artist and the Mirror of the Devout," in *Studies in the History of Art Dedicated to William E. Suida on His Eightieth Birthday*, London, 1959, 90–105, esp. 101–105, and fig. 14.

[38] Pilgrims' mirrors are analyzed and related to artistic imagery by Schwartz (as in note 37); Schwartz (103, fig. 13) reproduces a woodcut from the Nuremberg *Heiltumbuch* published by Peter Vischer in 1487 (Munich, Bayerische Staatsbibliothek), which shows pilgrims holding up mirrors as relics are displayed. Mirrors on pilgrim's staffs are shown in the woodcut illustrations to the 1504 Lyons edition of Guillaume de Deguileville's *Pèlerinage de la vie humaine*, a work discussed by R. Tuve, *Allegorical Imagery: Some Medieval Books and Their Posterity*, Princeton, 1966, esp. 207, fig. 70. Thanks to Michael Camille for this reference.

[39] It has been plausibly suggested that this is one of the chief developments that can be witnessed over his brief career—an increasingly subtle and complex use of light; see especially L. B. Philip, *The Ghent Altarpiece and the Art of Jan van Eyck*, Princeton, 1971, esp. 116–64.

Many Christian churches are oriented on an east-west axis, the front door facing west, the apse or choir directed toward the rising sun. If van Eyck's church had such an orientation, the light entering from the left in the panel would, at least in the northern hemisphere, be a physical impossibility: the sun would not get high enough in the sky to come in the north windows.[40] But if we allow van Eyck a reasonable knowledge of northern European church buildings, especially in the Netherlands, this striking fact emerges: in two major structures near his home in Bruges, such "northern" light is possible, especially in summer months when daylight is long-lasting. In addition, numerous other smaller churches in the same geographical area face north-south and some of them even face east—backwards.

In Tongeren, the great Gothic cathedral faces southwest, so that afternoon light comes in the left-hand windows of the nave (Fig. 9). At Tournai, the transitional Romanesque cathedral with Gothic choir faces north-west, so that, at least in the summer, morning light again enters the left-hand windows of the nave. In addition, eight parish churches in Tournai were built on a north-south axis and one, St. Quentin, which was built to face the town square, is entered from the east. In all these cases, light can easily enter the left side of the nave. In particular, St. Quentin has been plausibly suggested as influencing van Eyck's other architectural creations, like that of the *Annunciation* (National Gallery, Washington).[41] Thus the kind of "northern" light van Eyck portrayed in the Berlin panel is easily accounted for in the visible world.

A related question has loomed large in previous discussions of van Eyck's image: that is, can the actual edifice represented in this tiny panel be found in the world as well? Many churches throughout Belgium and northern France—from Ghent to Liège and Dijon—have been put forward as the prototype for van Eyck's minute and incredibly detailed interior.[42] The conclusion must be that van Eyck reproduced none, but learned from many of them. It is noteworthy that the great pilgrimage shrines referred to above seemed to have stimulated him most. The raised choir, but not the raised triforium and clerestory, is found at Halle; the gallery running under the clerestory windows occurs at Tongeren (Fig. 9), and so on.

Thus van Eyck's image does not document a single edifice, nor does its light necessarily illustrate a narrow symbolic concept, yet I do not think that we can underestimate the suggestive quality of the light effects in this painting. They are so rich and varied, so visually intriguing, that it would be hard to imagine them as scientifically observed, natural phenomena, alone. We may feel a psychological and emotional similarity between the depicted space and other experiences in the physical world, but there is no absolute correlation between the two. The miniature scale of the work prevents any but the bravest Alice in Wonderland from thinking she could easily enter the painted world. In van Eyck's oeuvre, we also are confronted with precious, enclosing frames. In the case of the *Madonna in a Church*, the original

[40] This is the theory proposed first by Panofsky (as in note 4), 147.

[41] T. Lyman, "Architectural Portraiture and Jan van Eyck's Washington Annunciation," *Gesta*, xx, 1981, 263–71.

[42] Dhanens (as in note 3), 328, mentions the various churches that have been proposed as forming the model for van Eyck's portrayal; as does J. Snyder, "The Chronology of Jan van Eyck's Paintings," in *Album Amicorum J. G. van Gelder*, The Hague, 1973, 293–97, esp. 296, n. 7.

frame, stolen in the nineteenth century, added over five centimeters (about two inches) of molding all around, thus sealing off the small image even more than the modern day, marble-ized, half-sized replacement does.[43]

How can we understand something so vividly realized and yet precious, magical, and ideal in its final impact? Modern critical discourse about Eyckian imagery has given us two extreme attitudes: on the one hand, that of a transformed symbolic realism conveying com-plex church doctrine, on the other, a descriptive realism of particulars. Both views seem to miss the vital center of the artist's work, where visual and psychological experience is mi-nutely particularized but never limited; where something appears that is actual, alive, and real, but at the same time endowed with powers beyond what we—in the twentieth cen-tury—conceive of as ordinary, everyday reality.

One of the most important and intriguing aspects of van Eyck's art is that the artist's reality is neither documentary nor minutely symbolic, but rather in ways generalized and idealized. Why and how is this the case? For the concept of realism in van Eyck's art, we must first of all keep in mind the fact that at this time reality was always potentially magical. There was not, as some have suggested, a "modern" or "stable" reality out there that van Eyck and his contemporaries were bent on capturing first, and then injecting with symbolic meaning. Yet van Eyck and his patrons' view of the world is not to be considered capricious or fantastic. They could consciously form what they were observing while continuing to feel the power of certain magical forces.

There are several ways in which I think we can further explain the phenomenon of van Eyck's idealized realism, especially in relation to the more specific audience for his work: wealthy, socially ambitious individuals such as the artist's known patrons Nicolas Rolin, George van der Paele, and Giovanni Arnolfini. For these men, another of whom no doubt commissioned the *Madonna in a Church*, van Eyck painted elitist images of popular devo-tion. Van Eyck's are not what I am tempted to call quaint votive records of actual miracles appealing to the masses, like, for instance, the Master E. S.'s image of the shrine at Ein-siedeln, Switzerland (Fig. 10).[44]

For van Eyck's patrons, we might also suppose that, in the prevailing climate of reli-gious scepticism, miracles did not often actually happen. The relic of the Holy Blood in Bruges had liquified every Friday in the fourteenth century. In the fifteenth, only occasional miracles were attributed to it.[45] Van Eyck was not painting specific miracles because, in part, in the minds of his patrons, such things existed increasingly as mythic ideals rather than as actual facts.

Still, in his paintings van Eyck's patrons routinely pretend to visionary powers. And their visions are surely meant to have a remote and timeless truth to them, not accessible to everyone. Van Eyck's church is empty: no accidental tourists here, only the noble Virgin

[43] See Dhanens (as in note 3), 325, 390. In more general terms C. Eisler, review of S. Ringbom, *Icon to Narrative*, in *Art Bulletin*, LI, 1969, 186–88, esp. 187, points out the importance of precious enclosing frames in northern art.

[44] For this work, see A. Shestack, *Master E. S.: Five-Hundredth Anniversary Exhibition*, Philadelphia, 1967, cat. no. 67.

[45] See, for instance, Toussaert (as in note 8), 259–65.

serenaded by an angelic choir. Clearly this is a socially elite ideal, both private and carefully regulated by artist and patron. Van Eyck imagines an ideal worldly experience—or, to put it another way, the worldly experience of an increasingly mythic ideal. Miracles do happen, if only rarely, in fifteenth-century Netherlandish art.

1. Rogier van der Weyden, Madonna in a Niche, ca. 1435, panel. Lugano, Thyssen-Bornemisza Collection (photo: Thyssen-Bornemisza Collection)

2. Anonymous Netherlandish artist, Virgin and Child, 1479, wood sculpture. Tongeren, Cathedral (photo: author)

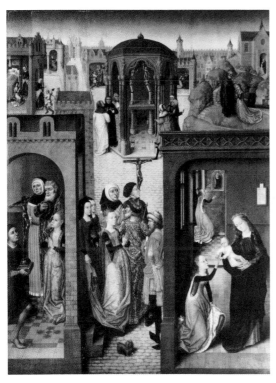

3. Master of the Saint Catherine Legend, Scenes from the Life of Saint Catherine, late fifteenth century, panel. Geneva, private collection (photo: A.C.L., Brussels)

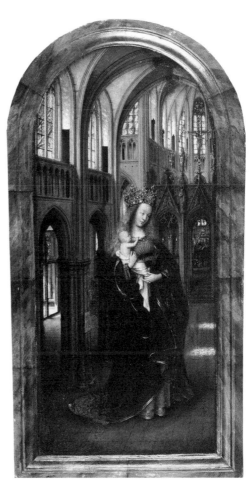

4. Jan van Eyck, Madonna in a Church, ca. 1440, panel. Berlin, Staatliche Museen, Gemäldegalerie (photo: Staatliche Museen)

5. Bruges Master of
1499, Diptych of
Christian de Hondt
Adoring the Virgin,
1499, panels. Antwerp,
Koninklijk Museum
voor Schone Kunsten
(photo: A.C.L.,
Brussels)

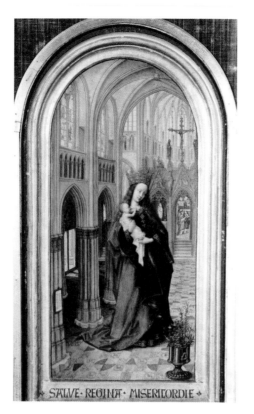
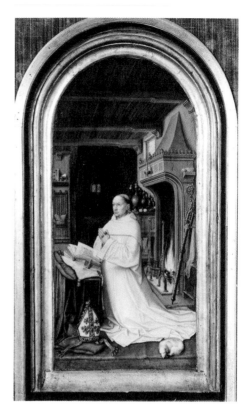

6. Jan Gossaert,
Diptych of Antonio
Siciliano Adoring the
Virgin, ca. 1513,
panels. Rome, Galleria
Doria Pamphilj
(photo: Istituto Cen-
trale per il Catalogo e
la Documentazione,
Rome)

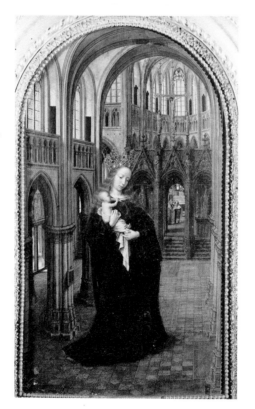

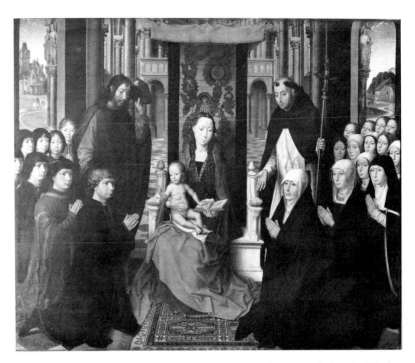

7. Anonymous Netherlandish artist, pilgrim's medal, fifteenth century, from 's-Hertogenbosch. Amersfoort, Rijksdienst voor het Oudheidkundig Bodemonderzoek (photo: R.O.B.)

8. Hans Memling, Jacob Floreins and His Family and Saints Adoring the Virgin, ca. 1485, panel. Paris, Musée du Louvre (photo: Reunion des musées nationaux, Paris)

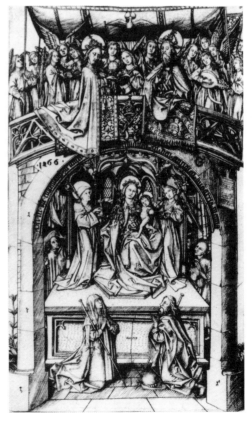

9. Tongeren, cathedral, view of nave, mid-thirteenth century (photo: author)

10. Master E. S., Madonna of Einsiedeln, 1466, engraving (Lehrs 81) (photo: British Museum)

The Annunciation to Christine:
Authorial Empowerment in *The Book of the City of Ladies*

•

V. A. KOLVE

WITHIN medieval studies, at the least, the best defense of iconographic analysis is that it is indispensable: many documents, both visual and verbal, draw upon a code of symbolic meanings as one of their expressive languages, and they cannot be fully understood without some knowledge of it. The large-scale reconstruction of that code—the cataloguing of its images and their multiple, sometimes contradictory, meanings—is essentially complete. It has been one of the major accomplishments of art history in this century. But as this volume bears witness, our use of that knowledge remains problematic in theory and in practice. I am one among a number of literary scholars who have been trying to discover what it might mean to read literature iconographically—to discover how a lively awareness of the symbolic codes shared by literature and the visual arts might guide and enrich our experience of medieval literary texts.[1] In this paper, I wish to approach that question through a specific example, Christine de Pizan's *Le Livre de la Cité des Dames*, written in 1405, and first translated into English in 1521 as *The Boke of the Cyte of Ladyes*.[2]

Christine de Pizan was a woman who made her living by writing—a career essentially without precedent in the earlier centuries. Her patrons included not only the French king

[1] See my *Chaucer and the Imagery of Narrative: The First Five Canterbury Tales*, Stanford, 1984, for an exploration of medieval iconographic theory (chaps. 1, 2, and 8) and a series of iconographic readings (chaps. 3–7) of the kind I offer here for Christine.

[2] I shall quote the English translation by E. J. Richards, *The Book of the City of Ladies*, New York, 1982, and the original French as edited by M. C. Curnow, "The *Livre de la Cité des Dames* of Christine de Pisan: A Critical Edition," Ph.D. diss., Vanderbilt University, 1975; hereafter referred to by their respective titles. They sometimes differ slightly: Richards translates London, Brit. Lib., MS. Harley 4431; Curnow edits Paris, Bib. Nat., MS. fr. 607; see *Book of the City of Ladies*, xlv. Richards's translation is of landmark importance, for it gave modern readers and non-medievalists access to the work for the first time. Christine's original remains unpublished to this day, but a printout of Curnow's edition of the text, valuable as well for its heroic 595-page introduction, can be obtained from University Microfilms International, Ann Arbor, Mich. The modern French translation, by T. Moreau and E. Hicks, Paris, 1986, is more recent still. The English translation made in 1521 by Bryan Anslay, printed by Henry Pepwell (London), has been reprinted in *Distaves and Dames: Renaissance Treatises For and About Women*, ed. D. Bornstein, Delmar, N.Y., 1978.

and queen (Charles VI and Isabel of Bavaria), but many of the greatest nobility of France.[3] Although several of Christine's major projects were translations, in others she is her own first subject, writing herself *into* the work so that her "signature" cannot easily be separated from it. She had good reason, in an age when authors and texts were often separated ("anonymous" being the most prolific of all medieval writers), and texts (knowingly or innocently) misattributed. There are men, she noted sagely, who claim her works must be forgeries, written by clerks or *religieux*, since no woman could be capable of them.[4]

Daniel Poirion said of her example, "For the first time in France, the study of a literary production cannot be separated from the study of the writer. Here, in the true sense of the word, is our first *author*, and that author is a woman In her poetry as well as in her philosophical works, she made a cause of the feminine condition, and her personal experience became a system and a style."[5] Poirion did not overstate the matter: to talk about *The Book of the City of Ladies* we must first talk briefly about Christine's life.[6]

She was born in Venice in 1365, though she did not live in that city long. Her father, Tommaso da Pizzano, a distinguished scholar educated at the University of Bologna, was invited to become physician and astrologer to Charles V of France, and so Christine was raised in Paris—in a court whose king was notably dedicated to books and learning, and with access to the University of Paris during one of its most brilliant periods.

Taking early note of her intellectual gifts, her father educated her as though she were a son, teaching her languages, philosophy, and something of the natural sciences that formed the basis of his own profession. In 1380, when she was fifteen, he married her to the young nobleman Etienne du Castel in what became, by Christine's own account, a happy marriage. But her "misfortunes" began in that same year, for the king died, and her father's place and influence within the court were soon greatly diminished. He himself died sometime in the 1380s, without having provided for his family, and in 1390 her husband died too, apparently of a contagious disease. Thus it came about that Christine found herself widowed at the age of twenty-five, with three children, her mother, and a niece all dependent on her for support. As she wrote later, introducing a poem on Fortune's role in human history (a poem of more than 23,000 lines, composed between 1400 and 1403), she survived only because Fortune, at the moment of her greatest loss, changed her from a woman to a man:[7]

[3] *Book of the City of Ladies* (as in note 2), frontispiece, reproduces from London, Brit. Lib., MS. Harley 4431, fol. 3, the portrait of Christine presenting her collected works to Queen Isabel and other ladies of the court. On fol. 178 of the same MS., she is shown presenting her book to the king.

[4] See *Lavision-Christine: Introduction and Text*, ed. Sister M. L. Towner, Washington, D.C., 1932, 143. For relevant discussion, see D. Bornstein, "Self-Consciousness and Self Concepts in the Work of Christine de Pizan," in *Ideals for Women in the Works of Christine de Pizan*, ed. D. Bornstein, Medieval and Renaissance Monograph Series I, Detroit, 1981, 11–28.

[5] D. Poirion, *Littérature Française: Le Moyen Age, 1300–1480*, Paris, 1971, 206; quoted by C. C. Willard, *Christine de Pizan: Her Life and Works*, New York, 1984, 223.

[6] Willard (as in note 5) offers a foundational study of the life and works; S. Lawson's introduction to her translation of Christine's *The Treasure of the City of Ladies*, Harmondsworth, 1985, provides a brief and accessible account of the life, as does Richards in the introduction to his translation (see note 2).

[7] *Le livre de la mutacion de fortune*, ed. S. Solente, 4 vols., Paris, 1959–66, I, 51–53 (lines 1325–61, 1395–1400). I quote (with some modification) the translation of these verses by Bornstein (as in note 4), 13–14. In *Lavision-Christine* (as in

Then my mistress [Fortune] came toward me,
She who takes joy from many,
And touched me all over my body;
I remember it well, each member
Was caressed and held in her hands.
Then she went away and I remained,
And as our ship sailed
In the waves of the sea
It struck against a huge rock.
I woke up and immediately—
There is no doubting it—
I felt changed all over.
My limbs seemed much stronger than before,
And my earlier sadness and crying had stopped.
I touched myself and was completely astonished.
Fortune, who had so transformed me,
Did not in fact hate me,
For suddenly the great fear and doubt changed
In which I had been so completely lost.
I felt much lighter
Than I was accustomed to,
My appearance was altered and made stronger,
My voice became deeper,
My body, harder and more agile.
But the ring that Hymen had given me
Fell from my finger,
Which saddened me, as well it ought,
For I loved it dearly.
Then I got up easily,
Indulging myself no longer in idle crying—
Crying that had only increased my distress.
I found within myself a strong and hardy spirit,
Which amazed me,
And proved that I
Had become a real man

As you have heard, I am still a man
And have been one now for more than thirteen years.
But it pleased me much more
To be a woman, as I used to be,
When I conversed with Hymen, god of marriage

note 4), 181, written in the same year as *La Cité des Dames*, Christine again wrote of herself as having been changed from a woman to a man.

This quasi-Ovidian metamorphosis—an allegory of the feminine spirit refashioned and regendered—is Christine's way of explaining how she managed to survive as a widow of small means and great responsibilities. To earn a living she turned to writing, first as a professional scribe and then as an author, producing over the next twenty years an extensive body of work in verse and prose, initially devoted to themes of love and grief (the *Cent ballades*) but increasingly concerned with the moral, social, and political condition of France. She dedicated her works to great princes, supervised the production of sumptuous copies for their libraries, and was apparently well rewarded for her efforts. She conceived of herself, with good reason, as a counselor to kings and princes.

The period of Christine's career that most concerns us began in 1399 when she initiated a famous literary debate on Jean de Meun's portion of the *Roman de la Rose*.[8] She was offended by the sometimes vulgar language of the poem—it dares to call testicles "coilles"— but even more by its misogyny and its cynical art of love. Six years later, she completed what many would call her masterpiece, *The Book of the City of Ladies*—a confrontational work that assails the medieval antifeminist tradition as false and unreasonable, dares to locate its origins in the male (rather than the female) character, and opposes to that tradition a small library of counterexamples—the lives of virtuous women.

Though the book is modeled in part on Boccaccio's *De claris mulieribus* (*Concerning Famous Women*, written ca. 1355–59), and draws on it for a great deal of historical material, the authorial "signatures" of the two books differ greatly. As a learned man, humanist by training and temperament, Boccaccio could write his book with easy confidence (Fig. 1),[9] freely recalling the lives of famous women from the classical past, some of them virtuous, some conspicuously not, while choosing to pass over "almost all Hebrew or Christian women among these pagans" since "they could not very well be placed side by side . . . and did not strive for the same goal": Fame or Renown.[10] Boccaccio included *only one* living woman— Joanna, queen of Sicily, his patron and possibly his lover—among the 104 representatives of the sex he brings forward, a strategy of exclusion he defends with witty, misogynous ease: "the number of illustrious [contemporary women] is so small that I think it more suitable to come to an end here rather than proceed."[11]

For all her learning, there was no way Christine de Pizan could write a revisionist book about women out of a posture as casually confident as Boccaccio's. Until very recently, as Sandra Gilbert and Susan Gubar have suggested, the chief concern of women writers has

[8] On the debate, see, e.g., E. McLeod, *The Order of the Rose: The Life and Ideas of Christine de Pizan*, Totowa, N.J., 1976, chap. 6, and for its texts, E. Hicks, ed., *Le débat sur le Roman de la Rose*, Paris, 1977; they are translated by J. L. Baird and J. R. Kane, *La Querelle de la Rose: Letters and Documents*, North Carolina Studies in Romance Languages and Literatures, Chapel Hill, N.C., 1978.

[9] On this manuscript, see M. Meiss, *French Painting in the Time of Jean de Berry: The Limbourgs and Their Contemporaries*, 2 vols., London, 1974, I, 287–90, and II, fig. 6 (in color).

[10] Giovanni Boccaccio, *Concerning Famous Women*, trans. G. A. Guarino, New Brunswick, N.J., 1963, from the author's preface, xxxviii.

[11] Ibid., 251 (from the conclusion). Boccaccio dedicated his book to Andrea Acciaiuoli, countess of Altavilla, with similarly fulsome praise, xxxiii–xxxv, declaring her second only to Queen Joanna. Only five of the 104 chapters concern women of the Christian era, the last of them being devoted to the queen (ibid., 248–50).

been less a Bloomian "anxiety of literary influence" than an anxiety concerning the act of authorship itself.[12] From within a culture that regarded literacy as basically a masculine prerogative—Christine's own mother had opposed her education[13]—Christine de Pizan had to fashion herself as author twice over: as a *female* author first, simply in order to survive, and then, in *The Book of the City of Ladies*, as a *feminist* author, determined to express a woman's truth.[14] To justify such revolutionary ambition, she needed a mandate—if not literally divine (as in the case of Saint Matthew [Fig. 2] or Saint Luke in the *Très Riches Heures*, owned by her patron, the Duke of Berry), at least something cognate to that suggested by the dove and the rays of light within those portraits of evangelists.[15] And so in the opening chapters of *The*

[12] S. Gilbert and S. Gubar, *The Madwoman in the Attic: The Woman Writer and the Nineteenth-Century Literary Imagination*, New Haven, 1979, quoted by M. Quilligan, "Allegory and the Textual Body: Female Authority in Christine de Pizan's *Livre de la Cité des Dames*," *Romanic Review*, LXXIX, 1988, 222–48, a powerful essay on Christine's presentation of the female body and her rewriting of material derived from three great masculine *auctores*: Jean de Meun, Boccaccio, and Vincent de Beauvais. See also M. Quilligan, *The Allegory of Female Authority: Christine de Pisan's 'Cité des Dames'*, Ithaca, 1991. On Christine's empowerment of herself as author, see also three distinguished essays by K. Brownlee: "Discourses of the Self: Christine de Pizan and the *Rose*," *Romanic Review*, LXXIX, 1988, 199–221; "Structures of Authority in Christine de Pizan's *Ditié de Jehanne d'Arc*," in *Discourses of Authority in Medieval and Renaissance Literature*, ed. K. Brownlee and W. Stephens, Hanover and London, 1989, 131–50, on Christine's self-identification with prophet and sybil figures; and, "Martyrdom and the Female Voice: Saint Christine in the *Cité des Dames*," in *Images of Sainthood in Medieval Europe*, ed. R. Blumenfeld-Kosinski and T. Szell, Ithaca, 1991, 115–135, which Professor Brownlee allowed me to see in manuscript. This third essay focuses on the martyred saint after whom Christine was named, whose life she wrote at unusual length and with some unusual emphases in Part III of the *Cité*.

[13] In a moving passage, Lady Rectitude says to Christine, "Your father, who was a great scientist and philosopher, did not believe that women were worth less by knowing science; rather, as you know, he took great pleasure from seeing your inclination to learning. The feminine opinion of your mother, however, who wished to keep you busy with spinning and silly girlishness, following the common custom of women, was the major obstacle to your being more involved in the sciences." To which Christine replies, "Indeed, my lady, what you say is as true as the Lord's Prayer," *Book of the City of Ladies*, 154–55; *Livre de la Cité des Dames*, 875–76.

[14] There are obvious problems in awarding Christine the honorary title of "feminist" in any full, modern sense of that word. She was an orthodox medieval Christian; she was not against marriage; she believed that women married to "peaceful, good, and discreet husbands" might appropriately be subject to their will, "for sometimes it is not the best thing for a creature to be independent"; and she counseled those unfortunate women married to unredeemably "cruel, mean, and savage" husbands to practice the virtue of patience and thereby earn merit for their souls. (See *Book of the City of Ladies*, 255, from Christine's concluding address to the ladies of the city.) But as B. Gottlieb put it in "The Problem of Feminism in the Fifteenth Century," in *Women of the Medieval World: Essays in Honor of John H. Mundy*, ed. J. Kirschner and S. F. Wemple, Oxford, 1983, 341, that question must involve more than simply asking "whether Christine de Pisan had the same ideas as Gloria Steinem." What cannot be doubted is that Christine was "pro-womanist" in powerful, revolutionary ways, and invented *on her own* a significant portion of the modern critique of misogyny. The following passage, for instance, makes clear Christine's understanding of gender as a social construct, and of the way victims often internalize the voices of their oppressors. Lady Reason rebukes Christine's despair with these words: "You resemble the fool in the prank who was dressed in women's clothes while he slept; because those who were making fun of him repeatedly told him he was a woman, he believed their false testimony more readily than the certainty of his own identity. Fair daughter, have you lost all sense?" *Book of the City of Ladies*, 6; *Livre de la Cité des Dames*, 622–23. For other views on Christine's contested feminism, see, e.g., F. D. Kelly, "Reflections on the Role of Christine de Pisan as a Feminist Writer," *Sub-stance*, II, 1972, 63–71; J. Kelly, "Early Feminist Theory and the *Querelle des Femmes*, 1400–1789," *Signs*, VIII, 1982, 4–28; R. Blumenfeld-Kosinski, "Christine de Pizan and the Misogynistic Tradition," *Romanic Review*, LXXXI, 1990, 279–92.

[15] Figure 2, illuminated by the Limbourg brothers, is reproduced in color in *The Très Riches Heures of Jean, Duke of Berry*, ed. J. Longnon and R. Cazelles, New York, 1969, pl. 16; for Saint Luke (also with rays of light and a dove) see pl. 17, and for Saint John (his divine authority differently signified) pl. 15.

Book of the City of Ladies, Christine invented a fiction to empower herself as author—a fiction quite astonishing in its brilliance and daring. Read iconographically, it has more to tell us than literary criticism, traditional or feminist, has so far understood.

Modern readers (apparently) have taken that fiction to be a straightforward personification allegory, its action fully illustrated in Figure 3, from the manuscript Christine prepared and presented to Queen Isabel sometime around 1410.[16] The story can be summarized as follows. One day, as Christine is seated among her books, troubled by her reading of the *Lamentations* of Mathéolus, a harsh satire against women, she finds herself suddenly visited by three women whose shining radiance fills the room with light. They identify themselves as Reason, Rectitude, and Justice, and each holds a symbolic object: Lady Reason, a mirror that confers self-knowledge as well as knowledge of the natural world; Lady Rectitude (*Droitture*), a shining ruler that separates right from wrong, good from evil, and fosters peace; and Lady Justice, a golden vessel from which she measures out what is deserved.

These ladies speak graciously to Christine, telling her they've come to rescue her and all women from the lies men speak against them, and to charge her with a specific task: to build a city as a defense and refuge for the feminine sex. They promise their assistance. Reason will help clear the land, dig the foundations, and raise the outer walls. Rectitude will help lay out the inner city, creating palaces, houses, public buildings, streets, and squares. And Justice will help complete the whole, constructing "the high roofs of the towers and of the lofty mansions and inns which will all be made of fine shining gold," populating them "with worthy ladies and the mighty Queen whom I will bring to you," and then placing "the keys in your hands."[17]

The stones from which the city is to be built are the lives of good women—"lives" quarried from prehistoric myth, classical history, Christian hagiography, and even Christine's contemporary France. Not every woman will qualify for entry:[18] to discuss all women as evil, Christine tells us, is a masculine error, not to be countered by an equally false generalization

[16] London, Brit. Lib., ms. Harley 4431, contains 29 separate works by Christine, and is the fullest collection of her revised writings. It is written entirely in her own hand, and its illumination was devised and directed by her. On this and the related manuscripts, see S. L. Hindman, *Christine de Pizan's 'Epistre Othéa': Painting and Politics at the Court of Charles VI*, Pontifical Institute Mediaeval Studies and Texts 77, Toronto, 1986, xix–xx, 15–16, and passim; also G. Ouy and C. Reno, "Identification des autographes de Christine de Pizan," *Scriptorium*, xxxiv, 1980, 221–38. Meiss (as in note 9), I, 8–41, 290, and II, figs. 1–155, offers a fundamental study of the painters and picture-cycles associated with Christine's works. See also C. Sterling, *La peinture médiévale à Paris 1300–1500*, I, Paris, 1987, 286–95 (on the *Cité des Dames* Master) and 310–17 (on the *Epître* Master). For other versions of the opening picture, see Meiss (as in note 9), II, figs. 35–37, and for a detail of the ms. Harley 4431 version in color, the front cover to *The Book of the City of Ladies* reproducing the stone-laying scene only. J. Dupont and C. Gnudi, *Gothic Painting*, New York, 1979, 158, reproduce in color the full, equivalent miniature from Paris, Bibl. Nat., ms. fr. 607, fol. 2.

[17] *Book of the City of Ladies*, 14; "et sera mon office de faire les haulx combles des tours et des souveraines menssions et heberges qui tous seront faiz de fin or reluysant. Et la te peuppleray de dignes dames avec la haulte Royne que je t'y amenray . . . et les clefs entre tes mains livreray," *Livre de la Cité des Dames*, 637. In that last detail, Christine imagines for herself an office parallel to that of Saint Peter, keeper of the keys of heaven.

[18] "For the walls of the city will be closed to those women who lack virtue," *Book of the City of Ladies*, ll; "car a celles ou vertu ne sera trouvée, les murs de nostre cité seront forclos," *Livre de la Cité des Dames*, 630.

that all women are good.[19] But by bringing together the histories of women who are remembered for strength, courage, high-mindedness, and goodness—the book's composite definition of feminine virtue—Christine asserts against Boccaccio's model the *continuity* of virtue in women's lives, from earliest times to the very moment of her writing.[20] The work may be said to authorize itself by a transcendent fiction: three allegorical ladies demand that it be written.

Literary critics have rarely done more with the opening scene and its three-fold conversation than summarize it, as I have done here. Some have briefly likened it to the opening of *The Consolation of Philosophy*, where Lady Philosophy visits Boethius in prison and offers him consolation.[21] Others have referred in passing to Christine's predilection, apparent in several of her works, for dividing complex ideas into three and creating a spokesperson for each of those parts. And Earl Jeffrey Richards has suggested a likeness to the "three blessed ladies" (*tre donne benedette*) of *Inferno* 2.124 whose intercession brought Virgil to Dante as his guide.[22] But I think a better model for Christine's invention is at hand, a model that engages her own concerns more deeply.

To approach it we must return to the opening of the text itself, which is full of iconographic detail customarily passed over in critical summaries. First, I wish to focus upon Christine's despair, in which she broods upon the misogyny of men's books, and comes near to complicity with the judgment they issue on her sex.[23] All the philosophers, poets, and orators she has read, she tells us, seem agreed on a single conclusion: "that the behavior of women is inclined to and full of every vice."[24] Examining her own character against that charge, and calling to mind many other women "whose company I frequently kept, princesses, great ladies, women of the middle and lower classes," she knows that is not true. But

[19] Lady Reason says to Christine, "there is nothing which should be avoided more than an evil, dissolute, and perverted woman, who is like a monster in nature, a counterfeit estranged from her natural condition But I can assure you that these attacks on all women—when in fact there are so many excellent women—have never originated with me, Reason," *Book of the City of Ladies*, 18; "il ne soit chose en ce monde qui plus face a fouyr, a droite verité dire, que fait la mauvaise femme dissollue et perverse si comme monstre en nature, qui est chose contrefaitte et hors de sa propre condicion naturelle Mais de blasmer toutes, ou tant en a de tres excellentes, je te promés que ce ne vint doncques de moy," *Livre de la Cité des Dames*, 642–43. There is a Boccaccian antecedent to this defense, in *Filocolo*, V, 8, with Boccaccio presenting himself (Idalogo) as a voice in need of (self-)correction.

[20] See *Book of the City of Ladies*, Bk. I, chaps. 13, 41, and Bk. II, chaps. 67, 68, for some contemporary French women.

[21] E.g., Richards, in *Book of the City of Ladies*, 260 ("Notes on the Text").

[22] Ibid. Richards refers to that moment in the journey up the mountain when Virgil encourages the weary Dante by telling him how Beatrice, prompted by Saint Lucy and the Virgin Mary, had visited him in Limbo and requested that he go to Dante's aid. As a source this is not implausible, for Christine revered Dante's learning and genius—she was among the first in France to adapt passages from the *Commedia* in her own work. But the parallel is structurally inexact. In Dante's poem the three "blessed women" do not inhabit the same heavenly space at the same time (the Virgin summons Lucy to her, then sends Lucy to Beatrice), nor do they as a trio confront Dante directly: Virgil is his sole interlocutor and guide. For illuminations showing the three ladies, see *Illuminated Manuscripts of the Divine Comedy*, 2 vols., ed. P. Brieger, M. Meiss, and C. S. Singleton, Princeton, 1969, II, pls. 47–52, and for commentary, I, 118–19. R. Jacoff and W. A. Stephany, *Inferno II*, in the *Lectura Dantis Americana* series, Philadelphia, 1989, 20–56, offer a discerning study.

[23] Christine's despondency is well depicted in London, Brit. Lib., MS. Add. 20698, fol. 70, illustrating *De Stede der Vrouwen*, a late fifteenth-century Flemish translation of the *Cité*; reproduced by Quilligan, "Allegory" (as in note 12), 244 (fig. 4). I emend the Flemish title, following Curnow's intro., *Livre de la Cité des Dames*, 300–301.

[24] *Book of the City of Ladies*, 4; "mais generaument aucques en tous traittiez philosophes, pouettes, tous orateurs desquelz les noms seroit longue chose, semble que tous parlent par une meismes bouche et tous accordent une semblable conclusion, determinant les meurs femenins enclins et plains de tous les vices," *Livre de la Cité des Dames*, 618.

the calumny has exhausted and overwhelmed her. Internalizing the masculine view of women, she finds herself questioning the goodness and justice of God.

> I finally decided that God formed a vile creature when He made woman, and I wondered how such a worthy artisan could have deigned to make such an abominable work which, from what they say, is the vessel as well as the refuge and abode of every evil and vice. And as I was thinking this, a great unhappiness and sadness welled up in my heart, for I detested myself and the entire feminine sex, as though we were monstrosities in nature. And in my lament I spoke these words: "Oh, God, how can this be? For unless I stray from my faith, I must never doubt that Your infinite wisdom and most perfect goodness ever created anything which was not good And how could it be that You could go wrong in anything? Alas, God, why did You not let me be born in the world as a man, so that all my inclinations would be to serve You better, and so that I would not stray in anything and would be as perfect as a man is said to be? But since Your kindness has not been extended to me, then forgive my negligence in Your service" I spoke these words to God in my lament . . . and in my folly I considered myself most unfortunate because God had made me inhabit a female body in this world.[25]

This long opening lament suggests the work will take the form of a theodicy,[26] an attempt to explain why a just and omnipotent God allows evil to exist. But with great originality Christine narrows the focus of that question to woman alone—why was woman created thus?—and does so initially out of a strategic surrender to the misogynist tradition. How, she asks, is she to reconcile the creature she is told she is with her love for God and her belief in his goodness?

Her suffering is *first* answered by an event illustrated only in two later manuscripts of the work, neither executed under Christine's personal supervision (Fig. 4),[27] but an event nonetheless made vivid *to the mind's eye* of any reader/listener by Christine's text itself:

[25] *Book of the City of Ladies*, 4–5; "Et en conclusion de tout, je determinoye que ville chose fist Dieux quant il fourma femme, en m'esmerveillant comment si digne ouvrier daigna doncques faire tant abominable ouvrage qui est vaissel, au dit d'iceulx, si comme le retrait et herberge de tous maulx et de tous vices. Adonc moy estant en ceste penssee, me sourdi une grant desplaisance et tristesce de couraige en desprisant moy meismes et tout le sexe feminin, si comme ce fust monstre en nature. Et disoye telz parolles en mes regraiz: / 'Ha! Dieux, comment puet cecy estre? Car se je ne erre en la foye, je ne doy mye doubter que ton inffinnie sapience et tres parfaitte bonté ait riens fait que tout ne soit bon? Ne fourmas tu toy meismes tres singulierement femme, et des lors luy donnas toutes telles inclinacions qu'il te plaisoit qu'elle eust? Et comment pourroit ce estre que tu y eusses en riens failly? . . . Helas! Dieux, pourquoy ne me faiz tu naistre au monde en masculin sexe, a celle fin que mes inclinacions fussent toutes a te mieulx servir et que je ne errasse en riens et fusse de si grant parfeccion comme homme masle ce dit estre? Mais puisque ainsi est que ta debonnaireté ne se est de tant estandue vers moy, espargnes doncques ma negligence en ton service, biaux sire Dieux' Telz parolles et plus assez tres longuement en triste penssee disoye a Dieu en ma lamantacion, si comme celle qui par ma foulour me tenoye tres malcontente de ce qu'en corps femenin m'ot fait Dieux estre au monde," *Livre de la Cité des Dames*, 619–21.

[26] A view expressed before me by S. Delany, *Writing Woman*, New York, 1983, 186.

[27] On this manuscript see *Livre de la Cité des Dames*, 424–34, with this miniature discussed, 426–28. A similar illustration was made for Brussels, Bibl. Roy., MS. 9235, fol. 5ab, ca. 1450–82 (ibid., 408–23, with this illustration described 412–13, 428), in which the ray of light descends from the ceiling. It is reproduced by L. Schaefer, "Die Illustrationen zu den Handschriften der Christine de Pizan," *Marburger Jahrbuch für Kunstwissenschaft*, x, 1937, 119–208, fig. 126, though the ray of light cannot be seen in the monochrome plate. I discuss these alternative miniatures (Figs. 3 and 4) more fully in the Afterword to this essay.

So occupied with these painful thoughts, my head bowed in shame, my eyes filled with tears, leaning on the pommel of my chair's armrest, I suddenly saw a ray of light fall on my lap, as though it were the sun. I shuddered then, as if wakened from sleep, for I was sitting in a shadow where the sun could not have shone at that hour. And as I lifted my head to see where this light was coming from, I saw three crowned ladies standing before me, and the splendor of their bright faces shone on me and throughout the entire room.[28]

This is the crucial moment of vision, the turning point for the entire work, but if we read it solely *ad litteram* we will underestimate entirely the claim it makes. The scene must be read iconographically, by which I mean we must imagine it vividly, then search our memory for other pictures and texts like it, whose meaning is stipulated or traditional, and finally re/consider the scene in the light of that tradition. Likeness is essential to such a congruence of images,[29] but differences matter as well.

For at this moment, surely, and as other details soon will confirm, the subtext behind Christine's text—the picture behind Christine's literary "picture"—is the Annunciation to the Virgin Mary. That event, too, came in the nature of an epochal intervention, breaking into a long history of sin, error and despair—the history of the world since the Fall. In the visual arts it is signaled by a few miraculous rays of light falling upon the woman chosen to bear the Redeemer, ending the Age of Vengeance, beginning the Age of Mercy.[30] In many representations of the scene, as in Figure 5, from the *Belles Heures* of the Duke of Berry,[31] rays of light, emanating from God the Father, enter the Virgin's room in a way no natural light could possibly enter (here through the roof); the Holy Ghost, as a dove, flies down those rays to overshadow the Virgin and engender the Son. Other representations, as in Figure 6, from the same duke's *Très Riches Heures*,[32] "naturalize" the light by showing it enter through a window, though that light radiates from God the Father rather than from the sun and carries symbolic meaning of its own. It was a commonplace of popular devotion that just

[28] *Book of the City of Ladies*, 6; "En celle dollente penssee ainsi que j'estoye, la teste baissiee comme personne honteuse, les yeulx plains de larmes, tenant ma main soubz ma joe acoudee sur le pommel de ma chayere, soubdainement sus mon giron vy descendre un ray de lumiere si comme se le soleil fust. Et je, qui en lieu obscur estoye, ouquel a celle heure soleil rayer ne peust, tressailly adoncques si comme se je feusse resveillee de somme. Et dreçant la teste pour regarder dont tel lueur venoit, vy devant moy, tout en estant, trois dames couronnees, de tres souveraine reverence, desquelles la resplandeur de leurs cleres faces enluminoit moy meismes et toute la place," *Livre de la Cité des Dames*, 621–22.

[29] See Kolve (as in note 1), chap. 1, for evidence from medieval faculty psychology supporting this emphasis on *texts* as well as pictures in discussing the data-bank of literary iconography.

[30] On the medieval periodization of world history in terms of the "three advents" of God, see V. A. Kolve, *The Play Called Corpus Christi*, Stanford, 1966, 58–59 (the first when he came to make man, the second when he came to redeem man, the third when he will come to judge man), and 97–98 on an alternative scheme, the "three times" (the time of natural law, from Adam to Moses; the time of written law, from Moses until the birth of Christ; the time of mercy, from that birth until the end of the world). As Elizabeth says to Zachariah in the N-Town Cycle, just after her Visitation from the pregnant Mary, "ffor now is cum mercy and venjauns is past / God wyl be born for mannys prow / to brynge us to blysse þat euer xal last," *Ludus Coventriae: or: The Plaie Called Corpus Christi*, ed. K. S. Block, Early English Text Society, E.S. 120, London, 1922, 121 (lines 150–52).

[31] Figure 5 is reproduced in color by M. Meiss and E. H. Beatson, *The Belles Heures of Jean, Duke of Berry*, New York, 1974, fol. 30, with commentary opposite.

[32] Figure 6 is reproduced in color as pl. 21 by Longnon and Cazelles (as in note 15) with commentary opposite.

as light passes through glass without altering it, so does the miracle of Christ's conception leave Mary's virginity unviolated.[33]

The mysterious ray of light that falls upon Christine—before a more generalized radiance fills the room—invites us to remember this Annunciation tradition.[34] But there is a signifying difference, too. In pictures of the Annunciation the rays of light typically fall upon Mary's breast, head, or ear—with the ear the least common version, although its theological authority was great. The miraculous engendering of Christ was understood to have been a *conceptio per aurem*.[35] As God the Father says to the angel Gabriel in the Wakefield play of the Annunciation, "She shall conceyf my derlyng, / Thrugh thy word and hyr heryng."[36] The Annunciation from the Psalter and Hours of Henry Beauchamp (Fig. 7) shows the Holy Ghost as dove executing a distinct left turn to ensure landing at her ear.[37]

Christine would have known one or more of these Annunciation traditions (all of which give prominence to mysterious rays of light) just as surely as the late fifteenth-century Bruges painter did whose opening miniature to ms. fr. 1177 we have already examined (see Fig. 4). He rendered Christine's description of the mysterious ray that precedes her three visitors in terms of one of the standard Annunciation models, with the light coming in through the window and falling upon her head—confirming (so to speak) my sense of the iconographic *core* of Christine's invention. But he also managed to get Christine's variation on the tradition slightly wrong. In her text, the light falls *upon her lap* ("sus mon giron"), and from that detail the scene's most finely nuanced meaning derives. (Compare the equation of pen and phallus in the *Roman de la Rose*, where writing is thought of as essentially a phallic act.) Christine appropriated the iconography of the Annunciation to present herself as called to a high destiny—"l'Annonce faite à Christine"—and at the same time, with great dignity, to acknowledge that the body she writes out of has conceived and given birth as all women do, save for the Virgin alone. Christine dignified her personal (gendered) history with a ray of light falling upon the place of ordinary conception and parturition. She too is called on to

[33] For a historical account of Annunciation iconography, with many pictures, see G. Schiller, *Iconography of Christian Art*, trans. J. Seligman, I, Greenwich, Conn., 1971, 33–52, and figs. 51–124.

[34] For Annunciation paintings from specifically Parisian manuscripts prior to and contemporary with Christine, see Sterling (as in note 16), e.g., figs. 39, 40, 52, 166, 167, 243, 306; or M. Meiss, *French Painting in the Time of Jean de Berry: The Boucicaut Master*, London, 1968, e.g., figs. 118–34, 316, 322, 326, 333, 483; or idem (as in note 9), II, passim.

[35] The phrase is a variation on Saint Augustine's "et virgo per aurem impregnabatur," which came to be understood as a physical description, and is a commonplace of Marian devotion. See G. M. Gibson, *The Theatre of Devotion: East Anglian Drama and Society in the Late Middle Ages*, Chicago, 1989, 214, n. 25, for further details and essential bibliography. It is theologically appropriate that Christ the Word (Logos) should be conceived through the ear.

[36] *The Towneley Plays*, ed. G. England and A. W. Pollard, Early English Text Society, E.S. 71, London, 1897, 88 (lines 69–70).

[37] Figure 7 may be seen in color as pl. 38 in R. Marks and N. Morgan, *The Golden Age of English Manuscript Painting 1200–1500*, New York, 1981. *Age of Chivalry: Art in Plantagenet England 1200–1400*, ed. J. Alexander and P. Binski, exhib. cat., Royal Academy of Arts, London, 1987, publishes fourteenth-century examples in ivory and stained-glass windows; see figs. 563 (p. 447), 595 (p. 466), 740 (p. 534). F. Cheetham, *English Medieval Alabasters: With a Catalogue of the Collection in the Victoria and Albert Museum*, London, 1984, offers three examples (pls. 96–98) in that medium. A fifteenth-century tympanum carving from the Frauenkirche in Würzburg has a long tube or pipe proceeding from God's mouth to the Virgin's very ear, with the dove already at her ear and the Christ child sliding toward it; see Schiller (as in note 33), I, fig. 104, or (better) Gibson (as in note 35), fig. 6.6 (p. 151).

conceive a true (or truer) Word, but as widow and mother, not as virgin mother or perpetually chaste bride.

On its own, the mysterious ray of light that figures so prominently in this text merely alerts us to an iconographic possibility. But the description of the Three Ladies that follows invites us to speculate further along the path we have begun. "I did not know which one to look at," Christine writes, "for the three ladies resembled each other so much that they could be told apart only with difficulty, except for the last one [Justice], for although she was of no less authority than the others, she had so fierce a visage that whoever, no matter how daring, looked in her eyes would be afraid to commit a crime, for it seemed that she threatened criminals unceasingly."[38] Lady Reason (who knows what Christine is thinking) explains that they are three daughters of God, "celestial beings" who "circulate among the people of the world here below,"[39] while Lady Rectitude confesses that she "reside[s] more in Heaven than on Earth," and Lady Justice identifies herself as "the most singular daughter of God, and my nature proceeds purely from His person."[40] As this introductory conversation draws to a close, Lady Justice's language grows more theological still: "I am in God and God is in me, and we are as one and the same," a formula extended a few lines later when she sums up her relationship with her sisters: "of the three noble ladies whom you see here, we are as one and the same, we could not exist without one another; and what the first disposes, the second orders and initiates, and then I, the third, finish and terminate it."[41]

Literary criticism has concerned itself only with differentiating the three women—an important task—but of equal importance is the fact they cannot readily be distinguished from each other. By anyone's definition (including their own), Reason must be part of Rectitude and both must be part of Justice, who must be part of each of them. The crowned ladies have been described as reflecting a medieval preference for threes, distantly related to Christianity's worship of a triune God. But that is inadequate. Christine doesn't merely present three ladies, she invites us to think of them as three-in-one and one-in-three—creating a female Trinity as the empowering fiction of her work, a Trinity that like its divine antecedent intervenes in human history in order to change it.

[38] *Book of the City of Ladies*, 8; "si que ne savoye laquelle regarder, car si fort s'entreressembloyent les trois dames que a paines congneust on l'une de l'autre, excepté que la derraine, tout [ne] fust elle de moindre auttorité que les autres, elle avoit la chiere si fiere que qui es yeulx la regardast, si hardi ne fust, qui grant paour n'eust de mesprendre, car adés sembloit qu'elle menaçast les malfaitteurs," *Livre de la Cité des Dames*, 625–26.

[39] *Book of the City of Ladies*, 9; "la providence de Dieu . . . nous a establies, quoyque nous soyons choses celestielles, estre et frequanter entre les gens de ce bas monde adfin de mettre en ordre et tenir en equité les establissemens faiz par nous meismes selonc le vouloir de Dieu en divers offices, auquel Dieu toutes trois sommes filles et de luy nee[s]," *Livre de la Cité des Dames*, 627.

[40] *Book of the City of Ladies*, 12, 13; "Je suis appellee Droitture, qui ou ciel plus qu'en terre ay ma demeure; . . . je suis Justice, la tres singuliere fille de Dieu, et mon essance procede de sa personne purement," *Livre de la Cité des Dames*, 633, 635.

[41] *Book of the City of Ladies*, 14; "Je suis en Dieu et Dieu est en moy, et sommes comme une meismes chose Et entre nous trois dames que tu vois cy, sommes comme une meismes choses, ne ne pourrions l'une sans l'autre; et ce que la premiere dispose, la .ii^e. ordene et met a oeuvre, et puis moy, la .iij^e. parchieve la chose et la termine," *Livre de la Cité des Dames*, 635, 636–37.

Again, the words of the text invite us to think iconographically, and to remember that the Trinity in medieval art was not always shown (as in Fig. 7) in the form of God the Father as an old man (here seen in the border's upper left corner) sending out the Holy Ghost as dove and the Son as a child (or homunculus) with Cross. Nor was the version we call the Throne of Grace the only nonnarrative image for the same—an image of God the Father supporting in front of him a miniature Son on the Cross, with the Holy Ghost as dove hovering between the two.[42] Readers of Christine's text need to know that in medieval art the Trinity was sometimes shown instead, especially in the fifteenth century, as three separate (sometimes identical) men, differentiated, if at all, by the properties they carry. The Hours of Catherine of Cleves (Dutch, ca. 1440) offers a richly varied repertory of such images—the Trinity in an Apse, the Trinity Enthroned, the Trinity with the Son Kneeling, the Trinity with the Son Showing His Wounds (Fig. 8), as well as a Trinity with Dove and Infant Christ, a Throne of Grace Trinity, and a Throne of Grace Trinity Adored, all illuminating the Sunday Hours of the Trinity. For students of Christine, these images are worth seeking out in John Plummer's facsimile edition of the manuscript.[43]

No canonical text exists describing the Trinity as three identical or near-identical men. This would risk the heresy of tritheism—the belief that the persons of the Trinity are three distinct gods.[44] But medieval painters, glaziers, and sculptors, faced with the task of making visual a noncorporeal three-in-one who are also one-in-three, sometimes found the image suited their needs.

Let a few examples represent something of its history. On Gertrud Schiller's evidence, the three-man Trinity first appears in the Grimbald Gospels at the beginning of the eleventh century, decorating an author portrait of Saint John.[45] But in fact an eighth-century example from the *Sacramentary* attributed to Gellone has recently been published, without comment on its considerable priority.[46] The image is found again in twelfth-century Greece,[47] and in twelfth-century Alsace, where Herrad of Hohenbourg's *Hortus Deliciarum* shows three

[42] See, e.g., Meiss (as in note 9), II, fig. 503 for the essential image, and figs. 829, 830 for variations on it. Cheetham (as in note 37), 296, proposes four chief types and publishes many examples (pls. 223–25, 230–35 are of the Throne of Grace kind), the Trinity being one of the most popular subjects in alabaster retable carving. See also *The Hours of Catherine of Cleves*, ed. J. Plummer, New York, 1966, pls. 38, 40, described below.

[43] Figure 8 is reproduced in color by Plummer (as in note 42), pl. 39. The Son is supported tenderly by the Father and the Holy Ghost; he holds a rough wooden Cross and rests his feet on a golden orb representing the earth. His halo alone is cruciform. See pls. 32, 35–40, for the full Trinity sequence, and cf. pls. 33, 34.

[44] For a brief account of this heresy, which began in the sixth century and was revived in the eleventh and twelfth, see the article "Tritheism" in *The Oxford Dictionary of the Christian Church*, ed. F. L. Cross, London, 1957, and for a brief introduction to the orthodox tradition, see the article "Trinitarian Doctrine" by K. B. Osborne in *Dictionary of the Middle Ages*, ed. J. R. Strayer, 12 vols., New York, 1982–89, XII, 189–98; its discussions of Roscelin of Compiègne, Boethius, and Abelard are pertinent to the tritheist controversy and its resolution.

[45] Schiller (as in note 33), I, fig. 5; the Trinity is shown at the top of the page as three men in three roundels, each worshipped by angels.

[46] See *The Reformation*, ed. P. Chaunu, New York, 1990, 32. The trio also appears standing in a late ninth- or tenth-century *Miscellany* in Rome, Bib. Vat., MS. Pal. Lat. 834, fol. 28. M. D. Anderson, *Drama and Imagery in English Medieval Churches*, Cambridge, 1963, 133, cites the tenth-century Sherborne Pontifical (Paris, Bibl. Nat., MS. Lat. 943), which shows the three persons on three *different* folios, 5v, 6r, 6v.

[47] Schiller (as in note 33), I, figs. 10, 11; see her discussion, 9–10.

identical seated divinities, with only the wounded feet of the central figure to identify him as the Son.[48] The tradition can be traced in Italy as well, in a Perugian antiphonary, ca. 1390–1400 (Fig. 9),[49] which crowds all three persons into the initial S of a *Sanctissime*, and in a Franciscan Missal and Book of Hours, 1380, where the three seated persons have mirror-image faces, wear matching robes, display cruciform halos, and hold identical books opened to a single text.[50] The image likewise occurs in fourteenth-century French manuscripts, including a miniature from a *Bible historiale* (Paris, ca. 1375) (Fig. 10), showing three identical persons holding a globe, a chalice with Host, and an open book.[51] But the tradition flourished particularly in the fifteenth century[52] —witness the Hours of Catherine of Cleves, already discussed, and the magnificent Hours of Etienne Chevalier, painted by Jean Fouquet during the years 1453–55, which devotes two paintings to the subject. Figure 11 shows the Coronation of the Virgin by her Son, with the Father and Holy Spirit looking on—the Coronation (expressive of the Son's love for his mother) being a subject obviously congenial to this version of the Trinity.[53]

There are a number of ways to account for this tradition, including an Old Testament text—Genesis 18—in which Abraham is visited in the vale of Mambre by the Lord as three men, whom Abraham addresses in the singular as "Lord," but whom he feeds as three. The Lord in return promises that Sara will conceive a son, in whom "all the nations of the earth shall be blessed."[54] Because the Genesis account alternates mysteriously between "the Lord"

[48] Herrad of Hohenbourg, *Hortus Deliciarum*, ed. R. Green, M. Evans, C. Bischoff and M. Curschmann, 2 vols., London, 1979, II, 13 (reproducing fol. 8), briefly discussed, I, 91; it can also be seen in J. F. Hamburger, *The Rothschild Canticles: Art and Mysticism in Flanders and the Rhineland Circa 1300*, New Haven, 1990, fig. 197.

[49] Figure 9 can be seen in color in *Francesco d'Assisi: Documenti e archivi codici e biblioteche miniature*, ed. F. Porzio, Milan, 1982, 216.

[50] See Chaunu (as in note 46), 32, reproducing Paris, Bibl. Nat., ms. Lat. 757.

[51] See also Toulouse, Bibl. Mun., ms. 91, fol. 121, reproduced by Hamburger (as in note 48), fig. 199, and discussed, 127; Hamburger's study of the Trinitarian miniatures in the Rothschild manuscript, 118–42, is of compelling interest, with 127–28 relevant to this reading of Christine, as is fig. 220, from Heinrich Suso's *The Exemplar* (discussed, 142).

[52] For English examples, see D. Gray, "A Middle English Illustrated Poem," in *Medieval Studies for J. A. W. Bennett*, ed. P. L. Heyworth, Oxford, 1981, 185–205, and fig. 1a, reproducing Cambridge, Fitzwilliam Museum, ms. 41-1950, fol. 55. See also Cambridge, Fitzwilliam Museum, ms. 375, fol. 42v, reproduced in F. Wormald and P. M. Giles, *A Descriptive Catalogue of the Additional Illuminated Manuscripts in the Fitzwilliam Museum Acquired Between 1895 and 1979*, 2 vols. Cambridge, 1982, II, fig. 53. Consult Cheetham (as in note 37), fig. 236 (with the Son shown as the suffering Christ), and M. D. Anderson, *The Imagery of British Churches*, London, 1955, 82, for other examples. The stained-glass version from Goodramgate, York (a ca. 1470 Coronation of the Virgin) can be seen in *Word, Picture, and Spectacle*, ed. C. Davidson, Early Drama, Art, and Music Monograph Series 5, Kalamazoo, Mich., 1984, fig. 48.

[53] Figure 11 can be seen in color in *The Hours of Etienne Chevalier*, ed. C. Sterling and C. Schaefer, New York, 1971, pl. 13, with commentary opposite. See pl. 27 for a three-man Trinity adored by the heavenly hosts, with the Virgin enthroned at their right. For other such Coronations of the Virgin, see the examples collected by Anderson (as in note 52), 146; Cheetham (as in note 37), figs. 142–43, furnishes others.

[54] I italicize the alternating registration of person(s): "And *the Lord* appeared to him in the vale of Mambre as he was sitting at the door of his tent, in the very heat of the day. / And when he [Abraham] had lifted up his eyes, there appeared to him *three men* [*tres viri*] standing near him; and as soon as he saw *them* he ran to meet *them* from the door of his tent, and adored down to the ground. / And he said: *Lord*, if I have found favour in *thy sight* [*oculis tuis*], pass not away from *thy servant* [*servum tuum*] And when *they had eaten* [*comedissent*], *they said* [*dixerunt*] to him: Where is Sara thy wife? He answered: Lo, she is in the tent. / And *he* [*the Lord*] *said to him* [*cui dixit*]: I will return and . . . Sara thy wife shall have a son," etc. (Genesis 18:1–16; Vulgate, with Douay/Rheims translation).

and "the [three] men" without noting a contradiction in number, Christian exegetes read the passage as prophetic of the Trinity.[55] Thus Abraham can be found worshipping God *in the heavens* in the form of three men holding a single book, as in the Bedford Breviary (Paris, ca. 1432–34)[56]—an interpretation of the event thought to bear Christ's own authority (John 8:56–58): "Abraham, your father, rejoiced that he might see my day; he saw it and was glad Before Abraham was made, I AM."[57]

But this version of the Trinity is especially connected with the Annunciation. It was to explain that event—in which God the Father sends God the Son to redeem the human race—that the one God worshipped by the Jews had to become theologically divisible. Fifteenth-century religious drama, in a play called *The Parliament of Heaven* or *Le Procès de Paradis*, sometimes dramatized that decision with a debate among the Four Daughters of God over the possibility of mankind's redemption. After Truth has argued against the claims of Mercy, and Justice against the claims of Peace, only a council of the Trinity (with the Son offering to die in man's place) can restore the Daughters to their prior harmony and love.[58] Figure 12, from a late fifteenth-century Parisian Book of Hours, shows (in its upper register) the Trinity witnessing the end of that debate—"Mercy and truth have met each other: justice and peace have kissed" (Psalms 84:11). Its consequence for human history, the Annunciation to the Virgin, is shown just below.[59] While the painter of this miniature could represent the Holy Ghost within its Trinity simply as a dove—a venerable option within the visual arts—a fifteenth-century dramatist might (for reasons of genre) find three speakers a more viable alternative. It is for this reason, one suspects, that the English N-Town cycle, like the Flemish *First Joy of Mary*, presents Father, Son and Holy Ghost as distinct *dramatis personae*, each speaking his own counsel.[60]

[55] The *Biblia pauperum* depicts the visit as prefiguring the Transfiguration of Christ, explaining it so: "Abraham saw three youths (that is, angels) who had accepted his hospitality: 'he saw three and worshipped one.' The three angels signified the trinity of Persons, but in that he worshipped one, he indicated the singleness of its Nature. In the same way, Christ in his transfiguration showed himself to be one true God in Nature, and of three Persons." See *Biblia Pauperum: A Facsimile and Edition*, ed. A. Henry, Ithaca, 1987, pl. m, and 71, 136, 154, for transcriptions, commentary, and Latin text.

[56] In Paris, Bibl. Nat., ms. Lat. 17294, fol. 278v, reproduced by Sterling (as in note 16), fig. 312.

[57] The event was depicted in Christian art as early as 432–40, in a mosaic on the walls of Santa Maria Maggiore in Rome. Commissioned by Sixtus III, it can be seen in J. Lassus, *The Early Christian and Byzantine World*, New York, 1967, pl. 23.

[58] See the classic study by S. C. Chew, *The Virtues Reconciled: An Iconographical Study*, Toronto, 1974, with many pictures; pls. 3 and 5 show three-man Trinities above. On Bernard of Clairvaux's and Mechthild von Magdeburg's importance to the theme, see Schiller (as in note 33), I, 10–11. The *Meditations on the Life of Christ: An Illustrated Manuscript of the Fourteenth Century*, ed. and trans. I. Ragusa and R. B. Green, Princeton, 1961, long attributed to Saint Bonaventure, begins with a meditation on this subject, an important source for its currency throughout Europe. Although the debate in this text is heard and resolved by God the Father (singular), the language is insistently Trinitarian in its emphasis, in the debate itself and again concerning the Incarnation (5–17): e.g., "For you must know that the exalted labor of the Incarnation belonged to the whole Trinity, though only the person of the Son was incarnated, as when one person is dressing with the aid of two others who stand at his sides holding the sleeves of the gown" (16). The 1525 black-letter edition of Nicholas Love's translation of the *Meditations* includes a woodcut illustration showing the Trinity as three identical men enthroned, holding a large single book upon their knees, with the Four Daughters below, and a very frisky Gabriel, clothed in a feather suit, eager to be on his way.

[59] This manuscript is closely related to a number of prayer books from the Paris atelier of Maître François (fl. 1473); see *The Wharncliffe Hours*, ed. M. Manion, London, 1981, pl. 18, figs. 34, 35, and 14–16, 58, for commentary.

[60] For the (truly extraordinary) N-Town dramatization of the Parliament, see Block (as in note 30), 97–104; it is based

In Christine's opening chapters to *The Book of the City of Ladies*, these two traditions—the miraculous beam of light and the three-man Trinity—come together. Both originate in the visual arts, not in sacred text, and were part of the iconographic language of the age, familiar to most Christians, even those who could not read. Closely scrutinizing Christine's modifications of tradition, we have noted that the rays of God's love and providence fall on her lap—not on her breast or head or ear—and that the Trinity that visits her is gendered feminine, its chief concern the welfare of the feminine sex. And we have noted significant similarities. Christine's trinity, too, is comprised of three persons scarcely distinguishable from each other, whose qualities or virtues are profoundly interrelated. And it comes to end a strife—not, as in the Annunciation to Mary, the strife between humankind and God (for the faithful Christian, that has long since been resolved), but the strife between man and woman,[61] a war waged steadily since the Fall. A lesser strife it may be, but its cost in human happiness is real. The Three Ladies come to bring peace, reconciliation, a new understanding. And like the earlier Trinity, they need an earthly woman to help them perform that monumental task.

This brings us back to Christine, as she writes herself into this text, and to her response to this great commission—a response (we shall see) itself fashioned on the Annunciation model. Like the Virgin, who was understood to have been for a time silenced and overwhelmed by the angelic announcement (Luke 1:29–30, 34), Christine presents herself as overwhelmed by the *destiny* that has been specially laid up for her: "we three ladies," says Lady Reason, "have come to you *to announce* a particular edifice built like a city wall, which has been *predestined and established* by our aid and counsel *for you* to build" (italics mine).[62] Lady Reason then moves closer still to the biblical subtext, paraphrasing the angel

on the Ps.-Bonaventuran *Meditations* (as in note 58), 16–20. On the Flemish *First Joy of Mary* (*Die eerste bliscap van Maria*), see L. R. Muir, "The Trinity in Medieval Drama," in *The Drama of the Middle Ages: Comparative and Critical Essays*, ed. C. Davidson et al., New York, 1982, 75–88, esp. 84–85. Muir offers a comprehensive account of the ways in which "God" (singular or triune) was presented on the medieval religious stage. *The Parliament of Heaven* (*Le Procès de Paradis*) was a staple in the great French Passion cycles, from Arnoul Greban's on, though in them (unlike the English and Flemish examples noted above) the Deity was customarily represented by a single actor. See also E. Mâle, *Religious Art in France: The Late Middle Ages. A Study of Medieval Iconography and Its Sources*, 2nd ed., ed. H. Bober, trans. M. Mathews, Princeton, 1986, 36–37, 40–43, for an argument (no longer much credited) that in this matter the drama functioned as intermediary between the *Meditations* and the visual arts. Mâle's fig. 25 (p. 42) offers a splendid three-man Trinity version of the *Procès* (from a late fifteenth-century *Legende dorée*).

[61] Lady Rectitude reminds Christine there are already some exceptions: "not all marriages are conducted with such spite, for there are those who live together in great peacefulness, love, and loyalty because the partners are virtuous, considerate, and reasonable. And although there are bad husbands, there are also very good ones, truly valiant and wise, and the women who meet them were born in a lucky hour You know this perfectly well from your own experience, for you had such a good husband . . . for whose sake the remorse over Fate's having taken him from you will never leave your heart," *Book of the City of Ladies*, 119–20; *Livre de la Cité des Dames*, 819. Bornstein (as in note 4), 14–17, notices the way *Lavision-Christine* offers a rather more complex account of the marriage, including this statement by Dame Philosophy: "there is no doubt that if your husband were living now, you would not be able to pursue learning as you have done. For household cares would not allow you to do so" (quoted, 16). The opening to *Book of the City of Ladies*, makes it clear that Christine's mother is the one in charge of household duties: it is she who calls Christine to supper (3).

[62] *Book of the City of Ladies*, 10–11; "nous trois dames . . . te sommes venues adnoncier un certain ediffice fait en maniere de la closture d'une cité fort maçonnee et bien ediffiee, qui a toy a ffaire est predestinee et establie par nostre aide et conseil," *Livre de la Cité des Dames*, 630.

Gabriel's salutation, "Blessed art thou among women," as she continues: "Thus, fair daughter, *the prerogative among women* has been bestowed on you to establish and build the City of Ladies"[63] —a phrase that will be applied to Mary herself just a few pages later ("Hers will be the honor and *prerogative among all other women*").[64] When Christine asks why valiant women of the past did not write books protesting men's calumny, Lady Rectitude again stresses Christine's *election*: "the composition of this work has been *reserved for you*"[65] God has tolerated this state of affairs for a long while, as he has tolerated other heresies against his Law, but now his purpose and Christine's career have become one. What is destined cannot be escaped.[66]

And so, prostrating herself before the beautiful ladies, Christine responds in language invoking one of the traditional antetypes of the Annunciation—the story of Gideon's fleece, miraculously wet with dew when the earth all around it was dry. Figure 13, from a block-book *Biblia pauperum*, can instruct us in the relationship. The Annunciation at center is foreshadowed by the temptation of Eve on the left and the miraculous fleece on the right. Printed at top right is this text: "According to Judges vi 36–8, Gideon prayed for a sign of victory in the fleece being filled with a fall of dew which prefigured the glorious Virgin Mary made pregnant without violation, by the pouring out of the Holy Spirit." Beneath that, a text, attached to the portrait of David reads: "The Lord shall descend like rain on a fleece" (Psalms 71:6), and beneath the picture itself: "Earth remained dry: the fleece is wet with dew." Lower still we read: "The Lord has created a new order of things on earth: woman is to be the protectress of man" (Jeremias 31:22).[67] The *Speculum humanae salvationis*, written in 1324, another hugely popular book using words and pictures to link Old Testament and New, likewise juxtaposes the image of Gideon's fleece and the Annunciation to the Virgin.[68]

This, surely, is the verbal matrix out of which Christine invents her reply to the ladies' announcement: "With the rain and dew of your sweet words, you have penetrated and moistened the dryness of my mind, so that it now feels ready to germinate and send forth new branches capable of bearing fruits of profitable virtue and sweet savor."[69]

[63] *Book of the City of Ladies*, 11; "Ainsi, belle fille, t'est [donné] la prerogative entre les femmes de faire et bastir la Cité des Dames," *Livre de la Cité des Dames*, 630.

[64] *Book of the City of Ladies*, 14; "a ycelle sera l'onneur et la prerogative entre les autres femmes," *Livre de la Cité des Dames*, 637.

[65] *Book of the City of Ladies*, 185; "ceste oeuvre a bastir estoit a toy reservé et nom mie a elles," *Livre de la Cité des Dames*, 924.

[66] Ibid.

[67] See Henry, ed. (as in note 55), 50, 131–32, 152, for the Latin text, translations, and commentary. The manuscript tradition of the *Biblia pauperum* goes back to the thirteenth century (Henry, 4), with numerous examples from all over Europe.

[68] On the Gideon's fleece/Annunciation typology in the *Speculum humanae salvationis* tradition, see A. Wilson and J. L. Wilson, *A Medieval Mirror: Speculum humanae salvationis 1324–1500*, Berkeley and Los Angeles, 1984, chap. 7 (154–55), and for a Middle English translation of the text, *The Mirour of Mans Saluacioun*, ed. A. Henry, Philadelphia, 1987, 69. Isaiah 45:8 may add further resonance to Christine's response: "Drop down dew, ye heavens, from above: and let the clouds rain the just. Let the earth be opened and bud forth a Saviour: and let justice spring up together. I the Lord have created him."

[69] *Book of the City of Ladies*, 15; "Qui pourra rendre graces souffisantes a tel benefice? Et qui ja avez, par la pluye et rousee de vostre doulce parolle sur moy dessendue, perciee et attrempee la secheresce de mon entendement, qu'il se sent des

But even in her rapture, Christine, like Mary, voices a commonsense concern. The Gospel reads: "And Mary said to the angel: How shall this be done, because I know not man?" (a question the N-Town play paraphrases, "I dowte not the wordys ye han seyd to me, But I aske how it xal be do").[70] Christine expands upon it so: "How," she asks, "will such grace be bestowed on me that I will recieve the boon . . . to build and construct . . . a new city? I am not Saint Thomas the Apostle [builder of churches in India] . . . and my feeble sense does not know the craft . . . or the practice of construction. And if, thanks to learning, these things were within my ken, where would I find enough physical strength in my weak feminine body to realize such an enormous task?"[71]

Christine soon answers her own question—"I know well that nothing is impossible for God,"[72] echoing Gabriel's explanation to Mary in Luke 1:37—and then accepts her destiny in words that directly translate the Vulgate version of Mary's response: "Dixit autem Maria: ecce ancilla Domini fiat mihi secundum verbum tuum" (Luke 1:38). Christine speaks the words gravely: "Behold your handmaiden, ready to serve. Command and I will obey, and may it be done to me according to your words."[73] Christine's subtext finally becomes naked text, furnishing the exact language of her acquiescence. With a courage that is both theological and personal, Christine has authorized herself as author. She stands ready to write her book.

I have no space to discuss the work's conclusion, except to note that the Great Queen promised by Lady Justice for this city will turn out to be none other than the Virgin Mary herself, leading a company of Christian women martyrs (Fig. 14).[74] At the moment of her

maintenant preste de germer et gitter hors plantes nouvelles disposees a porter fruit de prouffitable vertu et delittable saveur," *Livre de la Cité des Dames*, 638.

[70] Block (as in note 30), 105 (lines 249–50).

[71] *Book of the City of Ladies*, 15; "Comment sera fait a moy tel grace que je recevray don . . . de bastir et faire orendroit . . . nouvelle cité? Je ne suis mie saint Thomas l'aspostre . . . ne mon foible scens ne scet ne congnoist l'art . . . ne la pratique de maçonner. Et se ses choses par possibilité de science estoyent ores en mon entendement, ou seroit prise force souffisante a mon foible corps femenin pour mettre a oeuvre si grant chose?" *Livre de la Cité des Dames*, 638.

[72] *Book of the City of Ladies*, 15; "sçay je bien que riens n'est impossible quant a Dieu," *Livre de la Cité des Dames*, 639.

[73] *Book of the City of Ladies*, 15–16; "Et voycy vostre chamberiere preste d'obeir. Or commandez, je obeyray, et soit fait de moy selonc voz parolles," *Livre de la Cité des Dames*, 639. That Christine thought of "chamberiere" as translating the Vulgate's "ancilla" is clear. In her book's last chapter, she exhorts women to "follow the example of your Queen, the sovereign Virgin, who, after the extraordinary honor of being chosen Mother of the Son of God was announced to her, humbled herself all the more by calling herself the handmaiden of God," *Book of the City of Ladies*, 254–55; "qui aprés si grant honneur que on luy adnonçoit comme d'estre mere du filz de Dieu, elle tant plus s'umilia en ce appellant chamberiere de Dieu," *Livre de la Cité des Dames*, 1032. Curnow (ibid., 1045, n. 13a) linked these passages along with two others (one naming Saint Natalia as "chamberiere de Jhesu Christ," the other naming Nature "chamberiere de Dieu") to Luke 1:26–27 (an error for Luke 1:38), but offered no interpretation. Jean Michel, *Le Mystère de la Passion (Angers 1486)*, ed. O. Jodogne, Gembloux, Belgium, 1959, 9 (668–69), translates Mary's response similarly—"Vecy du Seigneur la chambriere; me soit faict celon ta parolle"—though the word "ancelle" was available, and often preferred by his fellow dramatists, who liked to rhyme it with "nouvelle" and "pucelle." On cultural and hagiographical backgrounds to this topos, see M. Goodich, "*Ancilla Dei:* The Servant as Saint in the Late Middle Ages," in *Women of the Medieval World: Essays in Honor of John H. Mundy*, ed. J. Kirschner and S. F. Wemple, Oxford, 1983, 119–36.

[74] Note that the Virgin carries a *book* as well as a sceptre. Mary's literacy—as a child in the temple, where her special study is the Psalms, and at the Annunciation, where her book is sometimes shown open at Isaiah 7:14, "Behold a virgin shall conceive and bear a son"—is also part of the iconographic matrix of Christine's self-image in this work. In some versions, the

entry, the Annunciation is recalled and reenacted one final time, as Lady Justice says, "Let all women now accompany me, and let us say to her: 'We greet you, Queen of Heaven, with the greeting which the Angel brought you, when he said, *Hail Mary*, which pleased you more than all other greetings.'" May it please you, she continues, to reside among the devout sex of women, "as their defender, protector, and guard My Lady, what man is so brazen to dare think or say that the feminine sex is vile in beholding your dignity?"[75] Christine's self-loathing as a woman, with which the action began, is definitively redressed.

In Christine's *City*, the Virgin is invoked not as an impossible standard by which all other women fail, but as a rebuke to misogyny. And she is welcomed as a queen. In these final pages, Mary, paragon of feminine humility, moves quite naturally into that position of power, just as Christine has proven equal to the task of building the literary city. The Virgin addresses the matter quite simply in her reply to Lady Justice's welcome: "I will live and abide most happily among my sisters and friends, for Reason, Rectitude, and you, as well as Nature, urge me to do so . . . for I am and will always be head of the feminine sex. This arrangement was present in the mind of God the Father from the start, revealed and ordained previously in the council of the Trinity."[76] The authentic Trinity is here credited with origi-nating the entire history that has brought Mary to this place and eminence, including the creation—by Reason, Rectitude, Justice *and* Christine—of this city of ladies, a city built "on the Field of Letters,"[77] where Mary will reign. That field, of course, is the very book we are reading.

The task Christine set herself in this work was to rescue Eve from Adam's abuse and oppression, and to reclaim the Virgin for the feminine sex, denying the massive clerical/theological appropriation of her person. To salvation history, it was essential that *Eva* be-come *Ave*, but in Christine's eyes Eva could be too much disdained. As Lady Reason tells Christine early in the book, "thanks to a woman, man reigns with God. And if anyone would

divine light falls upon Mary's book—not only marking her role in sacred history, but drawing attention to the fact that she can read. Before the illustrations to Christine's *City*, almost the only pictures that show a literate woman are those of the Virgin with a book or books in her cell (not infrequently she has more than one). In the fourteenth century, indeed, the visual arts had begun to show Saint Anne teaching the Virgin to read—an image lacking any authorizing text, but clearly intended to influence cultural behavior, inculcating the notion of the mother as teacher. It occurs most often in works or manuscripts commissioned for women. The tradition is particularly poignant vis-à-vis Christine, whose own mother disap-proved of her being educated. See P. Sheingorn, "The Wise Mother: The Image of St. Anne Teaching the Virgin Mary," *Gesta*, XXXII (1993), forthcoming. A magnificent panel painting of this subject (English, ca. 1335, now in the Cluny Museum) can be seen in color in J. Dupont and C. Gnudi, *Gothic Painting*, New York, 1979, 23.

[75] *Book of the City of Ladies*, 218; "Or viengnent doncques avecques moy toutes femmes et luy disons ainsi: 'Nous te saluons, Royne des cieux, du salut que l'ange t'apporta, lequel tu as agreable sur tous salus te disant Ave Maria . . . comme leur deffenderresse, protectarresse et garde O! Dame, qui est celluy tant oultrageux qui jamais ose pensser ne gitter hors de sa bouche que le sexe femenin soit vil, consideree ta dignité?'" *Livre de la Cité des Dames*, 975–76.

[76] *Book of the City of Ladies*, 218; "tres voulentiers je habiteray et demeureray entre mes suers et amies, les femmes, et avecques elles. Car Raison, Droitture, toy, et aussi Nature m'y encline . . . sy suys et seray a tousjours chief du sexe femenin. Car ceste chose fu des oncques en la pensee de Dieu le Pere, preparlee et ordenee ou conseil de la Trinité," *Livre de la Cité des Dames*, 976–77.

[77] *Book of the City of Ladies*, 16; Reason says, "Sans plus attendre allons ou champ des escriptures: la sera fondee la Cité des Dames," *Livre de la Cité des Dames*, 639.

say that man was banished because of Lady Eve, I tell you that he gained more through Mary than he lost through Eve when humanity was conjoined to the Godhead, which would never have taken place if Eve's misdeed had not occurred For as low as human nature fell *through this creature woman*, was human nature lifted higher *by this same creature*"[78] (italics mine).

In the face of conventional religious belief and popular misogyny, accustomed to conceiving Mary and Eve in fierce antithesis—as in an Italian panel painting of ca. 1380–1420 (Fig. 15), Mary "above" and Eve "below," Mary "maternal" and Eve "wanton,"[79] in other paintings Mary "within" and Eve "without"[80] —Christine de Pizan affirmed the continuity of virtue within her sex, even among pagan women, even among ordinary French women whom she herself knew. She did not restrict her praise (or sympathy) to the lives of female martyrs and saints. A courageous book, it begins with an act of extraordinary conceptual daring: Christine empowering herself as author by staging a Trinitarian Annunciation in her mind.

If one does not read the idea of Christine's book iconographically, one does not read fully the book she wrote.

AFTERWORD

It is possible now to raise a different, more technical question. Since the Annunciation was so clearly in Christine's mind as she conceived and wrote the text, why, in the five manuscript copies she commissioned for her patrons (the Group I manuscripts), do the opening miniatures not include a ray of light that would visually invoke the Annunciation model? A manuscript made in Bruges for the Burgundian court of Philippe le Bel (a Group IIb manuscript) does so—as we have seen in Figure 4.[81] But the manuscripts Christine personally supervised do not. Though one can only speculate on her reasons, the following explanation suggests itself.

The decorative program in manuscripts commissioned by Christine includes just three miniatures for the *Cité*: one for each of its parts. That means the opening miniature in such a manuscript (Figure 3 is representative) must do double duty, introducing the Three Ladies to Christine (a kind of prologue action) and then getting on to the essential business of Part I,

[78] *Book of the City of Ladies*, 24; "par achoison de femme, homme raigne avec Dieu. Et se aucun veulst dire que il fu banis par femme pour cause de dame Eve, je di que trop plus hault degré a acquis par Marie qu'il ne perdi par Eve, quant humanité est conjointe a deité, ce qu'il ne seroit mie se le meffait de Eve ne fust avenu Car de tant que nature humaine tresbucha plus bas par creature, a elle esté relevee plus hault par createur," *Livre de la Cité des Dames*, 652–53. Christine shapes the doctrine of the happy fall (*O! felix culpa*) to a specifically feminist purpose.

[79] Reproduced in color on the jacket of M. R. Miles, *Carnal Knowing: Female Nakedness and Religious Meaning in the Christian West*, Boston, 1989; see 139–41 for her discussion of the picture.

[80] See e.g., a fresco by Barna da Siena in San Gimignano, Collegiata, reproduced by C. J. Purtle, *The Marian Paintings of Jan van Eyck*, Princeton, 1982, fig. 14, in which a woman with distaff is shown outside the wall of the Annunciation chamber, eavesdropping on the angelic announcement being made within.

[81] *Livre de la Cité des Dames*, 346–589, describes and classifies all the extant MSS.; on Group IIb MSS., see 408–34, 576. For Group I MSS., see also Meiss (as in note 9), I, 290.

the clearing of the field and the building of the city's outer wall. Figure 4, in contrast, made a half century or more later, shows Christine's initial weariness and despair ("il sembloit que je fusse si comme personne en etargie"),[82] along with the mysterious ray of light falling upon her head, and the Three Ladies standing before her.

That picture illustrates the work's opening pages well, but were it the only miniature to Part I it would have this major disadvantage: it would fix the author in a posture of utter passivity for the entire first book, a "lethargy" wholly at odds with its content. Figure 3— Christine's commissioned version—not only illustrates more of the text, it presents the author in an active mode, standing at a table with books, engaging the Three Ladies in conversation, and showing herself as much a partner in that dialogue as in the allegorical wall-laying depicted alongside. A humanist emphasis can be discerned.

Everything we know about Christine's life and temperament confirms an active "self-portrait" as her likely preference, granted a program allowing for only two others: Christine in the company of women whom Lady Rectitude leads into the city (Part II), and Christine in the company of women who receive the Virgin Mary with saints at the city gates (Part III; see Fig. 14). The Brussels manuscript from Group IIb, with *four* miniatures devoted to Part I alone, neatly avoided that problem by making Christine's dejection and the mysterious ray of light part of its second miniature. It begins with an imposing picture of Christine, reading in a handsome study,[83] and shows in its third miniature Christine and Lady Reason at work in the Field of Letters; its fourth illustrates the battle between the Greeks and the Amazons.

But Christine chose to commission (perhaps for economic reasons) just three miniatures in all, one to introduce each part. She employed the best painters, and would have had to calculate their wages closely. But as a writer she could invent on a grander scale, free of economic constraints. And so we have (*in her text*) the lady-of-letters in her study, her ensuing lethargy and despair, the two-stage awareness of mysterious light, the humanist conversation with three personified ladies, and, finally, the casting of the task they lay upon her in terms that recall the Annunciation to the Virgin Mary.

It was (we may speculate) for reasons such as these that Christine did not include a *visual* allusion to the Annunciation in the miniature that opens the manuscripts she commissioned.[84] Pictorial notation was not strictly essential, for the Annunciation paradigm was

[82] *Livre de la Cité des Dames*, 619.

[83] Brussels, Bibl. Roy., MS. 9235, discussed above, note 27; its first picture is reproduced by F. du Castel, *Damoiselle Christine de Pizan: Veuve de M^e Etienne de Castel 1364–1431*, Paris, 1972, pl. CIX, though the setting is wrongly identified as the convent at Saint-Louis de Poissy, where Christine spent the latter years of her life. The 1475 Flemish translation of the work, *De Stede der Vrouwen*, has forty-one miniatures (with blank spaces allowed for still others); it too could afford a picture of Christine alone in her dejection (see note 23 above). Curnow (*Livre de la Cité des Dames*, 454) describes Geneva, Bibl. Publ. et Univ., MS. fr. 180 as showing, in its second miniature, rays of light that "emanate from the three Virtues and fall on Christine's lap," conflating (in commonplace medieval fashion) the two-stage experience of light so carefully detailed in her text. There, Christine first sees a single mysterious ray recalling the Annunciation, and then a radiance that fills the room shining from the Virtues themselves. Since Gabriel is never the *source* of light that falls on the Virgin, the light that first falls on Christine must seem to come from some wholly mysterious place. By the book's end, the whole city is resplendent with light ("reluysant"), and Christine tells all virtuous women that they may see themselves reflected in it (*Book of the City of Ladies*, 254; *Livre de la Cité des Dames*, 1032).

[84] Another kind of speculation might find here signs of a divided consciousness, seeing in Christine's choice of opening picture a psychological retreat from, or a strategic covering over, that which is theologically and culturally most daring in her

already deeply inscribed in her text, in hidden and symbolic ways. It is Christine the writer, not Christine the patron of illuminated manuscripts, who tells us what her work at its boldest dares to mean. But later readers and painters went further, responding to those verbal cues. Those manuscripts that include the mysterious ray of light bear witness to some ways in which *The Book of the City of Ladies* was read and its emphases assessed a half-century or more later, independent of the program of illustrations Christine invented when the work was new.

Christine had expressed a special interest in the relation between literature and the visual arts once before—in her *Livre de la Mutacion de Fortune* (completed in 1403), a universal history framed by a personal history, in which she *remembers* seeing within Fortune's Castle a great hall painted with the great deeds and heroes of the past, and then translates the "reading" of those visual pictures into the 23,000-plus verses of the poem. Figure 16 shows Christine examining those paintings in that "Salle de Fortune."[85]

But as her appropriation of Annunciation imagery in the *Cité* makes clear, Christine's interest in the visual arts was not limited to rhetorical *ekphrasis*, the detailed description of works of art, real or imagined, made in another medium. Christian art, with its biblical typologies and devotional symbols, offered richer possibilities by far. In common with many other writers of her age, Christine sometimes drew upon this symbolic language in the invention of her own narratives, knowing that *in the mind*, where literary and visual images become one, suggestive likeness can itself become a form of meaning.

text. S. Nichols, "Introduction: Philology in a Manuscript Culture," suggests such possibilities (in general, not vis-à-vis Christine) in *The New Philology*, a special issue he edited for *Speculum*, LXV, 1990, 8.

[85] On this painting, see Meiss (as in note 9), I, 9–10, 12, 291–92, and for other illustrations of the "Salle de Fortune" and its paintings, II, figs. 2, 29, 30. Notice the *tituli* (probably verse inscriptions) that accompany the "pourtraictures" on the walls. K. Brownlee, "The Image of History in Christine de Pizan's *Livre de la Mutacion de Fortune*," in *Contexts: Style and Values in Medieval Art and Literature* (*Yale French Studies*, Special Issue, 1991), 44-56, writes powerfully about this "double mimesis" of human history, an extended *ekphrasis* with antecedents in the *Aeneid*, the *Roman de la Rose*, the prose *Lancelot*, and Dante's *Purgatorio* (the First Terrace). Christine's *Epître d'Othéa* is likewise a work designed *for* miniatures, one for each of its hundred chapters; the decoration of its first manuscripts, like those of the *Cité*, was directed by Christine herself. See Meiss, (as in note 9), I, 23–41. And note the many chapters in the *Cité des Dames* that describe a statue made in memory of a brave woman's deed, with Christine's description of it clearly intended as an analagous artistic act (*Book of the City of Ladies*, 57, 62, 68, and passim).

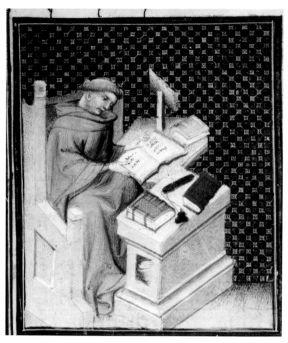

1. Boccaccio at his writing desk, from the Duke of Berry's *Des cleres et nobles femmes*, 1402–3. Paris, Bibl. Nat., MS. fr. 598, fol. 4v (photo: Bibliothèque Nationale)

2. Saint Matthew writing his Gospel, from the Duke of Berry's *Très Riches Heures*, Paris, 1413–16. Chantilly, Musée Condé, MS. 65, fol. 18v, detail (photo: Giraudon/ Art Resource)

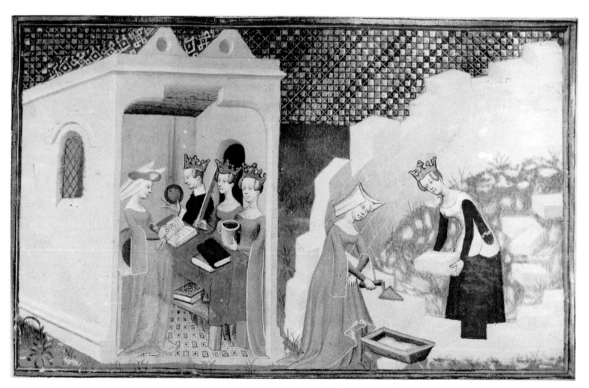

3. Christine Converses with Lady Reason, Lady Rectitude, and Lady Justice; Christine and Lady Reason lay the city's outer wall, Paris, ca. 1410. London, Brit. Lib., MS. Harley 4431, fol. 290 (photo: British Library)

4. Christine in Despair, Visited by Lady Reason, Lady Rectitude, and Lady Justice, Bruges, second half of fifteenth century. Paris, Bibl. Nat., MS. fr. 1177, fol. 3v (photo: Bibliothèque Nationale)

5. (bottom left) The Annunciation, from the Duke of Berry's *Belles Heures*, Paris, 1408–9. New York, Metropolitan Museum of Art, Cloisters Collection, 1954, MS. 54.1.l., fol. 30 (photo: Metropolitan Museum)

6. (bottom right) The Annunciation, from the Duke of Berry's *Très Riches Heures*, Paris, 1413–16. Chantilly, Musée Condé, MS. 65, fol. 26 (photo: Giraudon/Art Resource)

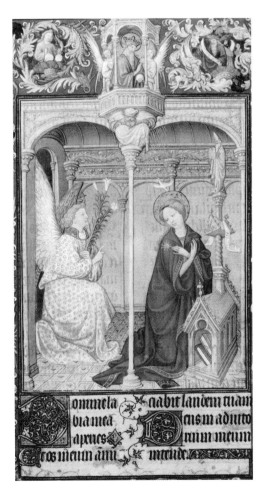

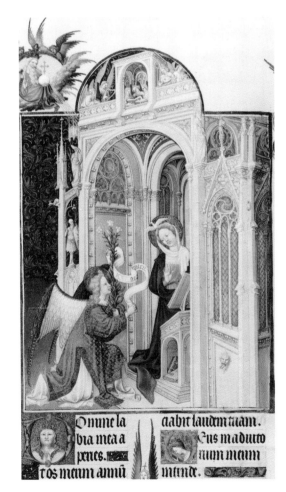

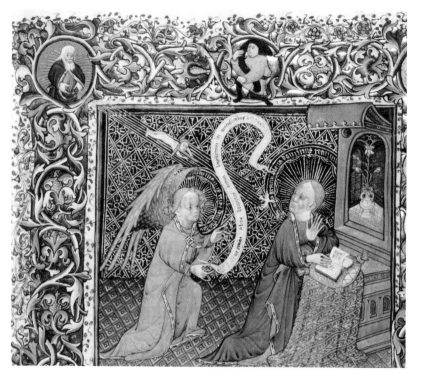

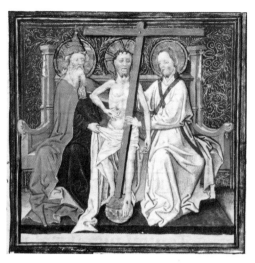

8. The Trinity with the Son Showing his Wounds, from the *Hours of Catherine of Cleves*, Dutch, ca. 1440. New York, Pierpont Morgan Library, MS. M. 945, fol. 88 (photo: Pierpont Morgan Library)

7. The Annunciation, from the *Beauchamp Psalter and Hours*, English, ca. 1439–46. New York, Pierpont Morgan Library, MS. M. 893, fol. 12 (photo: Pierpont Morgan Library)

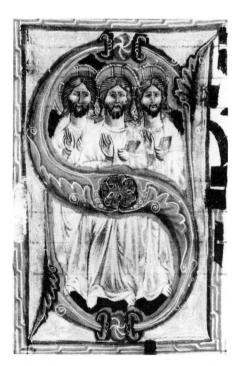

10. The Trinity, Paris, ca. 1375. Los Angeles, J. Paul Getty Museum, MS. 1, vol. I, fol. 3v, detail (photo: J. Paul Getty Museum)

9. The Trinity in a letter *S*. Perugia, ca. 1390–1400. Perugia, Bibl. Com. Augusta, MS. 2798, fol. 173v (photo: Biblioteca comunale, Perugia)

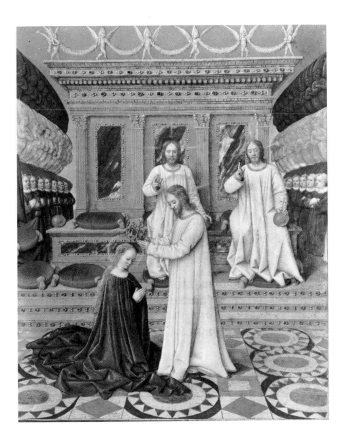

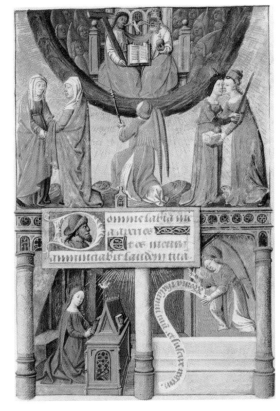

11. (top left) Jean Fouquet, The Coronation of the Virgin by the Trinity, from the *Hours of Etienne Chevalier*, Paris, ca. 1453–55. Chantilly, Musée Condé (photo: Giraudon/ Art Resource)

12. (top right) The Parliament of Heaven with the Annunciation, from a Book of Hours, Touraine, ca. 1473–80. New York, Pierpont Morgan Library, MS. M. 73, fol. 7 (photo: Pierpont Morgan Library)

13. (right) The Annunciation, prefigured by the Temptation of Eve and Gideon's fleece, from the *Biblia Pauperum* (Schreiber Edition I), pl. A, ca. 1460, woodcut. Dresden, Sächsische Landesbibliothek (after *Biblia Pauperum: A Facsimile and Edition*, ed. A. Henry, Ithaca, 1987, p. 48)

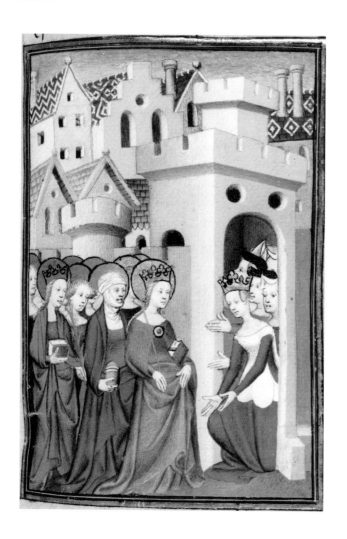

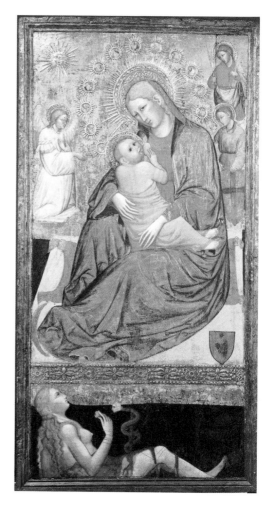

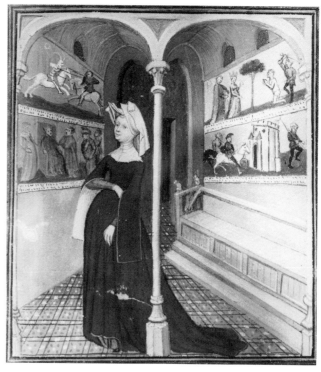

14. (top left) The Virgin with Saints Enters the City of
Ladies, Paris, ca. 1410. London, Brit. Lib., MS. Harley
4431, fol. 361 (photo: British Library)

15. (top right) Carlo da Camerino, Madonna of Humil-
ity with the Temptation of Eve, ca. 1380–1420, panel.
Cleveland Museum of Art, Holden Collection, 16.795
(photo: Cleveland Museum of Art)

16. (right) Christine Views History as Wall-paintings in
the *Salle de Fortune*, Paris, ca. 1410–11. Munich, Bayer.
Staatsbibl., MS. gall. 11, fol. 53 (photo: Bayerische
Staatsbibliothek)

The "Mystical Signature" of Christopher Columbus

•

JOHN V. FLEMING

UNDER THE DATE of 22 February, 1498, at Seville, Christopher Columbus uttered a legal document of primogeniture or *mayorazgo*, to use the proper Castilian term, in favor of his son Don Diego Colón. Among its stipulations was a clause establishing the hereditary character of the admiral's distinctive formal signature, usually called in recent professional literature his "mystical signature." Columbus directed that his heirs, on coming into their inheritance, were to sign "with the signature that I am accustomed to use now":

> que es una .X. con una .S. encima y una .M. con una .A. romana encima, y encima d'ella una .S. y despues una .Y. greca con una .S. encima con sus rayas y bírgulas como agora hago [1]

This signature (Fig. 1) has been the object of numerous specialized studies, many of which advance theories quite as amphigoric as those of the admiral himself. It will not be the purpose of this essay to review in detail earlier theories of the possible meaning(s) of the signature, but to suggest a fundamentally new approach, an *iconographic* approach, to its decipherment.

Practically all previous discussion of the Columbus signature has centered on its literal elements. This approach assumes that the signature is a hermetic *verbal* construct of a sort amply documented in Renaissance culture, the seven letters of which are the initial letters of seven words written in a definite order to construct a sentence, phrase, or simply a significant sequence of words. For example, one such solution, posited more than a century ago, is that the signature "means" *Spiritus Sanctus Altissimi Salvator Xristus Maria Yesus.*[2] Concerning one of these readings—the Maria expanded from M—there is something like universal consensus, and I am prepared to grant two others. At the same time I believe that the literal elements are in the first place intentionally polysemous—that is, bearing more than one intended and coherent verbal meaning—and, more importantly, that they are subordinate to a larger spatial and pictorial conception. In a rather surprising and even delightful fashion Columbus's signature presents us with *multum in parvo*, including evidence of the workings

[1] Cristóbal Colón, *Textos y documentos completos, I, Relaciones de viajes, cartas y memoriales*, 2nd ed., ed. C. Varela, Madrid, 1984, 193.

[2] A. Sanguineti, "Delle sigle usate da C. Colombo nella sua firma," *Giornale Linguistico di Archeologia, Storia e Letteratura*, x, 1883, 212–22.

of an iconographic imagination of some sophistication. In the second part of this essay I want to suggest that the signature is related to three classes of pictorial or quasi-pictorial genres— emblematic heraldry, religious signatures, and craft or professional signatures—and that it bears general analogies with a fourth, cartography. But I first draw attention to certain significant formal features of the signature that provide a useful background for the iconographical discussion.

The Signature and Sacred Geometry

The signature of Columbus is "mystical" or "cryptic" in the etymological senses of those words. That is to say, it conceals an internal spiritual meaning within the cortex of an external, literal meaning. As this technical vocabulary suggests, its model is in a general sense scriptural allegory, and, indeed, like the cryptogram signature of Francis of Assisi, it contains explicit scriptural elements. Its scriptural or pseudo-scriptural nature determines its most salient characteristic, and that is its polysemousness. Many medieval exegetes claimed that the meanings of scripture were "infinite"; and while I would make no such claim about the cryptogram constructed by Columbus, I do recognize that its authorial and intentional implications are almost certainly more numerous than I have grasped. In what follows I shall concentrate only on those principal themes—Marian devotion, astral navigation, pneumatic inspiration, prophylaxis, and the admiral's personal and political mythology—that are most readily accessible.

The most promising ingress to the structural qualities of the signature continues to be the document of *mayorazgo*. Columbus's description of it is at once precise and reticent. While he is explicit in identifying the letters of the construct and in establishing their precise spatial relationships one with another, his exegetical silence is deafening. Though the context offers a perfect opportunity, he says absolutely nothing about what the signature *means*. Different inferences may be drawn from this fact; possibly he assumed that the signature was generally understood and needed no further explanation. Verbal descriptions of coats-of-arms, sometimes composed of visual allegories, rebuses, and so on, were generally made in neutral descriptive terms. One simply must know that quartered castles and lions allude to the union of Castile and Léon. As I shall suggest presently, one unnoticed feature of the signature probably depends upon the reading of a rebus—a visual emblem in which an exact or approximate homophonic or homonymic relationship exists between visual and verbal signifiers. Yet if heraldry offers an analogy to the Columbus signature in its heptameral, literal element, it is odd that no early commentators, including Fernando Colón, who began his biography with various mystogogic forays, and Bartolomé de las Casas, who interested himself in all aspects of the admiral's piety, even alluded to its significance. It seems to me distinctly more likely that, on the contrary, the signature is an allegorical or hermetic device which by its very nature implies a mysterious or esoteric "solution" known only to its owner and a small circle of initiates.

Although the structure of the heptagram itself remains invariable, there is actually a certain variety in the final line of the numerous recorded examples of Columbus's signature. There are two main types. On one the final line reads "Xpo FERENS"; on the other, "El Almirante." At what point in his life did Columbus come to believe that he was a "Christ-Bearer"? Precept, according to Doctor Johnson, is generally posterior to performance; and there is little evidence to suggest that Columbus's signature was the witness to a fully developed prophetical mentality antedating the first voyage of 1492. On the other hand we need not follow Tudela y Bueso and Milhou in attributing, on the basis of the documentary evidence, such a vision *only* to the final years of Columbus's life. These scholars find in the chronological pattern of Columbus's signed papers a discernible evolution in his prophetical consciousness.[3] In its early appearances—if we convict one document alleging to be of 1493 of the fraud of which it appears guilty—the signature always reads "El Almirante." Later documents read "Xpo FERENS." My own view is that the latter is the personal and immediately onomastic form; the former, the official and titular form. Although it is the personal version of the signature that is the subject of my inquiry, the document of *mayorazgo* is quite specifically focused on the titular. Columbus insisted that his son Diego sign with the hereditary title: "He will write only 'el Almirante,' even though there are other titles that the King may give him or that he may earn" The deposition is itself so signed:

<div align="center">

.S.

.S. A .S.

X M Y

El Almirante
</div>

The language seems to imply that Columbus recognized possible alternatives to the final line. Although we lack conclusive documentary evidence, it is nonetheless probable that examples of the "Xpo FERENS" signature already existed by the time he drew up the *mayorazgo*.

Among the papers edited by Consuelo Varela are two anomalies. In an American document of 3 August, 1499, Columbus gave the title "Virey" (viceroy) instead of "Almirante."[4] In a letter patent of 26 April, 1498, the final line includes the name of its recipient: "El Almirante, . Ximeno de Briviesca."[5]

However, the personal versions of the signature have numerous other variations of a minor character, variations in what I shall call the punctuation marks in the final line. According to Varela's edition, with the single exception of the anomalous letter patent with the name of Ximeno de Briviesca, punctuation marks never appear in the titular signatures. But in some, though by no means all, of the personal signatures the glyphs "Xpo FERENS" are

[3] J. Peréz de Tudela y Bueso, *Mirabilis in altis: Estudio critico sobre el origen y significado del proyecto descubridor de Cristóbal Colón*, Madrid, 1983, 409–12; and A. Milhou, *Colón y su mentalidad mesianica en el ambiente franciscanista español*, Valladolid, 1983, 88–90.

[4] Varela (as in note 1), 260.

[5] Ibid., 199.

accompanied by a variety of diacritical marks in various combinations—a single or double point, and a single or double slash-mark. That these marks were not objects of indifference to Columbus himself is suggested by their explicit mention in the document of *mayorazgo*. It also seems clear that personal signatures with these marks must already have existed; otherwise his description of the arrangement of the seven letters "con sus rayas y bírgulas" would have been meaningless.

Since Columbus apparently found importance in these marks, we would do well to attend to them also, even though it is uncertain what the words *rayas* and *bírgulas* actually mean. It is possible, though doubtful, that they mean essentially the same thing: punctuation marks in general. In Columbus's prose there are many examples of awkward or portentous pleonastic structures, as in his description of the Bible as "las sacras y sagradas escrituras."

The word *raya*, derived from the Latin *radius*, clearly bears a linear implication—one of its modern meanings is the typographical dash—but I do not think Columbus used it with reference to any specific graphic form. The evidence suggests, instead, that the *rayas* are the imaginary lines of the geometrician, that construct the grid against which the seven letters are laid out. The word *rayas* thus suggests the importance, to Columbus, not merely of the literal content of the signature, but also of its arrangement. The phrase "con sus rayas y bírgulas" could thus mean something like the following: "with its geometrical format and punctuation points."

Bírgula is simply an hispanization of the Latin *virgula*, a diminutive of *virga*, meaning a branch, wand, or switch. Together with its vernacular cognates, the word *virgula* is very common in the vocabulary of calligraphy and grammatical analysis. It survives among other places in the modern French *virgule*, meaning comma, though the modern word is potentially misleading in its specificity. *Virgula* means "a little stroke," and in classical, medieval, and early modern texts it can denote almost any mark of punctuation. Most commonly it refers to the diagonal slash (/) that remains more or less uniform—in terms of its graphic character if not its nomenclature—from the earliest Latin inscriptions to the period of the early printed book.[6] This mark was frequently used in both manuscripts and printed books of Columbus's time to indicate rhetorical or syntactical pause or completion, in places where modern convention would suggest the comma, the period, or, indeed, other marks of punctuation.

While the slash mark with which Columbus's signature frequently ends is generally called the *virgula*, the word could also apply to the single points surrounding the three letters "S" or the double points before the "Xpo." I am convinced that it is obvious which *bírgulas* occupy the admiral's attention, and why: the twin points (:) that precede the "Xpo FER-ENS" and the single point and slash mark (./) that follow it (see Fig. 1). Their importance is that they, too, are the Christ-bearer's name.

Fernando Colón began his biography of his father with a meditation on the mystical meaning of the admiral's names, commenting on both the Italian and the Castilian versions (Colombo and Colón) of his surname. According to Fernando, Columbus chose the latter "because in Greek it means 'member'." This philological claim, though bizarre in context, is

[6] See E. Otha Wingo, *Latin Punctuation in the Classical Age*, The Hague, 1972, 95ff.

unimpeachably true. The Greek *kolon* does indeed mean member. Its typical context of usage in Greek, and its only context in Latin texts, is grammatical or rhetorical. The *kolon* is a member or part of a written or spoken statement. The Latin word for the complete expression of more than one thought in a sentence is *periodus*. The smaller unit of the *periodus*, roughly equivalent to the phrase, is the *comma*. Its larger unit, the independent clause, was the *colon*. It will be obvious, at least to English-speakers, that these three syntactical units have given their names to three common punctuation marks: the comma (,), the colon (:), and the period (.).

These terms entered European vernacular grammatical discourse in the Age of Humanism. In England they were apparently first used by Puttenham in the *Arte of English Poesie* (1589).[7] On the Continent they had appeared as much as a century earlier in the first translations of classical texts. In several instances translators or grammarians attempted to adapt from the older manuscript culture a uniform set of punctuation marks. These at first exhibited considerable variety, achieving a relative stability in most languages only in the seventeenth and eighteenth centuries. Among the German humanists, the only group to be the object of a synoptic study of punctuation practices, the medial "member" of discourse and its significant mark had a large number of names including *strichlin, virgula, colon, gemipunctus erectus, zwei punct,* and *membrum.*[8] The mark itself could be indicated in almost as many ways (:, , /, ./, etc.), but as can be seen in the modern English development, the word *colon* eventually became definitively identified with the mark (:). Obviously Columbus intended the glyphs ": Xpo FERENS" to be read as "COLON CHRISTOFERENS," or Colón the Christ-bearer. The mark (./) is also a recorded symbol of the *colon*, but I suspect that Columbus used it as the mark of *periodus*, or completion. Like the tau in Francis of Assisi's signature, the glyph (:) has to be read as a mark and as a word simultaneously.

So much for the *bírgulas*; what of the *rayas*? Before we approach the literal nature of the signature, we must consider its geometrical construction. For this purpose it may be useful to create a diagram in which the majuscule Latin letters are thought of as points on a grid:

a

b c d

e f g

[7] "For these respectes the auncient reformers of language, inuented, three maner of pauses, one of lesse leasure then another, and such seuerall intermissions of sound to serue (besides easment to the breath) for a treble distinction of sentences or parts of speach, as they happened to be more or less perfect in sence. The shortest pause or intermission they called *comma* as who would say a peece of a speach cut of. The second they called *colon*, not a peece but as it were a member for his larger length, because it occupied twise as much time as the *comma*. The third they called *periodus*, for a complement or full pause, and as a resting place and perfection of so much former speach as had bene vttered " *The Arte of English Poesie*, ed. G. Doidge Willcock and A. Walker, Cambridge, 1936, 74.

[8] See the tables in S. Höchli, *Zur Geschichte der Interpunktion im Deutschen*, Berlin, 1981, 316ff. According to B. Bischoff, *Paläographie des römischen Altertums und des abendländischen Mittelalters*, Berlin, 1979, 216, the Italian humanists influenced people like Nicolaus von Wyle and other early reformers of punctuation in Germany, who introduced a new and somewhat more uniform set of punctuation marks in the fifteenth century.

This diagram makes obvious the literally crucial fact that, in the vocabulary of medieval geometry, it is a construction *ad quadratum*, that is, based on the square. The last six letters make up two identical, contiguous squares (*bc, cf, fe, eb* and *cd, dg, gf, fc*) which share the common side *cf*. The figures *ab, bc, ca* and *ad, dc, ca* are regular right triangles, that is, half-squares, sharing the side *ac*. Another square, set on its point in "diamond" fashion, is defined by the lines *ba, ad, df,* and *fb*. If we define the length of the sides of the contiguous squares and of the right triangles as one, we can then calculate the length of the sides of the larger square as 2. The length of lines *ae, ag, ed,* and *bg* is $\sqrt{5}$.

The obvious significance of the design *ad quadratum* in this esoteric context is that it allows, indeed invites, the application of certain traditional ideas of Pythagorean harmony, and particularly the idea of the golden section, or the division of a line in extreme and mean ratio, to the interpretation of the signature as a whole. The golden section is achieved when any line *ab* is divided at point *c*

a————————————————c————————b

in such a fashion that the ratio of the length of the whole line to the longer of the two divided parts (*ab/ac*) equals that of the ratio of the longer part to the shorter part (*ac/cb*). The golden section has been brilliantly and comprehensively studied in terms of the history of architecture, aesthetics, and mathematical thought.[9] I commend interested readers to such larger treatments, since my own brief remarks here are intended to invoke merely a few elementary principles relevant to the Columbus hieroglyph. The elegance of division in extreme and mean ratio was known to Euclid, though the philosophical and mystical penumbra surrounding it is the accretion of later ages. The irrational numerical expression of the ratio, the golden number itself, is 1.618 . . . , sometimes denoted by the Greek letter *phi*, or one half of ($\sqrt{5} + 1$). One of its classical geometrical demonstrations begins with the construction of a rectangle formed of two identical squares, as in the figure *bd, dg, ge, eb*. Line *ed* on this figure becomes the hypotenuse of the right triangle *dg, ge, ed*. Its length, $\sqrt{5}$, added to the length of the shorter side of the triangle (1) and divided by the length of the longer side (2) yields the golden number.

Campanus, the thirteenth-century redactor of Euclid, found in the ratio something *mirabilis*: "Wonderful is the power of a line divided according to a ratio having a mean and two extremes: since most things worthy of the philosophers' admiration accord with it"[10] In Columbus's day his contemporary Luca Pacioli would call the golden section the *divina*

[9] See especially F. M. Lund, *Ad Quadratum: A Study of the Geometrical Bases of Classic and Medieval Religious Architecture*, 2 vols., London, 1921; M. C. Ghyka, *Le nombre d'Or*, 2 vols., Paris, 1931; and R. Herz-Fischler, *A Mathematical History of Division in Extreme and Mean Ratio*, Waterloo, Ontario, 1987. The geometrical basis of medieval architectural theory is explored in great depth in Lund's remarkable book. His pages on the pentagon and the pentangle (see esp. vol. I, 141–45) document with definitive proof the early medieval understanding of the construction of the pentangle within a circle, a knowledge explicit in the surviving texts of Boethian geometry, see *"Boethius" Geometrie II: Ein mathematisches Lehrbuch des Mittelalters*, ed. M. Folkerts, Wiesbaden, 1970, 131 (Geometria xi.8): "Intra datum circulum quinquangulum quod est aequilaterum atque aequiangulum, designare non disconvenit."

[10] Text in Herz-Fischler (as in note 9), 171.

proportio, the "divine proportion" in the literal sense that it reflected the most fundamental attributes of the Divine Being. From this divine proportion numerous other mysteries naturally flowed. One of the specialized contexts of the golden section was the construction of the pentagon within a circle, and from the pentagon a pentangle, or five-pointed star. It was this geometrical figure that gradually took on such multi-faceted symbolic associations, prominent among which were the associations with the mason's art, with the construction of the Temple, and with Solomon and his wisdom. The Columbus signature has an implicit pentangle of an unusual sort, constructed with four lines having the measurement of $\sqrt{5}$ (lines *ae*, *ag*, *bg*, and *ed*) with a fifth line, *bd*, having the length of 2. Such a pentangle is not, of course, regular—it is geometrically impossible to accommodate in a seamless integument Columbus's quadratic, pentangular, and heptameral schemes—but it is fundamental to one important meaning of the signature, the astral meaning. The five-pointed star may be regarded as a crown over the majuscule Roman M (point *f* in the diagram). Alternatively, we may think of point *f* as the center of a circle of a diameter of 2 around which the star orbits in such a fashion that points *e* and *g* are always touching its circumference.

The signature was probably also constructed with at least the stylistic gesture of invoking the principles of gematria, or kabbalistic number mysticism. In Hebrew, as in Greek, the letters of the alphabet could be used in the place of numerals, so that the meaning of a word could be "added up" by calculating the sum of its literal members. Although the practice of gematria was a prominent feature of Sephardic kabbalah of Columbus's day, there is no need to posit an immediate Jewish source for the admiral's possible interest in it, since it had long since been incorporated into the classical tradition of Christian exegesis, particularly that of the Apocalypse and apocalyptic themes, and especially in Spain.

One famous example was the exegetical equation by which Christ as the Logos was identified with the Spirit. The first divine words of the Apocalypse, both rhetorically and structurally emphatic, are these: "I am the Alpha and the Omega, saith the Lord God, which is and which was and which is to come, the Almighty" (Apoc. 1:8). The numerical value of alpha is one, that of omega, eight hundred. Hence by gematrial reckoning the "number" of Christ was eight hundred and one. Now as it happens the gematrial number of the dove, that is of the Greek word for dove, *peristera*, is also eight hundred and one.[11] This delightfully logocentric theorem of patristical mathematics was introduced quite early into the Iberian tradition of Apocalypse commentary by Apringius of Beja, and it would have been mother's milk to "prophetical" Franciscans.[12] As for the admiral himself, I presume that a learned, authoritative genealogy of his own columbanity or doveness would have proved irresistible.

The numerical values of the Columbus signature are as follows:

$$200$$
$$200 \quad 1 \quad 200$$
$$600 \quad 40 \quad 400$$

[11] See the calculation of the values in *Theological Dictionary of the New Testament*, vi, s.v. "peristera."

[12] See the discussion in *Apringii Pacensis Episcopi Tractatus in Apocalypsin*, ed. A. C. Vega, El Escorial, 1941, xiv–xvii.

If we again imagine a five-pointed star crowning the M (40), which we exclude from our calculations, we have, depending on how one looks at it, the possibility of 1601—that is 2 x 800 + 1—or six alternative partial sums of 801. I say "depending on how one looks at it," since the polysemous "readings" born of the science of gematria typically involve such short-cuts, approximations, or transparent finagles. That Columbus toyed with this idea is strengthened by the intellectual filiations of the astral detail of Apocalypse 1:16, where we learn that the apocalyptic Christ "had in his right hand seven stars." The second part of this essay will produce evidence to show that the "seven stars," whether or not specifically associated with *Ursa Minor*, have exegetical links with the Marian traditions that lie behind the signature as a whole.[13] The pentangle, or five-pointed star, also can be thought of in connection with the wounds of Christ, as it is for example in the *Hieroglyphica* of Columbus's cadet contemporary, Balzoni [Pierius]. Balzoni published an image of the "pentangular Christ" in which the geometrical design of a five-pointed star is superimposed on the body of the naked Christ in such a fashion that the five points touch the five wounds. The medieval antecedents of this conceit are present in the fine Middle English poem *Sir Gawain and the Green Knight*. Sir Gawain's shield, which has the mystical "endless knot" of Solomon on one side and an image of the blessed Virgin on the other, has a talismanic significance not wholly unrelated to that of the Columbus signature.

SOME ICONOGRAPHICAL ASSOCIATIONS OF THE SIGNATURE

A signature is by nature the "writing act" of a particular individual, usually a name. In the foregoing analysis I have tried to demonstrate in at least two ways the presence of hidden onomastic individuality in the signature. With a kind of punctuational rebus the admiral added to his given saint's name his self-appointed Castilian surname of Colón; and with a gesture of sacral mathematics, he invoked the dove with its implicit pun on the Latin and Italian forms of the surname. Since the dove (*columba*) is an emblem of the Holy Spirit, we are invited to "see" not merely a numerical "name" but the concept of pneumatic inspiration which the admiral claimed for himself. That is we are invited to "see" a pictorial icon not *pictorially* present in the signature.

Other implicit visual constructs lie behind the signature. I earlier suggested four—heraldic devices, religious signatures, craft signatures, and maps. Like the admiral's own coat of arms, in which the islands he discovered on the first journey and the quincuncial anchors of the mariner's trade are quartered with the castle of Castile and the lion of Léon, the signature celebrates the ennobling achievement of a great man. Like the autograph chartula of Francis

[13] In fact, the iconography of some of the manuscripts of Beatus, in which the seven stars approximate the form of *Ursa Minor* on a constellar chart, suggest that connection strongly; see for example, the illustration from the Bamberg Apocalypse reproduced by X. Baral i Altet, "Repercusión de la illustración de los 'Beatos' en la iconografía del arte monumental románico," *Actas des simposio para el estudio de los códices del "Comentario al Apocalypsis" de Beato de Liebana*, Madrid, 1980, III, 26, fig. 22. (The article itself is in vol. I, 35–50.)

of Assisi, to which I devoted a detailed iconographic study some years ago, Columbus's signature includes an acrostic of considerable complexity committed to a more or less learned and hermetic mystical theology.[14] It may likewise be described as a craft-mark. This obscure iconographic class, belonging to a proletarian world of semi-literacy, remains largely unstudied, though it has its lessons to teach. One particularly relevant and interesting document is a contractual statement signed with the names and/or marks of a number of late fifteenth-century fishermen from Puerto de Santa María, near the Franciscan house of La Rábida, where Columbus rusticated.[15] Many of the signatures on this document are visually macaronic, composed of both pictorial and verbal elements. The crude pictures include anchors, boats, fish, fishhooks, nets, oars, and other piscatorial accoutrements. In a similar fashion, I believe that Columbus's signature alludes to his principal trades, as he understood them in 1498: navigator of their serene majesties and prophet of Jehovah.

Each of the kinds of pictorial or quasi-pictorial signification so far mentioned deserves the focused attention of iconographers, but my own essay must move on to a fourth kind, namely medieval maps. The signature is animated by a cartographic spirit. However, medieval maps may bemuse us precisely because of an unexpected iconographic vocabulary that addresses spiritual or political ideas as opposed to empirical geographical relationships. The simplest and most ubiquitous of medieval *mappae mundi* are the so called T-O maps (Fig. 2). Probably current in antiquity, such maps enjoyed in the Middle Ages the plenary authority of Isidore of Seville. Though they reveal some varation, there is a standard grid. Within the great encircling watery "O" of the Oceanus, the three known land-masses of Terra, the continents inhabited by the three sons of Noah, are divided by a watery "T": to the east, Asia (top); to the north, Europe (lower left); and to the south, Africa (lower right).

The vertical shaft of the "T" is the Mediterranean Sea, the horizontal crossbar the imaginary line formed by the Don and Nile rivers. But of course the "T" is also a cross, a *tau* cross as in Francis's chartula, dividing the earth spatially into three parts which reveal the harmonic ratio (2:1).[16] T-O maps appear in books of the most sophisticated medieval geographers and cosmographers, including Pierre d'Ailly's *Imago Mundi* of about 1400, one of the most heavily annotated books in Columbus's library, but they are more clearly summaries of christology than of geography. At the very union of the crossbars is Jerusalem, the center of the world, and the explicitly named object of Columbus's life-long quest. Christ, the center, is likewise the cosmic force that holds together earth's far-flung corners in the famous Ebstorfer *mappa mundi*, which presents the earth as a kind of terrestrial body of Christ.

Such *mappae mundi*, with their vast iconographies of legendary lore, will baffle the cartographic historian for whom the beginning of wisdom is the Mercator Projection. Even that class of maps that most closely conforms to modern cartographic conventions, the portolan chart, which often catalogued in meticulous detail the ports, coastal towns, and watering stations of the Mediterranean, may startle us with its apparent confusion of rational

[14] J. V. Fleming, "The Iconographic Unity of the Blessing for Brother Leo," *Franziskanische Studien*, LXIII, 1981, 203–20.

[15] See *Le Navire de l'économie maritime du XV^e au XVIII^e siècles*, ed. M. Mollat, Paris, 1957, pl. xvi.

[16] J. T. Lanman, "The Religious Symbolism of the T in T-O Maps," *Cartographica*, XVIII, 1981, 18–22.

geography and allegorical whimsy. The most remarkable maps of this genre, by Opicinus de Canistris, are known to art historians. In one of Opicinus's most whimsical productions, a serviceable mariner's chart of the Mediterranean is framed within an eroticized geography of classical literary inspiration. The lecherous male head of Iberia, identified as "Boethius," bends with osculatory intention toward a cosmeticized female face of Africa, labeled "muse poetice."[17]

Mediterranean sailors who consulted their maps and charts probably did not see the hopeless muddle of fact and fiction we now describe, but a large eco-sphere of knowledge in which shadowy signs, at best mere surrogates for truth, pointed to cooperative truths of varying kinds. My argument is that Columbus's so-called mystical signature is actually a special kind of mariner's chart, which is informed by his particular religious vision and abstracted for the ceremonial and legal functions it was intended to serve. The art of navigation in Columbus's world was never an art of map-reading but of star-reading. The informing, heuristic principle of Columbus's metaphorical chart-signature is accordingly astral. The specific ground of its allusion, to which I shall presently return, is to *Ursa Minor*, the mariner's constellation par excellence. It is also necessary to mention, if only in passing, an aspect of the signature that is of importance equal to the astral. The broad genre of Columbus's signature, like that of Francis of Assisi, is the *crucigram*. The admiral's description of the signature started with the cross (the letter "X"), sometimes called by spiritual writers "the cross of the New Testament" to complement the letter "T", the "cross of the Old Testament."[18] I believe that Columbus intended multiple coherent "readings" in all directions along all the geometical lines (*rayas*) created both by analyzing the construct *ad quadratum* and by tracing a five-pointed star to crown the letter "M", as suggested above; my concern here, however, is strictly with the cruciform element:

.S.

.S. A .S.

M

The central cruciform readings point to the controlling idea: the idea of the *Stella Maris* or Polaris, the one star absolutely indispensable for astral navigation in the fifteenth century. The palindromic cross-bar—S A S—frames the phrase, StellA mariS; and the vertical axis is built around the three verbal elements in the incipit of the most famous of all Marian hymns—and of mariner's hymns—the *Ave, stella maris*.

This brings us back to the stars, for the star and cross were inseparable in Columbus's imagination. Polaris—also known as the Cynosure and the North Star, among many other names—was, before the earliest phases of recorded maritime history, the principal resource

[17] The Boethian theme, taken from the opening scene of the *Consolatio Philosophiae*, is one of several "sexual" interpretations of Europe and Africa in Opicinus's work. See R. Salomon, *Opicinus de Canestris: Weltbild und Bekenntnisse eines avignonesischen Kleriker des 14. Jahrhundert*, London, 1936, I, 65–77; see further J. Schulz, "Jacopo de' Barberi's View of Venice: Map Making, City Views, and Moralized Geography Before the Year 1500," *Art Bulletin*, LX, 1978, 450, fig. 14.

[18] Diego García, *Planeta*, ed. M. Alonso, Madrid, 1943, 317.

of the haven-finding art, almost, in fact, the natural emblem of the maritime trade. From early Christian times in the Mediterranean world, this star has been identified with the Virgin Mary, Star of the Sea. The constellation of which the *Stella Maris* is such a prominent member is *Ursa Minor*, the Lesser Bear, known to us as the Little Dipper. It has had many names in differing maritime cultures; the vernacular name by which it was generally called by Mediterranean sailors of the later Middle Ages was some form of the Latin *buccina*, a cow's horn. A constellation of seven stars, this fact has excited nearly inexhaustible allegorization from those—in effect everyone who has left a written opinion on the matter—who have identified its chief star with the Blessed Virgin. It is the heptameral nature of the constellation *Ursa Minor* that accounts for the seven-stanza structure of the vesper hymn *Ave, stella maris* and the seven-letter structure of Columbus's signature.

Of the numerous other structural analogues in the vast Marian literature of the later Middle Ages I shall mention only two. The first is the *Stella Maris* of John of Garland, the most famous and florid of medieval Latin poetic anthologies devoted to miracles of the Virgin. In addition to the nautical explanation of the term *stella maris* in the preface, this work contains a lengthy and complex poem called the *Spiritual Astronomy* in which numerous stars and constellations are related allegorically to the Virgin.[19] The second, Diego García's devotional and dogmatic treatise *Planeta*, a seven-letter word meaning "star" or "constellation," has the greater local interest of being Spanish and the greater thematic convenience of making quite explicit its astral lore.[20] It has a seven-book structure and its medial fourth book is devoted to the Virgin.

There may be implicit confirmation of the astral basis of the Columbus signature in a cognate icon—the coat of arms of the great naturalist of the Indies, Gonzalo de Oviedo. Oviedo admired Columbus, but he was also eager to insure that the triumphs of the second generation of explorers not seem dim by comparison with those of the first. He made much of being among the first Europeans to see the Southern Cross. The "discovery" of this constellation, visible only in the southern hemisphere, thrilled Europe. Oviedo actually prevailed upon the heralds royal to have the Southern Cross quartered into his family arms (Fig. 3). This gesture may well have been born of the anxiety of influence.

There are of course many medieval and Renaissance representations of *Ursa Minor*. The genre of the astral picture book, a classical form that still flourishes and which was known to the Middle Ages through such texts as the Leiden *Arathea*, fleshes out the constellar skeletons with imaginary bestial or mythological forms. Here the images reveal Arabic influence, for the individual elements of the star world are denoted by numerals rather than by letters.[21] In some images the abstract idea of astronomy is suggested by seven stars in a row (Fig. 4); perhaps the scriptural "Seven Stars" (the Pleiades) have been melded with the seven stars of *Ursa Minor*. A fairly close formal analogy to the geometry of the Columbus signature

[19] *The Stella Maris of John of Garland*, ed. E. F. Wilson, Cambridge, Mass., 1946, 99–105.

[20] García (as in note 18), 200: " . . . nomen suum in septem litteras installatum, tanquam epthatycus ex librorum numero vel vendicat vel sortitur."

[21] R. Katzenstein and E. Savage-Smith, *The Leiden Aratea: Ancient Constellations in a Medieval Manuscript*, Malibu, 1988, 20.

is found in the cuts made for technical marine manuals, such as the mid sixteenth-century *Arte de Navegar* of Pedro de Medina, demonstrating the method of making chronometric calculations from the "guards" of the *Stella Maris* (that is, stars Beta and Gamma of *Ursa Minor*) when the stars are near the horizon (Fig. 5). Finally, the abstracted constellation may appear—even at the cost of displacing the Apocalyptic image of a twelve-star stellarium—in images of Mary Immaculate.[22]

Here, indeed, is one iconographical key to Columbus's mind; for though the Marian association of the *Stella Maris* was ancient, the iconographical context in which it gained its widest popularity in the later Middle Ages was the ascendant theological lobby for the doctrine of the Immaculate Conception. In Columbus's world a popular type of Immaculist devotional image called the *Tota Pulchra* derived from a verse in the Canticle applied to Mary, in which the glorified Virgin is surrounded by a number (usually fifteen) of allegorical attributes, one of which was the *Stella Maris*.[23]

In the repertory of Marian attributes that make up the plenary pictorial anthology of the Immaculate Conception the star of the sea alone is extra-biblical. The garden enclosed, the fountain sealed, the spotless mirror, and all the rest, take their textual and lexical identities from the Scriptures. The star of the sea, however, though genetically connected to the Bible, is actually an exegetical creation of Saint Jerome, who provided it with the etymological meaning of the Hebrew name Miriam (Mary).[24] From such a semiotic perspective, the other attributes are all "signs" for Mary; but "Mary" is actually a "sign" for the star of the sea. The quasi-biblical authority of the image of the *Stella Maris* begins with Jerome, but it is textually guaranteed by the ubiquity and liturgical centrality of the ancient vesper-hymn "Ave, stella maris." That this hymn was in some circles regarded as the revelation of God rather than the invention of men is evidenced in an amusing way by Erasmus, who satirizes a theological argument based in its text. One of its lines—"Show yourself to be the Mother," in a context in which "Mother" is pretty clearly synonomous with "Boss"—might suggest a priority of power exercised by Mary with regard to Christ.[25] This implication in the Mariolatry of the later Middle Ages aroused the indignation and opposition of that small group of principled conservatives, erudite opponents of theological innovation, and actual reformers, who in the fifteenth century vocally resisted, not without bodily danger, the celebration of the feast of the Immaculate Conception. Christopher Columbus was decidedly not of their number. When, like an Adam in his "new" world he came to name his new-found isles, there was a perfect decorum in his choice. First, of course, Christ (San Salvador), then the Virgin (Santa María de la Concepción); then the earthly monarchs whom he served (Ferdinando and Isabella) and the Spain which they ruled (Hispaniola). Yet it would not be easy to explain precisely what Columbus's, or for that matter any of his contemporaries' committed,

[22] As in an "Immaculate Conception" of Francisco Pacheco; see note 33, below.

[23] For a thorough discussion of the theme, see the excellent article of M. Vloberg, "The Immaculate Conception in Art," in *The Dogma of the Immaculate Conception: History and Significance*, ed. E. D. O'Connor, Notre Dame, 1958, 475–80.

[24] See F. Wust, *Onomastica Sacra: Untersuchungen zum Liber Interpretationis Nominum Hebraicorum des hl. Hieronymus*, Leipzig, 1914, 441.

[25] See L. Halkin, "La Mariologie d'Erasme," *Archiv für Reformationsgeschichte*, LXVIII, 1977, 44–45.

at times bellicose, belief in the Immaculate Conception actually betokened. The doctrine of the Immaculate Conception, though unerringly logical, remains among the most experientially abstruse of Christian teachings. Its origins are coldy intellectual, indeed syllogistic, for it is a secondary or corollary necessity required by the Augustinian doctrine of Original Sin. That doctrine holds that all human beings generated after the Fall of our first parents, all those born of blood and the will of the flesh, are the inheritors of the virus and, if they engage in the works of the flesh, its transmitters. The teaching of the Immaculate Conception allowed, with respect to the most beloved of all the daughters of humankind, a means of honoring the process without suffering the conclusions. Perhaps a more generous way of describing matters would be to say that the doctrine was an evolutionary necessity of the incrementally expansive European love of the Blessed Virgin. The Franciscan argument, classically stated by Duns Scotus, was that everything good and noble that reasonably *could be thought true* concerning the Virgin probably *was true*.

The issue, which had once been debatable, is exemplified in the pictorial genre known as the "Scholastic Disputation" about the Immaculate Conception.[26] The doctrine, which has no explicit scriptural warrant, might be thought to face weighty scriptural opposition in Pauline pessimism. Unknown to the great fathers of the Church and to the early calendar it was rejected by the Angelic Doctor. But as the European love of the Virgin became more fervent, it also became more personal. To demur from acknowledging the plenary graces of Our Lady, once the posture of theological conservatism, was something akin to a calculated personal snub. There is a famous text to this effect, attributed to Saint Anselm: "Non puto esse verum amatorem Virginis qui celebrare respuit festum sue conceptionis" (I reckon that whoever disdains to celebrate the feast of the Conception is no true lover of the Virgin).

That is the sentence inscribed on Saint Anselm's banderole in paintings of the "Scholastic Disputation." The pseudonymous Anselmian text from which the *sententia* comes is a sailor's story, a widely circulated and occasionally illustrated sermon concerning the abbot Helsin. In the course of performing an important embassy for William the Conqueror, this ecclesiastical statesman found himself and his crew threatened by destruction at sea. "Despairing of saving their bodies, they loudly commended to their Creator the salvation of their souls alone, and they called upon the most Blessed Virgin Mary, Mother of God, the refuge of the miserable and the hope of the desperate. Suddenly they saw, in the midst of the waves not far from the ship, a man rather majestically garbed, and wearing a bishop's mitre."[27] The episcopal apparition told Helsin that the Virgin was willing to save the ship , but on one condition. The abbot at once promised that he would obey in everything should he escape this shipwreck. "Then promise," said the stranger, "to God and to me, that you will solemnly celebrate the day of the conception and creation of the mother of our Lord Jesus Christ, and that you will exhort others to celebrate it." At this the abbot, a prudent man, asked, "On what day is this feast to be celebrated?" "You are to celebrate this feast on December 8" was the rejoinder. "And what office," asked the abbot as he began to sink, "shall we use in the church

[26] See Vloberg (as in note 23), 486–90.

[27] I cite the translated text published in the appendices of Vloberg (as in note 23), 523.

services?" The answer was that "the entire office of her Nativity is to be recited for the Conception, except that instead of the word *Nativity*, you are to read *Conception*." The homilist's conclusion for allegorical seamen is that "if we wish to reach the port of salvation, we will celebrate the feast of the Conception of the Mother of God." I doubt that actual storm-tossed mariners came to any other conclusion!

We have already noted that in the most abstract iconology of medieval cartography Christ, the center of all things, was graphically present; and where the Son was, there also was the Mother. Among the most ancient pictorial relics of the mariner's craft is the windrose, which later developed into the compass card. The medieval windrose often had at its center the Virgin who also appears, as guardian and guide of sailors, on the more elaborate portolans and *mappae mundi* of the Renaissance, such as the famous map of Matthew of Venice of about 1600 in Paris. One very significant map, made by Juan de la Cosa (Fig. 6), usually identified as Columbus's first mate on the voyage of 1492, has a precise pictorial expression of Columbus's personal belief that his maritime destiny lay in the hands of the two heavenly Christ-bearers who had become his own internal psychic engines—the Virgin, *Stella Maris*, and Saint Christopher, the Bearer-over-water.

Since Columbus was a navigator, not a painter, traditional Marian iconography was relevant to the construction of his signature only in an indirect and analogous fashion. However, certain generalized Marian images and attributes claimed their particular and sometimes personal significance in his imagination. Although in my concluding discussion I will refer to images drawn chiefly from the well-known Bedford Hours in the British Library (1420s), comparable images and their allegorical associations were by Columbus's time more or less commonplace.[28]

For Columbus, one of the most pregnant Immaculatist images must have been that of the Virgin as dove, from Canticles 6:8: "Una est columba mea, perfecta mea, una est matris suae electa genetrici suae" (One is my dove; my perfect one is but one. She is the only one of her mother, the chosen of her that bore her). Among other implications of the text that Columbus might have found particularly rich is its gendered language. The "mother" of the only begotten Virgin is, according to the opulent medieval exegesis of this passage, a variety of grammatically feminine surrogates of Christ: the Church, Ecclesia, which is the "body of Christ" or the eternal Wisdom of the Father, Sapientia, Christ in his preexistent form. The discovery that Christ was apparently his own grandmother, potentially disturbing to more literal minds, was merely a paradox among other paradoxes to Cistercian spiritual writers, as I think it was also to Christopher Columbus, a man whose spiritual identification with the Virgin was constantly being pressed by the metaphor of Christ-bearing to the very limit of linguistic possibility. Columbus's own dove-ness, whether viewed as onomastical or gematrial fact, likewise involved a blurring of the boundaries of gender. The biography written by his son Ferdinand begins with an extended moment of etymological mystogogy relating to the admiral's name: "I was moved to believe that just as most of his affairs were directed by a secret Providence, so the variety of his name and surname was not without its

[28] See the commentary to plate vii in Vloberg (as in note 23).

mystery We may say that he was truly Columbus or Dove, because he carried the grace of the Holy Ghost to that New World which he discovered . . . as the Holy Ghost did in the figure of a dove when St. John baptized Christ; and because over the waters of the ocean, like the dove of Noah's ark, he bore the olive branch and oil of baptism, to signify that those people who had been shut up in the ark of darkness and confusion were to enjoy peace and union with the Church."[29]

The apparently confused allegory of the ark suggests the degree to which Don Fernando strains, at nearly any cost to rhetorical coherence, for an adequate metaphoric vocabulary. Yet there is good reason to believe that he accurately repeated the ideas of his father. To the evidence adduced in the first, "geometrical" part of this paper I would add the speculation that Columbus's self-selected and philologically unexpected Hispanic surname—Colón—was intentionally chosen in part to preserve the ambiguity represented by the modern Catalan *colom* (dove) and the modern Castilian *colon* (pioneer), both of which ideas are present in Fernando's explanation. Dove and ship are also joined in the Immaculist image, an early example of which appears in the Bedford Hours, of the dove sent out from Noah's ark.[30]

If the dove-Virgin had a special significance for Columbus the prophet, another Immaculist image, the seven-branched candlestick or lampstand, the minorah of Exodus 25:31, spoke to Columbus the navigator. Among the most splendid furniture of the tabernacle, and in modern popular iconography a distinctive emblem of Judaism, it was, throughout the Christian Middle Ages, a common furnishing in churches. Its textual reflexes in the Hebrew and Christian Scriptures are numerous, two of which are of specific relevance here: "I have looked, and behold, a candlestick all of gold, and its lamp upon the top of it: and the seven funnels for the lights that were upon the top thereof" (Zechariah 4:2). "And I turned to see the voice that spoke with me. And being turned, I saw seven golden candlesticks And he had in his right hand seven stars" (Apocalypse 1:12–16).

The Marian interpretation of Zechariah's prophecy, which appears as early as the twelfth century, influenced the visual representations of the text; and in the late fifteenth century a common family of septiform ecclesiastical chandeliers gave the idea plastic form.[31] Modern scriptural scholarship has established the genetic connection between the vision of Zechariah and the seven golden candlesticks of the Apocalypse, where the seven lights are explicitly linked with seven stars: "I saw seven gold candlesticks . . . and he had in his right hand seven stars." In a single image of the sort perhaps most famously represented by Dürer's Apocalypse the Marian and the prophetic, two of the admiral's fortes, thus happily merge (Fig. 7).

A final Immaculist image that may have had a special significance for Columbus the mariner was that of the Virgin trampling underfoot the ancient enemy in the form of a

[29] *The Life of the Admiral Christopher Columbus by His Son Ferdinand*, trans. B. Keen, New Brunswick, 1959, 4.

[30] Genesis 8:8; there is perhaps further Columban interest in the fact that in Joachimist circles, the "dove" was usually taken to betoken the Franciscan Order.

[31] P. Bloch, "Siebenarmige Leuchter in christlichen Kirchen," *Wallraf-Richartz-Jahrbuch*, XXIII, 1961, 55–190.

serpent or a dragon. The somewhat remote, protogospel source of this image is Genesis 3:15, where God curses the Serpent: "I will put enmities between thee and the woman, and thy seed and her seed: she shall crush thy head, and thou shalt lie in wait for her heel." The Anglo-Norman banderole of the Bedford Hours applies this text to the Marian image: "Une fame te casera la teste" (The woman shall crush thy head). And at the bottom of the same page, illuminating the sapiential text "From the beginning and before the foundation of the ages was I created . . . " is the rubric "Comment la vierge marie fust signifiee en l'ancient testament et comment elle mist le pied sur sathanas" (How the Virgin Mary was signified in the Old Testament and how she put her foot on Satan). Her staff, which is also a cross, actually pierces the monster's body like a lance.

Would not, once again, a navigator have seen this image with a navigator's eye—an eye trained on the literal Cynosure of all eyes, Mary Star of the Sea? There are three constellations at the north pole: the two bears, dippers, or wains (*Ursa Minor* and *Ursa Major*) and the Dragon (*Draco*). Thus eternally rotating in allegorical battle on the charter of the seaman's salvation, the night sky, are the astral Virgin and the astral enemy, *Stella Maris* and *Draco*. Though the scene shifts with the hour of the night and the month of the year, it remains fundamentally fixed in spiritually satisfying stasis. The Virgin, ever unmoved as all around her the great heavenly circus swirls and turns, forever crushes the serpent beneath her foot.

The Virgin, *Stella Maris*, as the guarantor and regulator of the map of the earth and the map of the sky alike, is a prominent image in Renaissance cartography and marine iconography. Increasingly, in the great age of the Franciscan missionaries, her image in such contexts is the image of the Immaculata, as in the splendid portolan chart of Matthew of Venice. In Seville, the armory and the treasury of the great enterprise of the Indies, there developed a local Marian pictorial dialect typified by a striking painting in which the old iconography of the Virgin of Mercy is applied to a specific maritime clientele of merchants and seamen.[32] Art historians call it *The Virgin of the Sailors*, and that name will surely serve for a Mary, *Stella Maris*, in which traditional associations of the Mother of Mercy and the Immaculata join. There is one Sevillan painting of the Immaculate Conception, by Francesco Pacheco (Fig. 8), that might have been painted by Christopher Columbus himself.[33] Pacheco has introduced a unique second extra-biblical attribute of the Immaculata: an emblem of a sailing ship next to seven stars. Like the first, the *Stella Maris* itself, it comes from the empirical experience of Mediterranian sailors. Since we have nothing that Columbus painted, we must return to what he so self-consciously drew. At the most basic level Columbus's signature "means" what any other signature means: it means a person. Thus the mode of its meaning, a mode deeply impressed by visual implication and pictorial association, should be of interest to iconographers.

[32] The "Virgin of the Sailors" by Alejo Fernández, as published by J. M. López Piñero, *El arte de navegar en la España del Renacimiento*, Barcelona, 1979, 77.

[33] D[iego] A[ngulo] I[ñiguez], "Vélazquez y Pacheco," *Archivo español de arte*, XXIII, 1950, lámina I (facing p. 352).

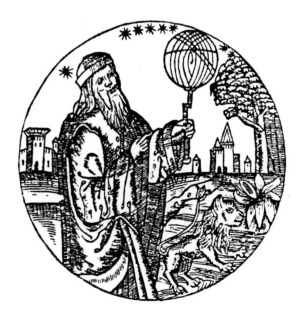

1. Signature of Christopher Columbus (after Juan Perez Tudela y Bueso, *Mirabilis in altis: Estudio crítico sobre el orígén y significado del proyecto decubridor de Cristobal Colón*, Madrid, 1983, cover)

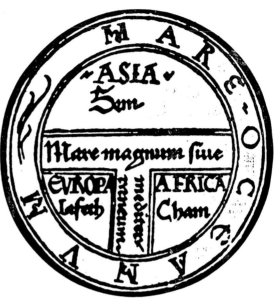

2. T/O map, from the first printed edition of Isidore's *Etymologiae*, Augsburg, 1472

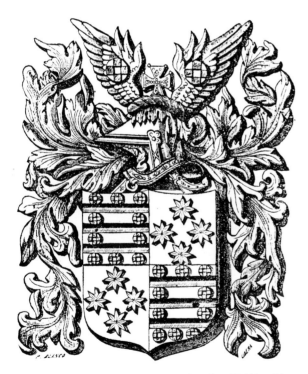

3. The arms of Gonzalo Fernandez Oviedo y Valdés with the quartered emblem of the Southern Cross, from the edition of the *Historia general y natural de las Indias*, J. Amador de los Rios, Madrid, 1852

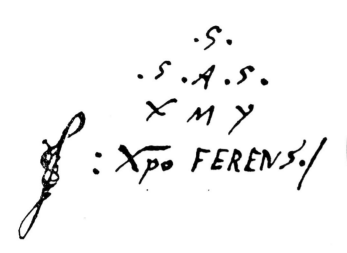

4. An astronomer (Johannes de Sacrobosco) and the seven stars, from the edition of the *Tractatus de Sphaera* with the commentary of Pedro Sánchez Ciruelo (1505)

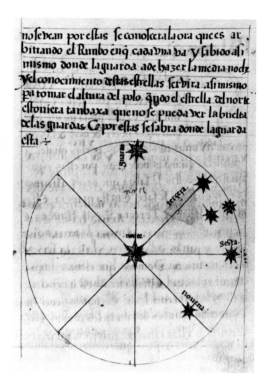

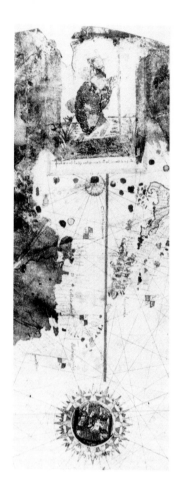

6. Portolan chart by Juan de la Cosa, detail, Saint Christopher bearing the Christ Child and Virgin and Child. Madrid, Museo Naval (after K. Nebenzahl, *Atlas of Columbus and the Great Discoveries*, Chicago and New York, 1990, pl. 10)

5. Mariner's chart of the *Ursus minor* by Pedro de Medina (after *A Navigator's Universe. The Libro de Cosmografía of 1538 by Pedro de Medina*, trans. U. Lamb, London, 1972, p. 65)

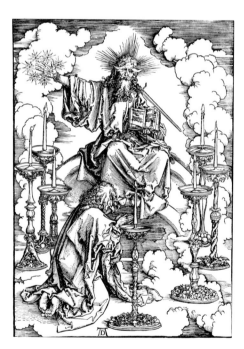

7. Albrecht Dürer, Image from the Apocalypse, woodcut

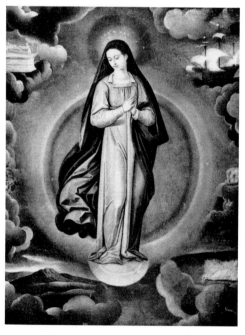

8. Francesco Pacheco, *Immaculate Conception*, detail (after *Archivo español de arte*, XXIII, 1950, plate facing p. 352)

Cleriadus et Meliadice: A Fifteenth-Century Manual for Courtly Behavior

•

HOWARD MAYER BROWN†

FIFTEENTH-CENTURY French romances in prose seem to have been intended as both entertainment and edification for the upper classes. Most of them tell stories of love and adventure, in which a young, handsome, valiant knight performs incredible feats of physical prowess, defending moral order or social justice—or merely showing off his skill at arms—in the service of a lady, often a beautiful princess, whom he loves and who loves him in return. Almost two hundred such romances survive, many of them written for the court of Burgundy, where such stories enjoyed an especially strong vogue.[1] One charming scene in *Cleriadus et Meliadice* offers a clue about the audience for whom these stories were intended. When the princess Meliadice visits the valiant knight Cleriadus for the first time after he has been wounded in a joust, she finds him sitting up in bed, reading a romance.[2]

Romances instruct as well as entertain.[3] They teach by example morality and codes of social behavior, even though they doubtless offer a highly idealized picture of the way people actually behaved. From them we learn what members of the upper classes were expected to know and how they were supposed to act in a variety of situations. We learn not only what skills they were supposed to possess, but also how they entertained themselves, how they arranged the most important events in their lives, and what they regarded as their moral values. Romances, in short, were partly normative; their authors wanted to teach social behavior as well as tell good adventure stories. From romances, therefore, we can reconstruct an image of social reality in the fifteenth century that although perhaps highly colored and ideologically charged, refracted as it is through an idealistic lens, can nevertheless help us to understand where, when, why, and how music was performed by and for the upper classes, and how various kinds of music and musicians related to one another in courtly society.

† As this volume was going to press we learned of the sudden death of Howard Brown in Venice.

[1] They are listed and described in B. Woledge, *Bibliographie des romans et nouvelles en prose française antérieurs à 1500*, 1954, reprint, Geneva, 1975; and also idem, *Bibliographie . . . Supplément 1954–1973*, Geneva, 1975. My first two paragraphs are copied from my essay, "Songs After Supper: How the Aristocracy Entertained Themselves in the Fifteenth Century," in *Musica Privata: Die Rolle der Musik im privaten Leben. Festschrift zum 65. Geburtstag von Walter Salmen*, ed. M. Fink, R. Gstrein, and G. Mössmer, Innsbruck, 1991, 37–52.

[2] *Cleriadus et Meliadice. Roman en prose du XVᵉ siècle*, ed. G. Zink, Geneva and Paris, 1984, 43.

[3] A point made, for example, in ibid., xliv–xlv.

A social history of music needs the maximum possible information if it is to be made three-dimensional. Iconography, for example, can be crucial in the process. The miniatures that decorate romances must be taken into account as much as the texts themselves, for they either supplement the text, supplying details not mentioned by the authors, or contradict it in ways that make clear just what the limits of reality were. Musicologists also need to correlate what is learned from the romances with the music of the fifteenth century—both what survives in the manuscripts of mostly polyphonic music and what we know to have existed but has disappeared.

It would be ideal to reconstruct a composite picture of fifteenth-century musical life from a study of all the romances, which would supply a framework and context to evaluate specific bits of information from a romance's individual passages. Relying wholly on the literal accuracy of a single text can be misleading, since literary works do not always mean precisely what they say and conclusions drawn from a single passage should be tested against other evidence. Nevertheless, at least a beginning toward forming a general picture of the nature of musical life at fifteenth-century courts can be made by studying a single romance, filling in from other sources the details it omits. *Cleriadus et Meliadice* is an appropriate romance to use as a point of departure, not only because of its normative character, but also because of its wealth of detail in its mostly passing references to events of daily life.[4] Moreover, at least three copies of it were decorated with miniatures that help explain its musical details.[5]

For example, *Cleriadus et Meliadice* reveals that princes and their courtiers, and thus perhaps by extension the upper-classes in general, were expected to attend mass every morning. In numerous passages, one or another character is described quite matter-of-factly as proceeding with the day's business only after attending mass, saying prayers, and eating breakfast.[6] Such details about fifteenth-century daily life are not otherwise so easy to discover. Doubtless many of these daily masses were said rather than sung, or, at most, chant furnished the only musical accompaniment. The Turin *Cleriadus*, though it does not show what these daily masses looked like,[7] does illustrate one much grander sacred service—the triple coronation in the cathedral of London of Cleriadus and his two cousins Amador and Palixés (Fig. 1).[8] The romance states merely that "une grant messe" was heard. The artist

[4] In addition to the modern edition of Zink (as in note 2), see also C. Page, "The Performance of Songs in Late Medieval France," *Early Music*, x, 1982, 441–50, written before the modern edition was published and without taking into account any source but that in London.

[5] In his modern edition, Zink (as in note 2) lists only three fifteenth-century sources of the romance that include illustrations: London, British Library, MS. Royal 20 C.ii; Turin, Biblioteca nazionale universitaria, MS. 1628 L.II.2 (incomplete and partially destroyed by fire in 1904); and the edition published in Paris by Antoine Verard in 1495 (unique copy in the Pierpont Morgan Library, New York).

[6] Daily masses in a private chapel or local church as well as masses for special occasions and occasions when a character gives thanks in church are mentioned in Zink (as in note 2), 9, 18, 56, 61, 106–7, 124, 134, 162,167, 193, 210, 211, 219, 230, 235, 241, 246, 273, 283, 333, 372, 379, 390–91, 398, 447, 479–80, 498, 527, 566, 596, 652, 657, 684, and 708.

[7] For pictures of fifteenth-century sacred services performed in private chapels, see E. A. Bowles, *Musikleben im 15. Jahrhundert*, Musikgeschichte in Bildern, III/8, Leipzig, 1977, pls. 99–102, 110–12.

[8] So far as I know, neither the miniatures in the Turin *Cleriadus* nor those in the 1495 printed edition have been

included a choir of five men and two boys singing from a choir book set on a lectern. The coronation mass in all probability included polyphonic compositions—why else would men and boys be singing together?—sung by a choir surprisingly small for so festive an occasion.

Most romances naturally tell us more about the secular than the sacred side of life, so it is helpful to have some general idea of how the musical forces were organized at a fifteenth-century court. Thanks to the series of splendid archival studies that have appeared in this century, we have a fairly precise picture.[9] Singers made up the musical members of the ruler's chapel. We do not know for certain if they also regularly sang secular music at court, but we can assume, I think, that courtly songs were performed by courtiers, as well as by members of the ruler's household who belonged to the flexible group of chamber musicians and by household servants with special musical talent. So far as instruments are concerned, four quite distinct groups played at court: (1) the trumpeters and drummers, who chiefly made ceremonial noises, (2) the bands of loud minstrels, who mostly played shawms and sackbuts, (3) the group of courtly minstrels who specialized in soft instruments, such as lutes, fiddles, harps and psalteries, and (4) the courtiers themselves who cultivated singing, dancing, and the art of playing instruments as a social accomplishment.

Cleriadus et Meliadice appears habitually to use the phrase *trompettes et menestriers* (trumpets and minstrels) indiscriminately to signify either instruments in general, trumpets alone, or trumpets and other instruments.[10] Since many romances make similarly ambiguous references, the texts require pictures to clarify precisely the authors' intentions (or at least the artists' interpretations of the authors' intentions).

Trumpets alone or trumpets and drums must have been used chiefly to play ceremonial music (such as fanfares) or to signal. They accompanied the prince as a prerogative of his position of power and prominence. In *Cleriadus et Meliadice*, the ruler and his entourage travel with ceremonial musicians, and on their arrival in a new city are also often greeted by *trompettes et menestriers*.[11] In some passages of *Cleriadus et Meliadice* the musicians are explicitly cited, in others their presence is merely implied. At least two mounted trumpeters are portrayed in the Turin *Cleriadus* (Fig. 2), among those accompanying the king and queen of England and the count and countess d'Esture on their visit to the Chevalier Vert

published before. Since the Turin manuscript is not paginated, I identify the location of the miniatures by their place in the romance. Fig. 1 decorates chap. XXX, see Zink (as in note 2), 521ff.

[9] My brief sketch of the musical organization of a fifteenth-century court is based on such studies of Italian courts as A. Atlas, *Music at the Aragonese Court of Naples*, Cambridge, 1985; I. Fenlon, *Music and Patronage in Sixteenth-Century Mantua*, 2 vols., Cambridge, 1980–82; and L. Lockwood, *Music in Renaissance Ferrara, 1400–1505: The Creation of a Musical Centre in the Fifteenth Century*, Oxford, 1984. The best recent study of music at the French royal court in the fifteenth and early sixteenth centuries is S. Bonime, "Anne de Bretagne (1477–1514) and Music: An Archival Study," Ph.D. diss., Bryn Mawr College, 1975.

[10] "Trompettes et menestriers" are mentioned in Zink (as in note 2), 106, 220, 221, 247, 251, 255, 407, 417, 426, 445, 455, 464, 522, 528, 547, 573, 579, 608, 646, 654, 658, 669, and 674. Trumpets alone are mentioned 109, 283, 668, 696, and 709. Minstrels alone are mentioned 13, 15, 26, 64, 256, 416–17, 445, 474, 643, 656, 664, and 674. "Instrumens," "Instrumens de plusieurs manières," or similar phrases are used to describe instruments 541, 598, 652, 689, and 698–99. And "Trompettes, clerons, menestriers, instrumens de tous estas" are mentioned 595.

[11] Instruments accompanying travelers or greeting them on their arrival are mentioned in Zink (as in note 2), 247, 407, 426, 522, 541, 595, 689, and 696.

(actually Cleriadus in disguise), even though the romance makes no mention of instruments.[12] *Cleriadus et Meliadice* also describes *trompettes et menestriers* as leading victors back from jousts,[13] and brides or bridal couples back home after a nuptial mass,[14] implying that many different kinds of instruments took part, although some fifteenth-century miniatures show such processions accompanied merely by trumpets or shawms.[15]

Trumpets seem also to have had signaling functions in the fifteenth century. *Cleriadus et Meliadice* and other romances describe rulers ordering public proclamations *à son de trompe*, and trumpets evidently signaled various maneuvers in battles and during sieges.[16] Trumpets signaled at jousts and tourneys, where they made a festive noise before the joust began, announced the beginning of the competition and the end of each round, and declared the event over at the end of the day.[17] Trumpets, which also accompanied the winners home from jousts, often drew attention to the heralds' cries of "Largesse largesse" at the evening celebrations when a particularly generous gift was offered by one knight to another.[18] Musicians are included in several of the jousts pictured in the Turin *Cleriadus*. Figure 3, for example, shows a joust to celebrate the wedding of Cleriadus and Meliadice. "Menestrelz, trompetes qui y estoient menoient grant bruit" reads the text, which the Turin artist has interpreted to mean players of two straight trumpets and one folded trumpet; a fourth man probably also plays a trumpet, though his instrument is barely visible in the picture.[19]

For the most part, these ceremonial trumpet players do not interest modern musicians very much since they assuredly only played fanfares and signals, albeit of sorts that might surprise us today. Judging from their construction, long straight trumpets could only have sounded a few overtones and thus played low-pitched sounds rather than the bright brassy fanfares we are used to from later ceremonials. But some attention should be paid to those trumpets that had a more musical function, in playing dances and other kinds of composed or improvised polyphony along with shawm bands.

Judging from pictures illustrating other prose romances, shawm bands, and even players of soft instruments, might also be included among the *trompettes et menestriers*, though

[12] Fig. 2 decorates chap. XIX of *Cleriadus*, see Zink (as in note 2), 235ff.

[13] See note 17 below.

[14] For instruments playing in connection with weddings, see Zink (as in note 2), 106, 547, 652, and 689. For music after a coronation, see ibid., 528, 549.

[15] For miniatures from fifteenth-century romances showing processions to or from weddings, see Bowles (as in note 7), 28–29, pl. 9 (where the procession is led by four trumpeters); and E. A. Bowles, *La pratique musicale au moyen âge*, Geneva, 1983, 54, pl. 23 (where the bride is serenaded by three shawm players on a balcony).

[16] Trumpets or trumpets and minstrels accompany public proclamations or play during battles and sieges in Zink (as in note 2), 107, 274, 287, and 360. Saracens playing "cors et buisines" are mentioned 274, 287. For illustrations of fifteenth-century proclamations, see Bowles (as in note 7), 142–43, pls. 136–38; and Bowles (as in note 15), 98, pl. 68. For fifteenth-century illustrations of battles, see Bowles (as in note 7), 78–85, pls. 63–70; and Bowles (as in note 15), 93–94, pls. 63–64.

[17] Trumpets or trumpets and minstrels playing at jousts are mentioned in Zink (as in note 2), 109, 220, 221, 455, 658, 668–69, and 709.

[18] Heralds cry "Largesse" to the sound of trumpets in Zink (as in note 2), 271, 463–65, 654, and 674.

[19] The quotation is from Zink (as in note 2), 658. Fig. 3 decorates chap. XXXVIII of *Cleriadus*, see Zink, 656ff. Other miniatures in the Turin *Cleriadus* showing trumpets at jousts decorate chap. XIX (with three trumpets; ibid., 212ff.), chap. XIX (with one trumpet; ibid., 225ff.), chap. XX (with two trumpets; ibid., 242ff.), chap. XXVIII (with two or three trumpets; ibid., 398ff.), and chap. XXVIII (with two trumpets; ibid., 432ff.). For other illustrations of fifteenth-century jousts with musical instruments, see Bowles (as in note 7), 68–77, pls. 52–62; only one of them, however, is taken from a romance.

neither the text nor the miniatures in *Cleriadus et Meliadice* describe or depict any such instruments. In other stories describing similar courts, shawm bands are illustrated playing separately from the trumpets at jousts or substituting for trumpets in processions.[20] By shawm bands, I mean those combinations of one, two, or sometimes even three shawms with bagpipes, folded or slide trumpets, or trombones.[21] These loud bands of unequally sized instruments surely played polyphony. Although some of the music was improvised, some was likely to have been composed; it is by no means out of the question that such bands played three- and four-part secular music—or even motets—of the variety we find in contemporaneous manuscript anthologies.

Trompettes et menestriers can also refer to rather more complex collections of instruments. Figure 4 shows Alexander the Great—in the guise of a fifteenth-century French nobleman—entering a city. From an Alexander romance, the illustration can be used, I think, to interpret the notices in *Cleriadus et Meliadice* of courtiers and rulers entering a city, returning victorious from a joust, or returning home after a wedding, accompanied by all manner of instruments.[22] The musical analysis of such a picture, however, is fraught with difficulties. I read the picture to reflect the variety of separate sounds possible in a fifteenth-century procession. Led by a single buisine player, there seem to be two solo harpists and a solo recorder player (unless the two musicians on either side of Alexander's cart are intended to be playing together), two duos of recorder and lute, and a third duo of lute and gittern (standard during this period), and, in the distant background, a wind player, perhaps a shawmist or another recorder player. From all these illustrations, it is clear that the phrase *trompettes et menestriers* can mean trumpets alone, trumpets and drums, shawm bands, or even an entire staff of household musicians, if Alexander's band can in fact be identified in that way.

We know from every romance, including *Cleriadus et Meliadice*, that the most usual venue and occasion for the performance of courtly music was during and after meals.[23] Trumpets sometimes marked the entry of courses; more often, shawm bands played during the meals. Although none of the illustrations for *Cleriadus et Meliadice* show musicians at meals, we can imagine them by studying similar scenes commonly found in other fifteenth-century romances. Figure 5, for example, from the romance of Charles Martel, shows a group of three shawms playing at a wedding banquet.[24]

[20] For fifteenth-century illustrations of shawm bands playing in processions or at jousts, see Bowles (as in note 7), 29–30, pl. 10; 38 (text illustration), 74–75, pl. 59; and 76–77, pl. 62; and Bowles (as in note 15), 52–53, pls. 21–22; 54, pl. 23; and 89, pl. 59.

[21] On shawm bands and the possibility that they played polyphony, see, among other studies, H. M. Brown, "Minstrels and Their Repertory in Fifteenth-Century France: Music in an Urban Environment," in *Urban Life in the Renaissance*, ed. S. Zimmerman and R. F. E. Weissman, Newark, Del., 1989, 143–64.

[22] The miniature is reproduced and briefly described in Bowles (as in note 7), 38–39, pl. 22.

[23] For instruments played at meals in *Cleriadus*, see note 40 below.

[24] The miniature, from Brussels, Bibliothèque Royale, MS. 8, fol. 326, is reproduced and briefly described in *L'iconographie musicale dans les manuscrits de la Bibliothèque royale Albert I^er*, ed. I. Hottois, Brussels, 1982, cat. nos. 1–3, 3–5, ill. 12. Another illustration from the same romance showing a banquet accompanied by two shawms and a folded trumpet is reproduced and briefly described in Bowles (as in note 7), 46–47, pl. 29.

At banquets, instruments not only played while the guests ate, but also interrupted the meal intermittently with special entertainments, called *entremets*, which consisted of soft instruments as well as loud.[25] Soft instruments are never explicitly mentioned in this connection in *Cleriadus et Meliadice*, but we can assume they were included under the general rubric *menestriers*, since we know from archival records and other sources that chamber musicians specializing in playing soft instruments and singing existed at fifteenth-century courts. Apollonius de Tyr, for example, hero of a romance circulated in a prose version in the fifteenth century, was portrayed as a knight forced to disguise himself as a minstrel. He sang and played the harp or fiddle (depending on which of several manuscripts is consulted) at courtly banquets.[26] And a minstrel who figures in the romance of Gerard de Nevers is able to play harp, psaltery, lute, and fiddle.[27] There was no reason to mention such instruments by name in *Cleriadus et Meliadice*; they are not an important part of the story. Such omissions are typical of the important details left out of romances, justifying the necessity of offering a composite view. Fragments of reality must painstakingly be reconstructed from whatever available sources can offer us.

While loud instruments are commonly depicted in romance illuminations, soft instruments are considerably rarer. Thus a miniature like that reproduced in Figure 6 from the romance of Alexander is valuable in showing an ensemble of soft instruments—harp, fiddle, and portative organ—performing an *entremet* for guests.[28] Such an ensemble is best suited for the performance of polyphony. It is difficult, therefore, to suppose that it was not intended to play the most obvious repertory that survives: courtly polyphonic songs written for these milieux and preserved in manuscript anthologies, in some cases without their texts in versions suggesting instrumental performances. Moreover, the possibility that at least one of the musicians is singing, a detail hard to discern in these pictures, cannot be ruled out. Certainly, in the text of the romance of Gerard de Nevers, who is disguised as a minstrel, he sings to the accompaniment of a fiddle, though in the several illustrations of the story he is shown playing a hurdy-gurdy (*vielle à roue*), an instrument more appropriate to the twelfth-century *chanson de geste* he is said to sing in the story, which takes place in what for the fifteenth-century audience was a long ago and far away time.[29]

My view that many of the songs sung during and after meals in the fifteenth century were polyphonic and accompanied by instruments is defended in another essay.[30] *Cleriadus*

[25] The word *entremets* is mentioned in Zink (as in note 2), 26, 251, 331, 460, 598, 605, 654, and 692.

[26] See *Le Roman d'Apollonius de Tyr*, ed. M. Zink, Paris, 1982, 90, 263, and 303. For a fuller discussion of the scene and its musical significance, see also Brown (as in note 1).

[27] For the incident involving Gerard and the minstrel, see *Gerard de Nevers. Prose Version of the Roman de la Violette*, ed. L. F. H. Lowe, Princeton and Paris, 1928, 31–32; and Brown (as in note 1).

[28] The miniature is reproduced and briefly described in Bowles (as in note 7), 48–49, pl. 32.

[29] For the incident involving Gerard de Nevers disguised as a minstrel, see Lowe (as in note 27), 32–34. For miniatures illustrating the scene, showing Gerard with a hurdy gurdy, see Hottois (as in note 24), 66–68, ill. 13; R. Wangermée and P. Mercier, *La musique en Wallonie et à Bruxelles*, 2 vols., Brussels, 1980, I, 77; and Bowles (as in note 7), 177 (Paris, Bibl. Nat., MS. fr. 24378, fol. 78′).

[30] Brown (as in note 1).

et Meliadice, though silent on that point, includes one incident important to the story involving the composition of a secular song.[31] Cleriadus sets to polyphonic music a poem Meliadice has sent him. First, he composes the song and writes it down, then he arranges it for harp, and finally he learns to play it by practicing it on his harp. The scene is pictured in all three of the illustrated versions of *Cleriadus*. Christopher Page reproduces the simplest of these versions, from the London manuscript, where Cleriadus is seen sitting in his room playing the harp.[32] In the Turin *Cleriadus* (Fig. 7), he has placed the written music on a ledge to practice it.[33] The printed *Cleriadus* of 1495 illustrates the scene with two vignettes: one labeled "Lettres amoureuses" showing Cleriadus writing a letter to Meliadice with his harp leaning against a wall, the second (Fig. 8) showing Cleriadus giving the written song to Meliadice, who is seated holding her harp, ready to sing it.[34]

Page has pointed out that nowhere in *Cleriadus* does it specify that this song (or, indeed, any other song) was accompanied by instruments,[35] but neither does it contradict the idea. Most of the descriptions of performances by courtiers for their own amusement are vague—stating merely that they sang, played, and danced—leaving the details to the reader's imagination. They need to be interpreted in the light of what we know from other romances and other sources and that *Cleriadus* omits or abbreviates. The romance never mentions, for example, minstrels who specialize in soft instruments.

We can easily establish the fact that verbs like *jouer*, *chanter*, and *harper* can mean to sing and play at the same time. Cleriadus composed songs, played the harp, arranged his newly composed song for his instrument, and may even have danced to it while he sang. Surely it must have occurred to him, as it had to Apollonius de Tyr, Gerard de Nevers, and the minstrel in the romance of Perceforest, to sing his song while playing the harp.[36] It stretches credulity too far to suppose that all fifteenth-century polyphonic chansons were intended to be performed by voices alone.

The reason why there are so few pictures of courtiers singing or singing and playing for their own enjoyment is not difficult to understand, since the plot of a romance seldom involves private music-making and artists rarely depicted anything beyond the significant parts of the story. In the rare examples showing courtiers singing for their own amusement, instruments are often present.[37] Although these pictures never explain what the courtiers are singing,

[31] Zink (as in note 2), 183–91.

[32] Page (as in note 4), 447, pl. 4.

[33] Fig. 7 decorates chap. XVII of *Cleriadus*, see Zink (as in note 2), 183ff.

[34] Fig. 8 appears in the 1495 edition (as in note 5), fol. 38.

[35] Page (as in note 4), 448. Songs are sung in Zink (as in note 2), 16, 106, 140–41, 255–57, 265, and 490–93, though instruments are not mentioned in connection with any of them. The fact that Meliadice received a chanson from Cleriadus written that morning is reported on pp. 481–82.

[36] On Apollonius and Gerard de Nevers, see notes 26 and 29 above. The passage from the romance of Perceforest where a minstrel composes and then sings a *lai* to the harp is quoted in S. Huot, *From Song to Book: The Poetics of Writing in Old French Lyrics and Lyrical Narrative Poetry*, Ithaca and London, 1987, 347–50.

[37] For a representative sample of pictures of courtiers singing for their own amusement (with and without instruments), see Bowles (as in note 7), 90–105, pls. 75–93. See also H. Besseler, "Umgangsmusik und Darbietungsmusik im 16. Jahrhundert," *Archiv für Musikwissenschaft*, XVI, 1959, 21–43; and H. M. Brown, "Instruments and Voices in the Fifteenth-Century Chanson," in *Current Thought in Musicology*, ed. J. W. Grubbs, Austin, Tex., and London, 1976, 89–137.

there is no reason to doubt that their repertory is to be found in the most obvious place: the manuscript anthologies of polyphonic love songs written and performed by and for the courtiers.

Although *Cleriadus* does not clarify the performing practice of fifteenth-century polyphonic love songs, it gives us tantalizing hints. It also offers rare glimpses of performances by large groups scarcely mentioned in the musicological literature. At the end of one banquet, for example, forty children dressed as wild men enter the hall strewing flowers, playing instruments "in all the manners instruments can be played."[38] Later in the romance, fifteen fifteen-year-old boys joust on counterfeit lions, while twenty girls of the same age, who had entered the hall on unicorns, sing and dance without instrumental accompaniment.[39] It is easier to imagine the songs the girls sang than the instrumental music the children played, although modern ideas about the sound of fifteenth-century music do not encompass a girls' chorus of twenty singing in unison a monophonic dancing song, much less a polyphonic *virelai* or *rondeau*. Nevertheless, it is much more difficult to conjure up the sound of forty children playing a variety of soft instruments, illustrating the futility of close readings of the romance texts. That the children played a variety of pieces in groups of twos, threes, and fours, and that one or more of the girls sang while the others danced, is not beyond the realm of possibility.

Cleriadus et Meliadice provides another insight into fifteenth-century reality by suggesting a particular order for the after-dinner dancing. Frequently, trumpets and minstrels begin to sound after the sweets have been eaten, grace has been said, the guests have washed their hands and the tables have been taken away. The musicians summon the diners from the various parts of the palace where they have been eating. The couples form and begin the dancing with *basses dances* accompanied by minstrels, almost certainly shawm bands. The courtiers eventually tiring of this kind of dancing, the minstrels are dismissed, and the dancing continues with *dances aux chansons* to the accompaniment of songs sung by the courtiers themselves.[40] This fixed order of events for a formal occasion is evidently a strong social convention in *Cleriadus et Meliadice*, although it remains to be seen whether courts everywhere in the fifteenth century observed it.

The difference between the two kinds of dances—those to shawms and those to singers—is suggested by the miniatures illustrating many romances. Normally, fifteenth-century miniatures show couples performing a sedate and dignified dance, doubtless a *basse dance*, with a shawm band playing from the balcony.[41] The London *Cleriadus* includes such a

[38] Zink (as in note 2), 530, reads: "de toutes les manières que on pourroit deviser de instrumens."

[39] Ibid., 605–7.

[40] Scenes where dancing after dinner consists first of *basses dances* and then *dances aux chansons* occur in ibid., 15, 251–57, 469–71, and 474 (where the courtiers begin dancing again to minstrels after they tire of *dances aux chansons*). While the order of dances is not given, other occasions when the courtiers danced are mentioned 64, 106, 265, 331, 417–19, 445–46, 464–65, 549, 573–76, 579–80, 598, 609, 643–46, 654–56, 664, 674, 692, 698, and 702. It should be noted that in some of these scenes no instruments at all are mentioned, although their presence can be inferred. The fact that courtiers wore special clothes for dancing is mentioned on pp. 457 and 644.

[41] For pictures of couples dancing to shawm bands and other instruments, see Bowles (as in note 7), 52–67, pls. 36–51.

scene.[42] It is relatively easy to imagine the music for such an occasion, since manuscripts survive containing the sequences of *basse dance* steps as well as the musical scaffolding for them. Over the slow-moving *cantus firmus* played by the larger shawm, fast-moving polyphonic parts were improvised by two more minstrels playing small shawm and trombone. A number of texts and miniatures, on the other hand, appear to suggest that *dances aux chansons* were round dances rather than couple dances, although no courtly monophonic repertory is known to exist before the very end of the fifteenth century. Perhaps the polyphonic sources should be more closely searched for evidence of true dancing songs. In any case, particular kinds of steps were associated with particular kinds of music.[43]

It would be convenient if this simple distinction between *basses dances* accompanied by loud winds and round dances accompanied by singing was maintained consistently, but this, alas, is not so. Fifteenth-century copies of the *Romance of the Rose*, in particular, sometimes show shawm bands accompanying the round dancing specified in the text (assuming that the *carole* of the romance refers specifically to a round dance).[44] The pictures may merely reflect a dichotomy between an older text and an artist's rendering of the scene in more modern terms, the fifteenth-century artist not knowing what a *carole* was, or, more likely, wishing to show the scene as splendidly as possible. But possibly they reveal a set of conventions more complex than the simple dichotomy I have outlined. Figure 9, for example, from the printed *Cleriadus* of 1495, shows couples dancing what seems to be a *basse dance* to an ensemble consisting of harp, lute, and recorder (instruments not mentioned in the text).[45] The pictures need to be read carefully and the question of just what they reveal about the musical realities of the fifteenth century debated, since only by speculative attempts to connect different kinds of evidence will we be able to reconstruct the sound of music from this distant past.

After a banquet recounted in the romance of Jean de Saintré, the guests danced as usual.[46] The text reads almost as though the author wished to list all the most common after-dinner dances: *basses dances*, *dances aux chansons*, and *moresques*, traditionally danced partly in blackface to imitate battles between Moors and Christians or to refer to pre-Christian fertility rites.[47] By extension, a *moresque* (or *moresca*) can be defined more simply as a fifteenth-century theatrical dance, performed after a meal by the courtiers themselves in disguise or at least in costume.

The dance of the girls on unicorns in *Cleriadus* would appear to have been such a theatrical dance. *Cleriadus* includes another episode that probably qualifies as a *moresque*.

[42] Reproduced in Page (as in note 4), 443, pl. 3. The details are very sketchy in the miniature, but it would appear the two minstrels in the gallery both play straight trumpets, a combination that cannot be entirely dismissed as a possibility for dance music in the fourteenth and fifteenth centuries.

[43] For pictures of round dances with no instruments present, see Bowles (as in note 7), 54–55, pl. 37; 60–61, pl. 43.

[44] For pictures of the *carole* from the *Romance of the Rose* accompanied by shawms or other instruments, see, among other sources Bowles (as in note 7), 60–61, pl. 45; and 158–59, pl. 153; and Bowles (as in note 15), 78–82, pls. 49–52.

[45] Fig. 9 appears in the 1495 edition (as in note 5), fol. 87.

[46] See A. de la Sale, *Jehan de Saintré*, ed. J. Misrahi and C. A. Knudson, Geneva, 1965, 170: "Lors furent basses dansses, chanssons et autres joieusetez et morisques très riches."

[47] On the *moresque* or *moresca*, see A. Brown, *New Grove Dictionary of Music and Musicians*, s. v. "Moresca," and the studies cited there.

Cleriadus and seven companion knights, dressed in white costumes, interrupt an otherwise conventional evening of entertainment. The eight white knights dance together, whereupon the king guesses that Cleriadus is paying homage to Meliadice who is wearing a white hat.[48] I take it that their dance was altogether different from the social dancing that had gone before: only men were involved, and their actions were presumably newly choreographed in contrast with the pre-determined patterns of steps common in social dancing. Figure 10 shows the scene as interpreted in the Turin *Cleriadus*.[49] *Moresques*, with their traditional costumes and a choreography more elaborate than the usual couple or round dances, were accompanied by shawm bands, if miniatures are to be believed.[50] But the Turin *Cleriadus* shows three minstrels—playing harp, pipe and tabor, and what probably is meant to be a recorder—accompanying the dance of the white knights.[51] The miniaturist, therefore, reveals that this is a possible ensemble to accompany dancing, although it may also be that the harp and recorder played together and the piper played by himself. No one to my knowledge has yet suggested what music accompanied these fifteenth-century theatrical dances; the surviving manuscripts of secular music should be searched to find compositions that might have been suitable. The earliest *moresques* and *morescas* known to me date from the sixteenth century. Romances suggest that *moresques* formed an important genre at court entertainments and that they were normally accompanied by instruments; we ought therefore to try to identify them.

Romances not only offer a broader framework for the variety of fifteenth-century courtly dances than any other kind of Franco-Flemish source, but also supply clues about the performance conventions of the secular music hardest to locate in its cultural context: the repertory of polyphonic courtly love songs performed for and to some extent by the courtiers themselves. Put simply, romances make clear that members of the upper class sang and played polyphonic love songs for their own enjoyment in private as well as to entertain their colleagues after dinner. In fact, romances supply the best information we have about the performance of a repertory of private music not susceptible to investigation through documents of payments or other more conventional means.

Our consideration of the repertory surely begins with the fact that the upper classes cultivated the art of singing, dancing, and playing musical instruments as desirable social accomplishments. Cleriadus played the harp, sang and danced beautifully, and could actually compose polyphonic music, which evidently identified him as an especially perfect knight. He

[48] Zink (as in note 2), 471–77.

[49] Fig. 10 decorates chap. XXVIII of *Cleriadus* (ibid., 458ff. and 474ff.).

[50] For pictures of fifteenth-century *moresques*, see especially Bowles (as in note 7), 64–65, pls. 47–48, which shows the dance of the wild men at the French royal court in 1393, when the king and four of his courtiers were badly burned from a fire started by the torches used in their dance, and one died. See also the *moresque* from Gerard de Nevers reproduced in R. Wangermée, *La musique flamande dans la société des XVe et XVIe siècles*, Brussels, 1965, pl. 63, and Wangermée and Mercier (as in note 29), I, 59.

[51] Although the instruments identified as recorders in plates 9 and 10 could as well be trumpets (or possibly shawms), their playing position, the fact that they are fingered, and the social context in which they appear all suggest they are recorders. These instruments begin to be included in works of art about the mid-fifteenth century, at the same time they are mentioned in literary works, assuming they are the "fleutes" mentioned in Zink (see note 54 below).

could even arrange his own composition for the harp. More than once *Cleriadus* describes the hero or his lady playing music for their own private enjoyment. Thus Cleriadus relaxes after a joust by playing the harp, and Meliadice is discovered in her room playing the harp.[52] But *Cleriadus* also describes knights and ladies amusing themselves with games—*jeux et esbatements*—as a part of the courting ritual or simply for entertainment. *Jeux et esbatements*, which could include games of various kinds, defined more closely meant playing chess, the harp, singing, or dancing.[53] When the losers of a joust Cleriadus has organized are put into "prison," they are in fact confined to a spacious room where all sorts of *gracieux jeux* have been set out for them: tables for chess and other games, as well as *herpes* and *fleutes* (which I take to be recorders).[54]

Romances offer the best synoptic view we can hope for of musical reality in the fifteenth century. They give us invaluable clues to the precise activities of the trumpeters at court, of the duties and makeup of the shawm bands, and of the more fluid group of household musicians specializing in soft instruments. Romances are the prime source of information about the kinds of music performed at midday dinner and evening supper, the principal occasions for music-making at fifteenth-century courts, about the variety of dances courtiers needed to know, and about when and where the courtiers themselves played, sang, and danced for their own amusement. They need to be combed more systematically for information. They will not give up all their secrets, however, until we take into account the illustrations, which both deepen and broaden our understanding of the texts, and until we are willing to speculate about the musical repertories to which the texts and pictures refer, and their relationship to what has survived and what has been irretrievably lost.

[52] Zink (as in note 2), 453, 197. At the beginning of the romance (p. 2), Meliadice is described as a beautiful princess who had been taught everything the daughter of a king should know, namely, reading, the harp, and chess.

[53] Zink (as in note 2), 23. Unspecified "jeux et esbatements" are mentioned on pp. 17 and 107. On p. 332 they are said to include chasing birds.

[54] Zink (as in note 2), 224, and 250.

2. The Court Visits the Chevalier Vert, from *Cleriadus et Meliadice*, chap. XIX, Turin, Bibl. naz. univ., MS. 1628 L.II.2 (photo: Biblioteca nazionale, Turin)

1. The Coronation of Cleriadus, Amador, and Palixés in London, from *Cleriadus et Meliadice*, chap. XXX, Turin, Bibl. naz. univ., MS. 1628 L.II.2 (photo: Biblioteca nazionale, Turin)

3. A Joust to Celebrate the Wedding of Cleriadus and Meliadice, from *Cleriadus et Meliadice*, chap. XXXVIII, Turin, Bibl. naz. univ., MS. 1628 L.II.2 (photo: Biblioteca nazionale, Turin)

4. Alexander the Great Enters a City, from the *Romance of Alexander*, Paris, Bibl. Nat., MS. fonds fr. 22547, fol. 245v (photo: Bibliothèque Nationale)

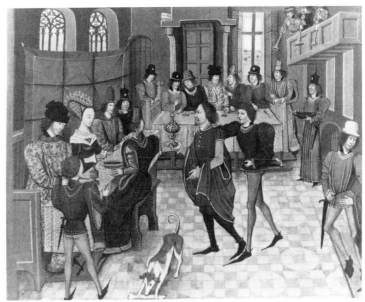

5. The Wedding Banquet of Beatrix of Cologne and Guérin de Metz, from *Histoire de Charles Martel*, Brussels, Bibl. Roy., MS. 8, fol. 326 (photo: Bibliothèque Royale)

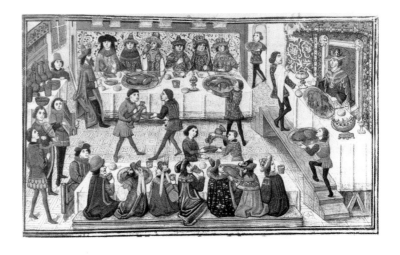

6. Banquet, from the *Romance of Alexander*, Paris, Musée du Petit Palais, MS. 456, fol. 298 (after E. A. Bowles, *Musikleben im 15. Jahrhundert*, Leipzig, 1977, pl. 32)

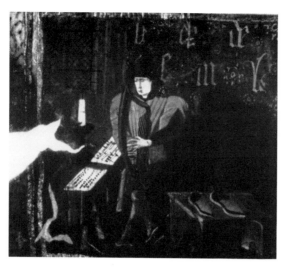

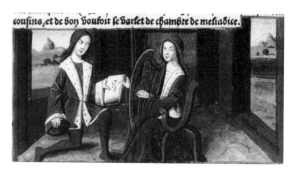

8. Cleriadus Gives His Song to Meliadice, from *Cleriadus et Meliadice*, Paris, 1495, fol. 38v. New York, Pierpont Morgan Library (photo: Pierpont Morgan Library)

7. Cleriadus Practices His Song, from *Cleriadus et Meliadice*, chap. XVII, Turin, Bibl. naz. univ., MS. 1628 L.II.2 (photo: Biblioteca nazionale, Turin)

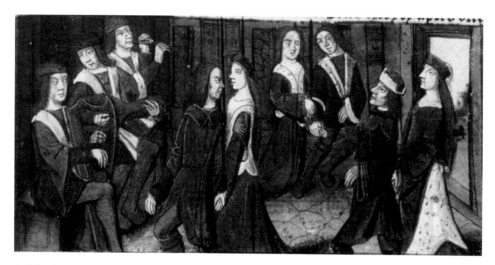

9. The Courtiers Dance a *Basse Dance*, from *Cleriadus et Meliadice*, Paris, 1495, fol. 87. New York, Pierpont Morgan Library (photo: Pierpont Morgan Library)

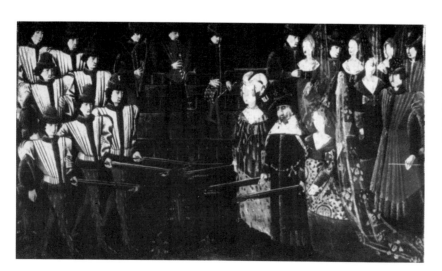

10. The Dance of the White Knights, from *Cleriadus et Meliadice*, chap. XXVIII, Turin, Bibl. naz. univ., MS. 1628 L.II.2 (photo: Biblioteca nazionale, Turin)

Images of Music in Three Prints
after Maarten van Heemskerck

•

H. COLIN SLIM

WHILE no written document about Maarten van Heemskerck (1498–1574) reveals any musical interests, several of his paintings and prints suggest that he was well acquainted with music.[1] They also reveal how musical instruments of his own time and those of classical antiquity fascinated Heemskerck, who lived in Italy from 1532 to 1537, years crucial to his stylistic development. Vasari, for one, testified to numerous Italian painters who were competent instrumentalists and even adept at composition.[2] It is thus easy to imagine that Northern painters might also have had similar musical talents. The topic of this paper is three prints made after Heemskerck's designs that include music. Together they may contribute in a modest way to the subject of this volume, since in each print music is used differently and carries different weight in communicating the meaning of the image.

Heemskerck's woodcut of The Prodigal Son with the Harlots is part of an undated cycle (ca. 1548) of the Prodigal's adventures before he returned penniless and penitent to his father (Fig. 1).[3] Using food, drink, and music, Heemskerck depicted that scene in the Vulgate of "vivendo luxuriose," translated in the King James Version as "riotous living." In the background, Heemskerck also showed the temporal result of "riotous living": the Prodigal is driven out naked, kicked by three lovelies whose attentions he enjoyed before he ran out of money.

The parable itself does not mention music until near the end, when the Prodigal's family celebrates his return. By the mid-sixteenth century, however, a good many paintings of the

[1] His Muse paintings in New Orleans, Museum of Art, and Norfolk, Chrysler Museum, for example, contain a French chanson and two arrangements for keyboard of Dutch songs; see R. Grosshans, *Maerten van Heemskerck. Die Gemälde*, Berlin, 1980, pls. 119, 132; and H. C. Slim, "On Parnassus with Maarten van Heemskerck: Instrumentaria and Musical Repertoires" (forthcoming).

[2] See H. C. Slim "Dosso Dossi's Allegory at Florence about Music," *Journal of the American Musicological Society*, XLIII, 1990, 43, with printer's errata accompanying the ensuing (summer) issue.

[3] See F. W. P. Hollstein, *Dutch and Flemish Etchings, Engravings and Woodcuts ca. 1450–1700*, VIII, Amsterdam, 1953, 235, no. 51 (no. 53 is signed *M. Heemskerck*). T. Kerrich, *A Catalogue of the Prints which have been engraved after Martin Heemskerck; or rather An Essay Towards such a Catalogue*, Cambridge, 1829, 72–73, believes that: "Heemskerck drew this upon the Block; that is, he adumbrated himself for the wood-cutter," but I. M. Veldman, *Maarten van Heemskerck and Dutch Humanism in the Sixteenth Century*, Amsterdam, 1977, 55, n. 3, suggests it was cut by Dirck Coornhert (on whom see below, notes 10, 16, 23, 28–32), while working for Heemskerck from 1547 to 1559; Grosshans (as in note 1), 219–20 and pl. 234b, supplies the approximate date.

Prodigal's dissipations are inscribed with real music for him and his dissolute company to sing and play. For example, in a Flemish painting in the Museo Correr, Venice (sometimes attributed to Coecke van Aelst), a late fifteenth-century chanson by Jacob Obrecht (ca. 1450–1505) has an integral role in the content. Accompanied by two women musicians, the Prodigal beats time and sings the text of Obrecht's chanson: "How shall we gamble with the money bag [?]; our gold is all gone. I am about to go outside to beg for it."[4] In the distant background, harlots drive the now penniless Prodigal from their midst.

In Heemskerck's woodcut, however, music and a musical instrument are used as the more general and long-accepted symbols of dissipation. The strange instrument played by one of the harlots seems to be some kind of a lira da braccio, the Renaissance version of the ancient lyre to which one improvised and sang, just as the harlot does in the woodcut. Five strings and a sickle-shaped peg box characterize the lira da braccio. Here the deep-waisted shape is uncharacteristic, while the lack of a bridge and the extremely shallow sound box are unrealistic. Variants of this peculiar instrument appear quite frequently in Heemskerck's work. In a lost painting of the Prodigal's dissipation that contained real music, one of the loose ladies played a curious viola da gamba.[5] Although it had a bridge for five strings, this instrument sported the same impossibly thin sound box, to say nothing of a support stick. Similar stylized viols da gamba appear in both Muse paintings by Heemskerck.[6] Likely derived from observation of real stringed instruments, they were surely transformed through his imagination.

The book of music on the harlot's lap in the woodcut makes no such complex allusion as that effected by Obrecht's chanson in the Flemish painting. The notation in Heemskerck's book is not merely stylized, but totally faked. This could have resulted simply from the difficulty in cutting the block, but Heemskerck was also content here to invest the book of music with no special meaning beyond that of a general symbol of dissipation.

A copper engraving by Cornelis Bos (ca. 1506–56), signed and dated *M Heemskerck / 1543*, again depicts the Prodigal in the foreground "wasting his living with harlots" (Fig. 2).[7] The background shows a later episode in the parable when the Prodigal feeds swine in the fields. Recollections of Rome are stronger in the engraving than in the woodcut. The foreground has classicizing elements such as the fountain and the harpy-like figure serving as a

[4] H. C. Slim, *The Prodigal Son at the Whores': Music, Art, and Drama*, Irvine, 1976, 16–20 and pls. 12, 13. Three additional sources for *Wat willen*, listed in C. Maas, "Towards a New Obrecht Edition. A Preliminary Worklist," *Tijdschrift van de Vereniging voor Nederlandse Muziekgeschiedenis*, XXVI, 1976, 86, 88, still fail to challenge the painting's crucial superiority in preserving the most text for Obrecht's chanson. R. W. Baldwin, "A Bibliography of the Prodigal Son Theme in Art and Literature," *Bulletin of Bibliography*, XLIV, 1987, 167–71, cites useful new studies.

[5] See Grosshans (as in note 1), pl. 121.

[6] See above, note 1.

[7] Hollstein (as in note 3), III, 125, no. 69: "The Concert" [*sic*], and ibid., VIII, 237. See also L. Preibisz, *Martin van Heemskerck*, Leipzig, 1911, pl. III; S. Schele, *Cornelis Bos, A Study of the Origins of the Netherland Grotesque*, Stockholm, 1965, 119, no. 26, and pl. 10; and Grosshans (as in note 1), pl. 233. Another engraving from 1562 by Philips Galle (1537–1612) after Heemskerck depicts a transverse flute and lyre but lacks musical notation; see Hollstein (as in note 3), VIII, 244, no. 283; Grosshans (as in note 1), pl. 235a; and *The Illustrated Bartsch*, ed. W. L. Strauss, 56, *Netherlandish Artists: Philips Galle*, ed. A. Dolders, New York, 1987, 115: "The Prodigal Son's Riotous Living."

headboard to the bed. The long trumpet, the classical lyre played by a Michelangelesque harlot, and the four-stringed horned lyre furnish equally powerful associations with Roman musical traditions, both ancient and those of Heemskerck's own time.[8] Clearly Heemskerck enjoyed the antique associations of the horned lyre since it reappears, along with the fantastic viol, in his Muse painting in New Orleans.

Notation notwithstanding, the first impression of real music in the copper engraving is only slightly less faked than the woodcut. The oblong format of the book on the Prodigal's knee suggests a single part book, but the notational elements of breves, minims, and rests that occur in a haphazard and nonfunctional manner belie real music. The squarish book held by the hermaphrodite has four staves of music on each opening. Clefs on each page and the shape of the volume suggest a choir book, a format normally disposing two voice parts on a verso and two voice parts on a recto. We read on the verso side below the first stave: "Scoen Liefken" (Handsome fellow), and on the recto side below the second stave: "vrest Den Her." (fear the Lord). "Scoen Liefken" is a textual incipit for three monophonic songs and for at least eight different polyphonic compositions found in musical sources from the 1520s through the 1570s.[9] However, such music as can be read in Heemskerck's engraving resembles none of these compositions. "Vrest Den Her" is perhaps from Proverbs 16:6: "The fear of the Lord makes men turn from evil," but again the musical notation resembles no settings of the text.[10] The engraver might have copied directly from Heemskerck's original design but garbled it in the process. We know that in both his later Muse paintings Heemskerck inscribed music accurately. The two verbal inscriptions in this engraving may in fact be meant not to identify musical compositions but to be read successively as "Handsome lad, fear

[8] For example, when in Rome, Heemskerck sketched a horned lyre held by Clio, one of several Muse figures on a sarcophagus then in St. Paul's Outside the Walls and now in the Terme Museum; see *Attraverso il cinquecento neerlandese. Disegni della collezione Frits Lugt*, Florence, 1980, pl. 51, bottom center ("Clio"); and the far left muse in E. Winternitz, *Musical Instruments and Their Symbolism*, New York, 1967, pls. 85a, 86, 87b.

[9] A partial list of these appears in the introduction by E. Schreurs to the facsimile edition, Peer (Belgium), 1987, 11–12, of *Het tvueetste musyck boexken*, Antwerp, 1551. Additional polyphonic sources I have checked are: *Répertoire international des sources musicaux*, ed. F. Lesure, Munich, 1960, 1554-31, nos. 2, 3 (different versions); The Hague, Koninklijke Bibliotheek, ms. 74/h/7, fol. 31 [correctly: 30–31], about which see G. Thibault, "Un manuscrit de chansons françaises à la Bibliothèque Royale de la Haye," *Gedenkboek aangeboden aan Dr. D. F. Scheurleer op zijn 70sten verjaardag*, ed. G. Adler et al., The Hague, 1925, 355, no. 26; and Munich, Bayerische Staatsbibliothek, Mus. ms. 1516, fol. 18, about which see M. Göllner, ed., *Tabulaturen und Stimmbücher bis zur Mitte des 17. Jahrhunderts*, Bayerische Staatsbibliothek, Katalog der Musikhandschriften, 2, Munich, 1979, 93, no. 25, and 99 with thematic incipit.

[10] See *De Bibel*, Antwerp, 1560, fol. Hh iiij: "in die vreese des Heeren wijcktmen van tquaet." The phrase also appears in Proverbs 1:7 and 9:10, and in Ecclesiasticus (Sirach) 1:11–12. A character called "De Vreese des Heeren" appears in a play, *Vreese des Heeren en Wijsheit* (ca. 1600), and the character appears at Berchem's production at Antwerp in 1561 and in yet another play at Brussels in 1599. D. Coornhert's play, *Abrahams Uutgang* (ca. 1570), first printed 1575, includes a "Timor Dei (Vreese Godts)." Coornhert's rhyming translation, *Recht Ghebruyck ende Misbruyck van tydlycke Have* (1585) of B. Furmer, *De rerum usu et abusu* (1575), also contains the phrase "vreest ghy God." On the plays, see W. M. H. Hummelen, *Repertorium van het Rederijkersdrama 1500–ca. 1620*, Assen, 1968, 120–21, 157, 180, 239, 247, 386–87; and on Coornhert's translation, see H. Bonger, *Leven en werk van D. V. Coornhert*, Amsterdam, 1976, 381–82, and K. Renger, *Lockere Gesellschaft: zur Ikonographie des verlorenen Sohnes und von Wirtshausszenen in der niederländischen Malerei*, Berlin, 1970, 54–56 and pl. 31. Bos's 1543 engraving is probably not connected, however, with the twenty-one-year-old Coornhert (Heemskerck's later advisor and engraver) living at Vianen in 1543. Late in life Coornhert published an abridged translation of Saint Augustine's commentary on the parable of the Prodigal Son; see Bonger, 384, and Renger, 67.

the Lord," which would seem appropriate for the career of the Prodigal Son. Thus the text's accompanying music is more explicit than the music in the woodcut, although in both scenes we easily accept the music as symbols of the Prodigal's dissipation. The text in the engraving, however, makes a significant difference because it assigns to the music a greater specificity.

My third example from Heemskerck's prints, titled by Ilja Veldman an Allegory of Good and Bad Music, exists in two states.[11] The first, dated 1554 and published by Hieronymus Cock (ca. 1507–1570), does not name Heemskerck.[12] However, the second state, dated 1610 and published by Hieronimus Hondius (1563–ca. 1611), cites him as "M. Heemskerck invent[or]" (Fig. 3).[13] The engraving depicts a procession moving from right to left, showing music's decadent qualities, embodied by the singers and a satyr who bears a large choir book on his back. The satyr, ordinarily a standard symbol for Luxuria,[14] may be present here for another reason since the print attacks not only the decadent qualities of music but also those of society. A mistaken belief (not corrected until some fifty years later), which was shared by Heemskerck's learned friend and likely collaborator Hadrianus Junius (1511–1575), that 'satire' derived linguistically from 'satyr' often caused artists to illustrate satire with a satyr.[15] Be this as it may, music's qualities of decadence lead at the far right to a bad end of drunkenness and poverty. Each segment of the engraving has Dutch and Latin phrases above and Latin sentences below that explain this unfortunate journey; for these, I follow Veldman's exemplary study, numbering them, for ease of discussion, from left to right, 1 through 5.

Segment 1 identifies singers and satyr above in Latin as "A group of people who waste their lives" and in Dutch as "The lost multitude." Below, two Latin lines read: "Generally a wastrel nation, born only to waste its fruits, busies itself with this [kind of] art."[16]

[11] See the fine study of Veldman (as in note 3), 74–76, and note 78.

[12] Leiden University, Prentenkabinet, no. N149HEE/79,80-I, illustrated in Veldman (as in note 3), 74–75, pl. 51.

[13] Kerrich (as in note 3), 102, cites this edition only, calling it an "Allegory." Veldman (as in note 3), 74, n. 78, cites a now unknown 1557 edition. Hollstein (as in note 3) lists none of these editions.

[14] Veldman (as in note 3), 76, n. 88, cites Alciati, *Emblemata*, Lyon, 1551, 80.

[15] See H. Junius, *Lexicon sive dictionarium graecolatinum*, Basel, 1548; repr. 1557, fol. Bbbb[6]v and his often-reprinted *Nomenclator omnium rerum propria nomina variis linguis explicata indicans*, Antwerp, 1567, 12, "Satyra"; and R. B. Waddington, "A Satirist's *Impresa*: The Medals of Pietro Aretino," *Renaissance Quarterly*, XLII, 1989, 661–64.

[16] Here I adapt a translation kindly offered by Professor Lucy Berkowitz. The word "frugiperda" (literally "fruit-losing") below segment 1 (with "Frugiperdarum" above) appears in classical literature solely in Pliny, *Natural Histories* 16.46.110. Pliny, paraphrasing Theophrastus's Greek, uses "frugiperda" to translate ὠλεσίκαρπον ("which loses its fruit") in Theophrastus, *Enquiry into Plants* 3.1.3, who had cited it from the *Odyssey* 10.510 (see the translation of Theophrastus by A. Hort, Cambridge, Mass. and London, 1948, 160–61.) Whether "frugiperda" in the engraving comes directly from Pliny, from Latin translations of Theophrastus (such as that of Theodore Gaza, 1483, reprinted 1529, 1534, and 1550), or from those of Homer is unknown. Pliny is a possible source because his next statement: "succeeding ages have interpreted the meaning of the word in the light of its own wicked conduct" seems relevant for the engraving. (See the translation of Pliny by H. Rackham, Cambridge, Mass. and London, 1960, 458–59.) A prose translation by Raphael Volterranus, *Odissea Homeri*, Rome, 1510, Book X, renders the Greek as "frugiperdae"; Coornhert's own translation of the Odyssey, *Deerste twaelf boecken Odysseae. dat is de dolinghe van Vlysse*, Haarlem, 1561, rendering it as "zonder vruchten." (See *De Dolinge van Ulysse*, trans. Coornhert, in "Bibliotheek der Nederlandse Letteren," ed. Th. Weevers, Amsterdam, 1939, 218, line 486, with modernized spelling.) Bonger (as in note 10), 30, 364, states that Coornhert knew no Greek, relying for his Dutch version on a Latin translation by Abbé Casparus, printed at Basel in 1551 (an edition I have been unable to locate). Yet, as the date of Coornhert's translation suggests and as Veldman (as in note 3), 91, n. 138, shows, he began serious study of Latin only ca. 1554–57. Using such a rare word as "frugiperda" surely indicates some scholar, perhaps Hadrianus Junius, supplier of verses for Heemskerck's *Momus* (1561) and for engravings from 1551 (see Veldman [as in note 3], 101–5), who not

Segment 2 includes two females: the first, called "Renown," holds a wreath; the second, named "Recompense-Reward," carries in one hand a scourge and in the other a moneybag, which she offers via "Cupid-Desire" to the first figure of segment 3. Below them is the sentence: "Renown and Reward encourage Diligence."

In segment 3, "Industria-Diligence" pulls the center cart. Holding a large tablet, she writes a soprano clef and a C mensuration sign on the first of ten ruled staves.[17] Her tablet is a cartella for composing, defined in 1611 as "a kind of sleeked pasteboord to write upon and [which] may be blotted out againe."[18] Her inscribed music differs from that on the satyr's back. Above and on either side of Industria-Diligence, two Latin sentences elaborating Plato's concepts about music found in the *Laws*, *Republic*, and *Timaeus* relate to the three figures on the cart she pulls.[19] The sentence to the left joins the musical term harmony to a harmonious balance of reason and sense: "When the senses hearken to reason's measure and when that measure restrains all free will, then there is nothing sweeter than that harmony." The sentence to the right links musical harmony to political harmony: "When joyous peace flourishes and just law holds sway, and the people hearken to the words of their rulers, then there is nothing sweeter than that harmony."

On the cart sits a male figure labeled "Genius," who, holding a frame harp and wearing a winged petasus, is thus Mercury, the inventor of the lyre[20] and a standard figure for creativity.[21] Also on the cart is a female named in Latin and Dutch "Delight," who sits next to a two-rank positive organ and holds a horned lyre. Below the keyboard are a viol and a lute. Musical symbolism informs the very cart itself: its visible wheel has small horns around it and its axle is a shawm. Genius and Delight share a pair of calipers on which balances a tiny winged "Musica." For Mercury, the creator, Musica holds aloft a wreath, while for Delight

only cited "frugiperda" in his *Lexicon* (1557 ed., fol. Rrr5v, as in note 15), but also employed "frugiperda" to define "Nebulo" (a knave) in his *The Nomenclator, or Remembrancer*, London, 1585, 528 (1567 ed. [as in note 15], 533). During 1554, when Heemskerck's print appeared, Junius only briefly left Haarlem (rector of the Latin school and physician there, late 1550–52) and returned to England (where he had practiced medicine ca. 1543–50), dedicating in October 1554 his *Philippeis sive epithalamium in Philippi et Mariae nuptias*, London, 1554, to King Philip and Queen Mary (married 25 July 1554). See A. J. van der Aa, "Junius (Hadrianus)," *Biographisch Woordenboek der Nederlanden*, IX, Haarlem, 1860, 236, and I. M. Veldman, "Enkele aanvullende gegevens omtrent de biografie van Hadrianus Junius," *Bijdragen en mededelingen betreffende de geschiedenis der Nederlanden*, LXXXIX, 1974, 377–78 and 381–84.

[17] See J. A. Owens, "The Milan Partbooks: Evidence of Cipriano de Rore's Compositional Process," *Journal of the American Musicological Society*, XXXVII, 1984, 281–82, and fig. 2 (a detail of Industria-Diligence).

[18] Ibid., 280.

[19] Veldman (as in note 3), 76, nn. 82–84.

[20] See H. G. Evelyn-White, trans., *Hesiod: The Homeric Hymns and Homerica*, London, 1970, 364–67, Hymn IV "To Hermes"; and M. Maas and J. M. Snyder, *Stringed Instruments of Ancient Greece*, New Haven and London, 1989, 26–27, 35–36.

[21] For example, Mercury is depicted about 150 years earlier in a Netherlandish manuscript, New York, Pierpont Morgan Library MS. 785, fol. 48, holding a lira da braccio, the Renaissance equivalent of the classical lyre; see E. Panofsky, *Early Netherlandish Painting: Its Origins and Character*, I, New York, 1971, 106–8; and II, pl. 65, fig. 136. Preceding the lira is a one-page commentary, fol. 46v, that emphasizes Mercury's regard for metrical and rhythmical song ("melica, metrica et rithmica") and for a pleasing and melodius voice ("grata vocis modulatio"). I owe transcription and translation to Kathy Chew. The inventory of musical instruments in MS. 785 by T. Ford, *RIdIM/RCMI Inventory of Music Iconography no. 3: The Pierpont Morgan Library*, New York, 1988, items 804–10, omits the lira on fol. 48. On the lira da braccio, see Winternitz (as in note 8), 86–98.

she offers a yoke. Below, the Latin reads: "Genius and Delight bring forth Music." The art of music must result from an ideal union of inventiveness and disciplined delight. Obviously the pair of calipers, denoting temperance and moderation, signifies a rational admixture of inventiveness and delight in musical composition.

Segment 4 includes three women, each holding one or more ears. The left woman, "Carelessness-Waste of Time," who spills sand from her hourglass, holds one ear; the middle woman, "Reputation-Delusion," who carries a mirror signifying illusion, holds a pair of ears; and the right woman, "Idleness-Sloth," who has some kind of an uprooted plant, holds a pair of ass's ears, an attribute of Sloth. The sentence below reads: "These three sisters serve Musica with their ears," a clear warning that ears can deceive and that music is here served badly by them.[22]

Segment 5 depicts "Prodigality-Foolish Generosity," who empties his moneybag before a man dressed like the singers in segment 1 and labeled "Troop of Singers-Penniless Company." Below we read: "This one squanders his wealth in paying the singers." On the cart sits "Bacchus-Drunkenness" served by "Immoderation" who holds broken calipers, a sign of intemperance. "Poverty" brings up the rear. Below them appears: "Drunkenness follows song and is in turn followed by poverty."

The subject matter in this engraving differs radically from that in the previous two. While music is again a symbol for dissipation, leading to a bad end, here it plays a more arcane role that is by no means immediately obvious, raising questions about its interpretation. Three layers of musical meaning are suggested, the simplest interpretation resulting from verbal references in the engraving to Platonic ideas on music. Boethius formulated these in his *De institutione musica* (early sixth century) as "three classes concerned with the musical art. The first performs on instruments, the second composes songs, and the third judges the instrumental performances and the composed songs. And since this third class is devoted totally to reason and thought, only it can rightly be considered musical."[23] The widely read sixteenth-century theorist of music Heinrich Glareanus (1488–1563) refashioned this persistent topos in his *Dodecachordon* (Basel, 1547) as "true musicians [are those] who judge not only by hearing but by reasoning."[24] The allegory thus probably attacks both performers and composers.

[22] Horace, *Satires*, 2.3.14, calls "desidia" (idleness) an "improba Siren" (deceitful Siren). Since Sirens could come in threes, Heemskerck's three women might also recall how Sirens in the Odyssey lured sailors through their ears to their doom; see *Horace: Satires, Epistles and Ars Poetica*, ed. H. Rushton Fairclough, Cambridge, Mass., and London, 1961, 152–53.

[23] See the slightly different translations in O. Strunk, *Source Readings in Music History From Classical Antiquity Through the Romantic Era*, New York, 1950, 86; and P. Weiss and R. Taruskin, *Music in the Western World: A History in Documents*, New York and London, 1984, 37–38. Coornhert, who was the engraver of the 1554 print and who may have furnished Heemskerck with its program (see above, notes 10 and 16, and below, notes 28–30), perhaps also knew *De institutione musica*, having published translations of Boethius's *De consolatione philosophicae* around 1557 and in 1585. See A. Grafton, "The Dutch Tradition," in *Boethius: His Life, Thought and Influence*, ed. M. Gibson, Oxford, 1981, 398, app. II.

[24] Book III, 113, 239; see the translation by C. A. Miller, "Musicological Studies and Documents," 6, Rome, American Institute of Musicology, 1965, 2, 247.

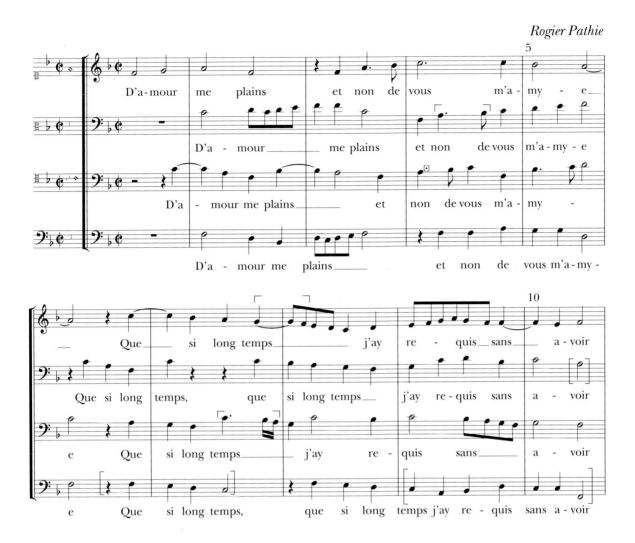

Text Fig. A. Rogier Pathie, opening breves of "D'amour me plains, e non de vous m'amye"

A second layer of meaning requires considerably more analysis and knowledge. In segment 3 the music that Industria-Diligence composes on her cartella enjoys the tacit approval of Genius and Delight in the cart and of Musica above them, and thus is presumably superior to the composition in the big choir book on the satyr's back. Although this work has no text, Veldman thought it was polyphonic sacred music, which the engraving allegedly attacks.[25] In point of fact, however, the music is the opening ten breves of a chanson by the Franco-Flemish composer Rogier Pathie (ca. 1510–after 1565), "D'amour me plains, e non de vous m'amye" (Fig. 4 and Text Fig. A).[26] From its first two editions at Paris in 1539, "D'amour

[25] Veldman (as in note 3), 75.

[26] Editions of the chanson are in R. Eitner, ed., *60 Chansons zu vier Stimmen* (Publikation älterer praktischer und theoretischer Musikwerke, 23), Leipzig, 1899, 101–2, no. 49 (after 1539-15 in *Répertoire international des sources musicaux*, as in note 9, but transposed a fourth higher) and in Thomas Crecquillon, *Opera omnia*, ed. B. Hudson, Rome, American Institute

me plains" enjoyed an enormous popularity for some one-hundred years, as demonstrated by no less than 26 prints, 4 manuscripts, and 21 printed arrangements for lute, viols, cittern, and keyboard instruments.[27] Indeed, its widespread popularity may be one reason why Heemskerck's engraver felt no need to include its words.

According to Veldman, the style of engraving of the 1554 print corresponds to that in some other prints also made after Heemskerck's works by Dirck Volkertszoon Coornhert (1522–1590). Coornhert began engraving for Heemskerck in 1547.[28] Veldman showed that Coornhert—humanist, poet, playwright, philosopher, theologian, statesman, civic administrator, and patriot[29] —supplied programs in many instances for Heemskerck. She argued plausibly that Coornhert also invented the program for this engraving, citing a poem in Dutch by Coornhert dealing with political and personal harmony. Each stanza of his poem concludes with the refrain line "lieflicker Muzyke,"[30] which is analagous to the "harmonia dulcius" lettered on either side of Industria-Diligence.

Young Coornhert was also a musician, which provides another reason for identifying him with this engraving. His earliest biographer noted: "He could play in a masterly fashion on the transverse flute, on the lute, and on the harpsichord."[31] Indeed, a portrait engraved about 1591 by Coornhert's student Hendrick Goltzius (1558–1617) includes, among other emblems of his fame, in the lower right-hand corner, viol, lute, shawm, long trumpet, and books of music.[32] Custodian from 1541 to 1544 of the huge collection of instruments, books and music owned by the van Brederode family at Vianen,[33] Coornhert had ample opportunity to practice and study music. First published in Paris in 1539 and then in Antwerp in 1543, "D'amour me plains" was the right vintage to have appealed to young Coornhert and we may assume that he supplied it to his collaborator, Heemskerck, for the 1554 engraving.

of Musicology, 1974, I, 26–27 (after *Répertoire*, 1543-16). A textless version save for an incipit "Nuhr leichtsinnig" in *Carmina Germanica et Gallica*, 2, ed. W. Brennecke (Hortus Musicus, 138), Cassel and Basel, 1957, 7–8, no. 18 (after Regensburg, Bischöfliche Zentralbibliothek, MS. A.R. 940–41, copied 1557–59), is identified in J. Kmetz, *Katalog der Musikhandschriften des 16. Jahrhunderts (Die Handschriften der Universitätsbibliothek Basel)*, Basel, 1988, 195, no. 26.

[27] No version of the chanson, printed or manuscript, totally agrees with the one in Heemskerck's engraving. For bibliography of this chanson, see L. F. Bernstein, "The Cantus-Firmus Chansons of Tylman Susato," *Journal of the American Musicological Society*, XXII, 1969, 206, no. 21; *New Grove Dictionary of Music and Musicians*, London, 1980, s.v. "Pathie, Rogier" (F. Dobbins); and Kmetz (as in note 26), 195, no. 26.

[28] Veldman (as in note 3), 55, who also (74, n. 78) cites Coornhert as engraver of a lost 1557 edition of the "Allegory."

[29] See Bonger (as in note 10), passim, and the listing of Coornhert's works in the *Bibliotheca Belgica*, I, Brussels, 1964, 694–767.

[30] Veldman (as in note 3), 76, n. 89; the poem was first printed in 1575 (*Bibliotheca Belgica* [as in note 29], 723–24). I wish to thank my colleague Willem van Overeem for translating it.

[31] "Hy conde seer meesterlijck spelen op de duytsche fluyte, oock op de luyte ende clavecimbel"; see Bonger (as in note 10), 21.

[32] Reproduced in ibid., frontispiece; see Hollstein (as in note 3), VIII, 41; and *Hendrik Goltzius 1558–1617: The Complete Engravings and Woodcuts*, ed. W. L. Strauss, II, New York, 1977, 510–11, no. 287.

[33] See Bonger (as in note 10), 13, 21–24; and J. J. Salverda de Grave, "Twee inventarissen van het huis Brederode," *Bijdragen en mededelingen van het Historisch Genootschap (gevestigd te Utrecht)*, XXXIX, 1918, 68–119, 159, partly cited by K. K. Forney, "Tielman Susato, Sixteenth-Century Music Printer: An Archival and Typographical Investigation," Ph.D. diss., University of Kentucky, 1978, 57–58; and partly in idem, "New Documents on the Life of Tielman Susato, Sixteenth-Century Music Printer and Musician," *Revue Belge de Musicologie*, XXXVI–XXXVIII, 1982–84, 40.

Although the engraving shows music for only the first two lines of the poem, since the same music was used for the second pair of lines, we actually have enough for the opening quatrain. The full text of the chanson follows:

D'amour me plains et non de vous m'amye
Que si long temps j'ay requis sans avoir
Mais si voulez estre son ennemye
Vous confrondrez mon dire et mon scavoir.
Vous seulle avez cest estime pouvoir
Si aultrement ne scay que faire et dire
Abaissez donc son rigoureux vouloir
Et me donnez le bien que je desire.

(Of Love I complain, not of you, my lady-friend,
Which for so long I have sought without possessing,
But if you want to be its adversary,
You will confound my word and learning.
You alone have this prized power,
Otherwise, I know not what to do and say,
Lessen then its stern will
And grant me the happiness that I long for.)

Obviously this chanson is some distance from the "polyphonic Church music" that Veldman suggested, its secular text weakening (though not entirely negating) her view that the engraving refers to attacks on contemporary sacred polyphony.[34]

Her interpretation apparently resulted from the dress of the singers. She wrote of a choir of boys and adults, who could be either ecclesiastics or laymen, observing that although their normal dress was a surplice, on ceremonial occasions they wore tabards.[35] The garments of these men, however, resemble surplices more than tabards. Although the headpieces worn by three of the adults could be those of either ecclesiastics or scholars, the tonsure of the second adult from the right seems decisively to define these singers as clerics.

Veldman's specific reading of the allegory as an attack on polyphonic church music rests on her incorrect belief that the music in segment 1 is sacred, but her general interpretation, i.e. that it is an allegory of good and bad music, is undoubtedly correct. To what extent does our new knowledge of the source of the music justify our probing more deeply? For example, how many viewers might have recognized "D'amour me plains" without its words? And why does a group of clerics and boys sing a chanson? May we then read the print as an attack on ecclesiastical singers performing secular music in general, and the amorous French chanson in particular, leading them to a bad end? Perhaps so, since in a 1526 discussion of the latest

[34] Veldman's general thesis (as in note 3), 76, that Glareanus in the *Dodecachordon* (essentially finished by 1538) "bitterly attacked the polyphonic church music of his day" is not sustainable. For example, her first citation, 76, n. 87, refers not to polyphony at all but to chant; moreover, it is inappropriately joined to her second citation (same note) occurring some 147 pages later in Glareanus, who castigates there not all polyphony, but only that exceeding four voices.
[35] Ibid., 75, n. 80.

hit tunes based on pernicious subject matter, especially those composed by Flemings, Erasmus complained that "in modern songs even if the text is not sung the foulness of the subject can be understood from the nature of the music."[36] He further deplored using secular melodies in sacred polyphony.[37]

If we interpret the print as an attack on ecclesiastical singers, we arrive at a third layer of meaning: an even subtler attack on church music of the times. Another Franco-Flemish composer, Thomas Crecquillon (ca. 1480–1557), used Pathie's chanson in his four-voiced Missa "D'amours me plains."[38] First published at Antwerp in 1545, Crecquillon's mass was well-known in the Low Countries and in Germany, appearing in several manuscripts copied there in the 1550s.[39]

For his mass, Crecquillon employed a method of composition known as parody technique, in which he quoted not just single voice parts from Pathie's chanson but substantial, polyphonic vertical slices from it. Howard Mayer Brown described Crecquillon's technique: "His use of models is usually straightforward and the original contours of the parodied works are easily recognizable in his reworkings."[40] Comparison of the openings of Crecquillon's Kyrie, Gloria, and, especially, the first Agnus Dei to that of Pathie's chanson confirms the accuracy of Brown's statement.

Around the time of Heemskerck's print, explicit condemnations were made about using secular songs in writing masses. In a letter of 1549, Bishop Cirillo Franco asked: "What the devil has [sacred] music to do with the armed man or with the nightingale, or with the Duke of Ferrara?"[41] Particularly relevant for our interpretation of Heemskerck's engraving is the complaint in 1555 by the composer-theorist Nicolò Vicentino (1511–ca. 1576), proving that people knew such songs well enough to recognize them: "Some will compose a mass upon a madrigal or a *French song* or upon a battle, and when such compositions are heard in the Church they induce everyone to laugh"[42] Thus, juxtaposing the opening of Pathie's chanson and a group of clerical singers performing from a choir book might well have been a means of suggesting Crecquillon's well-known parody mass built on this chanson—and, therefore, a satire of which a satyr could be proud.

In a print that criticizes ecclesiastical singers as "a wastrel nation, born only to waste its fruits," it can hardly be coincidence that the very piece they sing was appropriated in a mass

[36] See C. A. Miller, "Erasmus on Music," *Musical Quarterly*, LII, 1966, 347–48.

[37] See *New Grove Dictionary* (as in note 27), s.v. "Erasmus" (A. Dunning).

[38] See Crecquillon (as in note 26), 1–25.

[39] These are Leiden, Gemeentearchief, MS. 1442 (probably copied in Amsterdam for Leiden); Regensburg, Bischöfliche Zentralbibliothek MS. C 96; and Rostock, Bibliothek der Wilhelm-Pieck-Universität, MS. Mus. Saec. XVI-40 (1–5), about which see H. Kellman and C. Hamm, *Census-Catalogue of Manuscript Sources of Polyphonic Music 1400–1550*, Neuhausen-Stuttgart, II, 1982, 29; III, 1984, 99, 121; and IV, 1988, 419.

[40] *New Grove Dictionary of Music* (as in note 27) s.v. "Crecquillon, Thomas."

[41] K. G. Fellerer, "Church Music and the Council of Trent," *Musical Quarterly*, XXXIX, 1953, 583, n. 25. The letter was not published until 1564.

[42] Ibid., 582, n. 20 (italics mine). The facsimile edition of Vicentino, *L'antica musica ridotta alla moderna prattica*, ed. E. E. Lowinsky, "Documenta Musicologica," I, XVII, Cassel, 1959, is defective here precisely at Book IV, XXVI, 84, chapter and page being incorrectly numbered as XIX and 79, respectively.

composition familiar to them, and, indeed, to any singing cleric of the time. While this relevance was possibly in the mind of the program's inventor—undoubtedly Heemskerck's musically learned collaborator and engraver, Coornhert—the degree to which Heemskerck and Coornhert expected it to be understood remains unclear. And if this is unclear, how much more uncertain must be its understanding today, even though neither man likely had posterity in mind.

Viewed as a group, these three prints require a variety of explanations for their differing uses of music. Leaving aside legitimate questions about the abilities of copyists and engravers to depict music in them, a single historical reason most readily accounts for the sophisticated use of music in the allegory: Coornhert's return to Haarlem in 1546. His subsequent employment by Heemskerck also coincides with the appearance of real music in Heemskerck's Muse painting in New Orleans. It is possible, of course, that musical notation was simply more important in the 1554 allegory than it was in the two Prodigal narratives. Whatever may be the true explanation, the three prints remind us that music, like other potentially meaningful signs, resists easy, or even consistent, classification.

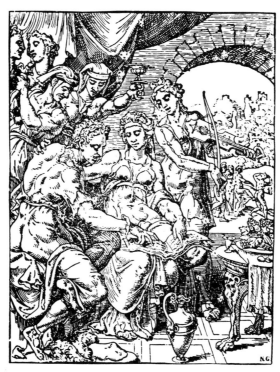

1. Maarten van Heemskerck, The Prodigal Son with
the Harlots, ca. 1548, woodcut (after F. W. P. Hollstein,
*Dutch and Flemish Etchings, Engravings and Wood-
cuts ca. 1450–1700*, VIII, Amsterdam, 1953, 235,
no. 51)

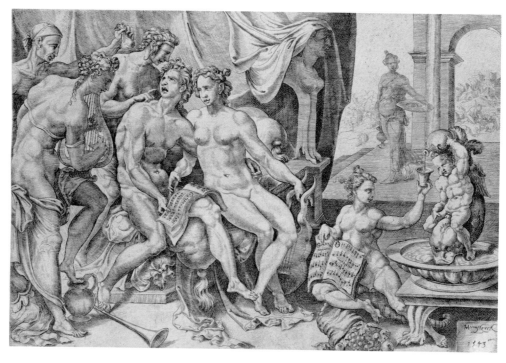

2. Cornelis Bos (after Maarten van Heemskerck), The Prodigal Son with the Harlots, ca. 1543, engraving.
Boston, Museum of Fine Arts, Bequest of William P. Babcock (photo: Museum of Fine Arts)

3. Maarten van Heemskerck, Allegory of Good and Bad Music [1554], second state published by Hondius and dated 1610, engraving. Haarlem, Municipal Archives (photo: Municipal Archives, Haarlem)

4. Detail of music book in Fig. 3

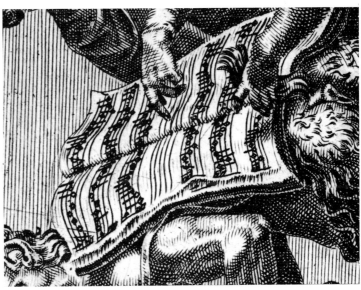

Index

•